Vaccines

The Story of a Drug

Painkillers: History, Science, and Issues
Victor B. Stolberg

Antipsychotics: History, Science, and Issues
Jeffrey Kerner and Bridget McCoy

Steroids: History, Science, and Issues
Joan E. Standora, Alex Bogomolnik, and Malgorzata Slugocki

Vaccines

HISTORY, SCIENCE, AND ISSUES

Tish Davidson

The Story of a Drug

 GREENWOOD™

An Imprint of ABC-CLIO, LLC
Santa Barbara, California • Denver, Colorado

Library of Congress Cataloging-in-Publication Data

Names: Davidson, Tish, author.
Title: Vaccines : history, science, and issues / Tish Davidson.
Description: Santa Barbara : Greenwood, an Imprint of ABC-CLIO, LLC, [2017] |
 Series: The story of a drug | Includes bibliographical references and index.
Identifiers: LCCN 2017006238 (print) | LCCN 2017009240 (ebook) |
 ISBN 9781440844430 (hardcopy : alk. paper) | ISBN 9781440844447 (ebook)
Subjects: LCSH: Vaccines. | Vaccines—History.
Classification: LCC RM281 .D38 2017 (print) | LCC RM281 (ebook) |
 DDC 615.3/72—dc23
LC record available at https://lccn.loc.gov/2017006238

ISBN: 978–1–4408–4443–0
EISBN: 978–1–4408–4444–7

21 20 19 18 17 1 2 3 4 5

This book is also available as an eBook.

Greenwood
An Imprint of ABC-CLIO, LLC

ABC-CLIO, LLC
130 Cremona Drive, P.O. Box 1911
Santa Barbara, California 93116-1911
www.abc-clio.com

This book is printed on acid-free paper ∞

Manufactured in the United States of America

For Scott who has listened patiently for many years.

Contents

Series Foreword

While many books have been written about the prevalence and perils of recreational drug use, what about the wide variety of chemicals Americans ingest to help them heal or to cope with mental and physical issues? These therapeutic drugs—whether prescription or over-the-counter (OTC), generic or brand name—play a critical role in both the U.S. healthcare system and American society at large. This series explores major classes of such drugs, examining them from a variety of perspectives, including scientific, medical, economic, legal, and cultural.

For the sake of clarity and consistency, each book in this series follows the same format.

We begin with a fictional case study bringing to life the significance of this particular class of drug. Chapter 2 provides an overview of the class as a whole, including discussion of different subtypes, as well as basic information about the conditions such drugs are meant to treat. The history and evolution of these drugs is discussed in Chapter 3. Chapter 4 explores how the drugs work in the body at a cellular level, while Chapter 5 examines the large-scale impacts of such substances on the body and how such effects can be beneficial in different situations. Dangers such as side effects, drug interactions, misuse, abuse, and overdose are highlighted in Chapter 6. Chapter 7 focuses on how this particular class of drugs is produced, distributed, and regulated by state and federal governments. Chapter 8 addresses professional and popular attitudes and beliefs about the drug, as well as representations of such drugs and their users in the media. We wrap up with a consideration of the drug's possible future, including emerging controversies and trends in research and use, in Chapter 9.

Each volume in this series also includes a glossary of terms and a collection of print and electronic resources for additional information and further study.

It is our hope that the books in this series will not only provide valuable information, but will also spur discussion and debate about these drugs and the many issues that surround them. For instance, are antibiotics being over-prescribed, leading to the development of drug-resistant bacteria? Should anti-psychotics, usually used to treat serious mental illnesses such as schizophrenia and bipolar disorder, be used to render inmates and elderly individuals with dementia more docile? Do schools have the right to mandate vaccination for their students, against the wishes of some parents?

As a final caveat, we wish to emphasize that the information we present in these books is no substitute for consultation with a licensed healthcare professional, and we do not claim to provide medical advice or guidance.

—Peter L. Myers, PhD
Emeritus member, National Addiction Studies Accreditation Commission
Past President, International Coalition for Addiction Studies Education
Editor-in-Chief Emeritus, *Journal of Ethnicity in Substance Abuse*

Preface

The World Health Organization (WHO) has declared that vaccines have had a greater effect on reducing death, disability, and illness than any public health advance except for safe water. The WHO compiles a list of medicines that it considers essential to human health. As of 2017, there are 32 vaccine-preventable diseases. These diseases are so devastating that vaccines against 23 of them are on the WHO essential medicine list.

Vaccines have changed the world. Smallpox once killed one of every three people who were infected. In 1980, thanks to comprehensive vaccination, it was declared eradicated. Gone. No more bodies buried in mass graves because there were not enough healthy people to bury them properly. No more scarred, disfigured survivors.

Polio, which once killed and paralyzed thousands every year, is close to eradication. As of early 2017, the disease was found only in Nigeria, Pakistan, and Afghanistan. The international fight to eradicate polio has been slowed by difficulties in reaching people in the affected areas, cultural misunderstandings, and political opposition, but polio eradication remains an achievable goal.

It is hard to underestimate the effect vaccines have had on the lives of ordinary people. Once common diseases in the United States are now rare and unfamiliar. In the 1920s before an effective diphtheria vaccine became available, at least 200,000 people in the United States contracted the disease each year. Between 10,000 and 20,000 of them died. The death rate in children under five was 20 percent. Now sometimes years go by without a single case in the United States.

In the early 1960s before there was a good measles vaccine, 500,000 cases of measles and 500 measles-caused deaths occurred in the United States annually. The rate of measles infection dropped by 93 percent in the years after introduction of the vaccine.

Why are vaccines so effective in preventing illness? When people get an infectious disease, the body makes antibodies to fight the disease. This process takes about two weeks. During that time, people gets sick, sometimes so sick that they die. However, if they recover, they then have antibodies left in their body ready to immediately fight the disease should they encounter it again. This means that they will not get sick from the exact same disease a second time.

The miracle of vaccines is that they stimulate the body to make antibodies against a specific disease *before* the individual becomes infected, and they do this without making the person sick. So when a vaccinated person encounters a disease he or she has been vaccinated against, the antibodies are already in place and ready to go to work to fight the disease. The result is that the vaccinated individual is immune to the disease and does not get sick.

Most people see vaccination as a positive health intervention and vaccinate their children. By the time American children reach age five, more than 94 percent have received all the vaccinations their state requires for school attendance. In 2015, Maryland and Mississippi had the highest vaccination rate in this age group (99.4 percent) while Colorado had the lowest (87.1 percent). Yet despite the fact that vaccination undeniably prevents disease, there are people opposed to the procedure. Their arguments range from claiming that vaccines do not work to believing vaccines cause autism and other disorders to objecting to the government requiring a healthcare intervention that they consider a personal choice.

No vaccine is completely effect or completely without risk despite the fact that they have saved millions of lives. This book explains how vaccines work and why they sometimes fail. It shows methods scientists have used to develop and test new vaccines over the past 225 years and how licensing and manufacturing regulations safeguard public health. Finally, the book examines why some people are opposed to vaccination, find vaccines more risky than the diseases they prevent, and believe that they are harmful.

Chapter 1

A Case Study: An Encounter with Measles

Jan and Rob O'Connor lived in Davenport, Iowa, when their first child, Fern, was born. Fern received her first vaccine, hepatitis B, before she left the hospital. As a new parent, Jan did not question this. She and her brothers had all been vaccinated. Getting shots was just part of childhood.

Fern received all the vaccinations on the schedule recommended by the American Academy of Pediatrics (AAP), although, as the months passed, it did seem as if she was getting a lot more shots than Jan remembered from her own childhood. The DTaP shots for diphtheria, tetanus, and pertussis made Fern fussy and irritable for a few days, and she got a warm, red spot at the injection site on her leg. These were minor inconveniences that cleared up in a day or two. At 15 months, Fern received the combined shot for measles, mumps, and rubella (MMR). Six days later, she cried for hours and had a fever of 104°F (40°C).

Rob was holding the fussing baby when her eyes rolled back in her head. Her body stiffened, and then she began twitching. Rob and Jan were terrified. Convinced that their baby was dying, they rushed Fern to the emergency room. By the time they got there, Fern appeared normal but exhausted. The emergency room doctor said she probably had experienced a febrile seizure brought on by her high fever. After taking steps to bring Fern's temperature down, the doctor discharged her with instructions to see her pediatrician about follow-up tests.

The next day Fern's fever was lower and she seemed normal. Her pediatrician reassured the O'Connors that although febrile seizures were frightening,

they caused no lasting damage. Tests showed no signs of epilepsy or other seizure disorders. Fern was a normal, healthy toddler. Neither Jan, Rob, nor the doctor made any connection between Fern's seizure and the MMR vaccination she had received the week before.

Fern continued to be a happy child with no major health issues. When she was three years old, her sister Piper was born. Piper also received early infant vaccinations. At age four, Fern had a second MMR shot. About five days later, she had a low fever, so she stayed home from preschool for two days. There was nothing unusual about this. She often missed school for colds and occasional fevers as most young children do.

A DIFFERENCE OF OPINION

Six months before Fern was to start kindergarten, the O'Connors moved to Ashland, Oregon. The family settled in. Jan made friends with some neighborhood mothers and found a pediatrician she liked to care for Fern and Piper.

Ashland was a lot different from Davenport. In Davenport, everyone Jan knew had vaccinated their children as a matter of course. In Ashland, Jan discovered a group of parents who were skeptical about the safety and usefulness of vaccines. A few of these parents were opposed to all vaccinations, but most were skeptical about specific vaccines. They questioned why children should be vaccinated against polio when the disease had been eradicated from the Western Hemisphere. Some objected to newborn vaccination against hepatitis B. They reasoned that the disease was transmitted through sexual contact, and their children would not be sexually active for years. Why stress a newborn's immune system with an unnecessary vaccine?

Stella, Jan's best friend in Ashland, was adamant that the MMR vaccine should be avoided because it caused all kinds of complications including developmental delays.

"Why take the risk?" Stella asked. "Who gets measles any more, anyway? No one."

Jan thought about that. She did not know a single child or even any person of her own age who had had measles.

Piper's first MMR shot was coming up. Jan spent time reading about the vaccine on the Internet. She found a variety of opinions. Some sites were scary. They claimed the vaccine was unsafe and blamed it for causing autism. She read story after story about children who had been developing normally and then regressed and lost skills after the MMR shot.

On the other hand, government and medical association sites insisted that the vaccine was safe and effective. They had statistics showing how it was

much safer to be vaccinated than to get measles. Measles, Jan read, could cause potentially fatal pneumonia as well as brain inflammation and blindness. But these sites also mentioned that the vaccine could cause side effects including the fact that about 1 in every 3,000 children developed febrile seizures after vaccination with MMR.

The mention of febrile seizures took Jan back to that frightening night she and Rob had rushed a convulsing Fern to the emergency room. Could Fern's seizures have been caused by MMR vaccine? From the information on the Internet, it looked as if the vaccine could have triggered Fern's fever. There was no way to know for sure, but Jan knew she never wanted to go through an emergency room experience like that with another child. Some websites claimed MMR vaccine could also cause serious developmental delays. Jan decided the risk of complications from the vaccine was too great. Piper would skip the MMR shot.

A VISIT TO THE PEDIATRICIAN

Piper was scheduled to get her first MMR inoculation at her 15-month checkup. Until this visit, she had received all the AAP-recommended vaccines. At her 15-month visit, Jan told the pediatrician Piper was going to skip the MMR shot.

"Why would you do that?" the doctor asked. "Don't you realize you're leaving your daughter susceptible to a very serious disease?"

He went on to explain how miserable measles made children and how some of the potential complications could affect them for the rest of their lives. Jan was adamant. She told the doctor what she had read on the Internet. The risk, she concluded, was not worth the benefit.

"Then you're going to have to find a different pediatrician," the doctor said. "I don't accept patients who skip vaccinations or want to alter the recommended vaccination schedule for no good medical reason."

Jan was stunned. "You mean I can't decide for myself what's best for my own child?" she asked.

"You can refuse to vaccinate, but you will have to find another pediatrician," the doctor repeated. "I can't have unvaccinated and undervaccinated children in my waiting room. They can spread deadly diseases to babies who are too young to be vaccinated and to older children or even parents who have immune system defects and can't be vaccinated."

"But no one gets measles today," Jan protested.

"That's because most people are vaccinated," the doctor insisted. "If you put 100 unvaccinated children in a room with a child with measles, 90 will get sick. It would be wrong for me as a physician to let that happen."

Jan left the doctor's office shaken and angry, but firm in her belief that Piper did not need any MMR vaccine. How dare the pediatrician throw her out of his practice? Did she not have the right to determine what was best for her child?

A SYMPATHETIC DOCTOR

Jan called her friend Stella, the person who had first started her thinking about the risks and benefits of vaccines. Stella, who selectively vaccinated her two boys, recommended a pediatrician sympathetic to the concerns of parents about vaccination risks. When Jan took Piper to the first appointment with the new doctor, he agreed that Piper did not need to get the MMR vaccination at 15 months. He did recommend that if by age 12 she had not had natural measles, she should be vaccinated because measles symptoms were more severe in teens and adults. He also suggested that Jan consider skipping Piper's vaccination for chicken pox and delaying vaccination for hepatitis A.

Jan was happy with the suggestions of the new doctor and the amount of time he spent listening to her concerns. She believed there were legitimate differences of opinions about vaccines. This doctor had encouraged her to think for herself about what was right for her family instead of locking her into a one-size-fits-all schedule. She felt comfortable with her decision.

When it came time to enroll Piper in public school, Jan filed a personal belief exemption from vaccination. Under Oregon law, all she had to do was fill out a form stating that she had a personal belief objection to MMR vaccination. With the exemption on file, the school had to enroll Piper.

The O'Connors' third child, Aspen, was born a year later. By this time, Jan had read more about vaccines and was convinced that the standard vaccination schedule was unnatural and wrong for her family. To the annoyance of the nurses at the hospital, she refused the newborn hepatitis B vaccination for Aspen and requested her pediatrician follow an alternative schedule that gave only one or two vaccines at a time. She reasoned that there was no sense in taking unnecessary risks by putting so many chemicals in an infant whose immune system was not mature. When the time came, she had Aspen skip MMR and polio vaccinations after she learned that the last case of native polio occurred in the United States in 1979. Jan used the same personal belief objection to enroll Aspen in daycare. None of her children developed mumps, measles, or rubella.

TRAVEL TO THE UNITED KINGDOM

The summer that Fern was 14 and Piper was 11, the girls were invited to spend a month visiting their cousins in Ireland. They had a wonderful time

kissing the Blarney Stone, watching the horses run at the Galway races, visiting the Giant's Causeway, and hanging out with their cousins' friends. As a special treat, the family took them to London for a week, where they took in Big Ben, the Tower of London, and the Changing of the Guard at Buckingham Palace. They flew home eager to start school and tell their Oregon friends about their first overseas visit.

The flight home was long, and by the time they arrived in Portland, Piper was feeling ill. She had a cough, sore throat, and a runny nose. Just a cold, Jan assured her. But the next day, Piper's head ached and her eyes were red and watery. She moped around all day and went to bed early. By the next morning, she had a fever. At bedtime, small red spots appeared on her forehead. They soon enlarged and spread to her arms and chest. Her temperature was 104°F (40°C). She was miserable and clearly very sick.

Jan called the doctor who said it sounded as if Piper had contracted measles during her overseas visit. He asked Jan to bring the girl to the back entrance of his clinic before regular office hours so that she would not infect other children. After seeing Piper and diagnosing measles, the doctor insisted that Piper stay under house quarantine until the rash had disappeared so that she did not infect other children. Other members of the family needed to avoid crowds and stay home as much as possible to avoid spreading the disease.

"Fern seems fine," Jan said. "She was vaccinated as a child. So were Rob and I, but what about Aspen? Is she going to get sick from being in the same house as Piper?"

"Almost certainly," said the doctor. "Measles is highly contagious, and it spreads through droplets in the air. Bring Aspen in today. I can give her a shot of immunoglobulin that contains measles antibodies. It's too late for a vaccine to keep her from getting sick, but these 'borrowed' antibodies might lessen her symptoms."

As Jan prepared to take Piper home, the doctor added, "Measles is a serious reportable disease. Expect a call from the public health department. I have to let them know we have a case here in Ashland even though Piper probably got infected overseas."

THE OUTCOME

Piper was miserable for about a week. Just as she was starting to feel better, she relapsed with a painful cough, fever, and pneumonia. After another trip to the doctor, she was given antibiotics for the pneumonia and gradually recovered. Piper was petulant and grouchy for days. She blamed her mother for

letting her get sick and missing the last week of summer vacation and the first two weeks of the school year.

Thanks to the immunoglobulin shot, Aspen developed a much milder case of measles. She still had a high fever and was miserable but recovered with no complications. She also missed two weeks of school. Fern, Jan, and Rob never got sick.

The public health department contacted the O'Connors. Fortunately, the school year had not started, so Piper had not spread the disease to her classmates. The health department tracked down everyone who was on the flight back from Ireland with Piper. In the end, she had spread the disease to only nine people who were on the plane with her. These people spread the disease to another 47 people.

Jan was left pondering whether she had made the right decision in having Piper and Aspen skip MMR vaccination. She felt guilty for Piper's and Aspen's ordeal and worried about all the people on the plane Piper had made sick. When she had made the decision for her daughters to skip the vaccine, Jan truly believed the risk of side effects were greater than the risk of getting sick. Now that she had seen what measles was like, she was not so sure.

That Rob, Fern, and Jan did not get sick was proof that the vaccine worked and that Piper's and Aspen's illness could have been avoided. Jan was thankful that both girls recovered without any permanent disabilities and that school had not been in session when they got sick. If they had spread the disease to their classmates, the outcome could have been much worse.

Jan remembered that her first Ashland pediatrician had told her that people no longer got measles because almost everyone was vaccinated. She had counted on herd immunity to protect her children, but that had failed. Jan still believed parents should have the right to decide if and when their children should be vaccinated, but after seeing first-hand how sick measles had made Piper and Aspen, she resolved that she would no longer try to persuade other parents to forgo vaccination. She also concluded that the prudent thing would be to put Piper and Aspen on a catch-up schedule for the vaccines they had missed.

Chapter 2

What Are Vaccines?

Vaccines are biological preparations that when introduced into the body cause an individual to acquire immunity to a specific disease. The word *immunity* comes from the Latin word *immunis* meaning exempt from a public duty such as paying taxes. In medicine, a person who develops immunity to a disease is exempt from, or will not be made ill by, that disease. Immunity from vaccination can last a lifetime or for a shorter period, depending on the disease, the effectiveness of the vaccine, and the strength of the individual's immune system response.

The administration of a vaccine is called inoculation, immunization, or vaccination. The words *vaccine* and *vaccination* are derived from the Latin name for the cowpox virus, *variola vaccinae*. Cowpox is a mild disease that cows can transmit to humans. It is closely related to the deadly and disfiguring human disease of smallpox. As detailed in Chapter 3, Edward Jenner, a British physician, was able to show in 1796 that inoculation with cowpox virus would produce a mild illness, but afterward the individual would be protected against falling ill from smallpox. Although Jenner and a century of scientists who followed him could not explain why people who developed cowpox were then immune to smallpox, his work introduced the concept of vaccination as a way to prevent serious disease.

Today, scientists understand how vaccines work to prime the body's immune system against certain diseases. As of 2017, vaccines to immunize against 26 illnesses were available in the United States. The American Academy of Pediatrics recommended that children receive vaccination against 14 of these diseases between birth and six years of age. Vaccines against at least six more diseases were not licensed for use in the United States. Vaccines are also commonly used in veterinary medicine to protect domestic pets and

livestock from a variety of illnesses and to prevent them from spreading some of these diseases such as rabies to humans.

The most dramatic example of the effect of immunization on public health has been the eradication of smallpox. Before routine vaccination against the disease was available, smallpox killed an estimated one of every three individuals who became infected. Many who survived were left disabled or disfigured. It took two centuries to refine an easily administered smallpox vaccine and implement a worldwide immunization strategy, and in 1980, the world was declared free of smallpox. A small amount of the smallpox virus is still kept in highly secured laboratories in the United States at the Centers for Disease Control in Georgia and at a Russian facility in Siberia. Keeping this stock of virus is controversial (as discussed in Chapter 8) because of its potential use as a bioterrorism weapon. For this reason, some members of the U.S. military are still vaccinated against smallpox.

Smallpox is the only human disease to be eradicated by a vaccine, but great success has been achieved in eliminating several other diseases from large areas of the world. For example, until the 1960s, each year poliomyelitis killed thousands of people, usually children, and left many more permanently paralyzed. Thanks to the development of an effective polio vaccine, as of 2017, the Western Hemisphere was free of polio. A small number of cases continued to be found worldwide in only three countries—Afghanistan, Pakistan, and Nigeria—where war and cultural misunderstandings have presented barriers to adequate immunization.

Of the current 32 human vaccine-preventable diseases, 20 are viral infections, 10 are bacterial, and 2 are bacterial toxins, which are damaging waste products that these bacteria produce. These vaccine-preventable diseases are listed in Table 2.1, and the ones used in the United States are discussed in detail in Chapter 5. Many vaccines come in more than one formulation and require more than one dose to stimulate adequate immunity.

We can see from Table 2.1 that vaccine-preventable diseases are serious illnesses with the potential to cause permanent damage or death. Yet despite their public health benefits, vaccines have always been controversial. Smallpox investigator Edward Jenner faced the wrath of religious leaders for suggesting that a disease of cows could prevent a human disease believed to be sent by God as punishment. Anti-vaccination leagues that developed in Britain and the United States in the1880s claimed that mandatory vaccination laws imposed on individual freedom of choice. Even today, anti-vaccination activists, including celebrities such as Jenny McCarthy and Jim Carrey, use traditional and social media to promote the belief that vaccination is the cause of other disastrous diseases and disorders.

Table 2.1 Vaccine-Preventable Diseases

Disease	Organism Vaccine Protects Against	Target Population for First Dose[†]
Adenovirus	Type 4 and type 7 adenovirus that cause a respiratory illness similar to influenza	Approved for military members ages 17–50 years only
Anthrax	*Bacillus anthracis* bacterium that can cause fever, shock, inflammation of brain	Most military members and overseas defense contractors; some people who handle wool, meat, and hides ages 18–65 years
Diphtheria	Toxin of the bacterium *Corynebacterium diphtheriae* that causes a covering to form at the back of the throat creating breathing problems	Children starting age two months
Hepatitis A	Hepatitis A virus that causes permanent liver damage	Children between 12 and 23 months; travelers to Mexico, Central and South America, Africa, Asia and Eastern Europe; men who have sex with men; people who use injectable street drugs
Hepatitis B	Hepatitis B virus that causes permanent liver damage and liver cancer	Newborns (can be infected at birth); men who have sex with men; people who use injectable street drugs
Haemophilus Influenzae type b (Hib)	*Haemophilus influenzae* type b that causes bacterial meningitis	Children age two months
Human papillomavirus (HPV)	Multiple types of HPV that cause genital warts and cervical, penile, and anal cancer	Girls and boys starting between ages 9 and 11 years
Influenza	Three or four strains of influenza virus that cause fever and secondary pneumonia. Composition of vaccine changes annually	Every year for everyone over age six months
Japanese encephalitis	Japanese encephalitis *Flavirus* that causes fever, seizures, coma	Travelers over age two months spending one month or more in rural Asia where the disease is common
Measles (rubeola)	*Morbillivirus* that causes fever, and can cause seizures, brain damage	Children ages 12–15 months
Meningococcal disease	Multiple types of *Neisseria meningitidis* bacteria that cause meningitis	Young children and adolescents

(continued)

Table 2.1 (Continued)

Disease	Organism Vaccine Protects Against	Target Population for First Dose[†]
Mumps	*Rubulavirus* that causes fever, swollen glands, and possible meningitis, deafness, sterility	Children ages 12–15 months
Pertussis (whooping cough)	*Bordetella pertussis* bacterium that causes severe coughing, difficulty breathing, seizures	Children age two months
Pneumococcal disease	Multiple types of *Streptococcus pneumoniae* bacteria that cause pneumonia	Children age two months and adults age 65 and older
Poliomyelitis	*Poliovirus* that causes paralysis	Children age two months
Rabies	*Lyssavirus* that causes death by attacking the nervous system	Only people likely to be exposed to rabid animals (preexposure vaccination) or who have been bitten by a potentially rabid animal (postexposure vaccination). No age restrictions
Rotavirus	*Rotavirus* that causes severe diarrhea and dehydration in infants	Children age two months
Rubella (German measles)	*Rubella* virus that can cause severe birth defects in fetus	Children age 12 months
Shingles	*Varicella zoster* virus. Same as chickenpox virus, but in older adults causes fever, painful blisters, nerve pain	Adults over age 50 years
Smallpox	*Variola major* and *Variola minor* viruses that cause fever, painful rash, high mortality	Some military members because of the threat of bioterrorism. No age restrictions
Tetanus (lockjaw)	Toxin of the bacterium *Clostridium tetani* that causes severe muscle contraction that can interfere with eating and breathing	Children age two months with a booster shot every 10 years for adolescents and adults (preexposure vaccination) and all ages after certain types of bites or wounds (postexposure vaccination)
Tuberculosis (Bacille Calmette-Guérin vaccine)	*Mycobacterium tuberculosis* bacterium that causes lung disease	Children in developing countries where the disease is common. Legal but rarely used in the United States. Also used to treat noninvasive bladder cancer in adults

(*continued*)

Table 2.1 (Continued)

Disease	Organism Vaccine Protects Against	Target Population for First Dose[†]
Typhoid fever (enteric fever)	Various types of *Salmonella enterica* bacteria that cause high fever, delirium, gastrointestinal damage	Travelers where the disease is common, mainly underdeveloped countries; 80% of cases come from Bangladesh, China, India, Indonesia, Laos, Nepal, Pakistan, or Vietnam
Varicella (Chickenpox)	*varicella zoster* virus that causes rash, itching, fever	Children age one year
Yellow fever	*Flavivirus* that causes bleeding from multiple sites, organ failure	Travelers to Africa, South America, and some Caribbean Islands
Vaccines Not Available in the United States		
Cholera	*Vibrio cholerae* bacterium that causes diarrhea, vomiting, dehydration	Not licensed for use in the United States but available in many other countries
Dengue	*Flavivirus* that causes fever and intense muscle and joint pain	Not licensed for use in the United States. As of 2017, licensed in 22 tropical countries
Leptospirosis	*Leptospira interrogans*, a spirochete bacterium that causes meningitis, hepatitis, nephritis, death	Not licensed for use in the United States. Available in Cuba, Japan, France. Limited effectiveness
Plague	*Yersinia pestis* bacterium that causes flu-like symptoms, swollen lymph nodes, 30%–60% fatalities	No longer available in the United States and little used elsewhere due to limited effectiveness
Q fever	*Coxiella burnetii* bacterium that causes high fever, headache, cough, gastrointestinal symptoms	Not licensed for use in the United States. Available in Australia, Canada, and elsewhere for high-risk populations
Tickborne encephalitis	*Flavivirus* that causes brain inflammation	Not licensed for use in the United States. Commonly used in Europe and Asia

[†]Recommendations based on information from the United States Centers for Disease Control and Prevention, 2017 for healthy Americans. Recommendations in other countries and for specific subpopulations with compromised health will vary. Many vaccines require multiple doses.

Vaccines work in complex ways that are hard to conceptualize. They are not always 100 percent effective, nor are they without some health risks for a small number of individuals. Vaccine risks and adverse reactions will be discussed in

Chapter 6, and Chapter 8 will explore the fears and public controversy that have arisen from the perception of these risks.

THE IMMUNE SYSTEM RESPONDS TO DISEASE AND VACCINATION

The immune system is the most widespread and complex system in the body. Every day, it fights off millions of different pathogens—disease-causing bacteria, viruses, fungi, and parasites—found in the air, in the ground, in our food, and on the surfaces we touch. The workings of the immune system and its interaction with vaccines are discussed in detail in Chapter 4. At this point, however, it is useful to have a general overview of how the system responds to disease or vaccination.

Tissues of the immune system are located throughout the body and include the thymus, spleen, bone marrow, and lymph nodes. These tissues produce and store white blood cells, also called leukocytes, which are disease-fighting cells. There are many different types of leukocytes, each with a separate immune system function. Although the immune system is not fully mature at birth, it still functions well starting from day one.

The immune system can protect the body only if it is able to distinguish a person's healthy cells (self cells) from diseased or abnormal self cells (sick self cells), and the cells of millions of different pathogens (nonself cells) that each of us encounters daily. This ability is critical to maintaining health and fighting disease because it assures that the immune system leaves healthy self cells alone and attacks only foreign pathogens or destroys only sick self cells such as those that have been infected with a virus or become cancerous.

Any nonself molecule that stimulates an immune system response is called an antigen. Most antigens are proteins or glycoproteins (a protein with a sugar molecule attached). Pathogens "carry" or, in the language of biology, "express" these identifying molecules on the surface of their cells. The word *antigen* is a contraction of "*anti*body *gen*erator," and stimulating the body produce antibodies is exactly what antigens do.

Antibodies, also called immunoglobulins (Igs), are tiny protein molecules that circulate freely through the body. They are 10 times smaller than viruses and 200 times smaller than bacteria, but they are a powerful force in defeating pathogens. Antibodies are produced by a type of leukocyte called a B cell, but only as the result of a long sequence of events involving many different immune system cells and communication molecules. B cells have the special ability to produce antibodies specific to each different antigen, even though there are millions of different antigens. Details of the response of

the immune system to a pathogen and antibody formation are discussed in Chapter 4.

Divisions of the Immune System

The immune system has two divisions that work together to fight infection: the innate immune system and the adaptive immune system. Cells of the innate system are the first responders when pathogens get past the physical barriers of skin or the mucous membranes that line body cavities. Innate system cells are nonspecific in that they can recognize and attack a wide range of pathogens. We see evidence of this attack in the inflammatory response when an infected area of skin becomes red, warm, and swollen. More widespread responses to immune system attacks on a pathogen include fever, increased mucus production, sore joints, general body aches, and localized internal pain such as an earache. These symptoms result from chemicals released by immune system cells to organize a defense against the invading pathogen and are a sign that the immune system is working hard.

When the innate immune system is overwhelmed and fails to contain a pathogen, the adaptive immune system kicks into high gear. The actions of two types of leukocytes, T lymphocytes (T cells) and B lymphocytes (B cells), are the mainstays of the adaptive immune system. These cells have two functions: (1) to rid the body of the invading pathogen primarily by producing antibodies and (2) to create long-lived memory cells that produce immunity to that specific pathogen.

Unlike the innate system where a single cell can respond to many different pathogens, the adaptive response is highly specific. Each cell (not each type of cell, but each single cell) in the adaptive immune system responds to the antigen of only one species or strain of pathogen. On first exposure to a pathogen, it takes 10–17 days for the adaptive system to develop maximal response. However, when a pathogen has been destroyed, memory cells remain in the body for years or a lifetime. When the pathogen is encountered again, these cells "remember" that pathogen and quickly stimulate the production of antibodies against it. The capacity to recognize a repeat pathogen and respond to it rapidly is called immunological memory. Immunological memory is the reason why people become immune to certain diseases such as measles, mumps, and chickenpox after recovering from the disease.

When individuals are vaccinated, they do not need to go through the process of becoming ill and recovering to develop immunological memory. Each vaccine contains an altered version of a pathogen that is strong enough to stimulate an adaptive immune response but not strong enough to cause

symptoms of disease. In this way, memory cells are formed without the risks associated with sometimes life-threatening diseases.

TYPES OF IMMUNITY

Immunity from disease can be either temporary or long term. Temporary immunity is called passive immunity and depends on antibodies from an outside source. Long-term immunity is called active immunity. It depends on the body making its own memory cells and antibodies. Both passive and active immunity can be acquired naturally or artificially.

Passive Immunity

Passive immunity involves "borrowing" antibodies. When a baby is born, it has an immature immune system, no prior exposure to pathogens, and no memory cells. Instead, an infant is partially protected from infection by antibodies acquired from its mother during fetal development. This type of immunity is designated naturally acquired passive immunity because it happens without any medical intervention, and it is short term.

There are five classes of antibodies (IgA, IgD, IgE, IgG, and IgM), but only two of them participate in the creation of naturally acquired passive immunity. Beginning around the third month of pregnancy, maternal antibodies in the class called IgG cross the placenta and enter the fetus. IgG is the only class of antibodies that is transferred to the fetus during development, but this class makes up about 80 percent of all antibodies. When a baby is born, it has the same IgG antibodies as its mother. If, for example, the mother is immune to measles, the baby will also have temporary immunity to measles. Another class of antibodies, IgA, is passed from mother to child in colostrum and breast milk. IgA antibodies provide the newborn with passive immunity mainly to pathogens found in the digestive system.

Passive immunity is always temporary because no memory T or B cells are made. In infants, this transferred immunity lasts from a few days to several months. The length of time the maternal antibodies remain effective and the rate of maturation of the newborn's immune system are taken into account when the U.S. Centers for Disease Control and Prevention (CDC) develops its recommended childhood vaccination schedule.

When passive immunity is induced through medical intervention, it is called artificially acquired passive immunity. Like natural passive immunity, the benefit is short term. Artificially acquired passive immunity can be induced by injecting blood plasma or serum, the clear part of the blood that contains

antibodies, from a person or animal that has developed antibodies to the disease being treated. Before there was a vaccine against diphtheria, the disease was treated by infecting a horse with diphtheria toxin, extracting the antibodies from the horse's blood, and then injecting them into an ill human. (This process did not kill the horse.) More recently, during the Ebola virus outbreak in 2014, antibodies from patients who had recovered from Ebola infection were given to actively infected patients in the hope of improving their chance of survival.

Artificial passive immunity can also be induced by the injection of monoclonal antibodies. Monoclonal antibodies are identical, laboratory-produced antibodies. They are derived from a single cell that has been cloned to produce many genetically identical daughter cells. Thus, daughter cells produce only one kind of antibody identical to the antibody the mother cell produced.

There are several ways of manipulating cells into producing the desired antibody including fusing mouse and human cells or genetically engineering yeasts or viruses to produce the desired antibodies. The resulting antibodies are then isolated and purified for injection. Monoclonal antibodies are used most often in treatment of cancers and autoimmune disease. In the future, they may be useful in creating a cancer vaccine.

Active Immunity

Active immunity results from the formation of memory T cells and memory B cells by the adaptive immune system against a specific disease. Protection is long term, lasting anywhere from years to a lifetime.

Natural active immunity develops when an individual becomes infected with a pathogen. The first time the individual is exposed to the pathogen, he or she becomes sick during the 10–17 days it takes the adaptive immune system to ramp up and produce enough antibodies to defeat the disease. Once the pathogen is destroyed, antibodies-producing cells die, but memory T cells and memory B cells remain in the body. The next time the individual is exposed to that same pathogen, the memory T and B cells are quickly activated. Within a few days, they produce enough antibodies to prevent the pathogen from reproducing and making the individual sick. This explains why, with rare exceptions, a person contracts diseases such as measles or chicken pox only once in a lifetime. Natural immunity is the strongest and most long-lasting type of immunity.

Artificial active immunity is induced by vaccination. Vaccines stimulate the immune system to make antibodies and memory cells against a specific disease without making the individual sick. As we will see in the next section, there are

several ways a vaccine can be designed to do this. The immune system's response to a vaccine often is not as strong or long lasting as it would be toward a naturally acquired pathogen. For this reason, several doses of vaccine may be required to create complete artificial immunity, and booster shots may be needed after a few years to maintain immunity. This is especially true when the pathogen is a bacterium.

Herd Immunity

Herd immunity, sometimes called community immunity, is the situation that arises when a large number of people or animals within a specific area have been vaccinated against a disease. With many disease-resistant individuals in a community, the chain of disease transmission is broken so that the entire community is protected from an outbreak of illness. The more infectious the disease, the higher the percentage of individuals who need to be disease-resistant to create herd immunity. Epidemiologists—scientists who study disease transmission—rate how transmissible a disease is by estimating the average number of people a single sick person will infect. From that, they determine what percentage of the population needs to be disease-resistant to create herd immunity.

Measles and pertussis (whooping cough) are the most transmissible of the vaccine-preventable diseases. A single person infected with either disease will infect between 12 and 18 other people. This translates into needing 92–94 percent of the population to be vaccinated to stop the spread of either disease. Tetanus is the only vaccine-preventable disease where herd immunity does not apply. The disease is caused by the toxins of a bacterium found in soil and manure. It cannot be transmitted from person to person.

Establishing herd immunity is important because no vaccine is 100 percent effective, and some members of a community will not be fully vaccinated either by choice because of lack of access to medical care, or because they have a medical condition that weakens the immune system and prohibits safe vaccination. Every person who is fully vaccinated helps to protect these vulnerable individuals as well as preventing illness in themselves.

Some individuals who choose not to vaccinate do so with the belief that herd immunity will protect them. This is likely to be true if enough people in their community are vaccinated. But as we have seen in the case study in Chapter 1, nonvaccinated individuals who move to an area where the vaccination rates are low or who travel abroad to areas where a disease is active are vulnerable to becoming ill and then spreading the disease to others, especially to individuals with already weakened immune systems who cannot be vaccinated for medical reasons.

Cell-Mediated Immunity and Humoral Immunity

Sometimes in talking about the immune system, the terms *cell-mediated immunity*, also called cellular immunity, and *humoral immunity* are used. *Cell-mediated immunity* refers to the immune system response orchestrated by T cells that have been activated by contact with a specific antigen. Cell-mediated immunity responses attack cells in the body that have become infected with a pathogen. Humoral or antibody-mediated immunity refers to the production of antibodies by B cells. The antibodies float free in the blood and lymph (humor is an ancient word referring to body fluids) and attack pathogens directly. The details of immune responses and the way in which they are coordinated are discussed in Chapter 4.

TYPES OF VACCINES

Researchers work to design vaccines that create the strongest immune system response with the smallest number of undesirable adverse events or adverse effects. Adverse events are any undesirable reactions that occur after administration of a vaccine, whether or not the vaccine is the cause. Adverse effects are serious reactions provably caused by the vaccine. The choice of effective design must also take into consideration nonmedical issues. For example, if a vaccine needs to be kept refrigerated, it may be a poor choice for use in developing countries where the electricity supply is irregular. Other considerations include the number of doses needed to create immunity, length of time the vaccine can be stored before it loses potency, ease of mass production and transport, and ease of administration. In order to meet the needs of different populations, some vaccines such as those targeting polio and influenza are produced in more than one form.

Live Attenuated Vaccines

Live attenuated vaccines contain living pathogens that have been weakened (attenuated) to the point where they still cause the immune system make antibodies and memory cells but do not cause illness. Live attenuated vaccines target viral diseases. These include adenovirus, chickenpox, measles, mumps, rotavirus, rubella, shingles, yellow fever, live attenuated influenza vaccine (LAIV), and oral polio vaccine (OPV). One or two doses of a live attenuated vaccine provide the most effective and long-lasting immunity of any type of vaccine. The only stronger immunity is active natural immunity, which is developed by contracting the disease and recovering from it.

Attenuation is achieved by growing generation after generation of a virus in a hostile environment. This hostile environment often is the cells of a nonhuman species. The virus gradually mutates to adapt to the new environment. As it adapts, it remains a live pathogen; however, it loses its ability to reproduce freely in humans while retaining the surface antigens necessary to stimulate the immune system. Bacteria are much more difficult to attenuate than viruses. The only live attenuated bacterial vaccines are the Bacille Calmette-Guérin vaccine (BCG) against tuberculosis, plague vaccine, and one form of typhoid vaccine. None of these vaccines is routinely used in the United States. More details on how vaccines are manufactured can be found in Chapter 7.

Live attenuated vaccines generally are not safe to give to individuals whose immune system is compromised by drug treatment (e.g., chemotherapy), disease (e.g., HIV/AIDS), or hereditary immune insufficiency (more than 250 different diseases). These vaccines also carry the very rare but serious potential for the pathogen in the vaccine to mutate in a way that makes it more virulent and capable of causing disease. This has occurred infrequently with the OPV. According to the Polio Global Eradication Initiative, virulent mutation occurs about once in every 2.7 million vaccinations with OPV. Fifty-two cases were reported worldwide in 2014. In the United States, OPV has been replaced with inactivated polio vaccine (IPV) in which mutation is not possible. Nevertheless, because OPV is given easily by mouth and does not require sterile injection equipment or special training to administer, it continues to be used in many developing countries.

Inactivated or Killed Vaccines

Inactivated or killed vaccines are created by making the pathogen inactive or dead so that it is unable to reproduce. Killing/inactivation is done by exposing the pathogen to chemicals (often formaldehyde), heat, or radiation. *Inactivated* refers to viral pathogens. Viruses are not considered living organisms because they cannot reproduce on their own; they must enter a host cell and use the resources of the host cell to replicate themselves. *Killed* refers to vaccines against bacterial diseases because bacteria are living organisms. With both inactivated and killed vaccines, the pathogen cannot reproduce inside the body and thus cannot mutate or cause disease. Inactivated/killed pathogens retain antigens on their surface to stimulate the production of antibodies and memory T and B cells, but the immune system response is weaker than with a live attenuated vaccine. Because the response is weaker, it takes multiple doses of inactivated/killed vaccine and booster shots to achieve and maintain immunity.

Despite the diminished immune system response, inactivated/killed vaccines have several advantages. They are safer than live attenuated vaccines because they can never cause the disease they are protecting against. They usually do not need to be refrigerated and sometimes can be freeze-dried for shipping to be reconstituted as needed. These features extend their lifetime and make them more accessible to people in developing countries. Inactivated/killed vaccines include hepatitis A, inactivated influenza vaccine (IIV), Japanese encephalitis (although a live attenuated vaccine is preferred in China), whole cell pertussis (not the form used in the United States), IPV, and rabies.

Toxoid Vaccines

In diphtheria and tetanus, illness is not caused by the pathogens themselves but by the toxins (poisons) the causative bacteria secrete. To make a toxoid vaccine, the pathogen is grown in a laboratory. The toxin it secretes is purified and then deactivated by exposure to formaldehyde or heat so that it is harmless. When injected into the body, a toxoid vaccine creates immunity by stimulating the production of antibodies that can inactivate any newly secreted toxin. Multiple doses and booster shots of toxoid vaccines are needed to maintain immunity. Although diphtheria and tetanus are the only toxoid vaccines given to humans, a toxoid vaccine is available to immunize dogs against rattlesnake venom.

Subunit, Polysaccharide, and Conjugate Vaccines

Most subunit vaccines are designed to prevent viral diseases. Theses vaccines contain anywhere from 1 to 20 antigens from a virus instead of including the whole virus. Subunit vaccines include anthrax, hepatitis B, influenza (Flublok), acellular pertussis (the pertussis vaccine used in the United States), and one type of typhoid vaccine.

To make a subunit vaccine, scientists first identify the antigens that cause the strongest immune response. This is a long, costly, and difficult process. Once the most active antigens are identified, the pathogen is grown in the laboratory and then treated with chemicals to break up and isolate the appropriate antigens. Alternately, subunit vaccines can be produced using genetic engineering. In this case, a gene from the pathogen that produces the desired antigen is injected into a nonpathogenic host cell. The host cell then produces a protein that contains the viral antigen, which is collected and purified for use in a vaccine. Subunit vaccines made using this type of genetic engineering are called recombinant vaccines.

Subunit vaccines are safe because they do not contain live pathogens. In addition, by using only specific antigens instead of the whole pathogen, the chance for adverse reactions is decreased. At the same time, there is an increased chance that immunity will be short-lived, and no memory T or memory B cells will be created.

Some disease-causing bacteria are encased in a polysaccharide (sugar) capsule that helps them evade immune system cells. Polysaccharide vaccines are a type of subunit vaccine made of pieces of this capsule. The immune system does not respond to these polysaccharide antigens as strongly as it does to protein antigens. Response is especially poor and inconsistent in children under two years old, possibly because of their immature immune system. Repeated doses of polysaccharide vaccines do not produce additional or prolonged immunity as they do with inactivated/killed vaccines. Versions of pneumococcal, meningococcal, and typhoid vaccines are polysaccharide vaccines.

To help solve the problem of weak immune response to pure polysaccharide vaccines, researchers developed conjugate vaccines in the late 1980s. These vaccines are made from pieces of the polysaccharide coat of a bacterium with a piece of protein chemically added to it. The protein boosts the immune system response, making the vaccine more effective and providing longer immunity especially in young children. The first conjugate vaccine was *Haemophilus influenzae* type b (Hib). As of 2017, pneumococcal and meningococcal conjugate vaccines are also in use.

Polyvalent Vaccines

Although a vaccine works against a single species of pathogen, within that species, there can be multiple strains or subspecies with related but slightly different surface antigens. To create the greatest resistance to disease, some vaccines contain antigens to immunize against two or more strains of the same pathogen. For example, the influenza vaccine contains antigens against three or four flu strains depending on the formulation. Vaccines that protect against more than one strain of the same pathogen are called polyvalent vaccines. Polyvalent vaccines provide broader immunity without requiring extra shots, although immunity may not develop as strongly or rapidly as with a monovalent vaccine. In most circumstances, the advantage of broader protection outweighs this disadvantage. Common polyvalent vaccines include HPV, influenza, meningococcal, pneumococcal, and polio.

Combination Vaccines

Combination vaccines are vaccines that produce immunity against two or more different species of pathogen. The most common combination vaccines

are diphtheria, acellular pertussis, tetanus (DTaP), and mumps, measles, and rubella (MMR). Newer combinations include the following:

- Hib and hepatitis B
- hepatitis A and hepatitis B
- MMR and varicella (chickenpox)
- DTaP and IPV
- DTaP, IPV, and hepatitis B
- DTaP and hepatitis B
- DTaP, IPV, and Hib

All combination vaccines go through rigorous testing to make sure that one component does not increase or decrease the effectiveness of another component. Some parents express concern that immature immune systems cannot handle exposure to so many different antigens at once. They may request that vaccines be given individually rather than as combination shot. This concern is addressed in Chapter 8. Advantages of combination vaccines include fewer healthcare visits, reduced cost, fewer shots, and a faster path to full vaccination. In developing countries, combination vaccines can reduce shipping, storage, and administrative costs as well as making complete vaccination easier to obtain for families with limited access to healthcare.

ROUTES OF ADMINISTRATION

The way a vaccine is administered depends on its purpose, how it is transported through the body, and which method of administration produces the fewest adverse effects. The location of administration depends on age. Children under age two years are given injections in the thigh muscle, while older children and adults normally are given injections in an arm muscle. Some vaccines are made in more than one form to serve different populations. For example, IIV and recombinant influenza vaccine (RIV) can be given intramuscularly as a shot, while LAIV is given as a nasal spray, but with age restrictions. Use of LAIV was temporarily discontinued in the United States for the 2016–2017 flu season because of concerns about its effectiveness.

The most common route of administration for vaccines is by intramuscular (IM) injection. IM vaccines include anthrax, diphtheria, hepatitis A, hepatitis B, Hib, HPV, influenza (IIV and RIV), Japanese encephalitis, meningococcal conjugate, pertussis, pneumococcal, inactivated polio, rabies, tetanus, DTaP, and most combination vaccines except MMR and MMRV.

Subcutaneous injections (SC) place the vaccine below the skin but above the muscle. Meningococcal polysaccharide vaccine (MPSV), varicella, zoster (shingles), and yellow fever, along with combination vaccines MMR and MMRV, are given this way.

Vaccines given orally (by mouth) are usually those that affect infection in the digestive system. Oral vaccines include adenovirus, cholera, oral polio, and rotavirus. Oral vaccines have the advantage of not needing sterile needles or special training for administration.

Intradermal (ID) administration is the least common route of administration. It involves injecting the vaccine with a sterile needle under only the top layer of skin. ID administration is the most difficult route of administration for most healthcare providers. BCG (tuberculosis) vaccine is always given ID, and one form of the influenza vaccine (Fluzone intradermal) can be given this way, although IM influenza immunization is much more common.

How Well Do Vaccines Work?

One way to look at how well vaccines work is to look at the reduction in vaccine-preventable diseases over time. A rigorous study of the effect of vaccination on public health in the United States published in the *New England Journal of Medicine* in 2013 looked at weekly totals of contagious diseases reported before and after a vaccine was introduced. The authors concluded that a total of 103 million cases of polio, measles, rubella, mumps, hepatitis A, diphtheria, and pertussis had been prevented since 1924. The greatest degree of prevention was of diphtheria—40 million cases since the vaccine was introduced in 1924, with 35 million cases of measles prevented since the vaccine was licensed in 1963. In another study, the World Health Organization estimated that vaccination against only four diseases—diphtheria, tetanus, pertussis, and measles—prevent 2–3 million deaths each year.

Despite these successes, no vaccine is 100 percent effective. Almost everyone who is vaccinated makes some antibodies to a vaccine, but some people do not make enough to prevent disease. Consequently, some people still get sick from a disease they have been vaccinated against. People can also fall sick after vaccination if they are already infected with the disease the vaccine is intended to prevent but do not yet show symptoms. This happens most often with pathogens that have a long incubation period. With measles, for example, it takes 7–21 days for a rash to appear after infection. This leads some people to believe that the vaccination caused the disease.

Overall, childhood vaccinations are about 90 percent effective. That means that 9 out of every 10 children vaccinated will not get a disease if they

have received the full recommended schedule of vaccine doses. Failure to receive all the required doses is a major cause of reduced immunity. For some diseases (e.g., diphtheria, tetanus), the effectiveness of the vaccine diminishes over time, and revaccination or booster shots are needed many years after initial immunization to maintain immunity. Adult vaccinations are still effective but less so than childhood vaccinations because as people age, their immune system responds less strongly to vaccines. Adults often make enough antibodies to lessen disease symptoms but not to completely prevent illness.

The influenza vaccine is the least consistently effective vaccine. The virus that causes influenza mutates rapidly creating different strains of the pathogen. Each year the influenza vaccine changes to contain antigens of three or four different flu strains based on data from a worldwide influenza tracking system. The decision about which strains to include must be made well in advance of flu season. When the match between influenza strains circulating in a community is good, the vaccine is highly effective. When the match is poor, people become sick from strains not included in the vaccine.

SUMMARY

Vaccines are biological preparations that stimulate the immune system to produce antibodies. Antibodies produced against each type of antigen are all different and highly specific. The presence of memory T and B cells after vaccination creates long-lasting active immunity. Passive immunity is temporary and no memory cells are created.

Vaccines are made in a variety of ways to produce maximal effect with a minimum of side effects. The most durable artificial immunity is produced by vaccines made of live attenuated pathogens. Inactivated/killed pathogens produce good immunity but require multiple doses and booster shots. Toxoid vaccines work against toxins secreted by bacteria rather than working directly against the bacteria.

Newer methods of vaccine production use only small parts or subunits of a pathogen. These vaccines reduce risk and minimize side effects but may need to be modified to produce an adequate immune system response. Multivalent vaccines contain antigens against several strains of the same pathogen. Combination vaccines contain vaccines against several different pathogens and reduce the number of healthcare visits needed to become fully vaccinated.

Vaccines can be administered intramuscularly, subcutaneously, orally, or intradermally depending on the vaccine. Nonmedical factors in vaccine choice

and design include ease of mass production, ease of transportation and storage, ease of administration, and cost.

Vaccines never provide complete protection against a disease. Childhood vaccinations are about 90 percent effective if the recommended vaccination schedule is followed. Adult vaccinations are less effective because of reduced immune system vigor.

Chapter 3

Vaccines: A Brief History

Attempts to make people immune to deadly and disabling diseases have been around for centuries. Some efforts have been successful. Others have been ineffective, and a few have been spectacular failures that caused harm. All vaccine researchers build on the work of other scientists. In many cases, several scientists or groups of researchers have worked in parallel on the same disease, producing vaccines with different levels of safety and effectiveness or that meet the needs of different populations.

Initially, individual researchers attempted to produce both animal and human vaccines. Later, university and not-for-profit organizations undertook vaccine research funded mainly by government grants. Today, much of the research on new vaccines and improvements in old ones is done in university and government research laboratories in conjunction with pharmaceutical companies. This chapter primarily discusses the development of the earliest vaccine for a particular disease. The vaccines currently in use, their administration, and limitations are discussed individually in Chapter 5.

SMALLPOX

For centuries, smallpox was a deadly disease feared by rich and poor, commoner and royalty. Generation after generation, smallpox swept across Africa, Asia, and Europe. The earliest evidence of the disease was found on the mummified body of the Egyptian King Ramses V who died around 1145 BCE.

Smallpox is only transmitted from person to person; there are no animal intermediaries or animal hosts. It spreads by inhaling droplets containing the

virus or by direct contact with fluid from smallpox sores. Travelers carried the disease along the great trade routes of the Ancient World—the Incense Route from the Arabian Peninsula to Egypt, the Silk Road that stretched from China to the Mediterranean Sea, and the Spice Route where ships hopscotched from Indonesia to India and on to the Horn of Africa. When the disease was carried to the Americas by Europeans, it wiped out entire tribes of native peoples and led to the extinction of the Aztec and Inca civilizations. Smallpox had no cure. About one-third of those who survived were left blind. Most survivors had permanent scars or disfigurement from the loss of facial tissue. But survivors were also immune from reinfection by the virus.

Smallpox has an incubation period of about two weeks. The first symptoms are headache, sore throat, back pain, and vomiting. A few days later, small pink spots appear, gradually spreading from the face to the limbs and trunk. These spots grow into itchy, fluid-filled blisters that merge and cover a large part of the body. The blisters scab over in about eight days and fall off in another week or two, leaving deep scars. Death comes from toxemia (blood poisoning), dehydration, and complications such as pneumonia, encephalitis (brain inflammation), and pulmonary edema (fluid in the lungs). Smallpox ranked high on the list of diseases that would benefit mankind by being controlled or eliminated

Early Attempts to Control Smallpox

Many attempts were made to prevent smallpox infection, and a reasonably successful technique called variolation developed in several cultures. Variolation is the process of taking a small amount of smallpox material and introducing it into a nonimmune person in the hope that the inoculated person will develop only a mild case of smallpox and gain long-lasting immunity to the disease. The first written evidence of successful variolation is in a Chinese manuscript written in 1549, but the practice appears to have been used for centuries before that in China, India, the Horn of Africa, and Central Asia.

There are two major strains of the smallpox virus, *variola major*, which is often deadly and *variola minor*, which causes much milder cases. The success of variolation depended heavily on using smallpox from a mild case as an inoculant. The process was not without risk. Bloodborne diseases such as syphilis and scrofula (a form of tuberculosis) could be transferred along with the smallpox virus, and inoculated individuals were temporarily contagious and needed to be isolated to prevent infecting anyone who was not immune. In addition, about 2 percent of people who were variolated developed cases of smallpox that killed them. Although this mortality rate would be unacceptable today,

with 80–90 percent of infants and 30 percent of all unvariolated people dying, undergoing the procedure seemed like a reasonable risk to many people.

Several methods were developed to transfer the inoculant. In China, scabs from people with smallpox were collected and dried for several weeks, which likely weakened their infective properties. Next, they were ground to a powder and put into a pipe. The pipe was inserted in one nostril and the ground scabs puffed into the nose. Variolated individuals developed a (hopefully mild) case of smallpox and immunity to a more severe case. In Sudan in the Horn of Africa, mothers wrapped a cloth around the arm of an infected child and then transferred the cloth to a noninfected child with the intention of stimulating a mild case of smallpox and its accompanying immunity. This procedure continued in Sudan until the late nineteenth century.

An effective technique was practiced in Turkey and other parts of the Ottoman Empire. The skin was scratched in several places with a needle. A small amount of fluid from a smallpox blister was inserted in each scratch and the area bandaged. Ideally, a mild case of smallpox and resulting strong immunity developed. This method was introduced in England and other parts of Europe in the first half of the eighteenth century.

Variolation Reaches England

Lady Mary Wortley Montagu (1689–1762) is credited with bringing variolation to England. Lady Montagu was something of an early feminist. She eloped rather than marry the man her father had chosen for her, survived smallpox that later killed her brother, traveled to Turkey with her husband, the British ambassador, wrote passionately about women and women's rights, and later in life, left her husband to live abroad with an Italian nobleman. While in Turkey, she was introduced to variolation.

In 1717, Lady Montagu wrote to her friend Sarah Chiswell in England describing the common practice of variolation in Turkey. She explained how groups of a dozen or more women would gather to be variolated or have the procedure done to their children. An older woman with expertise in variolation would provide aged, and thus probably weakened material, from a smallpox blister. She would introduce a small amount of the material into the arm of the person who was being variolated, and in about eight days, the variolated person would develop a fever, mild discomfort, and a few pox marks on the face. The pox spots would clear without much scarring, and the person would have gained immunity. Lady Montagu was so impressed with the effectiveness of variolation that she had the embassy doctor, Charles Maitland, variolate her young son.

The Montagus returned to London in 1718. In 1721, when a smallpox epidemic raced through the city, Lady Montagu asked Maitland, who had also returned to England, to variolate her daughter. Maitland invited other doctors to witness the procedure. At first, the public was skeptical, but Lady Montagu persuaded Caroline, wife of King George II, to have Maitland perform an experiment on six prisoners in Newgate Prison who were scheduled to be hanged. Each man was variolated with the condition that if he survived, he would be released. In a few weeks, six healthy men walked away from their death sentences. A similar experiment was performed on half a dozen orphans, none of whom developed smallpox. After that, the royal family had some of their children variolated, and the procedure gained acceptance.

Variolation in North America

Variolation became known in America in the early 1700s, but it was not widely accepted. Cotton Mather (1663–1728), a Boston minister best known for his vigorous support of the Salem witch trials, discovered that his slave, Onesimus, had been inoculated against smallpox as a child in Africa. Mather was intrigued by the idea. In 1721, a smallpox epidemic broke out in Boston. Mather encouraged colonial doctors to try variolation, but met with resistance from religious and medical leaders who denounced the procedure as unnatural and unlawful. At one point, outrage against Mather was so strong, that his house was fire bombed. He did, however, convince Dr. Zabidel Boylston (1679–1766) to variolate anyone who was willing to take a chance on the technique. When the epidemic was over, only 2 percent of variolated Bostonians had died.

The Revolutionary War (1775–1783) introduced variolation on a wide scale to the American colonists. Early in the war, American troops lay siege to the city of Quebec. During the siege, about half the Continental soldiers contracted smallpox, while British soldiers, many of whom had been variolated, remained healthy. The weakened Colonial troops were forced to withdraw, and the siege failed. As the war progressed, Continental troops continued to lose a significant number of men to smallpox in Boston and several other cities.

Commander-in-Chief George Washington, who had survived smallpox as a teenager, concluded that the disease threatened the effectiveness of the Army and wanted all soldiers to be variolated. He was opposed by the Continental Congress, which specifically forbade military variolation. Their opposition was based partly on fear that it would be impossible to isolate variolated men during their contagious stage and that mingling with nonimmune men would start a smallpox epidemic.

Nevertheless, in February 1777, Washington used a combination of political clout, backroom deal making (he had the anti-variolation head of the military medical service replaced with a provariolation physician), and a large dose of secrecy, to order all soldiers be variolated. Isolation centers were set up in private homes and churches. No large-scale outbreak of smallpox occurred, and after the fact, the Continental Congress approved Washington's move. The following year, the death rate of Continental soldiers from smallpox dropped from 17 percent to 1 percent. This was the first instance of mandatory inoculation in the United States. When the war was over and these soldiers returned home, they were living proof to their families and neighbors of the success of variolation.

FROM VARIOLATION TO VACCINATION

In the 1700s, folk wisdom said that people who became ill with cowpox were immune to smallpox, although no one could explain why. We now know that cowpox is caused by a close relative of the smallpox virus. The disease is zoonotic, meaning it can be passed from animals to humans. It causes mild illness and pus-filled blisters on the udders of cows and the hands and arms of people who are exposed to these blisters.

In the second half of the eighteenth century, a few scientists and even some farmers had successfully experimented with using cowpox to induce immunity to smallpox, but these incidents were isolated and not widely known. English physician Edward Jenner (1749–1823) realized that immunity could be deliberately introduced and then transferred from person to person. He put this understanding to widespread practical use, and it became the basis for vaccination.

Edward Jenner was born in Berkeley, Gloucestershire, the son of a minister. In his early teens, he was apprenticed to a physician and surgeon. Later, he studied at St. George's Hospital in London with some of the best surgeons of the time. After earning a medical degree from the University of St. Andrews in 1792, he returned to Gloucestershire to practice medicine.

Jenner knew about variolation; as a child, he was variolated and never contracted smallpox. Living in the country, he was familiar with the belief that cowpox protected against smallpox. In 1796, he developed the idea that the immunity provided by cowpox could be transferred not just from a cow to a human but from person to person. He tested his hypothesis by taking pus from blisters on the hand of a milkmaid, scratching the skin on the arms of the eight-year-old son of his gardener, and introducing the pus into the scratches. The child, James Phipps, became mildly ill with a low fever but

was completely healthy within two weeks. About six weeks later, Jenner inoculated James with fluid from a fresh smallpox blister. (One can't help but wonder how James's parents felt about this experiment.) Fortunately, no sign of smallpox developed. James was later inoculated a second time with smallpox material and remained healthy.

Jenner wrote a paper about his experiment, but it was rejected by the Royal Society. He experimented on a few more individuals, and eventually self-published a pamphlet about his results. He also actively recruited other physicians to perform cowpox vaccinations and supplied them with vaccine. By 1800, cowpox vaccination had spread across Europe. Variolation gradually fell into disuse as people became more familiar with the safer cowpox vaccine. In 1840, variolation became illegal in England.

Soon after the cowpox vaccine became available, a British physician sent a sample of it to Benjamin Waterhouse (1745–1846), a professor at Harvard University in Massachusetts. Waterhouse was enthusiastic about the vaccination procedure. In 1800, he wrote to then vice president Thomas Jefferson and sent him a sample of vaccine material. Jefferson was deeply interested, and when he became president, he created the National Vaccine Institute. His successor, President James Madison, signed the Vaccine Act of 1813. The purpose of the Act was to assure the purity of vaccine was maintained and to make vaccination available to every citizen. To this end, the Act stated that the post office could not charge a fee for carrying any mail weighing 0.5 ounces or less that contained smallpox vaccine matter.

LOUIS PASTEUR AND ANIMAL VACCINES

During the 1800s, animal diseases swept across Europe killing hundreds of thousands of animals and often triggering starvation conditions. Fowl cholera killed up to three-quarters of infected domestic and wild birds. Rinderpest, a cattle plague that was finally eradicated worldwide in 2010, killed almost 100 percent of infected animals. Anthrax was common in sheep and other grazing animals. Rabies, although less common, was always fatal. After the development of a human smallpox vaccine, these animal diseases came under intensive study by scientists and veterinarians who hoped to apply the lessons learned from Jenner's experiments to develop vaccines to protect livestock. Their techniques not only advanced the development of veterinary medicine but also advanced human vaccine development.

Louis Pasteur (1822–1895), the French scientist from whose name we get the word "pasteurization," was educated as a chemist but made significant contributions in microbiology. His study of fermentation showed that microbes

cause wine to ferment and milk to sour. This finally put to rest the theory of spontaneous generation that postulated living things could arise from nonliving material such as dirt, water, or corpses.

Fowl Cholera

When Pasteur began his study of disease prevention through vaccination in the late 1870s, he was already recognized as a prominent scientist and had received a patent on the pasteurization process for killing pathogens. Pasteur began investigating a vaccine for anthrax but soon switch his research to fowl cholera. Fowl cholera causes diarrhea, nasal discharge, fever, and loss of appetite in domestic and wild birds. In its acute form, it can kill within 12 hours of infection. Often, the first sign that a flock is infected is a large number of dead birds.

In 1876, Henri Toussaint (1847–1890) isolated and cultured the *Pasteurella* bacterium that causes fowl cholera. Pasteur either was given a sample of the bacterium or cultured it himself with the goal of developing a vaccine. In the late 1800s, the idea that microbes caused disease as postulated by Robert Koch (1843–1910), a German physician and microbiologist, was slowly gaining acceptance. Scientists had no concept of the immune system and no basis for understanding how immunity was acquired. In fact, Pasteur wrongly theorized that immunity occurred because the first infection with a microorganism depleted some essential nutrient that the body did not replenish. With subsequent infections, he believed that the microbe lacked a nutrient it needed to reproduce and thus did not cause illness.

In this climate of limited understanding, Pasteur undertook a series of trial and error experiments to reduce the virulence of the *Pasteurella* bacterium. He sequentially grew the bacterium in a mixture of different nutrients and under a variety of different conditions, after which he injected the resulting cultures into chickens to assess the bacterium's potency. Today, we understand that what Pasteur did by trial and error was to create conditions that gave an advantage to certain spontaneous mutations in the bacterium with the expectation that some of those mutations would produce a weakened strain of the microbe and promote immunity in chickens without killing them.

Pasteur's approach remained unsuccessful for months. At one point, he went on vacation, expecting his assistant to continue culturing and injecting chickens, but his assistant also took a vacation. By the time Pasteur returned, the cultures in his lab had grown undisturbed for an unusually long time. When Pasteur injected the chickens with this long-growing culture, to his

surprise, they became mildly ill and then recovered. Another scientist might have concluded that the long-cultured bacteria were dead and useless. In a moment of insight, Pasteur injected the recovered chickens with full-strength fowl cholera bacteria. All the chickens survived. Pasteur had created the first artificially attenuated (weakened) bacterium that could be used as a vaccine. And in a second stroke of insight, he realized that this technique could be applied to other disease-causing microbes.

Anthrax

After his success in creating a fowl cholera vaccine, Pasteur returned to his investigation of anthrax. Robert Koch in Germany had isolated *Bacillus anthracis* and demonstrated in 1876 that it caused anthrax. Anthrax affects mainly grazing animals but can be transmitted to humans who handle infected animals. In modern times, the bacterium can be processed to use as a bioterrorism weapon (see Chapter 9 for more on bioterrorism). The anthrax bacterium releases a toxin that causes illness. It also forms spores that can remain dormant (inactive) in soil for years and then reactivate to cause infection.

Pasteur was not the only researcher working on producing an anthrax vaccine. He and veterinarian Henri Toussaint had become competitors. In 1880, Toussaint announced that he had created an anthrax vaccine by heating the bacterium to 55°C (131°F) and successfully tested it on dogs and sheep. The idea of inactivating the bacterium with heat may have come from Pasteur's success in killing microbes in various solutions by heating (pasteurization), but the demonstration that a killed bacterium could be used as a vaccine contradicted Pasteur's theory that immunity arose from the depletion of a nutrient in the body. Dead bacteria would not use any nutrients, so if dead bacteria could produce immunity, Pasteur's theory had to be wrong.

Pasteur was man who did not like to be wrong and who expected to profit monetarily from his discoveries. He set about creating his own anthrax vaccine out of live attenuated bacteria and accepted a challenge for a demonstration of its effectiveness. On May 5, 1881, Pasteur publically vaccinated 24 sheep, 1 goat, and 6 cows. A similar number of animals were kept unvaccinated as controls. Twelve days later, he revaccinated the animals, and then on May 31, he injected them with live, virulent anthrax. Within three days, all the unvaccinated sheep and the goat were dead and the cows were sick. The vaccinated animals all lived. This public demonstration secured his position as France's most eminent scientist. Income from the sale of Pasteur's vaccine helped him to later establish the Pasteur Institutes. Today, 33 Pasteur Institutes worldwide still conduct highly regarded biological research.

During his lifetime, Pasteur avoided giving the details of the method he used to produce the anthrax vaccine but strongly suggested that he had used the same techniques that produced the fowl cholera vaccine. However, in 1985, Pasteur's laboratory notebooks became available to historians and scientists. On examination, it became clear that the anthrax vaccine Pasteur had used was not a live attenuated vaccine like the fowl cholera vaccine, but a vaccine using bacteria killed by exposure to the chemical potassium bichromate. In other words, his own work contradicted his theory of how immunity develops.

In 1998, the French government officially recognized Henri Toussaint as the discoverer of the first veterinary vaccine against anthrax. A human vaccine against anthrax became available in the 1950s but was discontinued due to lack of demand. An improved subunit vaccine is made today for use by members of the military and is stockpiled against the use of aerosolized anthrax (anthrax that can be inhaled) as a biological weapon.

Rabies

Pasteur wanted to apply his knowledge of livestock vaccines to the prevention of human diseases. For this reason, he chose to pursue a vaccine against rabies. Rabies infects the central nervous system of dogs, humans, and wildlife such as foxes, raccoons, skunks, and bats. The disease is transmitted through the bite of an infected animal, and infection is fatal. The pathogen that causes rabies is a virus, not a bacterium like the organisms that cause fowl cholera or anthrax. In Pasteur's time, no one knew what viruses were or how they differed from bacteria. Viruses cannot reproduce on their own the way bacteria can. Instead, they must enter a living cell and take over its metabolic processes to create more virions. In Pasteur's time, viruses could only be grown in warm-blooded animals.

Pasteur reasoned that if he sequentially transferred the virus through enough different hosts, he could produce an attenuated version for use in a vaccine. He began by taking nervous system tissue from the brains of dogs that had died of rabies and transferring the material into the brains of monkeys. Later, he switched to rabbits, which were less expensive and easier to handle.

After much experimentation, Pasteur found that when a piece of spinal cord from a rabbit that had died of rabies was dried under controlled conditions, it produced a weakened pathogen that did not cause full-blown rabies. The longer the spinal cord was dried, the weaker the virus became, so that he could create a controlled range of virulences. Pasteur then inoculated a dog with a piece of rabbit spinal cord in a broth solution starting with spinal material that had been

dried for about two weeks and that had produced the weakest response in the rabbit. Every day or two, he injected the dog with slightly more potent spinal material. Within several weeks, the dogs developed immunity and could withstand inoculation with fresh rabbit spinal cord containing full-strength rabies virus.

Pasteur hoped his technique would produce the same response in humans, but ethical considerations prevented him from experimenting on people. However, in July 1885, parents came to Pasteur with their son, Joseph Meister, a nine-year-old who had been bitten multiple times by a rabid dog. Since rabies was always fatal, they agreed the child should undergo the same treatment that had made dogs immune. Meister was given 13 inoculations progressing from the weakest to the most potent spinal material over a 10-day period. Almost miraculously, he remained healthy. This was the first example of therapeutic or postexposure vaccination, and it most likely worked because rabies has a long incubation period, typically from three to eight weeks. This gave the boy's body time to make antibodies against the weakened virus, a process that takes 10–15 days. Thus, antibodies were already present in Meister's body, giving him immunity before the full-strength virus from the dog bite became active. Pasteur was not a physician, and the experimental treatment of Joseph Meister was controversial. Émile Roux (1853–1933), a physician and Pasteur's laboratory colleague, refused to perform the injections on ethical grounds and in protest left Pasteur's laboratory for months. Had Meister died, Pasteur could have faced legal action. When the child lived, he became a hero.

Pasteur's technique for producing rabies vaccine was used for about 10 years, after which a chemical method of weakening the virus was developed. The human rabies vaccine used today is grown in human cells and still requires multiple injections for postexposure treatment.

OTHER LATE NINETEENTH CENTURY VACCINES

The period from 1880 to 1900 was a time of great scientific collaboration, aggressive competition, and even some feuds that produced major advances in microbiology and immunology. Between 1901 and 1910, the Nobel Prize in Physiology or Medicine was awarded three times primarily for work related to vaccines done in the preceding 10 years. Emil von Behring (1854–1917) won in 1901 for his work in understanding bacterial toxins and antitoxins that led to the development of a diphtheria vaccine. Robert Koch (1843–1910) received the award in 1905 for his work isolating the tuberculosis bacterium, and Paul Ehrlich (1854–1915) and Ilya Mechnikov (1845–1916) shared the

award in 1908 for the work that laid the foundation for the concept of anti-bodies and the theory of cellular immunity. Nobel Prize winners must be alive at the time of the award. Louis Pasteur would almost certainly have won had he lived until 1901, the first year the prizes were awarded.

The two powerhouses of vaccine research in the late 1800s were the French Pasteur Institute opened in 1888 and the Institute for Infectious Diseases in Germany headed by Robert Koch. The scientists involved in vaccine research all knew each other. They collaborated, feuded, and often spent time in each other's laboratories in order to learn specific techniques. They also frequently collaborated with veterinarians to develop animal vaccines and then applied what they learned to create or improve human vaccines. By the end of the nineteenth century, five human vaccines were in use against smallpox, rabies, typhoid, cholera, and bubonic plague.

Cholera

Five major cholera epidemics swept across Europe and Asia in the nineteenth century. The worst occurred from 1884 to 1891. Cholera is acquired by eating food or drinking water contaminated with *Vibrio cholerae*, a different pathogen from the causative agent for fowl cholera or hog cholera. Contamination usually comes from poor sanitation that allows feces of an infected person to enter the water supply. Cholera causes vomiting and copious watery diarrhea. Fluids can be lost at the rate of one quart (1 L) per hour. Death from dehydration can occur quickly if fluids and electrolytes are not promptly replaced.

Robert Koch isolated *V. cholerae* in 1883, but when the final epidemic of the nineteenth century began, no one had yet developed a vaccine to treat or prevent the disease. In fact, despite Koch's discovery, prominent scientists still disagreed on whether *V. cholerae* was the sole cause of cholera; many believed that the disease had multiple origins.

Jaime Ferrán (1852–1929), a Spanish physician, had been inspired by accounts of Pasteur's success with anthrax and rabies. He produced two veterinary vaccines before turning his attention to human cholera in 1885. Ferrán was able through sequential culturing to produce a cholera vaccine that he successfully tested in guinea pigs. He then inoculated himself, and when he experienced no disease, he proceeded to inoculate his family and friends, after which he reported his success to the Academy of Sciences in Paris.

Ferrán's success produced an invitation by city of Valencia to vaccinate 50,000 people during a cholera outbreak. The Valencia inoculations were successful. Only 1.3 percent of vaccinated individuals died from the disease

compared to 7.7 percent of unvaccinated people. Word of the Valencia experiment spread to other European countries.

Ferrán had the reputation of being a difficult man who feuded with many prominent scientists of his time. When a delegation from France came to evaluate the validity of his vaccine, he refused to provide any details about how it was produced. His motivation for secrecy came from a desire to make a profit by commercializing his discovery. In response to Ferrán's secrecy, the delegation wrote an unfavorable report on the vaccine. Although a different delegation later gave its approval to the vaccine, Ferrán's reputation was damaged. He moved on to head the Municipal Microbiology Laboratory in Barcelona. Another feud ended in his dismissal, after which he established a private laboratory where he continued his vaccine research without any major breakthroughs.

Meanwhile, Waldemar Haffkine (1860–1930) was also working on a cholera vaccine. Haffkine, a Russian Jew born Vladimir Aronovich Havkin, was unable to work in Russia because of his religion and his political activities. After completing a university degree, he spent two years working in Switzerland at the University of Geneva and then moved to the Pasteur Institute in Paris. In 1888, he produced an attenuated cholera vaccine by blasting the bacterium with hot air. Satisfied from animal testing that his vaccine was effective, he inoculated himself in 1892 with no ill effects. His success was hailed as a breakthrough by the popular press, but his scientific colleagues were unenthusiastic.

Spurned by the medical establishment in France, Germany, and Spain, and unable to return to Russia, in 1893, Haffkine moved to India to test his vaccine in a country where cholera was common. Upon his arrival, he was met with suspicion, hostility, and an assassination attempt allegedly by Islamic extremists. Eventually, he inoculated 116 volunteers in Calcutta (Kolkata). All 116 remained disease-free, while several people in the unvaccinated control group died.

Haffkine continued to vaccinate volunteers, but faced the problem that his vaccine made people too ill to work for two days. Many Indians lived at a subsistence level and could not afford to miss two days of work. Eventually Haffkine vaccinated 22,000 people. Records indicate that the death rate among the inoculated was about 2 percent compared to up to 45 percent of the uninoculated, but Haffkine was never able to successfully determine how long immunity lasted.

Typhoid

Typhoid fever, also called enteric fever, is caused by the bacterium *Salmonella enterica*. The disease is transmitted by contaminated food and

water, poor hygiene, and inadequate sanitation. Fever, a general feeling of illness, and abdominal pain frequently progress to delirium, intestinal hemorrhage, bowel perforation, and death. Today, typhoid is treated with antibiotics, but before the development of antibiotics in the1940s, there was no effective treatment.

In the late 1800s, public health officials knew that typhoid could be prevented by good sanitation, boiling or chemically treating water, and good personal hygiene. Nevertheless, these conditions were hard to achieve in crowded cities and military encampments. At the end of the nineteenth century, the disease was killing 5,000 people a year in England and 15,000 in the United States. It was worse in military encampments. During the Spanish-American War (1889–1902), the American Army recorded 20,738 cases of typhoid among soldiers that resulted in 1,590 deaths, compared to 270 combat deaths. As a result, vaccination against typhoid became mandatory in the American military in 1909.

In 1892, British physician Almroth Wright (1861–1947) went to work for the Army Medical Services. Wright was a difficult man, described by his biographer as possessing overwhelming arrogance and the ability to alienate his colleagues and subordinates. Raised by an evangelical Protestant father and a Swedish mother, he was violently anti-Catholic and antifeminist and not shy about sharing his prejudices. Yet, he possessed a brilliant mind and phenomenal memory.

At the suggestion of Waldemar Haffkine, the Russian vaccine researcher, Wright pursued the development of a killed typhoid vaccine. He announced his success in 1896, after first vaccinating himself (standard procedure for vaccine researchers at the time) and then 15 soldiers. At about the same time, German researcher Richard Pfeiffer (1858–1945) also announced success in creating a killed typhoid vaccine. Both men claimed that their vaccine had been developed first, an issue that remains unresolved today.

The new typhoid vaccine had drawbacks. It caused undesirable side effects such as headache, fever, pain at the injection site, and malaise. In addition, Wright was a sloppy record keeper. He could neither substantiate how effective the vaccine was nor how long immunity lasted. Wright's recordkeeping was so bad that he and Karl Pearson (1857–1936), a leading biological statistician, had bitter public fights about the validity of Wright's incomplete data. However, the vaccine appeared to work. Wright vaccinated about 2,800 soldiers who were sent to India where typhoid was common and only a handful contracted typhoid and died.

When the Boer War (1899–1902) broke out between the British Empire and the Boer Republics of Transvaal and the Orange Free State in South

Africa, there was a strong public outcry against mandatory vaccination. Typhoid vaccine was reportedly dumped off ships into the harbor at Southampton in protest, reminiscent of the Boston Tea Party in America a century earlier. The military acquiesced to public pressure and made vaccination of British soldiers voluntary. Ninety-five percent refused to be vaccinated because of fear, public opinion, and the unpleasant side effects of the vaccine. The results were disastrous.

Arthur Conan Doyle (1859–1930), a retired physician and author of the Sherlock Holmes stories, volunteered for three months at a hospital in South Africa at the height of the typhoid epidemic that developed at every military encampment. He was appalled at the level of disease. In a three-month period, he reported that there were 5,000 cases of typhoid and 1,000 deaths among soldiers and many more among civilians. Doyle had been vaccinated against typhoid before leaving England and was critical of the failure to make typhoid vaccination mandatory for soldiers. Over the entire course of the war, there were about 58,000 cases of typhoid and 9,000 typhoid deaths. Mandatory military vaccination in Britain did not occur until after World War I (1914–1918)

Plague

Plague, also called bubonic plague, is estimated to have killed 200 million people worldwide. The first recorded plague pandemic occurred between 541 and 544 BCE. The second great pandemic, known as the Black Death, occurred during the Middle Ages and killed one-third of the population of Europe. The third pandemic of this greatly feared disease began in China in the 1880s and reached Hong Kong in 1894.

Plague is a zoonotic disease. Fleas bite infected rats and then bite humans, transferring the causative bacterium, *Yersinia pestis*. Both rats and humans die in huge numbers. In humans, lymph nodes can swell to the size of a chicken egg accompanied by fever and headache, after which the bacterium enters the bloodstream causing bleeding from the nose, mouth, and rectum. Tissues die (gangrene) beginning with the fingers, toes, and nose, and turn black, giving rise to the name Black Death. Untreated, the death rate can reach 70 percent.

Alexandre Yersin (1863–1943), a Swiss national who became a naturalized French citizen, worked in Pasteur's laboratory and assisted in the development of Pasteur's rabies vaccine. In 1894, he was sent to Hong Kong to investigate the plague outbreak. At almost the same time, Shibasaburo Kitasato (1853–1931), a Japanese bacteriologist who had studied under Robert Koch, arrived

with the same intentions. Independently, these two men isolated *Y. pestis* within a few days of each other in 1894. Yersin also made the connection between dying rats, fleas, and the human disease.

Yersin returned to the Pasteur Institute in Paris where, working with colleagues, he prepared an antiplague serum. On his return to French Indochina (Vietnam), he set up a laboratory, later to become one of the worldwide Pasteur Institutes, to manufacture the serum, but the product proved unreliable and ineffective. Yersin then devoted his time to establishing a medical school in Hanoi. Kitasato went on to found Kitasato Institute, which later became Kitasato University in Japan. It was left to Waldemar Haffkine to develop a vaccine against plague.

In 1895, after developing a cholera vaccine, Haffkine contracted malaria in India and returned to England to improve his health. When he returned to Bombay (Mumbai) in September 1896, plague was racing through the city. In his makeshift laboratory, he grew *Y. pestis* in goat broth, beef broth being unacceptable to Hindus and pork broth unacceptable to Muslims. Within four months, he had developed a heat-attenuated vaccine that he believed to be safe and effective. On January 10, 1897, he convinced another doctor to inoculate him with the new vaccine in front of a witness.

Haffkine developed pain and fever for a week but no disease. The vaccine was then tested in prisoners, and when all survived exposure to plague, the vaccine was tested on a larger number of volunteers before it went into widespread use. In India, Haffkine became hero.

For the next five years, Haffkine worked on producing and improving the vaccine, but disaster struck in 1902. An outbreak of plague in the Punjab stimulated a massive vaccination effort. During the vaccination campaign, 19 villagers, all inoculated from the same bottle of vaccine, developed tetanus and died. British medical officials publically blamed Haffkine for providing contaminated vaccine and suspended him without pay.

An investigation that lasted almost five years finally concluded that Haffkine was not at fault. Forceps used to open the bottle of vaccine had been dropped on the ground where they picked up tetanus spores. Failure to resterilize the forceps had contaminated the vaccine. Haffkine eventually returned to work, but his reputation and relationship with his British medical colleagues was never the same.

Plague still exists in many parts of the world today, including the United States. In 2006, 13 American plague cases were reported, all in the Southwest. A vaccine against plague is not routinely used in the United States. Recognized early, the disease can be successfully treated with antibiotics. Although plague is most commonly transmitted by flea bite, it can also

be contracted by inhalation, which makes aerosolized plague a potential weapon of bioterrorism.

VACCINES OF THE EARLY TWENTIETH CENTURY

Developing vaccines was an international effort with many groups working on the same disease and making incremental advances before a final breakthrough led to a usable vaccine. Even after a vaccine was developed, efforts continued through both collaboration and competition to reduce adverse effects and improve effectiveness. In the first decade of the twentieth century, government requirements for regulating drugs increased, making various vaccines available at different times in different countries. Often, slightly different variations of a vaccine were in use in different parts of the world at the same time. This is still true today.

Tuberculosis

The World Health Organization (WHO) estimates that over recorded time tuberculosis (TB) has killed two billion people. Even today with a vaccine available, it kills about two million people every year. TB is an airborne disease. It spreads when a person inhales droplets exhaled by an infected person. Individuals living in crowded unsanitary conditions and those infected with human immunodeficiency virus (HIV) are especially at risk. The bacterium can infect any organ in the body, but most often it settles in the lungs. The causative pathogen, *Mycobacterium tuberculosis*, was identified by Robert Koch as in 1882, but developing a vaccine took almost 40 years.

Léon Charles Albert Calmette (1863–1933), a French Navy doctor, began his career studying malaria in Hong Kong. In 1895, he became director of the Pasteur Institute in Lille, France, and with Camille Guérin (1872–1961), a veterinarian, worked to develop antivenin to snake poisons. Later, the pair turned to developing a vaccine against TB.

Following Pasteur's approach for attenuating bacteria, Calmette and Guérin began with the bacterium *M. bovis*, which causes TB in cattle. They first tried culturing it in a mixture of glycerin and potato, but the bacteria clumped too much to be useful. To counteract this, they added ox bile. Ox bile successfully prevented clumping, and it unexpectedly weakened the virulence of the bacterium. Thus began a 13-year span from 1908 to 1921 during which Calmette and Guérin about every three weeks transferred the bacteria to fresh culture media to weaken them. By 1913, they were ready to test the resulting attenuated pathogen in cattle, but their research was interrupted by World War I (1914–1918).

The war caused a shortage of ox bile and almost put an end to the experiment Calmette and Guérin had put so much time and effort into, but they were able to obtain enough to keep their culture alive with the help of veterinary surgeons in the occupying German army who retrieved bile for them from slaughterhouses. By the end of the war, after 230 culture transfers, the pair was able to show that their attenuated bacterium protected guinea pigs, rabbits, cattle, and horses against TB. They named their vaccine Bacille Calmette-Guérin or BCG. Soon they were ready to try the vaccine in humans.

The first person to be inoculated with BCG vaccine was a healthy infant born in 1921 to a woman who died a few days later of TB. The vaccine was administered by mouth, and the child remained well and showed no adverse effects. Over the next three years, about 660 infants were given oral BCG. The results were so successful that the Pasteur Institute in Lille began to mass produce the vaccine. BCG was enthusiastically embraced in Spain, Germany, Scandinavia, and Canada, but scientists in the United States and Great Britain remained skeptical. And then disaster struck.

In 1930, in the German city of Lübeck, 250 infants were vaccinated. Two hundred eight developed TB, of which 72 died. After an almost two-year investigation, a German government panel concluded that the vaccine had been contaminated with live TB bacteria through negligent handling in Lübeck. Three doctors involved received prison sentences for their carelessness after a raucous trial at which many parents of the affected infants loudly express their anger.

BCG is an example of the many vaccines where different strains of attenuated pathogen evolve in different laboratories. In the case of BCG, there soon developed a Pasteur/Paris strain and a Copenhagen strain. In the 1950s, major trials involving different strains were performed in the United States and Great Britain. The Copenhagen strain used in Great Britain provided good protection against TB, especially in infants and children, while the strain used in the United States trials provided little protection overall and performed especially poorly in the Deep South.

Various theories developed concerning the role geography and exposure to native pathogens played in effectiveness of BCG. Several rather haphazard trials were organized through the late 1970s to test these theories, but no satisfactory explanations resulted. Partially because of these uncertainties, BCG inoculation has never been routinely done in the United States or the Netherlands, although it is used in almost every other country. It has been especially effective in preventing TB in children in developing countries.

Toxoid Vaccines: Diphtheria and Tetanus

Some bacteria make people sick because of a poison or exotoxin that they release. *Corynebacterium diphtheriae* and *Clostridium tetani*, which respectively cause diphtheria and tetanus, are two of these bacteria against which vaccines were developed in the first half of the twentieth century.

Diphtheria is primarily a respiratory illness although it can infect other parts of the body, especially the heart and nervous system. Symptoms include fever, nausea, headache, sore throat, and a deep croup-like cough. The potentially fatal effects of *C. diphtheriae* arise from its exotoxin, which kills cells lining of mucous membrane of the mouth, nose, and throat. As dead cells accumulate, a membrane forms that can quickly block the airway. Death comes from suffocation. In the early 1900s, mortality rates ranged from 5 percent to 10 percent, but reached as high as 20 percent in young children and in older adults.

Edwin Klebs (1834–1913), a Swiss-German pathologist inspired by the work of Louis Pasteur and Robert Koch, identified the bacterium that causes diphtheria in 1883. He named the organism that today we call *C. diphtheriae*—the Klebs-Loeffler bacterium in honor of himself and Friedrich Loeffler (1852–1915), a German bacteriologist who was the first person to culture the bacterium. Five years later, Émile Roux and Alexandre Yersin showed that a toxin the bacterium produced caused diphtheria, and in 1890, Shibasaburo Kitasato and Emil von Behring created a heat-attenuated version of the toxin that immunized guinea pigs against the disease. Von Behring was awarded the 1901 Nobel Prize in Physiology or Medicine for this work.

The heat-attenuated toxin caused too severe side effects to be used in humans, but it could be used to immunize horses to produce antitoxin serum. To do this, the attenuated toxin was injected into a horse. The horse made antibodies to the toxin without becoming sick. After several weeks, blood was drawn from the horse. Left to rest, the clear blood plasma that contained the antibodies formed by exposure to the attenuated diphtheria toxin rose to the top of a container, while blood cells sank to the bottom. The plasma was collected and purified. The resulting serum could then be injected into a person who had diphtheria. Horse serum antitoxin was first introduced in the United States in 1891. It was still occasionally used to treat diphtheria as of 2016 but can only be obtained from the U.S. Centers for Disease Control and Prevention (CDC).

Horse serum provided only temporary passive immunity, as the antibodies were essentially "borrowed" from the horse and did not stimulate the human body to produce its own antibodies. Diphtheria serum could help people fight the disease, but serum could not be used for routine vaccination. Still, this was

an important advancement against a disease that previously had no effective treatment. As early as 1895, the H. K. Mulford Company in Glenolden, Pennsylvania (just outside Philadelphia) was making and selling diphtheria antitoxin. This is thought to be the first domestically produced commercial biologic in the United States.

Serum treatment for diphtheria rapidly gained acceptance. However, a tragedy occurred in St. Louis in 1901. Serum from the blood of a horse infected with tetanus transferred tetanus infection to 13 children, all of whom died. This event had wide-reaching consequences, as it stimulated passage by Congress of the 1902 Biological Control Act. This act was the first time the federal government had exerted control over the production of commercial biological products. Chapter 7 discusses government regulation of biologicals in detail.

The next advance in creation of a diphtheria vaccine came from Theobald Smith (1859–1934). Smith, the American son of German immigrants, worked at the federal government's Bureau of Animal Industry studying diseases affecting livestock. Eventually, he was offered a professorship at Harvard University and position as director of the Massachusetts State Antitoxin Laboratory. In 1909, he demonstrated that when he administered neutralized diphtheria toxin simultaneously with antitoxin serum, the toxin-antitoxin combination conferred long-lasting active immunity without causing disease or creating unacceptable side effects.

The technique did have drawbacks. The toxin-antitoxin material had to be properly balanced to be effective. Improper balancing could, and occasionally did, cause death. Despite this, William H. Park (1863–1939), head of the New York City Department of Health Laboratory vigorously and quite successfully promoted a mass vaccination of children using toxin-antitoxin injections. This campaign was the first to rely heavily on numbers and statistics rather than narrative case studies to support the effectiveness of immunization. It was aided by the availability of the Schick test developed in 1910 by Béla Schick (1877–1967), a Hungarian immigrant pediatrician. This simple skin test showed whether someone was already immune to diphtheria and allowed health authorities target their vaccination campaign toward those who were most vulnerable.

The breakthrough for what we now call a toxoid vaccine came about accidentally in 1923 in the laboratory of British researcher Alexander Glenny (1882–1965). Containers for processing diphtheria toxin were cleaned with formalin—a dilute solution of formaldehyde. Apparently, some formalin remained after one cleaning, because next batch of toxin added to those containers was so weak that massive doses of it would not induce diphtheria in

guinea pigs. Gaston Ramon (1886–1963), a French researcher, took this information one step further and realized that the weakened toxin would produce active immunity in humans. By 1927, a toxoid vaccine was available for general use, and the number of diphtheria cases dropped substantially.

Gaston Ramon was also instrumental in developing a toxoid vaccine against tetanus. *C. tetani* is an anaerobic bacterium, meaning it grows in the absence of oxygen. Unlike most other vaccine-preventable diseases, tetanus does not spread from person to person. Spores are found in the environment, mainly in soil. They can exist for years and are resistant to some disinfectants and boiling for 20 minutes. When *C. tetani* spores enter a puncture wound (e.g., stepping on a nail) or deep tissue wound, they rapidly produce bacterial cells whose endotoxin is harmful to humans.

The exotoxin of *C. tetani* targets the nervous system causing muscles to spasm and contract. Jaw muscles contract so tightly that an affected individual cannot open his or her mouth, giving the disease its other name, lockjaw. Death comes when the muscles needed to breathe are paralyzed. At the Pasteur Institute, Gaston Ramon and his colleague Christian Zoeller (1888–1934) used formalin to attenuate tetanus toxin as Ramon had with diphtheria toxin. The result was a toxoid vaccine approved by the French Academy of Medicine in 1927 and soon routinely used in most developed countries. Because many soldiers had developed tetanus in World War I when they were wounded and their open wounds exposed to battlefield soil, in 1940, the U.S. Army added tetanus to its list of routine vaccinations for active duty personnel.

In 1947, a combination vaccine of tetanus and diphtheria (TD) for children was licensed in the United States. This improved coverage for tetanus immunity because it reduced the number of necessary shots and doctor visits. Later, a whole-cell pertussis vaccine was added to create DTP, a three-vaccine shot. The pertussis vaccine soon became the target of anti-vaccinationists and, partially because of the concerns they raised, today whole-cell pertussis vaccine has been replaced with the subunit acellular pertussis (aP) vaccine in the United States.

Whole-Cell and Acellular Pertussis

Pertussis is a highly contagious airborne respiratory illness commonly called whooping cough because of the "whoop" sound children make as they struggle to breathe. At first, pertussis looks like the common cold, but it then increases in severity and frequently leads to fatal complications, the most common of which is pneumonia. The disease can last four to eight weeks and is most lethal in infants whose airways sometimes swell shut. *Bortadella pertussis*, the

causative pathogen, was first identified in 1900 by Jules Bordet (1870–1961) and Octave Gengou (1875–1957) of the Pasteur Institute in Brussels, Belgium. It took five years for Bordet and Gengou to develop a culture medium in which to successfully grow the pathogen, but eventually they succeeded in culturing bacteria taken from Bordet's son.

As soon as it became possible to reliably grow *B. pertussis*, researchers in several different countries began developing both therapeutic sera and preventative vaccines. By the mid-1910s, killed whole-cell vaccines produced by three or four different researchers were in use, but all of them had substantial adverse effects, and their effectiveness had not been proven by any large-scale, controlled trials.

Unlike diphtheria vaccine, which stimulated mass vaccination programs, pertussis vaccines received a lukewarm reception from parents and the health-care community. It was viewed simply as one of several, now widely discredited, preventative and treatment therapies for the disease. Although the American Medical Association (AMA) Council had endorsed the vaccine in 1914 in its list of New and Non Official Remedies, it withdrew its official recommendation in 1931, indicating a lack of evidence in the vaccine's ability to prevent or treat pertussis.

This was the state of affairs in 1932 when a pertussis outbreak occurred in Grand Rapids, Michigan. The next year, Pearl Kendrick (1890–1980) and Grace Eldering (1900–1988) requested permission from their employer, the Grand Rapids laboratory of the Michigan Department of Health, to begin a pertussis research project. The women, both of whom ultimately earned Doctor of Science degrees from Johns Hopkins University, were told they could follow their interest in whooping cough but only after they finished all their other assigned lab work.

Working overtime, Kendrick and Eldering successfully developed an improved method of inactivating the pertussis pathogen using thimerosal, an antiseptic compound that contains mercury and one that would become a focal point of the anti-vaccination movement 50 years later. Equally important, Kendrick and Eldering designed and executed a well-controlled and rigorous clinical trial of the vaccine.

Up to that time, vaccines often were tested on small numbers of institutionalized individuals—orphans, the mentally retarded, and prisoners. Although this type of testing would be unacceptable today, it was common through the 1960s. Researchers argued that institutionalized adults owed a debt to society that they could discharge by participating trials. Institutionalized children, especially the mentally retarded, were often chosen because their living conditions were so deplorable that they had a much higher risk of contracting disease

than children in the community. In many of these studies, there were few, if any, control groups.

Kendrick and Eldering rejected this model. Instead, they enrolled large numbers of preschool children from the community and matched an unvaccinated control group with the vaccinated group by age, gender, and neighborhood. They also insisted on rigorous recordkeeping to prevent their results from being disputed. The outcome was clear. The new vaccine prevented whooping cough and had fewer adverse effects than earlier vaccines. Kendrick and Eldering also set new, higher standard for clinical trials.

In 1943, the American Academy of Pediatrics approved the vaccine for routine use, and the AMA followed suit the following year. In 1947, a combination vaccine of diphtheria, tetanus, and pertussis was approved. Note that the medical establishment refers to this vaccine as DTP, although it is popularly called DPT.

Problems with the pertussis vaccine were not over. The pertussis vaccine had always caused unwanted side effects, most often fever and soreness at the injection site, but soon after the DPT vaccine was approved, reports began to surface claiming that in rare cases, pertussis vaccine caused irreversible brain damage. These were later refuted, but questions about pertussis vaccine did not disappear. In 1974, questions about the safety of the vaccine arose in Great Britain and vaccination rates fell, followed by a large outbreak of pertussis several years later. A large 1979 study compared the frequency of adverse reactions of children who received DPT vaccine with those receiving DT. It showed the DPT vaccine produced significantly more adverse effects. As just one example, 46.5 percent of children receiving DPT developed a postvaccination fever compared with 9.9 percent in the DT group.

In the United States, the anti-vaccination movement was growing stimulated by a 1982 network television program titled *DPT: Vaccine Roulette*, which showed children whose injuries were allegedly caused by the DPT vaccine. Barbara Loe Fisher formed the anti-vaccination organization Dissatisfied Parents Together. Today, Dissatisfied Parents Together is called the National Vaccine Information Center. It is one of the largest and most active anti-vaccination organizations in the United States. As a result of the publicity from *DPT: Vaccine Roulette*, several hundred lawsuits were filed alleging that children had been harmed by the pertussis vaccine. Chapter 8 traces this vaccine safety controversy in detail.

Pressure built to develop a pertussis vaccine that was safer and had fewer adverse effects. Trials of an acellular pertussis (aP) vaccine were begun in 1985 and the first aP vaccine was licensed in the United States in combination with diphtheria and tetanus (DTaP) in 1991. The aP vaccine is a subunit

vaccine that contains only the small surface proteins from the *B. pertussis* cell that stimulate antibody production. It replaced whole-cell pertussis that was responsible for most adverse effects in the United States, but whole-cell vaccine is still used internationally.

THE HENS' EGG BREAKTHROUGH

Despite Pasteur's early success in creating a vaccine against the rabies by growing the virus in dogs and rabbits, working with viruses in the laboratory was difficult. Unlike bacteria, which have the ability to reproduce on their own, viruses must enter a living cell and reprogram the cell's resources to produce new virions. For researchers, this meant that human viruses had to be grown in animals such as ferrets, monkeys, and mice. Ferrets and monkeys were expensive, and cultures derived from mice could cause severe allergic reactions in humans.

This situation changed in 1931 when Ernest Goodpasture (1886–1960) developed a method of growing viruses in fertilized chicken eggs. Goodpasture, working at Vanderbilt University in Tennessee, wanted to grow fowlpox, a bird virus unrelated to chickenpox. He reasoned that eggs were sterile and much cheaper and easier to keep than live animals. Goodpasture sterilized the exterior of fertilized hens' eggs by washing them in alcohol. He then cut away a small piece of shell and injected the virus, which grew vigorously in the membrane surrounding the chicken embryo. This basic technique is still used today. The first two vaccines to be made using fertilized hens' eggs were those against yellow fever and influenza.

Yellow Fever

Yellow fever is a disease caused by a *flavivirus* transmitted by several species of *Aedes* and *Haemagogus* mosquitoes. Symptoms range from mild to fatal. Soon after infection, the individual develops fever, headache, nausea, dizziness, and lower back pain. Some people recover after experiencing only these symptoms, but in others, the disease progresses to cause internal bleeding, vomiting of blood, liver damage that causes jaundice and the yellowing of the skin that gives the disease its name, kidney failure, and death.

Yellow fever was brought to the United States from tropical ports by sailors. In 1793, an outbreak killed 10 percent of the population of Philadelphia, then the capital of the United States, and caused thousands more to flee the city. In 1889, the France abandoned its effort to build the Panama Canal after yellow fever and malaria combined killed at least 20,000 workers and sickened many

more. Only massive efforts at mosquito abatement allowed the Americans to open the Canal in 1914. In the twenty-first century, yellow fever still causes 30,000 deaths annually, most in sub-Saharan Africa.

Although by the early 1900s, it was accepted that mosquitoes transmitted yellow fever, the causative pathogen was not identified as a virus until much later. Hideyo Noguchi (1876–1928), a Japanese researcher working in the United States who had discovered that a spirochete (spiraled) bacterium caused syphilis, declared in 1918 that a spirochete also caused yellow fever. He quickly produced a vaccine against the disease. Although Noguchi claimed over 7,000 successful vaccinations, other researchers were unable to duplicate his work. Noguchi, known to be a sloppy record keeper and a difficult individual, was unable to substantiate his findings. Eventually, Max Theiler (1899–1972) and Andrew Sellards (1884–1942) proved that the Noguchi vaccine was totally ineffective against yellow fever because the pathogen that Noguchi had found actually caused a different tropical fever.

By 1927, two groups were working on ways to control yellow fever. The American group was based in Lagos, Nigeria. It was led by Henry Beeuwkes (1881–1956), former director of the Johns Hopkins School of Medicine and included Adrian Stokes (1887–1927), a British pathologist. Hideyo Noguchi also joined the group, determined to prove that his spirochete caused yellow fever despite the fact that Theiler and Sellards had definitively shown that he was looking at the wrong pathogen. Noguchi was a source of tension and dissention in the group, as he was known to be careless and secretive.

The Lagos group obtained blood that caused yellow fever in monkeys from an African man named Asibi. African monkeys were immune to yellow fever, so monkeys had to be imported from India at great inconvenience and expense. This yellow fever strain became known as the Asibi strain. Soon afterwards, problems started. Adrian Stokes contracted yellow fever and died. Hideyo infected about 1,200 monkeys imported at great cost, but when they were necropsied, he was unable to find any spirochetes in their infected livers. Noguchi's monkey experiments ended in 1928, when he also developed yellow fever and died. Unfortunately, the doctor who performed his autopsy also became infected. Yellow fever was a potent disease and he, too, died. By 1931, there had been 32 cases of yellow fever in researchers and laboratory workers and five deaths.

The second research group was based in Dakar, Senegal, and was associated with the Pasteur Institute. They also obtained blood that caused yellow fever. From this developed what was called the French strain of the virus. Jean Laigret (1863–1966), a member of the Dakar team, discovered that the yellow fever virus could survive in infected frozen livers. Shipping frozen liver was

much easier than shipping live, infected monkeys, and research then moved to the Rockefeller Institute in New York and the Pasteur Institute.

In New York, Max Theiler injected yellow fever virus into the brains of mice. During his research, he also contracted yellow fever, but his was a mild case and he survived. After 100 passages of the Asibi strain through mouse brains, Theiler thought he had weakened the virus enough to produce immunity without causing illness. However, the attenuated virus caused severe nervous system side effects. To help counteract this, just as in early diphtheria treatment, the virus was injected at the same time as serum from already immune individuals. This combination still had some problems, but was useable.

Meanwhile, the French group developed a vaccine that could be given by scarring the arm and inserting the vaccine under the skin similar to way that smallpox vaccine was administered. The Rockefeller vaccine was safer, but it required simultaneous injection of serum from immune individuals, and the amount of serum available was limited. The French vaccine had more nervous system side effects and often caused high fever, but large numbers of people could be vaccinated in a short time. During World War II, French troops were administered the French vaccine, and British and American troops received the Rockefeller vaccine.

Neither vaccine was free of problems. Max Theiler continued to experiment with other ways to grow both strains of the virus. Finally, after more than 100 passages of the Asibi strain through chicken embryos, he found a virus that had mutated so that it provided immunity without the simultaneous injection of serum and without causing unacceptable adverse effects. The virus could be commercially cultured on a massive scale in fertilized chicken eggs. Max Theiler won the Nobel Prize in Physiology or Medicine for his work on yellow fever in 1951. His virus, now known as strain 17D, serves as the basis for the yellow fever vaccine in use today, although modifications and improvements have been made. Use of the French vaccine was discontinued worldwide in 1982.

Influenza

Influenza is one of the most widespread and infectious airborne diseases. It is caused by *orthomyxoviridae* viruses. Influenza viruses are grouped into three types—A, B, and C. Type A is the most virulent, while type C rarely causes illness. Influenza infection makes the lungs susceptible to secondary infections, most often pneumonia, and these secondary infections are the most common cause of flu-related death.

Influenza viruses cause problems for vaccine makers that many other viruses do not. The genetic material in influenza viruses consists of eight gene segments of ribonucleic acid (RNA). When the virus reproduces, this RNA is often copied incorrectly leading to small changes (point mutations) in the virus's genome. Gradual change through point mutations is called antigenic drift, and it results in gradual changes in two surface proteins, hemagglutinin (H) and neuraminidase (N), that stimulate antibody formation. Because of antigenic drift, vaccine makers must adjust their influenza vaccines every year to keep up with these changes.

Occasionally, large changes in the H and N proteins occur, often setting off pandemic infection. These large changes, called antigenic shift, are believed to occur when a single host cell is simultaneously infected with two strains of influenza virus, and large amounts of RNA are exchanged. Antigenic shift produced the virus that caused between 20 and 40 million deaths worldwide during the 1918–1919 influenza pandemic.

British researchers Wilson Smith (1897–1965), Christopher Andrewes (1896–1988), and Patrick Laidlaw (1881–1940) first isolated the influenza virus from ferrets in 1933, and the race to develop an influenza vaccine was on. Alice Chenoweth (1903–1998) developed a live vaccine by growing the virus in mouse lung cells. Wilson Smith produced a live vaccine and Thomas Francis (1900–1969) produced a killed vaccine using Goodpasture's technique of incubating the virus in fertilized chicken eggs. These early influenza vaccines were given to soldiers during World War II, but they were not very satisfactory both because antigenic drift made them less effective and because of adverse effects.

In 1957, a serious influenza epidemic developed in Hong Kong. In April of that year, Maurice Hilleman (1919–2015), an American virologist working at Walter Reed Medical Hospital, read about this epidemic that had apparently been overlooked by influenza surveillance organizations. He acquired a sample of the Asian flu virus and set about testing the blood of thousands of individuals looking for someone who had antibodies against it. The only people he could find were a few elderly individuals who had survived the 1889–1890 influenza epidemic. Hilleman correctly recognized that an antigenic shift had occurred in the virus, and almost no one was immune. He predicted an outbreak of pandemic proportions.

Over objections of some disbelieving scientists, Hilleman went directly to vaccine manufacturers and pushed them (some say bullied them) into immediately starting vaccine production against the new virus strain. He also contacted chicken farmers directly and told them not to kill their roosters,

because the virus needed to make the vaccine could only be grown in fertilized chicken eggs.

The pandemic arrived, and between June and October 1957, 40 million people were vaccinated. Seventy thousand Americans and four million people worldwide died from influenza that year, but many more were saved by thanks to Hilleman's insistence on rushing to produce a new vaccine.

With a better understanding of antigenic drift and improved worldwide influenza surveillance, scientists have been able to tweak the influenza vaccine annually so that more often it matches the most common strains of influenza expected in the community. However, the method of growing the virus in eggs did not change much until Herbert Boyer (1936–) and Stanley Cohen (1935–), founders of the biotechnology company Genentech, opened up the field of genetic engineering.

Genetic engineering allows pieces of DNA or RNA from organism A to be placed in the cell of another species, organism B. Organism B then makes the protein coded for by the DNA of organism A. This artificial transfer of genetic material opened new possibilities in vaccine development, and today, recombinant influenza vaccines are grown in cell cultures in the laboratory. Laboratories also produce subunit vaccines that use only the antigenic surface protein of the virus. Live and killed influenza vaccines still continue to be made using viruses grown in chicken eggs.

Polio Vaccine: Salk versus Sabin

Paralytic poliomyelitis, formerly called infantile paralysis, is a disease caused by *poliovirus*. The live virus is shed in feces and usually spreads by the fecal-oral route—that is, by ingesting fecal-contaminated material. Polio most often affects young children. A child can go to bed feeling mildly ill and wake up partially paralyzed. American President Franklin D. Roosevelt (1882–1945) is perhaps the best known person to have been paralyzed by polio as an adult.

Polio virus grows in the intestine and then moves into lymphoid tissue such as the tonsils, Peyer's patches, and nearby lymph nodes. From there, it enters the bloodstream where it can migrate into nerve tissue. In severe cases, it destroys the gray matter of the spinal cord, which contains interneurons (nerve cells) that relay signals essential for motor coordination. Nerve cell destruction results in severe permanent paralysis in less than 1 percent of cases. Many more people experience mild paralysis. Postpolio syndrome, a condition of progressive muscle weakness, can develop 15 or more years after recovery from the disease. How and why this condition develops in some polio survivors is unknown.

The story of the development of a vaccine against polio is often told as a competition between Jonas Salk (1914–1995) who created a killed polio vaccine and Albert Sabin (1906–1993) who produced a live vaccine. These men, especially Salk, were treated as heroes, but they could not have made these vaccines without the work of other researchers who laid the foundation for their breakthroughs. The scientists who did the preparatory research were less charismatic and often did basic research whose value was more difficult to explain to the public.

Hilary Koprowski (1916–2013), a Polish refugee, came to the United States in 1944 and went to work for the pharmaceutical company Lederle. He was the first person to produce a vaccine against polio. His accomplishment is often overlooked because of his personality, his status as a refugee, and the fact that he worked in private industry.

Koprowski knew that the polio virus affected the nervous system, so he attenuated polio virus by culturing it in rat brains. In 1948, he was satisfied that the virus was weak enough not to cause disease but strong enough to stimulate antibody production. He tested it first on himself and later on 20 children. Neither he nor any of the children got sick and all produced antibodies against polio.

When Koprowski presented his results to the medical community, Albert Sabin savaged him for testing a live vaccine in humans, despite the fact that Sabin himself was working to develop a live polio vaccine. Although Koprowski's vaccine was not accepted in the United States, 250,000 doses were given to people in the Belgium Congo (now the Democratic Republic of the Congo) in 1958. The vaccine proved to be highly effective and safe, but later it was implicated in a controversy related to AIDS that is detailed in Chapter 8.

The other scientists whose research was instrumental in the development of polio vaccine were recognized by the scientific community but are often left out of the public polio vaccine story. John Enders (1897–1985), Thomas Weller (1915–2008), and Frederick Robbins (1916–2003) successfully grew polio virus in a culture of human skin and muscle cells taken from babies who died shortly after birth. This was the first time that polio virus had been grown in something other than nerve tissue. The Enders group accomplishment made working with the virus in the laboratory much easier and opened a new direction in tissue culture of viruses.

Enders, Weller, and Robbins were awarded the Nobel Prize in Physiology or Medicine in 1954. Alfred Nobel's will had specified that in Physiology or Medicine, the prize should be given only for a new discovery, not for advances with direct social impact. Ironically, Salk and Sabin, whose work saved

millions of lives, never won a Nobel Prize, something Salk remained bitter about until his death in 1995.

Jonas Salk is a hero of the polio vaccine story. While in medical school, he worked with Thomas Francis (1900–1969) on an influenza vaccine and became hooked on virology research. After World War II as the director of virus research at the University of Pittsburgh, he turned his attention from influenza to polio, a disease that reached epidemic proportions in the United States in 1952. American parents spent the summer of that year afraid to let their children play outside, swim, or even get together with friends in an effort to prevent their children from contracting the disease.

Salk's research was funded by the National Foundation for Infantile Paralysis, now called the March of Dimes Birth Defect Foundation. The organization changed its name after a successful fundraising campaign that encouraged ordinary citizens to send one dime to the White House in honor of paralyzed president Franklin Roosevelt's birthday. By the time the campaign ended, it had collected 2.5 million dimes to fund polio research. The work to find a polio vaccine was the first large-scale medical research project substantially funded by small contributions from ordinary citizens.

Salk used Enders techniques to grow polio virus in monkey kidney cells and then inactivated the virus with formaldehyde and purified it. In 1953, Salk was so confident about the vaccine's safety and effectiveness that he vaccinated himself, his wife, and his three children. By 1954, the inactivated polio vaccine (today designated IPV) was ready for a larger test, so he requested volunteers. Far more children were volunteered by their parents than could be accommodated in the field test. Despite Albert Sabin's vigorous protest against the killed vaccine, 440,000 people were vaccinated and the results compared with those of an equally large unvaccinated control group.

On April 12, 1955, Thomas Francis, who had been hired to evaluate the data, went directly to the popular press and announced that the massive field test had been successful, even though the vaccine reduced the rate of polio only by half when compared to the control group. The news caused a sensation and headlined in practically every newspaper in America. Francis's announcement also infuriated the medical community because the results were not published first in a medical journal. Jonas Salk became an instant hero, more so because he never personally profited from his vaccine. Thousands of people sent him letters of thanks and gifts of money, clothing, and even a car.

Five laboratories were selected to produce the Salk vaccine. One of those, Cutter Laboratories in Berkeley, California, failed to properly filter the vaccine during production. Some of the cells from the culture in which the virus grew slipped through the filter. The polio virus was hidden inside these cells and

became active once the vaccine was injected. More than 100,000 people were vaccinated with the contaminated vaccine, and they passed on the virus to another 100,000 people. By the time the manmade epidemic ended, 70,000 people had developed mild cases of polio, about 260 had been permanently paralyzed, and 10 had died. Despite this accident, Salk's vaccine was embraced in the United States and Europe.

At about the same time Salk was working on developing a killed polio vaccine, Albert Sabin was developing a live attenuated virus in a laboratory at the University of Cincinnati. He correctly believed that a live virus would create stronger immunity against polio than the killed Salk vaccine. Too many people had already been vaccinated with the Salk vaccine in the United States to run a valid, large-scale field test. In a rare example of Cold War cooperation, Sabin's live attenuated vaccine was successfully tested in thousands of people in the Soviet Union and Eastern Europe between 1957 and 1961. A live single-strain vaccine was licensed in the United States in 1960, and a three-strain version followed in 1963. The trivalent stain won the endorsement of the AMA. For many years, live attenuated vaccine was the standard inoculant in the United States.

Live polio vaccine, now called oral polio vaccine (OPV) because it is given by mouth, has several advantages. It is more effective than IPV. Three doses create long-lasting immunity against three strains of polio in 95 percent of vaccinated individuals. OPV also stimulates cells in the mucous membrane lining the intestine to produce antibodies, something IPV does not do. This reduces the amount of live virus shed in feces and disrupts the chain of disease transmission. Because OPV is given by mouth, it can be administered by trained volunteers rather than healthcare professionals, and its administration requires no sterile equipment, a substantial advantage in developing countries.

OPV also had two disadvantages. It causes polio in about one of every 2.7 million vaccinations, and the live virus has the potential to mutate and change into a virulent strain that could cause polio. This has happened, although it is an extremely rare event. In the 1990s, Americans became less tolerant of the risks posed by all vaccines including OPV. Because of the possibility that OPV could cause polio, its use was discontinued in the United States in 2000. As of 2017, OPV continues to be used elsewhere in the world, especially in developing countries where its advantages outweigh this disadvantage.

Three strains of the polio virus can cause disease, and for many years, the antigens against all three strains were included in both IPV and OPV. On April 17, 2016, all countries using OPV were told to destroy their OPV three-strain stock and use a new two-strain stock. One strain of *poliovirus* had been eradicated worldwide. Continuing to use the three-strain vaccine

created a risk that the strain now eliminated, if left in the vaccine, could mutate into a version of the virus to which no one had immunity. This could potentially start a new polio pandemic, just as polio is on the verge of becoming the second vaccine-preventable disease to be completely eradicated worldwide.

THE 1960s

Antibiotics came into widespread use in the mid-twentieth century. These "miracle drugs" are effective against many deadly bacterial diseases, but they do not harm viruses. Once effective treatment for bacterial diseases became widely available, interest and funding shifted toward creating vaccines against viral diseases for which there were no cures.

Success and public acceptance of polio vaccine inspired researchers. Enders techniques for growing the polio virus in human cells gave them new tools. Vaccine research began to move from university and hospital laboratories to pharmaceutical companies. Between 1963 and 1969, pharmaceutical companies licensed vaccines to combat three common diseases—measles, mumps, and rubella (German measles). Maurice Hilleman (1919–2005), a researcher at the pharmaceutical company Merck, was involved in the creation of all three vaccines and many more.

Maurice Hilleman might well be called Mr. Vaccine. He worked on about 40 different animal and human vaccines first at E. R. Squibb & Sons and later for many years at Merck. Nine of the vaccines he played a substantial role in developing are on the AMA list or recommended childhood vaccinations.

Hilleman was born into a farming family in Miles City, Montana, and was raised by relatives on a neighboring farm after his mother and twin sister died at the time of his birth. He attended local colleges and wanted to go to medical school, but could not afford to, so he pursued a PhD in microbiology at the University of Chicago. Upon graduation, his professors urged him to go into academia, but the practical side of his farm upbringing led him to work in industry where he could produce something useful—vaccines. He developed a life-long reputation for profanity-laced straight talk, an unrelenting work ethic, total dedication to vaccine safety, and little tolerance for those who did not share his professional values. As noted earlier in this chapter, Hilleman was instrumental in pushing the production of a vaccine against the 1957 Asian influenza virus. In the 1960s, he became interested in developing vaccines against other viral illnesses.

Before 1963, almost every child contracted measles by age 15. Measles are caused by an extremely contagious airborne *Morbillivirus* that infects only

humans. Symptoms include high fever, cough, runny nose, and a flat red rash that last about 10 days. Measles also suppress immune system response to other infections. About 30 percent of people experience complications that can be as severe as blindness, brain inflammation, seizures, ear infections, and pneumonia. Death occurs in about 2 of every 1,000 cases, nearly twice the mortality rate of prevaccine polio.

Thomas Peebles (1921–2010) first isolated a strain of measles virus while working in the laboratory of Nobel Prize winner John Enders. Samuel Katz (1927–), working in the same lab, produced a live attenuated virus by passing the virus through human kidney cells, human amniotic tissue, and then the membrane of fertilized chicken eggs. The resulting vaccine was licensed in 1963 despite some questionable adverse effects (mainly fever). Within a few years, measles cases in the United States dropped by 99 percent.

Also in 1963, an inactivated measles vaccine was introduced. This vaccine failed to provide long-lasting immunity. Consequently, children vaccinated with the inactivated virus tended to contract measles in adolescence and often experienced more severe cases. Hilleman and his colleagues at Merck continued to address the problems associated with the 1963 vaccine. When an improved live attenuated vaccine was licensed in 1968, the 1963 vaccines were phased out. The measles vaccine used today has been further improved to reduce adverse effects while providing life-long immunity.

Maurice Hilleman had a special relationship with the mumps, another childhood viral disease. In March 1963, his daughter, Jeryl Lynn woke him saying she felt sick. The glands in front of her ears were sore and swollen. She had mumps. After putting her back to bed, Hilleman drove to his lab, picked up a test tube full of nutrient broth and some swabs, returned home, woke up Jeryl Lynn, and swabbed her throat. Jeryl Lynn's virus became the basis for a live attenuated mumps vaccine.

Mumps is often thought of as a benign disease, and for many of the one million people it infected in the United States each year before immunization was available, it was an annoying but uncomplicated illness. But occasionally the virus traveled to the lining of the brain and spinal cord, causing meningitis, paralysis, and deafness. In men past puberty, the virus could cause sterility. During World War I, mumps was the third most common communicable disease in the U.S. Army behind influenza and gonorrhea. The virus caused almost 56 cases per thousand soldiers. Sick soldiers are a liability to the Army, so there was strong interest in developing a mumps vaccine.

Hilleman grew the Jeryl Lynn mumps virus in a broth of chicken embryo cells. Once the virus reproduced, he would move it to new broth. With each move, the virus became better adapted to destroying chicken cells. This also

meant that it was becoming less well adapted or weaker at destroying human cells. After five passages through new broth, the virus appeared weakened enough to produce immunity without illness.

Hilleman tested the vaccine on Jeryl Lynn's younger sister and on a small group of institutionalized mentally retarded children. Today, using mentally challenged children would be unacceptable, but through the 1960s, it was a common practice. After this small successful test, Hilleman and his colleagues conducted a larger study on children in a Philadelphia suburb. Unlike the institutionalized children, the parents of these children were asked to give their consent. The trial was a success, and the vaccine was licensed in 1967.

The third big vaccine developed in the 1960s was against rubella. Rubella, or German measles, usually causes few complications except in pregnant women. The women become only mildly ill, but the virus causes birth defects in the fetuses they are carrying. Australian physician Norman McAlister Gregg (1892–1966) published a paper connecting rubella infection with birth defects of the eye in 1941, but his observations were not widely accepted until Australian statistician Henry Oliver Lancaster (1913–2001) did an extensive analysis of the medical records of children at the Australian Institute for the Deaf and Dumb 10 years later.

From 1963 to 1964, a wave of rubella swept across America. The next year about 20 thousand babies were born with rubella-caused birth defects. The most common defect was deafness; the most severe were congenital heart defects and mental retardation. Doctors knew about the birth defect risk, but at that time abortion was illegal. A few doctors quietly offered to perform therapeutic abortions at the request of infected women, but most families were left with no choice but to worry and pray that their baby would be born healthy.

Maurice Hilleman took up the challenge of developing a rubella vaccine. He acquired virus from a sick child and weakened it by growing it first in monkey kidney cells and then in duck embryos. In 1965, he once again used a small group of mentally retarded children to test the vaccine. All developed antibodies to rubella, and when rubella broke out in their institution, 88 percent of the vaccinated children remained disease free. Hilleman was ready for a large-scale test of the vaccine, but he was thwarted by politics.

Mary Lasker (1900–1994), widow of advertising millionaire Albert Lasker (1880–1952), was a major financial backer of medical research. In the 1960s, she supported the work of Paul Parkman (1932–) and Henry Meyer (1928–2001) in developing a rubella vaccine, and she did not want Hilleman competing with them. Mary Lasker was strong willed and well connected to many influential people. She put pressure on Hilleman and his boss,

Max Tishler (1906–1989) to stop their rubella vaccine research. They reluctantly agreed. The Parkman/Meyer vaccine was licensed in 1969. Hilleman took that vaccine and improved, but at the same time, Stanley Plotkin (1933–) working at the Wistar Institute in Philadelphia was creating a still better rubella vaccine that was still in use in 2016.

Stanley Plotkin knew from a young age that he wanted to be a doctor. He earned a medical degree and joined the Air Force in 1957 where he hoped to learn to fly. Instead, he was assigned to the Epidemic Intelligence Service and sent to the Wistar Institute in Philadelphia where he researched polio and anthrax for the Air Force. After leaving Wistar in 1961, Plotkin went to London to complete his pediatric training. He arrived in the midst of a rubella epidemic. Seeing so many babies with rubella-caused birth defects deeply affected him. After completing his London training, he returned to Wistar to focus on rubella research.

When Parkman and Meyer needed rubella virus, they swabbed the throats of infected individuals. Plotkin chose instead to look for rubella virus in the cells of aborted fetuses. His reasoning was that the fetus was a sterile environment while throat swabs could be contaminated by other pathogens. Leonard Hayflick (1928–), another researcher at Wistar who was not involved in vaccine research, used cells from aborted fetuses to study aging. It is unclear whether these cells came from fetuses that were miscarried (a miscarriage in medical language is called a spontaneous abortion) or from intentionally induced abortions. Hayflick shared his fetal cells with Plotkin. Plotkin used them to grow the rubella used in an improved vaccine. This was the first live attenuated vaccine produced from virus grown in human cells.

Plotkin's rubella vaccine was licensed without controversy in Europe in 1971, but it ran into problems in the United States. First, Albert Sabin, still an influential researcher, mounted a challenge against the vaccine just as he had against Koprowski's and Salk's polio vaccine. Sabin's concern was that the fetal cells Plotkin used might contain some unknown infectious agent—he hinted darkly at cancer—that could be transmitted to the vaccine recipient. Sabin had never worked on rubella and had no scientific basis for his fear. The scientific community dismissed his concerns, but the Plotkin vaccine was not licensed in the United States until 1979.

That was not the end of the rubella vaccine controversy. In the 2000s, a woman named Debi Vinnedge, founder of the antiabortion organization Children of God for Life, raised ethical questions about the use of cells from aborted fetuses to make the vaccine. She went as far as to write the Vatican to ask the Pope to instruct Catholic doctors and nurses not to administer the vaccine and to advise Catholic parents to refuse it. The Church rejected the

idea that immunizing with the rubella vaccine was sinful, even though it did not approve of the way the vaccine was produced. As of 2017, Vinnedge was still opposing on moral grounds the use of vaccines produced using fetal cells. She does not, however, object to all vaccines, only those whose production involves aborted fetal tissue.

Individual vaccines for mumps, measles, and rubella had been approved in the United States during the 1960s. In 1971, under the direction of Maurice Hilleman, Merck licensed a trivalent vaccine that immunized against mumps, measles, and rubella (MMR) in a single shot. As will be detailed in Chapter 8, this combination vaccine has been the center of a great deal of controversy.

MODERN VACCINES

Beginning in the early 1980s, the anti-vaccination movement began to grow (see Chapter 8). A generation of parents who had never seen children with some of the illnesses vaccines prevent started questioning the safety and necessity of vaccination. The tolerance for risk decreased, and government regulation increased. Between 1970 and 1985, several marginally successful vaccines were developed, but they never received widespread acceptance. After 1985, several new vaccines were added to the CDC recommended schedule of childhood vaccinations.

Haemophilus Influenzae Type B (Hib)

Hib is one of a group of bacteria that are encased in a polysaccharide (complex sugar) coating. The polysaccharide shell helps protects the bacterium from destruction by the immune system. Protected bacteria present a special problem for vaccine makers. Unlike surface proteins to which the immune system reacts strongly, surface polysaccharides stimulate only a weak response. This make it difficult for the body to destroy these pathogens, and it makes it equally difficult for researchers to create a vaccine that stimulates enough antibody production to create immunity.

Hib is potentially fatal, especially in infants. It can cause meningitis (infection of the covering of the brain and spinal cord), pneumonia, and other serious infections. The first Hib vaccine was approved in 1985, but it did not produce adequate protective antibodies in children under the age of 18 months. Unfortunately, this is the age group most likely to be killed by Hib infections.

The first Hib vaccine was withdrawn from the market in 1988 when a new and more effective Hib vaccine was licensed. The new vaccine was a conjugate

vaccine. Conjugate vaccines were made possible by advances in technology that allow a piece of antigenic protein to be chemically hooked on to the polysaccharide coat of the bacterium. The protein boosts the immune system response so that it makes enough antibodies to create immunity even in young children.

Meningococcal and Pneumococcal Vaccines

Meningococcal and pneumococcal bacteria are also polysaccharide-coated bacteria. Meningococcal bacteria cause high fever, stiff neck, sensitivity to light, confusion, vomiting, and meningitis. Even with treatment, 5–10 percent of people die and up to 20 percent more are left with brain damage, deafness, and other permanent disabilities. Several vaccines against these bacteria were developed beginning in the mid-twentieth century. Their effectiveness was of limited duration and none produced immunity in young children.

It took until 2005 for a conjugate meningococcal vaccine to be licensed that protected very young children against the bacterium. Since then, several other versions of the vaccine have been approved. Although cases of meningitis have substantially decreased in the developed world, a February 2016 outbreak at Santa Clara University in California caused hundreds of college students to get emergency vaccinations.

Development of pneumococcal vaccine against the most common strains of the bacteria (there are over 90 strains) followed the same pattern of development as the meningococcal vaccine. First, a purely polysaccharide vaccine was developed that did not produce immunity in young children. This was followed in 2000 by the first conjugate vaccine, which was then improved on by increasing the number of strains against which the vaccine is effective. A polysaccharide vaccine is still given to adults over age 50, but the conjugate vaccine is used for children.

Chickenpox and Shingles

Chickenpox and shingles are caused by the same virus, *varicella zoster*. For most people, chickenpox is a mild childhood disease that causes fever, itchy fluid-filled blisters, and headache. For infants, people with suppressed immune systems (e.g., people with HIV/AIDS or who are receiving chemotherapy), and some healthy adults, the disease can be so serious as to require hospitalization. Occasionally deaths occur from complications.

When people recover from chickenpox, the *zoster* virus remains in their body and can reactivate to cause shingles years later. Shingles causes painful

fluid-filled blisters, usually only on one side of the body. The pain can be severe and last from two to four weeks or occasionally longer. There is no effective treatment. Often shingles develops along a nerve near the eye. In some cases, this results in blindness in that eye. Most at risk are adults over age 50 who have weakened immune systems.

The chickenpox vaccine was developed in the 1970s in Japan by Michiaki Takahashi (1928–2013), a microbiologist at Osaka University. Maurice Hilleman adjusted Takahashi's vaccine for use in the United States. Nevertheless, approval was delayed until 1995 because of several concerns. First, scientists were unsure how long immunity lasted. Chickenpox is much more severe in adults than in children. Physicians did not want to create a group of immune children only to have them become infected as adults if immunity waned. Second, since chickenpox is a mild disease for most people. Many parents, already concerned about the number of vaccines their children received, questioned whether vaccination was necessary and appropriate. Third, only people who get chickenpox can develop shingles. Vaccination would be introducing a virus into the body that might later cause health problems. Although these objections still exist causing some parents to refuse the vaccine for their children, a live attenuated vaccine is approved as a part of the CDC routine vaccination schedule for children.

Hepatitis A and Hepatitis B

Hepatitis A and hepatitis B are liver diseases. Hepatitis A is transmitted by ingesting food or water contaminated with feces that contain live hepatitis A virus. It can also be contracted by eating raw or undercooked shellfish raised in feces-contaminated water. The disease is most common in developing countries where water and sewage treatment are limited. Most Americans acquire the virus abroad.

After being ingested, the virus leaves the gut and migrates to the liver. Symptoms include nausea, vomiting, low-grade fever, rash, and jaundice. Many people have few symptoms, and most people recover without permanent liver damage. The first vaccine against hepatitis A was licensed in 1996. Two vaccines are available as of 2016. They are made of inactivated virus and are expected to provide immunity for about 20 years.

Hepatitis B is a more serious disease than hepatitis A, as it can lead to fatal liver cancer. The first hepatitis B vaccine was created by Maurice Hilleman at Merck and simultaneously by a group at the Pasteur Institute. Although the Hilleman vaccine was approved by the FDA in 1981, it had a social problem that it could not overcome.

Hilleman's hepatitis B vaccine was made from blood plasma taken from drug addicts and homosexual men, two groups most likely to be infected with hepatitis B. Although the virus was thoroughly inactivated using three different chemical treatments and tests showed it was highly effective, the public had trouble accepting it because of its origins. Then the AIDS epidemic broke. No one wanted to touch a vaccine made from blood products, especially blood from homosexual men and drug addicts, for fear that it contained HIV.

Merck discontinued making Hilleman's vaccine in 1986 not because it was unsafe or ineffective, but because no one would buy it. A hepatitis B vaccine acceptable to the public and not associated with blood was developed using the recombinant RNA technology and licensed by Merck that same year. Usage increased dramatically resulting in a 99 percent decrease in liver cancer, although the necessity of giving this vaccination to newborns is challenged by many vaccine skeptics (see Chapter 8).

Rotavirus

Rotavirus causes fever, vomiting, and severe diarrhea leading to dehydration in infants and young children. Children in daycare are especially at high risk because the virus is common and is spread through fecal-oral contact. Before the introduction of a vaccine, rotavirus caused between 2.1 and 3.2 million cases of diarrhea each year in the United States resulting in 55,000–77,000 hospitalizations and as many as 60 deaths. Worldwide, at least two million children under age five are hospitalized from rotavirus infection each year, and more than half a million die.

RotaShield, the first rotavirus, was licensed in the United States in 1998. It was voluntarily withdrawn from the market by its manufacturer, Wyeth, 14 months later because it caused intussusception in some infants. Intussusception occurs when one part of the small intestine slides inside another part of the intestine. This creates blockage and a medical emergency. RotaShield is a rare example of a vaccine that went through clinical trials and reached the market without this problem coming apparent.

In 2006, two new rotavirus vaccines were licensed. Rotatix is effective against a single strain of *rotavirus*. The other is RotaTeq is a recombinant vaccine that protects against five strains of *rotavirus*. Recombinant vaccines are made by artificially combining genetic material from several strains of the virus. Since the introduction of these two vaccines, hospitalization for rotavirus has dropped by 94 percent in the United States.

Human Papillomavirus

No twenty-first century vaccine has caused as much discussion as the vaccines against human papillomaviruses (HPV). There are more than 130 strains of HPV, of which about 40 are sexually transmitted. The sexually transmitted HPVs are responsible for genital warts, precancerous changes in the tissues of the vagina and cervix, and cervical cancer. Penile cancer and anal cancer have also been linked to the virus, as have an increased risk of throat and esophageal cancer. Harald zur Hausen (1936–) was the first person to show that HPVs were related to cervical cancer. He shared the 2008 Nobel Prize in Physiology or Medicine for this discovery.

The first HPV vaccine was developed at the same time in the United States and Australia, with Ian Frazer (1953–) and Jian Zhou (1957–1999) of the University of Queensland receiving priority recognition. In 2006, the first HPV vaccine was licensed in the United States. It was a recombinant vaccine that protected against four strains of the virus. Since then, additional vaccines have been licensed. The most recent came into use in 2014. It is a recombinant vaccine genetically engineered to protect against nine strains of HPV.

Opposition to HPV vaccine comes from conservative groups who object to making HPV mandatory for school attendance. (This requirement varies from state to state.) They point out that HPVs are transmitted through sexual activity and that children cannot catch HPVs by attending school with an infected child the way they could catch measles or influenza.

Opposition also comes from parents and organizations that claim that the vaccine will promote early sexual activity. The vaccine is designed to be given to preadolescent girls and boys in three doses beginning at age nine. It is effective only if given before the start of sexual activity.

Still another group of parents believes that HPV vaccination will lead young people to believe that they have immunity to other sexually transmitted infections when in fact they do not. Controversy continues in 2017, although many states have backed off requiring HPV vaccination for school attendance.

With the success of HPV vaccine in preventing cervical and anal cancers, more emphasis has been put on developing other cancer vaccines. In addition, vaccine researchers are actively searching for vaccines to prevent diseases such as malaria, HIV infection, Zika, and Ebola. In late 2015, Mexico approved the first vaccine against dengue fever. By 2017, it had been approved in 11 countries, although there was some controversy about its effectiveness. Chapter 9 looks these and other possible developments in the future of vaccines.

SUMMARY

The desire to control contagious diseases through vaccination dates back centuries. Nevertheless, along with the desire to prevent disease has come skepticism about introducing modified pathogens into the body. Many attempts to develop vaccines have failed and in some cases, even caused harm, causing skeptics to question the validity and usefulness of vaccination. Nevertheless, advances in immunology, virology, and genetic engineering continue to produced safer vaccines with fewer adverse effects. This does not mean that vaccines are 100 percent safe or 100 percent effective. Overall, however, vaccines have substantially improved human health and saved millions of lives worldwide.

Chapter 4

How Vaccines Work

The goal of vaccination is to develop long-term immunity against disease caused by a specific organism. Developing immunity through vaccination without causing illness is a multifaceted process that involves physical and chemical changes in the immune system and activation of a communication pathway that coordinates the response of individual cells and chemical reactions. To understand how vaccines stimulate immunity, it is necessary to understand the details of how the immune system works.

IMMUNE SYSTEM TISSUES AND ORGANS

Unlike all other organ systems in the body except the endocrine system, the immune system is spread out among tissues and organs physically unconnected to each other. The lymphatic system serves as the main link among these various tissues and organs.

The lymphatic system is a series branching tubules or ducts distinct from, but with connections to, the veins of the circulatory system. It moves lymph, a colorless fluid that contains leukocytes (white blood cells), through the body. About 550 bean-shaped masses of tissue, the lymph nodes, are found at various places along the lymph ducts, such as in the neck, under the arms, and in the groin. Lymph nodes filter lymph and screen it for pathogens and abnormal cells. When people talk about having "swollen glands," they are actually talking about enlarged lymph nodes that have been activated to fight disease.

Immune system cells begin life in the bone marrow as hematopoietic (blood producing) stem cells. Bone marrow is a spongy material made up of blood vessels and connective tissue found in the interior of bones, especially the ribs,

sternum (breastbone), pelvis, and upper part of the long bones of the arms and legs. Hematopoietic stem cells have the potential to differentiate into red blood cells (erythrocytes) and a variety of white blood cells including all the different types of immune system cells.

Some immune system cells mature in the bone marrow, while others mature and are activated in specific tissues, and still others migrate to the thymus where they undergo maturation. The thymus is a lymphoid organ located above the heart and behind the breastbone. It is at its largest during puberty, weighing between 1 and 1.5 ounces (20–35 g). In young adulthood, it begins to shrink and change into fatty tissue. The spleen is another organ with significant immune function. This brownish organ weighs about 6 ounces (170 g) and lies between the ninth and eleventh ribs on the left side of the abdomen. The spleen contains an abundance of blood vessels and lymph ducts and acts as a filter, removing antibody-coated bacteria and damaged cells. The inner part of the spleen, called the white pulp, contains a high density of antibody-producing B leukocytes (B cells).

Other clusters of lymphoid tissue are found in the appendix, adenoids, tonsils, and Peyer's patches, which are located in the lower portion of the small intestine. Sometimes because of injury or infection, the spleen or other lymphoid tissue must be removed. People can live without these organs, but their susceptibility to infection is increased.

DISTINGUISHING SELF FROM NONSELF

The immune system can protect the body only if it is able to distinguish a person's healthy cells (self cells) from diseased or damaged self cells (sick self cells) and the millions of different pathogens (nonself or foreign cells) that enter the body daily. The ability to attack only foreign cells and leave self cells alone is called immune tolerance. The discovery of immune tolerance developed out of the results of early skin grafting operations. Doctors found that grafted donor skin usually was rejected by the recipient for no obvious reason such as infection. Eventually, researchers discovered that all self cells carry, or in the language of biology, "express" a set of marker molecules on their surface called the major histocompatibility complex (MHC). In humans, the MHC molecules are also referred to as human leukocyte antigens (HLAs). No two humans express the exact same MHC; even identical twins have minor differences in these proteins.

MHC molecules act as a uniform that tells the immune system which cells are on the body's team. Cells without the proper self MHC are identified as foreign and are targeted for destruction. Almost all early skin grafts were

rejected because of a poor match between the donor's MHC and the recipient's MHC, so the recipient's immune system identified the donated skin as foreign and destroyed it. Viruses and bacteria also express identifying molecules on their surfaces. Since they are not the same as self cells' MHC markers, they are identified as foreign and attacked by leukocytes of the immune system.

The system for telling self from nonself is very effective but not perfect. Some pathogens have evolved ways to escape detection. For example, some bacteria such as *salmonellae* that cause typhoid fever are covered by a coating that protects them from being engulfed by immune system cells or destroyed by toxic chemicals. Other pathogens such as viruses enter healthy body cells where they are initially shielded from attack. For vaccines to be effective, researchers must find a way to combat these evasion techniques.

Sometimes immune tolerance fails and immune cells are inappropriately triggered to attack healthy self cells. When this happens, a person is said to have developed an autoimmune disorder. Common autoimmune disorders include multiple sclerosis, rheumatoid arthritis, systemic lupus erythematosus, and type 1 diabetes. Scientist do not yet understand what triggers the immune system to destroy the body's healthy self cells, although clues suggest that some autoimmune disorders are associated with specific variations in the genes that direct the production of cell surface proteins. People with immune system disorders or other conditions that weaken the immune system may not be able to safely receive certain vaccines.

THE INNATE IMMUNE SYSTEM

As explained in Chapter 2, the immune system has two parts, the innate immune system and the adaptive immune system. The innate immune system is evolutionarily ancient; elements of it are found in almost all living things. The system is called "innate" because its elements are present at birth and do not require any outside stimulation to develop. The innate system is part of what is called cell-mediated immunity.

Three characteristics distinguish the innate immune system. First, the response is nonspecific; that is, the innate system responds in the same way to all pathogens. Innate system cells are able to recognize a wide variety of pathogens as well as noninfectious proteins such as honeybee venom. They can do this because many different pathogens carry an identical set of identifying proteins on their surface called pathogen-associated molecular patterns (PAMPs). PAMPs are antigens that stimulate the same immune response regardless of the species of pathogen.

Second, the innate response is immediate. Maximal response is achieved in a short time—minutes to hours rather than days. Third, the response of the innate system does not change no matter how many times it encounters the same pathogen. Unlike cells in the adaptive immune system, cells of the innate system have no immunological memory to help them destroy repeat pathogens more efficiently.

First Barriers to Pathogens

The first line of defense in the human innate immune system consists of physical and chemical barriers that prevent a many pathogens from penetrating the body.

- Intact skin prevents the entry of bacteria and viruses. Sebaceous skin glands secrete an oily, waxy substance that helps waterproof the skin. Sweat glands give the skin an acidic pH of between 4 and 5 (pH 7 is neutral), making it inhospitable to many bacteria.
- Mucus in the mouth and mucous membranes that line the airways and the genitourinary tract trap pathogens. Coughing and sneezing help to expel pathogens. Mucus also contains antimicrobial proteins.
- Tears and saliva wash away pathogens and contain chemicals that inhibit their growth.
- The stomach contains strong acid that kills many pathogens.
- Vaginal secretions are slightly acidic, which discourages microbial growth.
- Semen contains antimicrobial proteins and zinc, which kill many pathogens.

Response to Pathogen Penetration

A pathogen that gets past the external physical and chemical barriers of the innate immune system and penetrates the body damages healthy cells. Damage occurs whether the pathogen is a bacterium, virus, fungus, or parasite. The injured cells release chemical messengers known as eicosanoids and cytokines. Eicosanoids make the blood vessels near the injury site relax and become more permeable or leaky. Blood flow to the area increases, and increased permeability lets immune system cells escape from the circulatory system and flood the damaged area. Eicosanoids also sensitize pain receptors and increase tissue temperature to slow pathogen growth.

Cytokines are signaling molecules that cause leukocytes to move toward the injured area, a process called chemotaxis. Cytokines and other chemical messengers also coordinate activities of the arriving leukocytes. Together, the actions of these chemicals produce an inflammation reaction. Localized signs of inflammation include redness, swelling, heat, and soreness at the site of infection. Responses that are more widespread include fever, increased mucus production such as a runny nose, swollen joints, general body aches, and localized internal pain such as a sore throat or earache.

In response to infection, the body increases production of leukocytes. After a few days, this allows infection to be detected by a common laboratory test called a complete blood count (CBC). A reported "high white cell count" (i.e., an abnormally large number of leukocytes in the blood) is a good indication that the immune system has geared up to fight infection or disease.

CELLS OF THE INNATE IMMUNE SYSTEM

All immune system cells are leukocytes (white blood cells). There are three classes of leukocytes in the innate system. Granulocytes are cells that contain packets or granules of destructive chemicals that, when activated, are released to kill pathogens. Phagocytes are cells that can change shape so that their cytoplasm flows around a pathogen. Once the pathogen is trapped inside the phagocyte, it is destroyed, a process called phagocytosis. Innate lymphocytes are cells that have some characteristics of adaptive system cells but are considered part of the innate system.

Some cells types classified as innate system cells such as macrophages and dendritic cells also play crucial roles in the adaptive immune response. In addition, many immune system cells have other functions in the body. For example, mast cells, basophils, and eosinophils are involved in mediating allergic reactions, and natural killer cells are thought to play a role in preventing a woman's immune system from killing nonself fetal cells during pregnancy. The discussion below focuses only on the role immune cells play in responding to disease or vaccination.

Granulocytes

Neutrophils are the most abundant leukocyte in the body and the first immune system cells to arrive at damaged tissue. Attracted by chemicals released from damaged cells, they migrate out of the bloodstream and into damaged tissue within minutes. When they reach the site of tissue damage, neutrophils release signaling molecules to attract more cells to the area. They

then change shape and phagocytize (engulf) and destroy the pathogen. Neutrophils also release granules of chemicals with antimicrobial properties that help limit infection. Finally, neutrophils send out a spider web of filaments to trap pathogens and slow their spread. These hard-working cells die within one to two days but are quickly replaced because the body can make about 10 billion new neutrophils each day. Pus that accumulates at wound sites is made up mostly of dead neutrophils.

Eosinophils and basophils also migrate to the damaged tissue in response to chemical signals. Eosinophils develop and mature in bone marrow. Once mature, they circulate in the blood until activated by signaling molecules. Eosinophils release cytokines and enzymes that kill pathogens. These cells are most effective in controlling parasitic worms (e.g., helminths) and appear to play a role in fighting viral infections.

Basophils are the least common type of leukocyte. They contain large granules that release histamine, a chemical that dilates blood vessels, makes the vessels more permeable, and increases blood flow to damaged tissue. Basophils often gather at sites where external parasites such as ticks, lice, or fleas have broken the skin. Mast cells are similar to basophils and perform similar functions. They are more commonly associated with allergic reactions than with immune system response.

Phagocytes

Macrophages (literally "large eaters") are the largest of all the leukocytes. They are the clean-up crew of the immune system. Macrophages begin life as monocytes. Monocytes leave the bone marrow and move through the bloodstream and into many types of tissue where they mature into macrophages. Macrophages clear the body of dead and dying cells. This is an ongoing function that does not require stimulation by immune system chemical signals. However, when a macrophage detects a chemical message from a damaged cell, it moves to the area of damage.

Macrophages arrive at the infection site about 48 hours after neutrophils. Here they perform two jobs. First, they clear away dead and dying neutrophils. Second, they surround pathogens and "eat" them through phagocytosis.

Unlike phagocytic neutrophils, macrophages do more than kill the pathogen. Once the pathogen is destroyed, the macrophage takes a bit of the pathogen's protein and incorporates it into a molecule that it then moves to its own cell surface. This changes the macrophage's surface marker proteins so that now the macrophage looks to other immune system cells like a foreign or nonself cell. The process of using bits of the pathogen to create a new surface

marker protein is called presenting the antigen. Remember that an antigen is any substance that stimulates the production of antibodies. Here, the antigen is the bit of foreign protein from the pathogen. As we will see in the section on the adaptive immune system below, antigen presentation by a macrophage is an essential step in the production of antibodies by cells of the adaptive immune system.

Dendritic cells are also antigen presenting cells (APCs). They are even more efficient than macrophages at antigen presentation. The role of macrophages in antigen presentation has been understood for a long time. Dendritic cells, however, were not discovered until 1973. They were first recognized as a link between the innate and adaptive immune response by Ralph Steinman (1943–2011), a Canadian immunologist who worked at Rockefeller University in New York City. Steinman named the cells for their tree-like branches; dendritic cells are not related to the similar-sounding dendrites found on nerve cells. Steinman received the Nobel Prize in Medicine or Physiology in 2011 for his work in understanding the role of dendritic cells in the immune system.

Immature dendritic cells are found in tissue that has contact with the outside environment such as skin and the mucous membranes lining the airways and the digestive system. Immature dendritic cells are constantly searching for invading pathogens. When a pathogen is located, it is phagocytized, and the dendritic cell undergoes a maturation process during which protein from the pathogen is processed and a bit of the pathogen's antigen is presented on the surface of the dendritic cell. The mature dendritic cell then migrates to the thymus where it stimulates an unactivated or naïve T lymphocyte (T cell) that is part of the adaptive immune system.

All human cells that contain a nucleus (red blood cells are the largest group that do not have nuclei) have some ability to process foreign proteins and present antigens, but dendritic cells and macrophages are so much more efficient at antigen presentation that they are often called *professional* APCs. These cells form an essential link between the innate and adaptive immune system.

Innate Lymphocytes

Natural killer (NK) cells are classified as cells of the innate immune system, but like professional APCs, they straddle the line between the innate and adaptive system. NK cells are neither granulocytes nor phagocytes, but are lymphocytes, just as are T cells and B cells of the adaptive system. They mature in bone marrow and other lymphoid tissue such as the spleen, tonsil, thymus, and lymph nodes, after which they enter the circulatory system.

NK cells do not directly kill pathogens. Instead, they recognize and kill compromised or altered self cells. These may be self cells that have been taken over by a virus that has hidden in the cell or self cells that have become cancerous or damaged. Unlike other immune system cells that recognize foreign cells because their MHC proteins are different from self cells, NK cells appear to recognize self cells that have been damaged and are missing some of their surface proteins. This ability is especially useful in detecting tumor cells, which begin life as self cells and then mutate into cancer cells. Recent research also suggests that NK cells have a memory function similar to the T and B memory cells of the adaptive immune system. Table 4.1 summarizes the characteristics and immune system function of innate system cells.

THE COMPLEMENT SYSTEM

The complement system is a cascading series of chemical reactions that involve both innate and adaptive system cells. Its name comes from the fact that it "complements," or helps, the immune system's ability to remove pathogens from the body. The system consists of about 30 small proteins that circulate separately in inactive form in the blood. When these proteins are activated by chemical signals from immune system cells, they come together in a way that allows them to punch holes in the cell membrane of pathogens. Fluid enters through the holes, and the cell bursts, a process called cellular lysis.

The complement system is a positive feedback system. Complement proteins initiate chemical reactions that draw more immune system cells to the site, which, in turn, stimulate an increased complement response. The complement system also attaches molecules to pathogens that coat them to make them more attractive targets of immune system cells. This process is called opsonization. The word "opsonize" is derived from a Greek word meaning a delicious side dish. In essence, the complement system marks pathogens to make them a tastier to immune system cells. Complement proteins also assist in making pathogens form clumps (agglutinate), so that multiple pathogens can be killed by a single immune system cell.

THE ADAPTIVE IMMUNE SYSTEM

The adaptive immune system, sometimes called the acquired immune system, is evolutionarily younger than the innate immune system. Complete adaptive immune response is found only in jawed vertebrates, although some related elements of the system are present in other life forms. The system is

Table 4.1 Cells of the Innate Immune System

Cell Name	Cell Type	Characteristics	Immune System Function
Neutrophil	Granulocyte	Most abundant leukocyte (60%–70% of total leukocytes)	First responder to infection Especially responsive to bacterial infection and environmental toxins; also attacks fungi
Eosinophil	Granulocyte	Found in highest concentration in mucous membranes of respiratory, digestive, and urinary tracts	Attacks large parasites and bacteria
Basophil	Granulocyte	Least common leukocyte	Releases histamine to cause dilation of blood vessels and induce inflammatory response; attacks skin parasites
Mast cell	Granulocyte	Found in connective tissue, skin, lining of digestive system	Releases histamine to cause dilation of blood vessels and induce inflammatory response; attacks internal parasites
Monocyte	Phagocyte	Immature macrophage	Develops into marcrophage
Macrophage	Phagocyte	Largest leukocyte Professional antigen presenting cell Link between innate and adaptive immune system	Engulfs pathogen, processes its protein, and presents it to T cells. Removes dead and damaged neutrophils and pathogens
Dendritic cell	Phagocyte	Professional antigen presenting cell Link between innate and adaptive immune system	Most efficient cell at engulfing a pathogen, processing it, and presenting it to T cells
Natural killer cell	Lymphocyte	Recognizes self cells with missing marker proteins. Part of both innate and adaptive immune system	Removes virus-infected cells and tumor cells. May be retained as a type of memory cell.

called "adaptive" because long-term changes occur when cells of the adaptive system interact with pathogens.

The two main types of leukocytes in the adaptive system are T lymphocytes (T cells) and B lymphocytes (B cells). The body contains between one and two trillion of these cells, which make up between 20 and 40 percent of all white blood cells. Ninety-eight percent of T and B cells are found either in lymph or in tissue; only 2 percent circulate in the blood. If all the T and B cells were extracted from the body, their weight would be approximately equal to that of the brain. The receptors on the surface of these cells can recognize at least 100 million unique antigens.

Three characteristics distinguish the adaptive immune system from the innate immune system:

- The adaptive response is highly specific. Each cell (not each type of cell, but each single cell) in the adaptive immune system responds to only one antigen. That means it attacks only one species or strain of pathogen, while each innate cell can recognize many different pathogens.
- The primary response is slow. On the first exposure to a pathogen, it takes 10–17 days to develop maximal response compared to the minutes to hours of innate cell response.
- When a pathogen has been destroyed, T and B memory cells remain in the body. They "remember" the pathogen and respond quickly if the same pathogen is encountered again. This secondary response to a repeat pathogen reaches maximal effectiveness within two to seven days, fast enough so that the individual does not become ill. The creation of memory cells is the basis for active immunity. Vaccines substitute for infection with a pathogen in creating memory cells. The capacity to create immunological memory does not exist in the innate system response.

Antigens and Antibodies

The adaptive immune system rids the body of pathogens by the production of antibodies. Antibodies, also called immunoglobulins (Igs), are tiny proteins produced by B cells. Antigens and antibodies work like a lock and key system. Each antibody has a binding site that will bind only with a matching antigen. Antibodies are 10 times smaller than a virus and 200 times smaller than a bacterium, but they are a powerful force in defeating pathogens. There are five classes of immunoglobulins, each with a different immune function. The location and function of each class immunoglobulin is described in Table 4.2.

Table 4.2 Classes of Human Immunoglobulins

Class of Immunoglobulin/ Antibody	Characteristics	Function
Immunoglobulin A (IgA)	Found in secretions of mucous membranes and fluids such as tears and breast milk	Protects against pathogens entering the body particularly through mucous membranes
Immunoglobulin D (IgD)	Remains attached to the surface of B cells	Initiates B cell response
Immunoglobulin E (IgE)	Receptors on basophils and mast cells	Attacks parasites and lyses them; stimulates inflammation Involved in allergic reactions
Immunoglobulin G (IgG)	Most numerous of all Igs in blood and lymph; can cross placenta to provide temporary passive immunity to fetus and newborn	Works with complement system to enhance phagocytosis; neutralizes toxins (e.g., tetanus); neutralizes viruses
Immunoglobulin M (IgM)	Produced only on first exposure to pathogen	Works with complement system to agglutinate cells Highly effective in killing bacteria

Antibody proteins assemble in a Y shape. The Y has one of five different stems. All antibodies in the same class (IgA, IgD, IgE, IgG, IgM) have the same stem. Each arm of the Y has a heavy chain on the inside of the arm and a light chain on the outside of the arm. The pieces of the Y are linked by sulfur bonds (S-S). Antibodies bind to antigens at the end of the Y arms. Figure 4.1 illustrates the anatomy of a generic antibody.

Creating Antibody Diversity

Antibodies can recognize, bind to, and destroy millions of different antigens. As of 2015, the human genome was thought to contain about 19,000 genes. One would expect that the genome would need to be much, much larger to code for the millions of unique antibodies and T-cell receptors the body produces. How do so few genes produce this huge variety of unique receptors and antibodies? The answer lies in the structure of the antibody and a process of shuffling DNA called somatic diversification or V (variable) D (diversity) J (joining) recombination.

VDJ recombination was discovered by Japanese Scientist Susumu Tonegawa while working at Massachusetts Institute of Technology. For his discovery, he was awarded the Nobel Prize in Physiology or Medicine in 1987. VDJ occurs

Figure 4.1 Anatomy of an Antibody

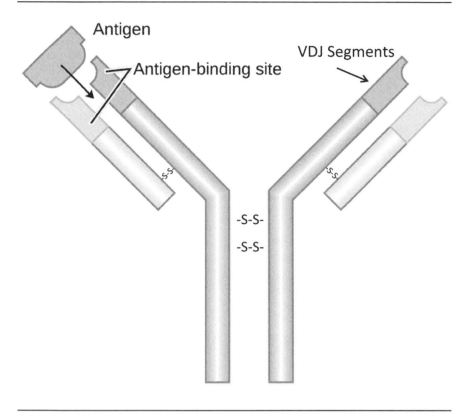

Source: Adapted from National Institutes of Health. National Human Genome Research Institute. "Talking Glossary of Genetic Terms." Online at https://www.genome.gov/glossary/

only in T cells and B cells and only early in their maturation process. In T cells, VDJ is responsible for the rearrangement of genetic material that creates a unique antibody receptor on the surface of each T cell. In B cells, VDJ is responsible for the shuffling genetic material to produce antibodies, each capable of interacting with only one type of antigen.

In VDJ recombination, only three gene segments, V, D, and J, are involved. Each segment contains multiple bits of genetic material—about 40 V bits, 30 D bits, and 6 J bits. Through the actions of enzymes, one bit from each these segments is randomly selected and recombined to produce genetic material that will direct the production of either a T-cell receptor or a B-cell antibody. The genetic material not selected plays no role in this process and is snipped away by other enzymes.

Calculating the possible combination of VDJ bits—40 V × 30 D × 6 J = 7,200—shows that this is not nearly enough variety to recognize all

possible antigens. However, remember that antibodies contain three protein chains. One chain, the heavy chain, is recombined as described above. Two other chains, the light chains, undergo recombination of the V and J segments, but lack the D segment. Therefore, each light chain has 40 V × 6 J = 240 combinations. When the chains are linked to form an antibody, the possible number of combinations becomes 7,200 (heavy chain) × 240 (light chain 1) × 240 (light chain 2) = 414,720,000. This number of possible genetic combinations is more than enough to recognize every antigen an individual is exposed to during a lifetime.

In addition, the V, D, and J gene segments are areas of hypermutation. This means that the sequence of base pairs that make up the DNA for these regions undergoes frequent spontaneous change much more often than occurs in other parts of the gene. Recombination and hypermutation allow immune system cells to adapt to the antigens of newly evolving pathogens. In fact, scientists have shown that T and B cells can respond to artificial antigens that have never appeared in nature. A visual demonstration of the process of VDJ recombination can be seen in a YouTube video at https://www.youtube.com/watch?v=-zEMfAXPLUA.

T Cells

T cells arise from stem cells in bone marrow and differentiate into several subtypes. Immature T cells leave the bone marrow and migrate to the thymus. In the thymus, they undergo VDJ recombination and a complicated maturation process that results in each T cell having a surface receptor that can bind with a unique antigen. The T-cell receptor is like a lock and the antigen is a key. Just as a lock will open only with the correct key, a T-cell receptor will only become active when it encounters the correct antigen. When an activated dendritic cell migrates to the thymus, it presents its antigen to the T cells gathered there. When the dendritic cell meets a T cell that has a receptor that matches its antigen, the cells bind, and the T cell becomes a functional immune system cell.

One problem that arises from random VDJ recombination is that with so many different possible T-cell receptors, some are likely to match the MHC proteins on healthy self cells. The immune system has evolved a way to prevent this. Any T cells with receptors matching the MHC protein of healthy self cells die and never leave the thymus. This keeps the body from destroying its own tissue.

Cytotoxic T Leukocytes

Based on their surface protein markers, there are two major subtypes and several minor subtypes of T cells, all with different immune functions. One major T-cell subtype has the CD8 protein on its surface. In the thymus,

when a dendritic cell activates a CD8+ T cell (the + indicated the presence of the protein), the T cell undergoes clonal expansion. During this process, the T cell divides repeatedly to create a huge number of identical CD8+ daughter cells. These cells are destined to become cytotoxic T leukocytes (CTLs) also referred to as killer T cells. CTLs leave the thymus and enter the bloodstream. When they encounter an abnormal self cell with an antigen that matches their receptor (e.g., a cancer cell or a self cell infected with a virus), they bind with that cell and destroy it by releasing chemicals that punch holes in the target cell's membrane and disrupt the cell's internal metabolism.

Helper T Cells

T cells expressing the CD4 protein are also activated by dendritic cells. These T cells undergo clonal expansion, creating many CD4+ daughter cells, but the CD4+ cells become helper T cells (TH). TH cells leave the thymus and migrate to the site of infection. Unlike CTLs, helper T cells (there are several different subtypes) cannot directly kill pathogens. Instead, they secrete chemicals that communicate instructions to other immune system cells. Some of these chemicals help B cells differentiate into antibody-secreting cells. Others help CTLs mature into active killers. A select group of TH cells matures into T memory cells through an incompletely understood process.

Memory T Cells

Besides the specificity of the adaptive immune system, its other special attribute is the ability to create a data bank of cells that remember specific antigens and respond quickly if the antigen is encountered later in life. In order to develop this data bank, the body creates memory cells. Some T cells instead of being activated as functional CTLs or THs become long-lived memory T cells. Scientists are still unraveling the exact process by which memory cells are formed. They have identified at least three different types of memory T cells that are distinguished by their surface proteins and the chemicals that they secrete. Understanding how memory cells are made and activated is important to vaccine research because these cells can remain in the body for years and are the cornerstone for conferring active immunity to disease.

Regulatory T Cells

Once a pathogen has been cleared from the body, the immune response needs to wind down. Regulatory T cells (Tregs), also called suppressor T cells, play a role in stopping the activities of other immune cells. About 10 percent of

Table 4.3 Cells of the Adaptive Immune System

Cell Name	Cell Type	Cell Function
Cytotoxic T cell CD8+ cell	T lymphocyte	Directly kills virus- or bacteria-infected cells and abnormal cells through the release of toxins
Helper T cell CD4+ cell	T lymphocyte	Releases cytokines that direct the action of other immune cells and activate antibody formation by B cells.
Regulatory T cell	T lymphocyte	Releases chemicals that wind down the immune response once a pathogen has been controlled and prevent immune response against self cells
Memory T cells	T lymphocyte	T cells that remain in the body after a pathogen has been eliminated until activated by a second encounter with the pathogen
Immature B cell	B lymphocyte	Differentiates into plasma cell or memory B cell
Plasma cell	B lymphocyte	Secretes antibodies after stimulation by helper T cell
Memory B cell	B lymphocyte	B cells that remain in the body after a pathogen has been eliminated until activated by a second encounter with the pathogen

CD4+ helper cells become Tregs. Although their role is not well understood, Tregs appear to strip APCs of their antigen, thus stopping the adaptive immune response. They also may kill active T cells by binding with them and releasing destructive chemicals. Tregs appear to help maintain immune tolerance and may play a role in preventing maternal antibodies from killing fetal cells during pregnancy. The different types of adaptive immune system cells and their functions are summarized in Table 4.3.

The Role of B Cells

B cells, like T cells, arise from stem cells in the bone marrow. Unlike T cells, B cells do not migrate but undergo VDJ recombination and mature in bone marrow. In contrast to T cells, B cells recognize foreign antigens directly when they encounter them in blood and lymph; they do not need to have the antigen engulfed, processed, and presented to them to be activated.

Once a B-cell receptor binds to a matching antigen, the B cell is activated and begins to divide. Most of the resulting identical daughter B cells become plasma cells. Plasma cells secrete antibody molecules directly into the blood and lymph at the astounding rate of 2,000 per second for three to five days. These antibodies are identical, and they are specific to the antigen that activated the mother B cell.

With help from the complement system, an antibody may link to multiple pathogens, making them clump so that they are easier for phagocytes to destroy. Also in conjunction with chemical signals from the complement system, antibodies can opsonize pathogens, making the pathogen more susceptible to destruction by macrophages, or they can bind to the pathogen so that it can no longer attach to and damage healthy body cells. Some bacteria release toxins that cause illnesses such as diphtheria and tetanus. These toxins act as antigens. B cells make antibodies against the toxin and can block the site of toxin production.

Memory B Cells

Not all B cells become antibody-producing plasma cells. Under the direction of chemicals released by helper T cells, some B cells become memory B cells. Like memory T cells, the formation of memory B cells is not completely understood. Memory B cells play a critical role in adaptive immunity. They remain in the body for a long time and respond promptly by producing a swarm of antibodies when challenged by a pathogen they have already met.

VACCINES AND IMMUNITY

The goal of immunization is to produce active immunity by stimulating the immune system to create long-lasting memory cells without the vaccinated individual developing symptoms of disease. Some vaccines provide lifetime immunity. Others protect for decades and some for only a few years. For a disease such as rotavirus, which is life threatening only to very young children, a vaccine given to protect infants only during the time when they are most vulnerable is highly effective. If immunity weakens as children age, rotavirus may cause gastrointestinal upset, but it is unlikely to produce life-threatening dehydration the way it could in an infant. Other vaccines such as the one against tetanus provide immunity for about 10 years. Tetanus affects people of all ages and therefore requires people continue to get booster shots throughout their lives to maintain immunity.

Although researchers can determine how effective a vaccine is across an entire population, they can neither predict which individuals will have a response adequate to prevent disease nor can they determine exactly how long immunity will last for any specific individual. Testing for antibody production after vaccination shows that about 10 percent of vaccinated children fail to develop adequate immunity, although many of them do not become sick because they are protected by herd immunity.

The strength of an individual's response to a vaccine depends on:

- The method of constructing the vaccine. Live attenuated vaccines stimulate a stronger response than subunit vaccines.
- Age. Some young children have immune systems that are not mature enough to fully respond to a vaccine. Older people's immune systems respond less strongly than younger ones.
- Individual variations in person's immune system biology.
- Health status of the individual and medications being taken at the time of vaccination. Some medications and diseases depress the immune system.
- Proper transport and storage of the vaccine. Live attenuated vaccines can be weakened or destroyed if not properly handled or used after their expiration date.

SUMMARY

The immune system consists of tissues and organs spread throughout the body. The parts of the immune system communicate both through the release of chemical signaling molecules and cell-to-cell contact. Humans have antigens (MHC surface markers) on their cells that differ from the antigens on foreign cells. A healthy immune system can distinguish between healthy self cells and nonself cells and attacks only nonself or sick self cells.

The innate immune system contains three classes of cells: granulocytes, phagocytes, and innate lymphocytes. Individual cells of the innate immune system can recognize many different pathogens because these pathogens have similar surface markers (PAMPs). Damaged tissue releases chemicals that rapidly attract innate immune system cells that in turn activate other immune cells and the complement system. The complement system is a cascade of molecules that boosts immune system response. The innate system responds the same way no matter how often it is exposed to the same pathogen.

The adaptive immune system has two classes of cells: T lymphocytes (T cells) and B lymphocytes (B cells). These cells respond to signals from innate cells and the complement system. Adequate first response takes a week or more. T cells differentiate into helper T cells (there are several subtypes), killer T cells (cytotoxic T lymphocytes), memory T cells, and regulatory T cells. B cells differentiate into plasma cells and memory B cells under stimulation by T cells and signaling molecules. B cells produce antibodies (immunoglobulins) that are specific to a single pathogen protein (antigen). The body produces antibodies that can recognize millions of different antigens through a reshuffling of genetic

information called VDJ recombination that happens only in B and T cells. Regulatory T cells help shut down the immune response once a pathogen has been eliminated.

Memory cells allow the adaptive system to respond rapidly enough to repeat exposures of a pathogen to prevent disease symptoms. This ability is called immunological memory, and it is the basis for active immunity. Vaccines produce immunity by stimulating the immune system to produce memory cells without causing illness. Immunity can last from a lifetime to a few years or less depending on the type of vaccine and the individual's response. Childhood vaccines are about 90 percent effective in preventing disease. Adult vaccines have a lower rate of effectiveness. This means that some people who are fully vaccinated may still become sick, although the severity of symptoms usually is lessened, and many are protected from illness by herd immunity.

Chapter 5

Effects and Applications

Every year, the U.S. Centers for Disease Control and Prevention (CDC) releases recommended immunization schedules for children and adults. These schedules are based on recommendations of the Advisory Committee on Immunization Practices (ACIP). This committee was established as part of the 1944 Public Health Service Act. For each vaccine, ACIP considers the age at which the vaccine should be administered, the number of doses needed to achieve immunity, optimal time between doses, frequency and severity of adverse effects of the vaccine, precautions to be observed in the administration of the vaccine, and contraindications for vaccination.

The World Health Organization (WHO) also makes vaccine recommendations as part of its Global Vaccine Action Plan that aims to strengthen and extend coverage of routine vaccinations worldwide. The WHO recommendations are developed by the Strategic Advisory Group of Experts (SAGE) on Immunization established in 1999. These experts consider the same basic criteria as ACIP, but their recommendations can differ based on the needs and limitations of various national immunization programs and the prevalence of disease in different parts of the world.

The information below is based on the CDC 2017 recommended immunization schedule. This schedule is endorsed by ACIP, the American Academy of Pediatrics (AAP), the American Academy of Family Physicians (AAFP), and the American College of Obstetricians and Gynecologists (ACOG). Information on vaccines not routinely used in the United States is based on the WHO recommendations. Vaccines are listed alphabetically, not by age

of administration with a separate listing for vaccines not routinely used in the United States.

DIPHTHERIA, TETANUS, AND PERTUSSIS

Immunization against diphtheria, tetanus (also called lockjaw), and pertussis (whooping cough) is given as a combination vaccine administered by intramuscular injection in the thigh of young children and the arm of older children and adults. Diphtheria, tetanus, and acellular pertussis (DTaP) is the combination used in the United States for children younger than age seven years. Acellular pertussis contains only antigens from the pertussis pathogen and causes fewer adverse events that killed whole-cell pertussis vaccine, which is written as either DPT or DTwP. Whole-cell pertussis is still used internationally. Some studies show that it provides longer lasting immunity than DTaP.

DT is an alternative for children who cannot tolerate any pertussis vaccine. Capital D, T, and P indicate full-strength doses of each vaccine. Less frequently used is a four-combination vaccine that immunizes against diphtheria, tetanus, pertussis, and polio (Kinrix) and a five-combination vaccine against hepatitis B, diphtheria, tetanus, pertussis, and polio (Pediarix). These two vaccines have administration schedules and age restrictions that differ from DTaP and DT.

A slightly different formulation called Tdap (lower case d and p indicate reduced-strength doses) is used for children over age seven and adults. Td is a booster shot given to adults every 10 years because childhood immunization does not provide life-long immunity.

Diphtheria

Symptoms of diphtheria are caused by a toxin released by the bacterium *Corynebacterium diphtheriae*. The vaccine is made by harvesting the toxin and chemically inactivating it. The inactivated toxin does not cause disease but still stimulates the body to make antibodies against it. Vaccines made in this way are called toxoid vaccines.

Diphtheria begins with symptoms similar to the common cold. However, *C. diphtheriae* bacteria stick to the epithelial cells lining the airways. As toxin is released, it damages the cells. Soon a membrane forms made of dead cell, red and white blood cells, and fibrin, a protein that helps blood clot. The membrane can completely block the airway, resulting in death by asphyxiation.

In the mid-1920s before an effective diphtheria vaccine became widely available, at least 200,000 people in the United States contracted diphtheria each year. Between 5 and 10 percent of them died, with the death rate rising to 20 percent among children under age five. Today, diphtheria appears only sporadically in the United States, usually among the homeless, people who were incompletely immunized, and travelers from regions where the disease is active.

Elsewhere in the world, outbreaks periodically occur such as those in the early 2000s in the Baltic States, Eastern Europe, and sub-Saharan Africa. A person who is completely immunized and symptom-free can be a carrier for the disease and can transmit it to someone who does not have immunity.

Tetanus

Tetanus is caused by a toxin called tetanospasim that is excreted by the anaerobic bacterium, *Clostridium tetani*. Tetanus vaccine is a toxoid vaccine made by chemical inactivation of tetanospasim. Tetanus is different from other vaccine-preventable diseases in two ways. It cannot be passed from person to person and becoming infected does not confer natural acquired immunity. Immunity can only be achieved through vaccination and maintained through booster shots.

Spores of *C. tetani* are found in soil and animal feces worldwide. The spores are hardy. They can survive up to 20 years and are resistant to heat and disinfectants. Spores enter the body through a break in the skin that can be as minor as a splinter or the prick of a thorn. Once in the body, they are activated and produce bacteria. In about a week, symptoms appear that include painful muscle contractions and muscle stiffness, difficulty swallowing, and heavy sweating. Between half and three-quarters of people with tetanus cannot open their jaw, thus the common name of lockjaw. One in 10 people infected with tetanus die.

Tetanus is uncommon in countries with comprehensive immunization programs. Fewer than 30 cases occur in the United States each year, all in unvaccinated or incompletely vaccinated individuals. In developing countries, the rate of tetanus is highest in newborns who acquire the disease through contaminated equipment used to cut the umbilical cord.

Immunity created by the tetanus vaccine decreases over time. Even after receiving a complete series of childhood vaccinations, older children and adults need a tetanus booster in the form of Td or Tdap every 10 years to maintain full coverage.

Pertussis

Pertussis is a respiratory infection commonly called whooping cough. It is caused by the bacterium *Bordetella pertussis* and is transmitted by face-to-face contact, sharing a confined space with an infected person, and contact with nasal and respiratory secretions of an infected person.

Pertussis begins with symptoms similar to the common cold, but soon a violent coughing develops that can last several minutes and makes breathing difficult. The "whoop" of whooping cough is the sound the person makes while trying to breathe. Chronic coughing lasts six weeks or longer.

In the United States, outbreaks of pertussis occur every two to five years. In 2010, there were 27,550 reported cases and 7,518 deaths, the greatest number in 50 years. A smaller outbreak occurred in 2014. Although people of any age can contract pertussis, most deaths occur among infants too young to be vaccinated and in unvaccinated young children. Worldwide an estimated 48.5 million cases and 295,000 deaths occur annually.

Administration of DTaP and DT

DTaP is a combination vaccine against diphtheria and tetanus and pertussis. DT lacks the pertussis component. Before 1992, pertussis vaccine was made using whole killed bacteria and the combination vaccine was called DPT. Whole killed pertussis bacteria caused most of the adverse reactions to the vaccine. To reduce side effects, an acellular version of pertussis vaccine was developed. Acellular pertussis uses only inactivated proteins that cause the disease, not the whole bacterium. The improved vaccine containing acellular pertussis causes fewer adverse reactions than the older whole-cell version.

DTaP is administered to children ages of six weeks to six years. The recommended schedule calls for five doses given at ages 2, 4, and 6 months, between 15 and 18 months, and between 4 and 6 years. This schedule can be altered so long as adequate time is allowed between doses.

Administration of Tdap and Td

Tdap and Td are vaccines for children over age seven years and adults. A single dose of Tdap is recommended for children ages 11 (the preferred time) through 18 years, especially if these children have close contact with an infant too young to be vaccinated. Adults who have not received Tdap, which was licensed in the United States in 2005, should receive one dose of the vaccine. Otherwise, they should receive a Td booster every 10 years.

Pregnant women are given a single dose of Tdap between weeks 27 and 36 of pregnancy, to be repeated with each pregnancy. The antibodies the mother makes to the vaccine cross the placenta and provide some protection to the baby during the first weeks of life when its immune system is too immature for DTaP vaccination to be effective.

Side Effects

Adverse effects with DTaP are usually mild but quite common. One in four children develops redness, soreness, swelling at the injection site, and/or fever. These adverse effects are more common after the fourth or fifth doses. In about 3.3 percent of children, swelling may extend along the entire arm or leg and last for a week after the fourth or fifth injection. Other mild side effects include fussiness in about one-third of children, poor appetite (10 percent), and vomiting (2 percent).

Moderate adverse effects are less common and include seizures (twitching, jerking, or staring), which occur in about 1 of every 14,000 children, nonstop crying for three or more hours (1 of every 1,000 children), and fever over 105°F (40.5°C) in 1 of every 16,000 children.

Severe adverse events are rare. Serious allergic reactions occur less than once in every one million doses. Long-term seizures, coma, and brain damage have been reported, but these conditions occur so infrequently that it is not clear if they result from exposure to the vaccine or from other causes. See Chapter 8 for a discussion of the controversies that have surrounded DPT vaccine.

Special Populations

DTaP should not be given, or should be given with special care, in certain situations. Parents should discuss any conditions that may alter the administration of the vaccine with their child's pediatrician.

- Children who have had a severe allergic reaction to a dose of DTaP should not complete the immunization series.
- Children who have experienced a brain or nervous system disease within seven days of vaccination with DTaP should not complete the immunization series.
- Moderately or severely ill children and adults should wait until they are healthy to be vaccinated.
- Parents of children who have had seizures, cried nonstop for three or more hours, or had a fever over 105°F (40.5°C) after vaccination

should discuss the advisability of continuing immunization with DTaP with their pediatrician.

Postexposure Prophylaxis

Postexposure prophylaxis is the administration of a drug or vaccine after known or suspected exposure to a disease with the goal of preventing the disease or reducing its severity. Tdap may be given to any individuals exposed to a documented case of pertussis regardless of their current immunization status.

Individuals with a wound that may have exposed them to tetanus (e.g., a puncture wound, animal bite, or one contaminated with soil) are routinely given Td if their immunization status is unknown or if they have not had a Td booster dose within 10 years. ACIP also recommends that individuals injured in bombings or natural disasters where they are likely to have soil in their wounds receive a Td booster if their immunization status is unknown or if they have not had a Td booster within five years. Even in people who have had a recent booster shot, an additional one causes no increased health risks.

HAEMOPHILUS INFLUENZAE TYPE B

Haemophilus influenzae type b (Hib) is a bacterial disease. Despite the word *influenzae* in its name, it has no relationship to viral influenza. Many adults have Hib bacteria in their nose and throat and do not show symptoms, but they can spread the disease to children through face-to-face contact and respiratory droplets.

So long as Hib bacteria are confined to the nose and throat, they cause few problems. However, Hib can become invasive and enter other parts of the body causing serious or fatal illness. Before a vaccine was available, invasive Hib was the leading cause of bacterial meningitis in children. Meningitis is the infection of the lining of the brain and spinal column. It can leave children blind, deaf, paralyzed, or with brain damage. Symptoms include fever, drowsiness, and stiff neck. Hib can also cause pneumonia, bloodstream infections (bacteremia), and epiglottitis. Other pathogens besides Hib can cause these diseases. Before an effective Hib vaccine came into widespread use in the early 1990, there were between 20,000 and 25,000 serious cases of invasive Hib in the United States in children under age five. By 2012, only 25 cases were reported in this age group.

Vaccine Administration

Hib vaccine is a conjugate vaccine. Hib bacteria are encased in a polysaccharide (complex sugar) coat. The immune system, especially in children less than

two years old, does not respond strongly to vaccine that contains only polysaccharide from the bacterium. To solve this problem, vaccine makers create what is called a conjugate vaccine by attaching a protein to the polysaccharide coat. Immune system cells, even in infants, respond strongly enough to the protein-polysaccharide combination to create immunity to Hib.

Hib vaccines are intended for use in children between the ages of six weeks and five years. They are administered by intramuscular injection. Three Hib vaccines (PedvaxHIB, ActHIB, and Hiberix) are in use in the United States. Their main difference is the type of protein they add to the Hib polysaccharide, but they also have different administration schedules. Hib is also included in a two-vaccine combination for Hib and hepatitis B (Comvax), a two-vaccine combination against Hib and meningococcal disease (MenHibRix), and a five-combination vaccine that immunizes against diphtheria, tetanus, pertussis, poliomyelitis, and Hib (Pentacel).

Hib vaccines that require four doses (ActHIB, Hiberix, MenHibRix, Pentacel) are recommended to be given at ages 2, 4, and 6 months with a fourth booster dose at 12–15 months. Hib vaccines that require three doses (PedvaxHIB, Comvax) are given at 2 and 4 months with a booster at 12–15 months. If the recommended sequence is interrupted, catch-up doses can be given without starting the series over. After age five, children are vaccinated against Hib only under special circumstances (see special populations below).

Side Effects

The Hib vaccine has some of the fewest adverse effects of any childhood vaccine. Those that it does have tend to be mild and transient, lasting only two or three days. These include redness and swelling at the injection site and a low fever. Serious allergic reaction is estimated to occur fewer than once in one million doses.

Special Populations

Children over age five years normally are not given Hib vaccines. Nevertheless, certain situations may change the recommended administration schedule. Individuals should discuss any conditions that may alter the administration of the vaccine with their child's pediatrician.

- Children under age six weeks should not receive Hib vaccine.
- Children who have had a severe allergic reaction to Hib vaccine (extremely rare) should not complete the immunization series.

- Moderately or severely ill children should wait until they are well to be vaccinated.
- Children ages one to five years with certain medical conditions are at higher risk of developing invasive Hib disease than healthy children and may need an altered administration schedule and/or an additional dose of vaccine. These include children receiving chemotherapy or radiation therapy, children with certain spleen abnormalities, and those with sickle cell disease or HIV infection.
- A supplemental dose of Hib vaccine is recommended two weeks before surgery for children undergoing nonemergency removal of the spleen.
- Unimmunized children ages 5–18 years with HIV infection should receive one dose of the vaccine.
- People older than five years who are receiving hematopoietic stem cell transplants should be revaccinated.

HEPATITIS A

Hepatitis A vaccine is made of formaldehyde-inactivated whole virus. Two different vaccines are in use in the United States, Havrix and Vaqta. Both come in two formulations, one for children ages 12 months through 18 years and the other for adults age 19 years and older. Two doses of either vaccine create almost 100 percent immunity in both children and adults. The *picronavirus* that causes hepatitis A was first isolated in 1973, and the first vaccine became available in the United States in 1995. Routine childhood vaccination was recommended by the CDC beginning in 2006.

Hepatitis A causes acute liver inflammation. It is found in the feces of infected people and is transmitted by the fecal-oral route, most often by contaminated food (especially raw shellfish and other uncooked foods), contaminated water (usually from sewage spills), and poor hygiene. The largest volume of virus is shed in feces one to two weeks before symptoms occur. Once jaundice (yellowing of the skin due to liver damage) develops at about two weeks, the amount of virus shed decreases substantially.

Symptoms are nonspecific and age dependent. Many children younger than age six years show no symptoms. Those that do often have stomach pain and diarrhea. Older children and adults are likely to develop a fever, jaundice, dark urine, abdominal pain, nausea, and fatigue. Symptoms can last up to two months with relapses for six months. There is no treatment, but the disease is rarely fatal.

Hepatitis A is uncommon in the United States. Only 1,398 cases were reported in 2011, a decrease of more than 90 percent since vaccination began.

Elsewhere in the world, hepatitis A is common, especially in regions where sanitation and water treatment are poor, including Mexico, parts of the Caribbean, Central America, South America, Asia (except Japan), Africa, the Middle East, and Eastern Europe. Since many young children in these areas acquire hepatitis A but show no symptoms, the worldwide prevalence of the disease is difficult to determine.

Although hepatitis A and hepatitis B sound similar, hepatitis A is an acute, or short-lived, disease. Once recovered, there is normally no permanent damage. Hepatitis B is a chronic disease that causes long-term serious liver damage that can lead to cirrhosis, liver cancer, and death. People need to receive separate vaccines to immunize against hepatitis A and hepatitis B. A combination vaccine against both hepatitis A and hepatitis B (Twinrix) is available only for adults.

Vaccine Administration

Hepatitis A vaccine is administered as an intramuscular injection. Two doses are required for full coverage. The CDC recommends that children receive the first dose between 12 and 23 months of age with a booster dose at least 6 months later. Children not vaccinated at this time can be given two catch-up doses later. Adults can begin the two-dose series at any time, but should receive at least one dose one month before traveling to an area where hepatitis A is common.

Some groups are at higher risk of acquiring hepatitis A and should be routinely vaccinated. These include:

- Individuals of all ages traveling to areas where hepatitis A is common
- Members of a family planning to adopt or care for a child from an area where hepatitis A is common
- Aid workers traveling to sites of natural disasters where water and sewage treatment is likely to be disrupted
- Individuals with blood clotting disorders
- Men who have sex with other men
- Individuals who use street drugs

Side Effects

Most people experience no or mild adverse effects from hepatitis A vaccination. Mild adverse effects include soreness at the injection site, headache, loss of appetite, and tiredness. Allergic reaction to the vaccine is serious but extremely rare.

Special Populations

Certain medical situations may change the recommended administration of hepatitis A vaccine. Individuals should discuss any conditions that may alter the use of the vaccine with their physician.

- Anyone who has had a severe allergic reaction to the antibiotic neomycin or to any other component of the vaccine should not be vaccinated.
- Moderately or severely ill individuals should wait to be vaccinated.
- People with chronic liver conditions generally can be safely vaccinated.
- Sewer workers and plumbers may wish to consider vaccination.
- Food handlers may need to be vaccinated based on local prevalence of hepatitis A.

HEPATITIS B

Hepatitis B is a liver disease caused by hepatitis B virus (HBV). The virus is transmitted by contact with body fluids from an infected person. Contact can occur through sexual activity; sharing needles, syringes, razors, or toothbrushes; unintended needle sticks or other accidental blood contact; or exposure to fluids from an infected mother as an infant passes through the birth canal. HBV is 100 times more contagious than human immunodeficiency virus (HIV). One milliliter (one-fifth of a teaspoon) of infected blood is enough to pass the disease to a noninfected person.

Some infected individuals develop acute (short-term) hepatitis B infection, a brief illness that causes symptoms such as fatigue, loss of appetite, vomiting, and diarrhea about three months after exposure to the virus. Sometimes, especially in infants and children, acute infection progresses to chronic (long-term) hepatitis B infection. People with chronic infection often show few symptoms and may not be aware that they are infected until the disease causes liver damage (cirrhosis) or liver cancer.

Hepatitis B is a major problem in the developing world, with an estimated 350–400 million people infected worldwide. In the United States, about 1 million people have chronic hepatitis B infection and about 4,000 die of complications of the infection each year. The rate of hepatitis B in the United States has dropped by 82 percent since routine childhood vaccination began in 1991, and the disease has practically been eliminated in native-born Americans under age 20. New infections occur most often in men between the ages of 25 and 44 years.

Vaccine Administration

Hepatitis B vaccine is a recombinant subunit vaccine given by intramuscular injection (IM) in the thigh of children under one year and in the arm of older children and adults. One of two single-antigen forms of the vaccine (Engerix-B and Recombivax HB) is normally given at birth because 90 percent of infected newborns go on to develop chronic hepatitis B.

Two combination vaccines also contain the hepatitis B antigen. The combination vaccine Pediarix immunizes against hepatitis B, diphtheria, tetanus, pertussis, and polio. It can be given only between the ages of six weeks and seven years. Twinrix is a combination vaccine against hepatitis A and hepatitis B used to immunize at-risk adults. Among adults, healthcare workers and first responders are at especially high risk of contracting infection through accidental contact with contaminated blood.

Timing of Administration

Three doses of hepatitis B vaccine are required to produce complete immunization for 90 percent of people under age 40; coverage gradually decreases in people over age 40. The CDC recommends that newborns be vaccinated before being discharged from the hospital and ideally within 12 hours after birth. A second dose of vaccine is given at one month and the third at six months. Babies not born in a healthcare setting should be vaccinated as soon as possible after birth.

If the timing of the recommended hepatitis B immunization schedule is interrupted, it is not necessary to start the series over again. The individual should simply follow the CDC catch-up schedule as soon as possible. Postexposure vaccination can reduce the risk of developing hepatitis B but only if the individual is vaccinated very soon after exposure.

Side Effects

Hepatitis B vaccine causes few adverse effects. The most common are minor and transient. They include soreness at the injection site, fatigue, low-grade fever, headache, and dizziness. The most serious adverse event is anaphylaxis, a life-threatening allergic reaction that occurs after about 1 in every 600,000 doses. People who are allergic to yeast, which is used in the manufacture of the vaccine, or any of its other components, should not be vaccinated.

Special Populations

Certain medical situations may change the recommended administration of hepatitis B vaccine. Parents should discuss any conditions that may alter the use of the vaccine with their child's pediatrician.

- Immunocompromised individuals, including those with HIV infection, may respond less strongly to hepatitis B vaccine. These individuals should have blood tests done to check the level of antibodies they form in response to vaccination. Booster shots may be needed.
- Adults on hemodialysis should have their antibody levels checked annually. Booster shots may be needed.
- Pregnant and breastfeeding women should delay receiving hepatitis B vaccine unless there is an urgent need. The safety of the vaccine in these populations has not been well studied.
- Moderately or severely ill individuals should delay vaccination until they are well unless there is an urgent need.
- People whose immunization status is unknown can receive the full three-dose course of vaccine. Extra doses of hepatitis B vaccine do not increase health risks.

HUMAN PAPILLOMAVIRUS (HPV)

HPV vaccine protects against up to 9 of the 40 types of papillomavirus that are known to infect humans. The virus infects the genital areas of both men and women and the lining of the cervix in women. HPV is transmitted by vaginal, oral, or anal sexual contact with an infected person. Newborns can also acquire the virus from an infected mother while passing through the birth canal.

Some types of HPV cause cervical, vaginal, anal, penile, or throat cancer and may be implicated in esophageal cancer. Other types cause genital warts. There is no cure for HPV infection, but as of 2017, three different vaccines were available in the United States to immunize against up to nine types of HPV. All the vaccines are subunit vaccines made with recombinant DNA technology. They cannot cause HPV infection or cause cancer.

A quadrivalent vaccine, HPV4 (Gardasil), was approved in 2006. It immunizes against HPV types 16 and 18, which together cause 70 percent of cervical cancers, and types 6 and 11, which cause 90 percent of genital warts. The vaccine is approved for males and females 9–26 years of age. A bivalent vaccine, HPV2 (Cervarix), was approved in 2009. It immunizes against HPV types

16 and 18 and is appropriate for females ages 10–25. This vaccine is not approved for males of any age. In December 2014, a 9-valent vaccine, HPV9 (Gardasil-9), was licensed in the United States. It immunizes against HPV types 6, 11, 16, 18, 31, 33, 45, 52, and 58 and is approved for use in males and females ages 9–26 years.

The recommended age for the first dose of HPV vaccine is 11 or 12 years, although the vaccine may be given to children as young as nine years old. Some parents have questioned why children should be vaccinated against a sexually transmitted infection at such a young age. The goal is to immunize children before they are sexually active because HPV is extremely widespread, highly contagious, and often causes no noticeable symptoms. Many people do not realize they are infected and pass the infection to their partners. HPV vaccines will prevent certain types of HPV, but they have no effect on infections the individual has already acquired at the time of vaccination, another reason for recommending vaccination at a young age. Children who are not vaccinated at the recommended age can be given the vaccine up to age 26 years.

HPV infection is the most common sexually transmitted infection worldwide. The CDC estimates that 79 million Americans are infected with HPV with somewhere between 6 million and 14 million new infections occurring each year. Most of the new infections are in people ages 15–24. For many people, HPV infection resolves on its own with no complications. Depending on the type of HPV, some people develop genital warts. Genital warts can be treated but recurrent outbreaks are common.

Other types of HPV enter cells and cause changes that result in cancer. The CDC estimates that about 27,000 HPV-associated cancers are newly diagnosed in the United States each year. Ninety-nine percent of cervical cancers and 71 percent of penile cancers are associated with HPV infection. The American Cancer Society estimates that about 4,000 American women die each year from cervical cancer, a decrease of more than 50 percent since 1986. Worldwide cervical cancer rates are much higher, causing an estimated 454,000 deaths in 2010.

Vaccine Administration

All HPV vaccines are recombinant vaccines. They cannot cause the disease they are intended to prevent. The vaccines must be refrigerated at 35°F and 46°F (2°C and 8°C) until used. They are given by intramuscular injection.

Three doses of HPV vaccine provide immunity in 99 percent of individuals. The first dose is recommended at age 11 or 12 years. A second dose is given either one or two months after the first dose. The third dose is given six

months after the first dose. If the series is interrupted, it does not need to be started over. Individuals who have started the series with HPV2 or HPV4 can complete it with HPV9, but if the full three-dose series was completed using HPV2 or HPV4, revaccination with HPV9 is not recommended.

Side Effects

HPV vaccine has only mild adverse effects. Most common are redness, pain and swelling at the injection site. About 10 percent of people develop a slightly elevated temperature. Allergic reaction to the vaccine or other serious adverse events have not been reported.

Special Populations

Certain medical situations may change the recommended administration of HPV vaccine.

Individuals should discuss any conditions that may alter use of the vaccine with their physician.

- Anyone who has had a severe allergic reaction to yeast protein or any other component of the vaccine should not be vaccinated.
- Anyone who has a severe reaction to a dose of HPV vaccine should not complete the series.
- Pregnant women should wait to be vaccinated until after the birth of the child.
- Moderately or severely ill individuals should delay vaccination until they are well.
- Immunocompromised individuals should check with their physician, but most, including those with HIV infection, can be safely vaccinated.

INFLUENZA

Influenza is a highly contagious disease spread through tiny respiratory droplets that are sneezed or coughed into the air by a person who is infected with flu virus. The virus can also spread through direct contact, such as by kissing or drinking from the same glass as an infected person. Influenza is seasonal. In the Northern Hemisphere, it begins in November, peaks in February, and gradually tapers off in late spring. The CDC estimates that between 10 and 20 percent of all people in the United States contract influenza each year.

People are infectious one day before symptoms appear. Symptoms include fever, chills, headache, body aches, sore throat, runny nose, and dry cough. After about four days, symptoms diminish, but people remain contagious until symptoms completely disappear. For most people, influenza is unpleasant but not life threatening. For some, it can be fatal. Children under age two years, the elderly, and people who are immunocompromised or who have a heart or lung disease are the most likely to die from influenza. In addition, the influenza virus weakens the body, increasing the chance of developing an opportunistic infection such as S. *pneumoniae* or by *H. influenzae* that cause pneumonia. Between 100,000 and 200,000 people are hospitalized in the United States each year with influenza or its complications, and 20,000–36,000 of these people die. The WHO estimates that worldwide, there are 3–5 million cases of influenza each year causing 250,000–500,000 deaths.

There are three types of influenza viruses called A, B, and C. Influenza C causes only mild illness, usually in children. Influenza B makes people sicker than influenza C but accounts for only 20 percent of flu cases. Influenza A is responsible for serious illness and widespread epidemics. It sickens people of all ages. Multiple subtypes or strains of the influenza A virus cause infection in humans. Other strains cause disease in chickens, ducks, wild birds, pigs, horses, ferrets, whales, and seals.

Vaccines against influenza are different from other vaccines because their composition must change every year. Influenza viruses mutate easily, frequently creating new strains. Past immunizations and previous exposure to influenza do not provide protection against new strains. In 1952, the WHO established the Global Influenza Surveillance and Response System. As part of this program, laboratories worldwide test hundreds of thousands of sample from patients with influenza to determine which strains are most common and to detect the emergence of new strains. They use this information to give advice on which strains should be included in the vaccines for the following year. The prevalence of influenza in any year depends on how well the strains in the vaccine match the strains of influenza present in the community and how many people have been immunized.

Vaccine Administration

Influenza vaccination is recommended for all people over age six months with the few exceptions noted below under Special Populations. Because the strains of influenza circulating in the community vary from year to year and because immunity wanes over time, everyone age six months and older should be revaccinated each year in the early autumn (Northern Hemisphere) or early

spring (Southern Hemisphere), since influenza is a cold weather disease. It takes two weeks for a person to develop adequate antibodies to provide immunity, so early vaccination is encouraged.

Each year influenza vaccine protects only against either three strains (trivalent vaccine) or four strains (quadrivalent vaccine) of influenza, so it is still possible to contract the disease if the strains in the vaccine do not match the strains common in the community.

Multiple types of influenza vaccine are used in the United States. Not all vaccines are appropriate for all people. Vaccines used in the 2016–2017 influenza season are listed in Table 5.1 below.

Table 5.1 Influenza Vaccines for the 2016–2017 Influenza Season in the United States

Type of Vaccine	Age Indications	Administration	Brand Names
Inactivated, quadrivalent (IIV4)	Children ages 6–36 months	Intramuscular in thigh	Fluzone (reduced dose)
Inactivated, quadrivalent (IIV4)	People over age 3 years	Intramuscular in arm	Fluarix, FluLaval, Fluzone Quadrivalent
Inactivated, quadrivalent (IIV4)	Adults ages 18–64 years	Intradermal in arm	Fluzone Intradermal
Inactivated trivalent (IIV3)	Adults age 65 years and older	Intramuscular or arm	Fluzone Trivalent High Dose
Inactivated trivalent (IIV3)	Children ages 9–18 years	Intramuscular, needle injection	Afluria
Inactivated trivalent (IIV3)	Adults ages 18–64 years	Intramuscular, jet injector	Afluria
Inactivated trivalent (IIV3)	People over age 4 years	Intramuscular in arm	Fluvirin
Adjuvanted inactivated trivalent (aIIV3)	People age 65 years and older	Intramuscular in arm	Fluad
Inactivated cell-culture-based quadrivalent (ccIIV4)	People over age 4 years	Intramuscular in arm	Flucelvax
Recombinant trivalent (RIV3)	Adults over 18 years	Intramuscular in arm	Flublok
Live attenuated quadrivalent	Not recommended for 2016–2017 influenza season	Intranasal	FluMist

Source: http://www.cdc.gov/flu/protect/vaccine/vaccines.htm

Inactivated influenza vaccines (IIVs) are produced by growing the virus in chicken eggs, harvesting it, and then inactivating it with chemicals. These vaccines contain a small amount of egg protein. The virus in cell-culture-based inactivated vaccine (ccIIV4) is grown in canine kidney cells and then inactivated. Recombinant influenza vaccine (RIV) is made in the laboratory using only proteins from the coat of influenza viruses and not the whole virus. It does not contain egg protein and can be used to vaccinate individuals with egg allergy.

Side Effects

Common adverse effects of influenza vaccine in children and adults from all versions of the vaccine include soreness or redness at the injection site, runny nose, nasal congestion, cough, headache, and muscle ache. Mild fever is more common in children than in adults but is still infrequent. People who are allergic to eggs may experience an allergic reaction. To avoid this, they can receive the recombinant RIV formulation or the cell-culture-based ccIIV4 that is grown in dog kidney cells. These formulations do not contain egg protein. Children who receive influenza vaccine at the same time as DTaP or pneumococcal vaccine (PCV13) may have an increased risk of fever seizures.

Questions have been raised about whether vaccination against influenza increases the risk of developing Guillain-Barré syndrome (GBS), a rare neurological disorder. Studies have found that influenza vaccination does not increase the risk of GBS in people who have never had the disorder but that risk of recurrence, although rare, is slightly higher in people who have had GBS and recovered.

Special Populations

Although immunization against influenza is generally recommended for everyone over age six months, certain medical situations may dictate which type of vaccine is most appropriate. Only a very few individuals should not be vaccinated. Individuals should discuss any conditions that may alter administration of the vaccine with their physician.

- Anyone who has had a severe allergic reaction to a previous dose of influenza vaccine or any of its components should not be vaccinated. People who have egg allergy should discuss vaccination with their healthcare provider.

- Anyone who has had GBS within six weeks of having received influenza vaccine should not be vaccinated. People who have had GBS and recovered should discuss the advisability of vaccination with their physician.
- Moderately or severely ill individuals should wait until they are healthy to be vaccinated.
- Children between the ages of six months and eight years receiving influenza vaccine for the first time should receive two doses at least 28 days apart.
- The following groups may be vaccinated with inactivated vaccine, but should not receive live attenuated vaccine: children under age 2 and adults over age 49 years; immunocompromised individuals; people with chronic medical conditions, recent or recurrent wheezing or asthma; children under 18 years who are receiving long-term aspirin therapy; pregnant women; anyone who have taken antiviral medication within 48 hours prior to vaccination.
- Caretakers and family members of people who are immunocompromised should not receive live attenuated vaccine. Live virus can be shed for up to three weeks and can transmit influenza to an immunocompromised person.
- Pregnant women can safely be vaccinated with inactivated vaccine during any trimester of pregnancy.

MEASLES, MUMPS, AND RUBELLA

The vaccine that immunizes against measles, mumps, and rubella (MMR) is given as a single injection in the United States. Single-antigen vaccines against each individual disease are not available. The combination vaccine, available since 1971, contains live attenuated viruses and provides lifelong immunity to all three diseases. The vaccine is manufactured as a freeze-dried powder and reconstituted with sterile solution before use. Reconstituted vaccine must be shielded from light and stored in the refrigerator or freezer. A combination vaccine against measles, mumps, rubella, and varicella (MMRV, brand name ProQuad) was licensed in 2005.

Measles

Measles, also called rubeola (not to be confused with rubella or German measles) is highly contagious. It spreads by respiratory droplets exhaled by an infected person. If 100 unvaccinated people are in a room with an infected

person, on average 90 will develop measles. The virus can remain infective in a sheltered space such as a closed room for up to two hours. People are contagious four days before and four days after the measles rash appears.

Measles is characterized by a high fever of 103–105°F (39.4–40.5°C), rash, conjunctivitis (pink eye), runny nose, cough, headache, and body aches. Symptoms last around two weeks. About one-third of people, especially those under age five years and adults, develop complications. Complications can be minor (e.g., ear infection), permanent, or fatal. Serious complications include pneumonia (the most common cause of measles-related death), encephalitis (brain inflammation), convulsions, deafness, blindness, and intellectual disabilities.

Before a measles vaccine was licensed in 1963, on average 500,000 cases of measles and 500 measles-caused deaths were reported in the United States each year. About 90 percent of children contracted the disease by age 15 years. By 2000, native measles was declared eliminated in the United States. Some parents question the need for continued vaccination (see Chapter 8).

Travelers arriving from parts of the world where measles is active continue to bring the disease into the country, and outbreaks occur every few years, primarily among people who have refused vaccination. In 2015, a measles outbreak traced to an infected individual who visited Disneyland spread the illness to six states, Canada, and Mexico. In April 2016, another outbreak occurred among unvaccinated children in Tennessee. Worldwide, 30 million children contract measles each year and 1 million die.

Mumps

Mumps is a viral infection spread by respiratory droplets and direct contact. The virus reproduces in the nose, throat, and surrounding lymph glands for 12–25 days, after which it spreads to other tissues and can cause swelling and inflammation in the salivary glands, meninges, pancreas, kidney, ovaries, or testes. Swelling of the salivary (parotid) glands located under the ear and along the jaw on one or both sides is the most prominent sign. Before swelling occurs, symptoms of mumps are nonspecific—body aches, fatigue, and low fever.

Complications from mumps include orchitis (testicular swelling) in some men past puberty, most often only on one side. Rarely do mumps cause male sterility. Other complications are uncommon. Swelling occurs in the ovaries of about 7 percent of postpuberty women but does not affect fertility. Other complications include aseptic meningitis (a condition in which inflammation of the meninges is not caused by a pathogen), deafness, or hearing loss (transient or permanent).

As with measles, most mumps cases in the United States originate with people coming from countries where mumps is common. Fewer than 60 percent of countries who belong to the WHO routinely administer mumps vaccine, putting unvaccinated visitors at high risk for contracting the disease. In 2016, an outbreak of mumps at Harvard University affected more than 40 people.

Rubella

Rubella is a mild viral infection spread by respiratory droplets. Symptoms include low fever, light rash that begins on the face and spreads downward, and swollen glands. As many as half of all people who contract rubella show no diagnostic symptoms. Complications are rare in healthy children. A large percentage of adult women develop joint pain and stiffness that can last up to one month.

The most serious outcomes of rubella infection appear in the developing fetus of a woman who contracts the disease during pregnancy. The virus that causes rubella can cross the placenta and cause birth defects in the fetus, a condition called congenital rubella syndrome. The most serious consequences occur when the woman is infected during the first trimester of pregnancy. Eighty-five percent of babies born to mothers infected during this time have birth defects. Rubella-caused defects are rare after the twentieth week of pregnancy. Congenital rubella syndrome can lead to the following complications in the fetus: death, miscarriage, or preterm delivery; deafness (most common defect); eye defects such as cataracts, glaucoma, and retinopathy; heart defects; spleen and liver damage; seizures; intellectual and developmental delays.

Routine vaccination has made rubella rare in the United States today. An estimated 91 percent of all Americans are immune to the disease. Rubella is still common in parts of the Russian Federation, Europe, and many developing countries, putting unvaccinated travelers are risk.

Administration of MMR Vaccine

Both MMR and MMRV are given as subcutaneous (under the skin but not in the muscle) injections. Two doses are recommended. The first should occur between the first birthday and 15 months. Any dose given before the first birthday must be repeated after the child reaches one year. The second dose can be given as early as 28 days after the first dose but is routinely given between ages four and six years, ideally before the child starts school.

The CDC recommends that to decrease the chance of febrile seizures, children receiving the first dose of MMR be given a separate dose of varicella (chickenpox) vaccine rather than the combined MMRV vaccine, even when the vaccines are given at the same office visit. MMRV, if desired, can be used for the second dose up to age 13 years. MMR can be given to all children over one year and to adults. Two doses of MMR provide 99 percent coverage against measles, 88 percent coverage against mumps, and 95 percent coverage against rubella.

Adults born after 1957 who do not have documented proof of vaccination should receive a single dose of MMR. The exception is pregnant women. Women who wish to become pregnant should wait at least 28 days after vaccination before trying to conceive. Should an adult be deficient in immunity to one of the diseases in the vaccine—for example, if a man had measles and rubella as a child but never contracted mumps—it is safe to vaccinate the adult with MMR. The extra dose of MMR vaccine against diseases to which an individual is already immune causes no health problems.

Side Effects

Allergic reactions can occur as with any vaccine but are rare with MMR vaccine. Fever is the most common side effect. It is associated with the measles component of the vaccine. Five to fifteen percent of people who develop a fever have a temperature of 103°F (39.4°C) or higher 5–12 days after vaccination. The fever lasts one to two days, and febrile seizures are possible, especially in children. Children ages 12–23 months who receive MMRV instead of MMR as a first dose are more likely to develop a high fever.

Other adverse effects of MMR vaccination include joint pain (associated with the rubella component), soreness at the injection site, and mild rash (associated with the mumps component). Low blood platelet count (thrombocytopenia) occurs two to three weeks after vaccination in 1 of every 30,000–40,000 people. There have been suggestions that MMR vaccination is associated with the development of autism spectrum disorder (see Chapter 8). As of 2017, the Institute of Medicine (IOM) and the American Academy of Pediatrics (AAP) had independently reviewed the evidence regarding this potential link. Both groups concluded that evidence does not support an association.

Special Populations

Certain medical situations may change the recommended administration of MMR and MMRV. Individuals should discuss any conditions that may alter the administration of the vaccine with their child's pediatrician.

- Anyone who has had a severe allergic reaction to the antibiotic neomycin or any other component of the vaccine should not be vaccinated.
- Pregnant women or those trying to become pregnant should wait to be vaccinated until after the birth of the child.
- Immunocompromised individuals with leukemia, lymphoma, generalized malignancy, or immune deficiency diseases should not be vaccinated.
- Individuals who have a suppressed immune system from taking steroid drugs or chemotherapy should wait one month (steroids) or three months (chemotherapy) after treatment has stopped before being vaccinated.
- People with a family history of seizures should not be vaccinated.
- People who have recently received a blood product should wait to be vaccinated.
- Moderately or severely ill individuals should delay vaccination until they are well.
- Children allergic to eggs can be safely vaccinated.

MENINGOCOCCAL DISEASE

Meningococcal disease is caused by the bacterium *Neisseria meningitidis*. There are 13 strains (serogroups) of this bacterium, 6 of which (A, B, C, W, Y, X) cause illness in humans. *N. meningitidis* can cause meningitis, bloodstream infection (bacteremia), and sometimes pneumonia or arthritis. These diseases can also be caused by other bacteria and viruses.

N. meningitidis lives in the throats of about 10 percent of healthy people without causing symptoms. Although these people are not sick, they can spread the disease through close contact such as kissing, sharing food and drinks, or being in the same room or house with someone for more than four hours a day. Risk of developing meningococcal disease is age related. Children under age 1 year and teens and young adults ages 16–23 years living in close contact with other young people (e.g., in college dorms, prisons, military barracks) are at highest risk. Individuals of any age who are immunocompromised are also at high risk of developing meningococcal disease.

Meningococcal disease spreads less easily than influenza or measles, but symptoms appear suddenly and intensely. Symptoms include sudden onset of high fever, headache, stiff neck, sensitivity to light, nausea, and vomiting that can rapidly progress to hypotension (low blood pressure), shock, coma, and death. A child can appear healthy and 12 hours later can be near death.

Even with treatment, 10–20 percent of people with meningococcal disease die. The rate is highest (about 33 percent) for people who develop bloodstream infection. About 12 percent of survivors are left with permanent damage such as limb amputation, skin grafting scars, hearing loss, kidney damage, seizures, and intellectual disabilities. Worldwide, an estimated 500,000 cases of meningococcal disease occur each year and at least 50,000 people die.

Vaccine Administration

The meningococcal vaccine picture as of 2017 is somewhat complicated. Vaccines exist that protect against five of the six strains that cause most human disease; no vaccine exists against strain X. However, no single vaccine protects against all five strains, and several different kinds of vaccines exist to meet the needs of different age groups.

Meningococcal bacteria are encased in a polysaccharide coat. The immune system of children less than two years old does not respond strongly enough to a vaccine that contains only polysaccharide from the bacterium to create immunity. To solve this problem, vaccine makers create a conjugate vaccine by attaching a harmless protein to the polysaccharide material. The added protein stimulates adequate immune system response to protect against disease.

Conjugate meningococcal vaccines (MenACWY) protect against strains A, C, W, Y, but do not provide protection against strain B, a common cause of disease in the United States. Both MenACWY vaccines are approved for people ages 9 months to 55 years and are administered by intramuscular injection. Although approved for use in children under age two, the CDC recommends these vaccines only for a select group of young children (see Special Populations below), not for routine vaccination of all children. The dosage schedule for special population children varies by age and brand of vaccine.

The CDC does recommend routine vaccination with MenACWY for children ages 11–18 years. Ideally, preteens should receive one dose of the vaccine between ages 11 and 12 years with a booster at age 16. Because college-age individuals are at high risk for contracting meningococcal disease, many universities require proof of vaccination before enrolling. An outbreak of bacterial meningitis caused by strain B occurred at Santa Clara University in California in 2015 resulting in emergency vaccinations.

Polysaccharide meningococcal vaccine (MCV4) is approved for all people over age two years and is delivered subcutaneously. It provides the same coverage as MenACWY vaccines. Menhibrix is a combination vaccine licensed in 2012 that creates immunity against *Haemophilus influenzae* type b and

Table 5.2 Types of Meningococcal Vaccines

Type of Vaccine	Brand Names	Strains Covered
Conjugate quadrivalent (MCV4)	Menactra Menveo	A, C, W, Y
Polysaccharide quadrivalent (MPSV4)	Menomune	A, C, W, Y
Recombinant	Bexsero Trumenba	B
Conjugate combination	Menhibrix	C, Y, and Hib

N. meningitidis strains C and Y (but not A and W). It is given as an intramuscular injection at 2, 4, 6, and 12–15 months. This fulfills the recommended administration of Hib vaccine and provides protection against some but not all meningococcal disease. Table 5.2 lists the different types of meningococcal vaccines and the strains of *N. meningitidis* they protect against.

Two separate vaccines provide protection against only meningococcal serogroup B. Although they protect against the same strain, the series should be completed using a single brand of vaccine. Neither vaccine is approved for children under age 10 years. Bexsero is a recombinant vaccine for people ages 10–25 years. It is given as an intramuscular injection. Two doses are needed to confer immunity and should be given one month apart.

Trumenba is a recombinant vaccine also approved for people ages 10–25 years. It can be given intramuscularly on a two-dose schedule with six months between the first and second injection or on a three-dose schedule with one month between the first and second injection and a third injection six months after the first dose. The preferred schedule depends on the risk level of the individual for contracting meningococcal disease.

Side Effects

All meningococcal vaccines cause only mild adverse effects. The most common are pain and soreness at the injection site, headache, and fatigue. Allergic reaction to the vaccine is serious but extremely rare.

Special Populations

Certain medical situations may change the recommended administration of meningococcal vaccine. Individuals should discuss any conditions that may alter the use of the vaccine with their physician. Some individuals should not receive meningococcal vaccine or should delay vaccination.

- Anyone who has had a severe allergic reaction to any other component of the vaccine should not be vaccinated.
- Unless there is urgent need, pregnant or breastfeeding women should wait to be vaccinated until the birth of the child or until they are not breast-feeding, as these vaccines have not been well studied in this population.
- Moderately or severely ill individuals should wait to be vaccinated until they are healthy.

People who *should* get the vaccine even when they are out of the recommended age range include:

- children and adults who have no spleen, a damaged spleen, sickle cell disease.
- children and adults who lack certain complement proteins that are necessary for immune function.
- children and adults traveling to sub-Saharan Africa between December and June when meningococcal disease is common.
- adults who work with *N. meningitidis* in the laboratory or in a manufacturing environment.
- members of a community where there is an outbreak of meningococcal disease and their risk of exposure is high.
- individuals taking the drug eculizumab (Soliris).
- immunosuppressed and immunocompromised individuals who may not respond strongly to the vaccine and have reduced immunity.

PNEUMOCOCCAL VACCINES

Pneumococcal vaccines immunize against pneumococcal disease caused by certain strains of the bacterium *Streptococcus pneumoniae*, also called pneumococcus. Pneumonia can be caused by other bacteria, viruses, and fungi, but pneumococcus is a leading cause of invasive, life-threatening pneumonia. Infection with pneumococcus can also cause bacteremia (bloodstream infection), meningitis, and empyema (accumulation of pus between the lung and chest wall), all of which can be fatal. The bacterium is also responsible for less severe diseases including some ear and sinus infections.

As of 2017, about 100 different strains of *S. pneumoniae* had been isolated. The bacterium lives in the nose and throat of about one-quarter of the population without causing symptoms. These people can spread pneumococcal disease through sneezing, coughing, and saliva. Often parents with no symptoms infect their infants. Pneumococcal disease is an opportunistic infection that often follows another respiratory infection, especially influenza.

Two pneumococcal vaccines are used in the United States. Both are given by intramuscular injection and must be kept refrigerated at temperatures between 35°F and 46°F (2°C and 8°C) until used. Because there are so many different strains of *S. pneumoniae*, neither vaccine completely protects against pneumococcal disease.

A pneumococcal conjugate vaccine known as PCV13 (Prevnar 13) is given to infants, some children, and adults. It protects against 13 common strains of *S. pneumoniae* that are responsible for about 60 percent of all invasive cases of pneumococcal pneumonia in children. In the United States before routine vaccination, *S. pneumoniae* was responsible for about 13,000 cases of bacteremia, 700 cases of meningitis, and 200 deaths in children each year. Worldwide, pneumococcal pneumonia causes about 1.2 million deaths annually in children under age five years.

A polysaccharide pneumococcal vaccine, PPSV23 (Pneumovax 23), is given to adults and children over age two with specific medical conditions. It protects against 23 common strains of pneumococcus that cause severe, invasive disease. In the United States, about 400,000 people are hospitalized every year with pneumococcal pneumonia and 18,000 older adults die from the disease.

Administration of Pneumococcal Conjugate Vaccine PCV13

PCV13 is a conjugate vaccine licensed in 2010. It replaces an earlier conjugate vaccine, PCV7, that was first used in 2000. *S. pneumoniae* is encased in a polysaccharide coat. The immune system of children younger than two years does not respond strongly to vaccines containing only polysaccharide from the bacterium. To solve this problem, vaccine makers have developed conjugate vaccines by attaching a harmless protein to the polysaccharide material to stimulate the immune system. Even infant immune systems respond to the protein-polysaccharide combination well enough to make enough antibodies to protect against pneumococcal disease.

The recommended childhood schedule for vaccination with PCV13 consists of doses at 2, 4, and 6 months with a booster shot at 12–15 months. The vaccine can be given at the same time as other vaccines such as DTaP that conform to this schedule. Children not vaccinated before seven months of age should follow a catch-up schedule. Healthy children between the ages of two and five years who have received no doses of PCV13 need only a single dose. PCV13 is also recommended for all adults over age 65 and younger adults with certain medical conditions (see Special Populations below). The vaccine is given even if the individual has received PPSV23. Recommendations for PCV13 administration for adults will be re-evaluated in 2018.

Side Effects of PCV13

Adverse effects of PCV13 tend to be common but mild and transient. About half of all children receiving the vaccine become drowsy, have diminished appetite, and develop tenderness and redness at the injection site. About one-third of children show swelling at the injection site and a mild fever. One-fifth have a fever higher than 102.2°F (39°C). Most babies become fussy and irritable. Adults report similar mild reactions along with chills, headache, and muscle ache.

Special Populations

PCV13 should not be given, should be given on a different schedule, or given to older children and adults in certain situations. Individuals should discuss any conditions that may alter the administration of the vaccine with their physician.

- Children who are allergic to any components of PCV13 should not be vaccinated.
- Children who receive PCV13 at the same time as inactivated influenza vaccine may have an increased risk of fever seizures. Parents should discuss this possibility with their pediatrician.
- Moderately or severely ill children and adults should wait until they are healthy to be vaccinated.
- Children ages two to six years who are immunocompromised, have chronic heart or lung disease, diabetes, cerebral spinal fluid (CSF) leak, cochlear implant, sickle cell disease, or other blood diseases should be given two doses of PCV13 at least eight weeks apart.
- Adults over age 18 who are immunocompromised, have had a splenectomy (spleen removal), have sickle cell disease, HIV infection, leukemia, lymphoma, Hodgkin disease, multiple myeloma, generalized malignancy, chronic renal failure, cochlear implants, or CSF leak should receive a dose of PCV13 vaccine before receiving PPSV23. If an individual has already received a dose of PPSV23, a special timing schedule must be followed for vaccination with PCV13 and future doses of PPSV23.

Administration of Polysaccharide Vaccine PPSV23

PPSV23 (Pneumovax 23) contains polysaccharide from the outer coating of 23 strains of *S. pneumonia*. The vaccine has been in use since 1983

and replaces a vaccine against 14 strains that is no longer manufactured. PPSV23 is ineffective in children under age two years because the immune system of children this young does not respond to pure polysaccharide vaccines. PPSV23 is between 60 and 70 percent effective in preventing invasive pneumococcal disease caused by the 23 strains included in the vaccine.

PPSV23 is recommended for all adults age 65 years and older, even if they have received PCV13. The vaccine is also recommended for immunocompromised individuals over age two years and adults below age 65 years with specific medical conditions (see Special Populations below). Revaccination for healthy people is recommended five years after the initial shot, as immunity decreases over time especially in the elderly.

Side Effects of PPSV23

Between one-third and one-half of people vaccinated with PPSV23 report pain, redness, and some swelling at the injection site. These adverse events are transient, usually lasting less than two days, and are more common after the second dose than after the first. Fever and muscle pain are uncommon (less than 1 percent of people), and serious adverse events are rare.

Special Populations

Certain medical situations may change the recommended administration of PPSV23. Individuals should discuss any conditions that may alter the use of the vaccine or timing of vaccination with their physician.

- People who have a severe allergy to any of the components of the vaccine should not be vaccinated.
- Moderately or severely ill individuals should delay vaccination until they are well.
- Immunocompromised people over age two years, including those who have had a splenectomy, have sickle cell disease, HIV infection, leukemia, lymphoma, Hodgkin disease, multiple myeloma, or chronic renal failure should receive PPSV23 before age 65, but should not be revaccinated until after age 65 rather than at 5-year intervals.
- Adults age 19 and older who have asthma or smoke cigarettes should be vaccinated before age 65.
- In certain Native American populations at high risk for pneumococcal pneumonia, people over age two should be vaccinated.

- Certain time intervals must be observed in administering PPSV23 to individuals who have already been vaccinated with PCV13 and vice versa. Individuals should alert their physician if they have previously received either of these vaccines.
- Individuals whose vaccination status is unknown or unclear can be vaccinated.

POLIOMYELITIS

Poliomyelitis is a contagious viral disease with variable effects ranging from few to no symptoms (about 72 percent of people) to headaches, fever, stomach pain, and vomiting (about 25 percent) to permanent paralysis and death (less than 1 percent). The virus lives in the gastrointestinal tract and is spread by contact with contaminated stool (fecal-oral route) and by airborne droplets from infected individuals.

In first half of the twentieth century, polio paralyzed on average 10,000 children annually in the United States. An epidemic in the early 1950s killed about 6,000 people and paralyzed 27,000 more. With the development of a polio vaccine, native disease was eliminated in the United States in 1979. In 2016, thanks to the Global Alliance for Vaccines and Immunization (GAVI), and the Global Polio Eradication Initiative, both international public-private partnerships, polio was reported only in Nigeria, Afghanistan, and Pakistan.

Two polio vaccines are in use worldwide. An inactivated polio vaccine (IPV) is used in the United States. Oral polio vaccine (OPV), which contains live attenuated virus, is used elsewhere in the world. The development of these vaccines and the reasons why different vaccines are used in different countries is discussed in Chapter 3.

Initially both IPV and OPV were formulated to provide immunity against type 1, type 2, and type 3 strains of *poliovirus*. However, type 2 has been declared eradicated worldwide, and OPV has been reformulated to contain only live attenuated virus against type 1 and type 3 *poliovirus*. In a massive worldwide effort by the Global Polio Eradication Initiative, all remaining OPV containing live attenuated type 2 virus was to be destroyed by boiling, bleaching, or burying in concrete containers during the two-week period between April 17 and May 1, 2016, after which only the new, two-strain vaccine was to be used. By omitting the type 2 virus, OPV is more effective against types 1 and 3 and reduces the chance of mutation of the type 2 strain into a variant that could cause serious illness.

Administration of Inactivated Polio Vaccine (IPV)

Inactivated polio vaccine is given as an intramuscular injection in the thigh of young children and the arm of older individuals. IPV uses inactivated virus as the antigen to stimulate antibody production. Because the virus is incapable of reproducing, it cannot cause polio. The vaccine must be kept refrigerated at temperatures between 35°F and 46°F (2°C and 8°C) until it is used.

Some people, especially in developed countries, question whether vaccination against polio is necessary since the disease has been eliminated for more than 20 years in many countries including the entire Western Hemisphere, where the last case was recorded in 1993. In 2016, polio was reported in only a few places in the world. Nevertheless, war, political hostility to vaccination, and natural disasters still create openings for its resurgence. Vaccination is recommended until the disease is eradicated worldwide. Eradication is possible because, like smallpox and measles, only humans contract polio; there is no animal reservoir for the disease.

The recommended schedule for IPV administration calls for four doses, the first two given at 2 and 4 months, a third dose between 6 and 18 months, and a booster dose between the ages of 4 and 6 years. IPV is included in several combination vaccines such as the four-vaccine combination that immunizes against diphtheria, tetanus, pertussis, and polio, the five-vaccine combinations against hepatitis B, diphtheria, tetanus, pertussis, and polio, and the five-combination vaccine against diphtheria, tetanus, pertussis, poliomyelitis, and Hib. Combination vaccines have administration schedules and age restrictions that differ from IPV. In meeting these schedules, children given a combination vaccine may receive a fifth dose of IPV, which causes no health complications. Ninety percent of children are immune to polio after two doses of IPV and 99 percent after three doses, but the duration of immunity is not known.

Side Effects of IPV

IPV causes few adverse effects, the most common being temporary soreness at the injection site. The vaccine contains small amounts of the antibiotics streptomycin, polymyxin B, and neomycin. People allergic to these antibiotics could have a severe allergic reaction to IPV. Adverse effects of combination vaccines are the same as for each individual vaccine.

Special Populations

Certain medical situations may change the recommended administration of IPV. Parents should discuss any conditions that may alter the administration of the vaccine with their child's pediatrician.

- Individuals who have a severe allergy to any of the components of IPV, including the antibiotics neomycin, streptomycin, or polymyxin B, should not be vaccinated.
- Anyone who has had a severe reaction to a dose IPV should not complete the immunization series.
- Moderately or severely ill individuals should delay vaccination until they are well unless there is an urgent need.
- Adults normally do not receive IPV, but adults such as humanitarian aid workers traveling to areas where polio is active and people who work with *poliovirus* in the laboratory or in vaccine manufacturing settings should consider receiving a booster shot of IPV. Adults who have never been vaccinated should receive a complete three-dose series.

Administration of Oral Polio Vaccine

Oral polio vaccine has not been used in the United States since 2000, but it is the polio vaccine of choice in many other countries. After April 17, 2016, all OPV should be the "new formulation" that contains live attenuated *poliovirus* type 1 and type 3. The vaccine is given by mouth. Like IPV, it must be kept refrigerated.

The WHO recommends a three-dose series of OPV beginning as early as six weeks of age, with four weeks between doses. The WHO also recommends the addition of a dose of IPV at 14 weeks. This can be given simultaneously with the third dose of OPV. In countries where polio is present, a dose of OPV at birth is recommended, followed by the standard series. Many countries, however, have alternate schedules based on the needs of their population.

OPV is more effective at stimulating immunity than IPV. One dose of OPV creates immunity in almost half of the recipients. Three doses provide almost 100 percent coverage, and immunity is lifelong.

Side Effects of OPV

Because OPV contains live attenuated virus, the virus in the vaccine can reproduce. In very rare cases (1 in 2.4 million doses), the virus can cause a

serious adverse event called vaccine-associated paralytic poliomyelitis (VAPP). VAPP is believed to occur when the attenuated virus spontaneously mutates into a more virulent form that can cause paralytic polio. The risk of this occurring is greatest with the first dose and is most likely to occur in immuno-compromised children. Between 1980 and 1999, 154 cases of VAPP were reported in the United States, which is why the country switched to IPV in 2000.

A side effect of OPV is that live polio virus are shed in stool for up to six weeks after vaccination. Unvaccinated individuals who are exposed to virus-contaminated stool can develop polio, although many develop only mild cases and then have life-long immunity. This feature helps support herd immunity.

ROTAVIRUS

Rotavirus is a virus that infects the lining of the intestine and causes high fever, vomiting, and severe diarrhea. There are multiple strains. Rotavirus is especially dangerous to infants because loss of large amounts of fluid can cause fatal dehydration. Before rotavirus immunization became available in 2006, almost every child under age five years contracted the disease. The virus caused between 2.1 and 3.2 million cases of diarrhea in the United States each year, resulting in about 250,000 emergency room visits, 55,000–70,000 hospital-izations, and 20–60 deaths. Since 2006, the vaccine has prevented between 74 and 87 percent of all rotavirus illness in the United States, and severe cases of rotavirus-caused diarrhea have decreased between 85 and 98 percent.

Worldwide, rotavirus is the leading cause of dehydration in children. It causes about 125 million cases of diarrhea and between 500,000 and 527,000 deaths each year. The problem is especially acute in developing countries where access to clean water, rehydration fluids, and medical care is limited. In poor and developing countries, 80 percent of infants contract the disease in the first year of life when they are most vulnerable compared to 65 percent who become sick in their first year in wealthier and developed countries.

Vaccine Administration

Rotavirus vaccines are given only to infants. Two rotavirus vaccines are available in the United States as of 2017; additional vaccines are used in other countries. Rotarix is a monovalent live attenuated vaccine that protects against one strain of rotavirus. RotaTeq is a genetically engineered (recombinant) vaccine that protects against five strains of rotavirus.

Timing of Administration

Both rotavirus vaccines are given orally beginning no earlier than six weeks of age. Rotarix requires a two-dose regimen. The recommended schedule is to give the first dose at two months and the second at four months. The first dose should not be given after age 14 weeks and 6 days, and the last dose should be given before the baby becomes 24 weeks old.

RotaTeq is given in a three-dose series at two, four, and six months. The first dose should not be given after age 14 weeks and 6 days, and the last dose should be given before the baby becomes 32 weeks old. Children who have not received three doses by the age of 32 weeks do not receive catch-up doses.

Side Effects

Most babies experience no adverse effects from rotavirus vaccine. For those that do, the most common side effects are fussiness or irritability, mild diarrhea, vomiting, and runny nose. Very rarely babies who have recently been vaccinated develop a type of bowel blockage called intussusception in which one part of the intestine slides into and blocks an adjacent part of the intestine. This condition also occurs in unvaccinated babies for unknown reasons. Intussusception is a medical emergency requiring surgery. Studies have found that immunization against rotavirus increases the likelihood of intussusception over the naturally occurring or background rate by a tiny amount estimated at 1 in 20,000–100,000 infants.

Special Populations

The rotavirus vaccine should not be given, or should be given with special care in certain situations. Parents should discuss any conditions that may alter the administration of the vaccine with their child's pediatrician.

- Babies who have had intussusception or another bowel blockage should not receive rotavirus vaccine.
- Babies born with severe combined immunodeficiency (SCID) should not be vaccinated.
- Babies who have a severe allergic reaction to a dose of rotavirus vaccine should not complete the immunization series.
- Moderately or severely ill babies should wait until they are healthy to be vaccinated.
- Parents of babies born with gastrointestinal abnormalities should consult their physician about their child's risks.

- Parents of babies with weakened immune systems, such as those with HIV infection, taking steroid drugs, or who are receiving cancer treatment, should consult their physician about benefits and risks of vaccination.
- Babies can shed live rotavirus in their stool. If a family member is immunocompromised, the risk to this individual of contracting rotavirus diarrhea should be considered against the benefit to the baby.

SHINGLES

Shingles, also called herpes zoster, is caused by a reactivation of *varicella zoster*, the same virus that causes chickenpox. Only individuals who have had chickenpox can develop shingles. Chickenpox symptoms disappear within about two weeks. However, the *varicella zoster* virus enters nerve cells where it remains inactive, often for as many as 30–40 years. If the virus is reactivated, the individual develops shingles. The mechanism for reactivation is not well understood, but it appears to be connected to weakening of the immune system. Most shingles develop in people over age 60 years, although the virus can reactivate in much younger people who are immunocompromised (e.g., have HIV infection, certain cancers, or are receiving chemotherapy).

Shingles is a painful but not life-threatening disease. The first sign is itching, burning, or painful sensation on the skin. This is followed in one to five days by a rash that usually develops only on one side of the body. The rash is accompanied by pain and often headache and low fever. The rash evolves into fluid-filled blisters that crust over in about two weeks.

About 20 percent of people who develop shingles experience long-lasting pain so severe that it interferes with activities such as bathing, dressing, and sleeping. Pain usually is located in the area where the rash appeared and can last for months after the rash has disappeared. Prolonged pain from shingles is called postherpetic neuralgia (PHN). As of 2017, there was no treatment for PHN. Permanent vision impairment or blindness caused by blisters along the nerves going to the eye is a less common complication. About 15 percent of people who develop shingles have blisters in the eye area, although many fewer develop vision deficits.

About one in three people will develop shingles during their lifetime. An estimated 500,000 to 1 million cases occur in the United States every year. People who live to age 85 years have a 50 percent chance of experiencing shingles. Most people have only one outbreak, although repeat outbreaks are possible, especially in immunocompromised individuals.

Shingles is not contagious; it cannot be passed from person to person. However, if a person who has never had chickenpox or has not been vaccinated against the disease comes into direct contact with fluid from shingles blisters (e.g., a grandparent with shingles holding a child too young to be vaccinated against chickenpox), that person may become infected and develop chickenpox.

Vaccine Administration

Shingles vaccine is approved for people over age 50 years in both the United States and the European Union. The vaccine (Zostavax) contains the same live attenuated virus as varicella vaccine given to prevent chickenpox, except that the shingles vaccine is 14 times stronger than the dose given to immunize against chickenpox. The increased strength is necessary because the immune system of older individuals does not respond as strongly or make as many antibodies as the immune system of younger people. The vaccine is given as a single dose by intramuscular injection usually around age 60 years. Shingles vaccine is just over 50 percent effective in preventing shingles, but it is 67 percent effective in preventing PHN.

Side Effects

Shingles vaccine causes few adverse effects, and those that it does cause are mild. The most common are transient pain, swelling, itching, and redness at the injection site. A few people develop a mild rash.

Special Populations

Certain medical situations may change the recommended administration of shingles vaccine. Individuals should discuss any conditions that may alter the use of the vaccine with their physician.

- Shingles vaccine contains gelatin and the antibiotic neomycin. People who have had a severe allergic reaction to either these or other vaccine components or to chickenpox vaccine should not be vaccinated.
- People who have diseases and disorders that compromise the immune system (e.g., HIV infection), are taking immune-suppressant drugs, have certain blood and lymph cancers, or are receiving chemotherapy or radiation should not be vaccinated.

- Moderately or severely ill individuals should wait until they are healthy to be vaccinated.
- Pregnant women should wait until the birth of the child to be vaccinated.

VARICELLA (CHICKENPOX)

Varicella vaccine (Varivax) is a live attenuated vaccine that protects against chickenpox, also called varicella. It is given either as a single-antigen vaccine or as a four-combination vaccine against measles, mumps, rubella, and varicella (MMRV [ProQuad]). The single-antigen vaccine has been available in the United States since 1995 and the combination vaccine since 2005.

Chickenpox is caused by *varicella zoster* virus. It is spread by breathing in respiratory droplets expelled into the air through coughing and sneezing of an infected person or by direct contact with broken pox blisters. If 1 infected person is in a room with 100 unvaccinated individuals for several hours, about 85 unvaccinated people will contract chickenpox. Incubation time is generally 14–16 days. People are infectious two days before a rash appears. If varicella vaccine is given within three days postexposure to the virus, it is between 70 and 100 percent effective in preventing illness or modifying the severity of symptoms.

Chickenpox causes a red rash that begins on the face and moves downward. Soon the rash turns into very itchy, fluid-filled blisters that cover the body. Blisters can also form on the mucous membranes lining the airways and genitals. After four or five days, the blisters crust over. People remain infectious until all blisters have formed a crust. Fever accompanying chickenpox in children rarely goes above 102°F (38.8°C). Symptoms are often more severe in adolescents and adults.

Before the advent of the varicella vaccine, about 4 million cases of chickenpox occurred in the United States each year accounting for 11,000 hospitalizations and 100 deaths. Ninety percent of children contracted the disease by age 10 years. By 2000, vaccination coverage had reached 80 percent, and the disease caused fewer than 10 deaths annually. Worldwide, the prevalence of chickenpox depends on the extent of vaccination programs. Almost all unimmunized people contract the disease. In temperate climates, the disease is most common in young children, while in tropical climates, the disease affects a higher number of adolescents and adults.

Vaccine Administration

Varicella vaccine is given to children on the same schedule as MMR and can be given at the same office visit. If not given at the same time, 30 days should

pass before the second vaccine is administered. Both MMRV and single-antigen varicella are given subcutaneously. Children should receive the first dose between 12 and 15 months of age with the second dose between 4 and 6 years, although it can be given earlier. People over age 13 years, including adults who have not been vaccinated, should receive two doses four to eight weeks apart.

Side Effects

Although allergic reaction can occur with the use of any vaccine or drug, serious reactions to varicella vaccine are rare. The most common adverse effects are soreness, redness, or swelling at the injection site, and low fever. About 4 percent of people develop a mild rash within three weeks of vaccination. Consult the information on MMR for information on side effects of MMRV.

Special Populations

Certain medical situations may change the recommended administration of varicella vaccine. Parents should discuss any conditions that may alter the administration of the vaccine with their child's pediatrician.

- Varicella vaccine contains gelatin and the antibiotic neomycin. People who have had a severe allergic reaction to either these or any other vaccine component should not be vaccinated.
- Vaccination may not be appropriate for people who are immunocompromised, taking immune-suppressant drugs, have cancer, or are receiving chemotherapy or radiation.
- People who have recently received a blood product may need to wait to be vaccinated.
- Moderately or severely ill individuals should wait until they are healthy to be vaccinated.
- Pregnant women should wait until the birth of the child to be vaccinated.

VACCINES NOT ROUTINELY GIVEN IN THE UNITED STATES

Vaccines against rabies and tuberculosis are not part of the recommended vaccination schedule in the United States. These vaccines are much more routinely used in developing countries where rabies and tuberculosis are common.

However, both vaccines are licensed for use in the United States and are of great value when administered to selective populations.

Rabies

The most common vaccine administered to a select civilian and military population is against rabies. Rabies is caused by a virus that attacks the central nervous system. Left untreated it is fatal. Dogs, cats, ferrets, rabbits, skunks, raccoons, coyotes, foxes, and bats are all susceptible to rabies and can transfer it to humans. The virus is found in saliva and normally is transmitted by the bite of an infected animal. Once the virus enters the body, it travels along nerve cells until it reaches the brain and spinal column where it reproduces and eventually destroys the nervous system. It can take weeks or months for diagnostic symptoms to appear. By the time they appear, little can be done to stop the progress of the disease. Initial symptoms are general—headache, fever, and fatigue—but as the virus increases in concentration, symptoms develop such as anxiety, confusion, and hallucinations, ending with hypersalivation (the classic "foaming at the mouth" symptom), extreme fear of water, and death.

Rabies vaccine is used like any other vaccine to prevent someone from acquiring the disease. Individuals who receive preexposure vaccination include veterinarians, animal handlers, cave explorers (because bats live in caves and frequently carry rabies), and people who work in the manufacture of rabies vaccine or in research laboratories where the virus is studied. Others who might benefit from preexposure vaccination include people who work with wildlife in a context where they might encounter rabid wild animals and travelers, humanitarian aid workers in developing countries, and military personnel likely to be exposed to animals in parts of the world where rabies is common.

Rabies vaccine is also highly effective if given promptly (the sooner the better!) after a person is exposed to rabies. This use is called postexposure prophylaxis. Postexposure prophylaxis is effective only because the rabies virus reproduces slowly, giving the body the two weeks or so it need to make enough antibodies to control the disease.

Rabies cases are rare in the United States thanks to almost universal vaccination of dogs and cats and because of programs to spread vaccine-laced bait for wild animals in areas where rabies is common. Only 55 cases have occurred in the United States since 1990, 90 percent of which occurred from contact with wild animals, mostly bats. Nevertheless, in the United States, somewhere between 16,000 and 39,000 people are vaccinated each year after being bitten

by an animal that may have been rabid. Rabies occurs on every continent except Antarctica. The WHO estimates that the disease causes about 50,000 deaths and that 10 million people receive postexposure prophylaxis each year, mostly in Africa, the Indian subcontinent, and Asia where packs of feral dogs are common.

Rabies vaccines (Imovert and RabAvert in the United States) are made from chemically inactivated virus and are delivered by intramuscular injection. Preexposure vaccination consists of three doses on days 0, 7, and 21 or 28. Pregnant women seeking preexposure vaccination should wait until the baby is born unless risk of exposure to rabies outweighs risk to the fetus.

Postexposure prophylaxis for people who have never been vaccinated consists of extensive wound cleansing, four doses of rabies vaccine on days 0, 3, 7, and 14, and a dose of human rabies immune globulin (HRIG) on day 0. The immunoglobulin provides short-term passive immunity until the body generates antibodies to create long-lasting active immunity. People who have been vaccinated within five years of exposure to rabies usually receive two doses of vaccine plus HRIG. Since rabies is a fatal disease, there are no age or health restrictions on who receives postexposure prophylaxis, although serious allergic reactions are possible.

Tuberculosis

The Bacille Calmette-Guérin (BCG) vaccine, first tested in humans in 1921, is the oldest vaccine still in use today. It is used to prevent tuberculosis in individuals who are not already infected. Tuberculosis is an airborne contagious disease caused by the bacterium *Mycobacterium tuberculosis*. It is most common in areas where people live crowded together in conditions of poverty. The vaccine contains live attenuated bacteria. It does not protect against all strains of the bacterium that cause tuberculosis, including drug-resistant strains. Observational studies suggest that overall effectiveness is about 50 percent, although for unknown reasons, effectiveness can range from almost completely ineffective to 80 percent effective in different geographic populations.

Although tuberculosis is uncommon in the United States, the WHO estimates that there are between 8 and 10 million cases of tuberculosis worldwide every year causing one to two million deaths. BCG vaccine is officially recommended in 180 countries, but not in the United States. In counties where tuberculosis is common, the vaccine is routinely given to newborns and young children, as it can be given safely only to people who are not already infected. In the United States, the vaccine is used only rarely and on an individual basis after consultation with an expert on tuberculosis. It may be given as a

protective measure to uninfected children who cannot be separated from adults with untreated or ineffectively treated tuberculosis and to select health-care workers who have direct contact with tuberculosis patients.

Oddly, BCG has been found to be an effective treatment for early or non-invasive bladder cancer. The vaccine is injected directly into the bladder and allowed to remain there for several hours. The patient then urinates, but some BCG cells remain in the bladder. They appear to attract immune system cells to the bladder where they attach to and destroy cancer cells, although it is not clear why this happens.

VACCINES GIVEN ONLY TO U.S. ARMED FORCES

As of 2017, new military recruits are given the same CDC-recommended vaccinations, boosters, and catch-up doses of vaccines that are recommended for the civilian population. In addition, select personnel also are immunized against smallpox, anthrax, and adenovirus. These vaccines are reserved for military members, some civilians attached to the military (e.g., overseas military contractors), and very occasionally civilians in high-risk occupations. Who is vaccinated depends on the branch of service and the occupational risk of the individual. In addition, many military members receive vaccines approved for both civilian and military use based on health risks likely to be encountered during their deployment (see Vaccines Given Travelers below).

Adenovirus

There are 52 types of adenovirus that cause a variety of respiratory, gastroin-testinal, and other infections. The adenovirus vaccine protects against type 4 and type 17 viruses that cause acute respiratory disease and influenza-like symptoms, eye and other infections, and serious complications such as pneu-monia. The vaccine is approved only for use by military personnel ages 17–50 years. Adenoviruses are particularly likely to infect new recruits because of their close living quarters. Before immunization, up to 80 percent of trainees contracted the virus and at least 20 percent had symptoms serious enough to require hospitalization. A vaccine (now discontinued) was developed in 1956 and used until 1998. No vaccinations were done between 1998 and 2011, at which time the immunization program was resumed with a new vaccine.

Adenovirus type 4 and type 7 vaccine is a live attenuated vaccine given as two oral tablets, one for each type of virus. Adverse effects are generally mild and include headache, cold-like symptoms, abdominal pain, nausea, and

diarrhea. About 1 percent of individuals develop a fever. Serious health problems developing within six months of vaccination, which may or may not be related to the vaccine, include pneumonia, blood in urine or stool, and inflammation of the gastrointestinal system.

Anthrax

Anthrax spores are ranked among the top twenty-first century bioterrorism threats. They spread easily and remain infective for decades. For this reason, anthrax vaccine is recommended for military personnel, researchers who work with the disease, and a few civilians who work with animals and animal hides. During the Persian Gulf War in 1991, about 150,000 American troops were given anthrax vaccine. In 1998, the program was expanded to service members working in high-risk areas and those involved in homeland defense. These vaccinations were controversial.

Anthrax is caused by toxins released by the bacterium *Bacillus anthracis*. This bacterium forms long-lived spores that are eaten by grazing animals. They then develop into anthrax bacteria. Humans contract the disease by coming in contact with an infected animal. The bacteria usually enter through a break in the skin. This form of anthrax is called cutaneous anthrax, and it is most often contracted by people who handle wool or hides. It causes skin ulcers, fever, and fatigue. If untreated, 20 percent of people die. Anthrax can also be acquired from eating raw or undercooked meat from an infected animal. This form of anthrax causes nausea, vomiting, and fever. It can be fatal.

The military is primarily concerned with inhalation anthrax. If *B. anthracis* is inhaled, within a few days it causes severe breathing problems, shock, meningitis, and death. Anthrax in various forms has been used as a bioterrorism weapon since the 1930s, but the main threat comes from concentrated aerosolized anthrax, which is not easy to produce but is easy to distribute (see Chapter 9). Aerosolized anthrax spores enclosed in letters were delivered by regular postal mail to various political figures and news organizations in the United States in 2001, setting off an anthrax scare. Twenty-two people became sick and five died. The sender was thought to be a biodefense researcher who later committed suicide.

Anthrax vaccine adsorbed (BioThrax) is a toxoid vaccine made by chemically inactivating the toxin produced by *B. anthracis*. It contains neither live nor dead anthrax bacteria and cannot cause anthrax. The vaccine has been licensed in the United States since 1970. It is administered by intramuscular injection for preexposure immunization and subcutaneously for postexposure prophylaxis. Preexposure immunization consists of a primary series of three

injections at day 0, one month, and six months followed by boosters at 6 and 12 months after the final primary injection. Yearly boosters are recommended to sustain immunity. Postexposure prophylaxis is given at day 0, two weeks, and four weeks along with antibiotics. The effectiveness of postexposure prophylaxis in humans remains unclear because it is based only on animal testing.

Serious allergic reactions occur less than once in every 100,000 doses, but milder adverse events such as redness, soreness, and itching at the injection site, muscle aches, headaches, and fatigue are common. Preexposure vaccination should not be given to pregnant women, immunocompromised individuals, and others with certain allergies and health problems. Because of the seriousness of inhaled anthrax, there are few limitations on postexposure prophylaxis.

Smallpox

The military has a long history of involvement in the development and testing of vaccines. During the Revolutionary War, General George Washington recognized that the British had a significant manpower advantage because many of their soldiers had been variolated against smallpox. Smallpox is a deadly disease killing about 30 percent of people who are infected. Variolated British soldiers contracted the disease at much lower rates than Continental soldiers who had no immunity to smallpox. As early as 1777, Washington ordered variolation of new recruits, and the incidence of smallpox among his troops fell from 17 percent to 1 percent.

Routine civilian vaccination against smallpox ended in 1972 because benefits did not outweigh the risks. Smallpox was declared eradicated worldwide in 1980. Nevertheless, the U.S. military continued to vaccinate new recruits until 1984. Between 1984 and 1990, smallpox vaccination was intermittent because of vaccine shortages and inoculation was temporarily discontinued in 1990. The temporary stop continued until December 2002 when, faced with the possibility of smallpox being used as a weapon of bioterrorism, vaccination resumed for medical response teams and troops deployed to high-risk areas.

Smallpox vaccine (ACAM2000) contains a live pox virus that is a close relative of the smallpox virus. The virus causes a much milder reaction than the smallpox virus, but it still activates the immune system to make antibodies against smallpox virus. (For a discussion of how this works, see Chapter 3, From Variolation to Vaccination). Because smallpox vaccine contains live virus, vaccinated individuals can pass the virus to unvaccinated individuals for a period of several weeks after vaccination. Special care of the vaccination site must be taken during this time and certain activities are restricted.

Special training is required for doctors before they are allowed to handle smallpox vaccine. The vaccine is given by a process called scarification. A drop of vaccine is inserted with a two-pronged needle under the skin of the upper arm but not deep enough to cause bleeding. The site becomes red, itchy, and bumpy, and most people develop a fever. The scarification site must be kept covered and completely dry until the scab that forms drops off and new skin covers the site (2–4 weeks). Contact with the site or with bandages and clothing that have been in contact with the site can spread the virus to unimmunized people. Clothing and bedding that may have been in contact with the scarification site must be washed separately. There are other restrictions on activities (e.g., swimming, handling infants).

Rash, fever, and head and body aches are common adverse effects. Very serious and sometimes permanent adverse events include myocarditis and pericarditis (infection of the heart muscle and surrounding membranes), encephalitis, severe skin infections, and blindness. People who are immunocompromised or who have heart disease should not be vaccinated. People who have had eczema or atopic dermatitis are at higher risk for serious side effects. The vaccine has not been studied in pregnant or breastfeeding women. As of 2017, only select military personnel were being vaccinated against smallpox, but the Department of Defense claims to have enough vaccine stockpiled to immunize all Americans in case of a bioterrorism emergency. See Chapter 9 for a discussion of bioterrorism.

VACCINATIONS GIVEN TO TRAVELERS

Certain vaccines called geographic niche vaccines are given only to civilians and military personnel who visit or live in specific locations. Recommendations vary depending on the location, length of stay, and health of the traveler. The U.S. CDC tracks disease prevalence and worldwide traveler health requirements in a publication called the *Yellow Book*. This information is available online at the CDC's Travelers' Health website at https://wwwnc.cdc.gov/travel.

The Travelers' Health website allows individuals to enter their destination, information on their stay, and any special health considerations they have (e.g., pregnant, immunocompromised, travelling with children). The site then provides up-to-date information about required and recommended vaccines and health warnings for the chosen location. A second portal provides more detailed information for health professionals. The WHO maintains information on current disease outbreaks at http://www.who.int/en.

Geographic niche vaccines are discussed below, but disease risk can change rapidly. Travelers are urged to check these websites well in advance of travel for the most recent information. Some vaccines require multiple doses over several weeks to create strong immunity, so travelers should take the timing of vaccinations into consideration when planning travel.

Japanese Encephalitis

Japanese encephalitis is caused by a *flavivirus* and is spread by the bite of an infected mosquito. Risk of contracting the disease is greatest for individuals spending an extended period in parts of rural Asia. The vaccine is given mainly to military personnel and people such as missionaries and humanitarian aid workers who will be working in rural areas. Tourists visiting major Asian cities and staying less than one month are unlikely to contract the disease. Japanese encephalitis virus causes fever, stiff neck, nausea, and vomiting. Symptoms appear about two weeks after the individual is infected. Some people go on to develop encephalitis. About 25 percent of people who progress to encephalitis die and another 50 percent are left with permanent disabilities.

The Japanese encephalitis vaccine (IXIARO in the United States, JESPECT in Europe and Australia) contains chemically inactivated virus and cannot cause the disease. A live attenuated vaccine is used in China. The vaccine is administered as an intramuscular injection. It is recommended for travelers over age two months who will be staying in rural locations where the disease is common. The vaccine is given as a series of two shots 28 days apart. People over age 17 may receive a booster after one year. Adverse effects are generally mild and include headaches and body aches and fatigue. About 1 percent of people develop soreness at the injection site.

Typhoid

Typhoid fever, also known as enteric fever, is caused by *Salmonella typhi* bacteria. People acquire the bacteria through contaminated food and water. Typhoid causes a high fever, intense stomach pain, tenderness and abdominal distension, headache, fatigue, weakness, and sometimes a rash. If untreated, typhoid infection kills about 30 percent of individuals. Increasingly, some strains of typhoid are antibiotic resistant, complicating treatment even when high-quality medical care is available. About 3 percent of people who recover from typhoid become carriers of the disease. They can infect other people even though they have no symptoms themselves. The most famous carrier is

Typhoid Mary (Mary Mallon 1869–1938) who in the early 1900s infected more than 50 people in New York City.

In areas where typhoid infection is common, travelers can avoid the disease by drinking only bottled water, avoiding uncooked foods, and peeling fruits and raw vegetables. Vaccination is only 50–80 percent effective in preventing the disease, so even if vaccinated, individuals must be careful about what they consume. Typhoid is rare in the United States. About 80 percent of cases in the United States occur in people who have travelled to Mexico or developing countries in Asia, South America, and Africa. Typhoid is especially common in rural and nontourist areas where water and sewage treatment is limited and in areas where natural disasters have caused contamination of the water supply with sewage. Worldwide, about 22 million people contract the disease each year and between 200,000 and 600,000 die.

Vaccination is suggested for only for responders to natural disasters and people living in high-risk areas for six weeks or more, especially if they are in rural areas or small towns. People in close contact with a typhoid carrier and those working in laboratories with *S. Typhi* are also vaccinated.

Yellow Fever

Yellow fever is caused by a *flavivirus* transmitted by several species of *Aedes* and *Haemagogus* mosquitoes found in Africa, Central America, and South America. Flaviviruses also cause Japanese encephalitis, dengue fever, tick-borne encephalitis, and Zika virus disease. Many people develop influenza-like symptoms—fever, chills, head and body aches, nausea, and fatigue from yellow fever infection. In about 20 percent of infected individuals, the disease progresses to severe symptoms including liver damage, severe bleeding, multiorgan failure, and death. There is no specific treatment. A list of countries where yellow fever is common can be found at https://wwwnc.cdc.gov/travel/yellowbook/2016/infectious-diseases-related-to-travel/yellow-fever#4728

Yellow fever vaccine (YF-Vax) is a live attenuated vaccine given subcutaneously. The vaccine is almost 100 percent effective. The CDC reports only 23 failures in more than 540 million doses. As of June 2016, a single dose of the vaccine was regarded as providing lifelong immunity. Before this date, a booster was required every 10 years. International Health Regulations allow countries to demand proof of immunization against yellow fever for entry into the country, and some may be slow to lift the 10-year booster requirement. International travelers should check the entry requirements of the countries they plan to visit.

Yellow fever vaccine is suitable for all individuals over age nine months traveling to places where the disease is found or working with the virus in the laboratory or a manufacturing facility. Mild effects include headache, muscle ache, and low fever. Pregnant women, immunocompromised individuals, and people severely allergic to eggs (the virus is grown in chicken eggs), gelatin, or any other component of the vaccine should not be vaccinated. Severe allergic reactions occur only once in one million doses.

VACCINES NOT USED IN THE UNITED STATES

Each country has its own vaccine approval process that aims to balance vaccine risks with the needs of its population based on the prevalence of each vaccine-preventable disease and the effectiveness of the vaccine. The result is that not all vaccines are available in all countries. There are several reasons for this, some of which are listed below:

- A disease is so rare in a particular country that there is no need to vaccinate against it.
- Regulatory agencies have decided the vaccine is not adequately effective to justify licensing it.
- Regulatory agencies feel the adverse effects of the vaccine outweigh its benefits.
- Regulatory agencies want more information about the vaccine and the conditions of its production before it is licensed.

Cholera

Cholera is an intestinal infection caused by the bacterium *Vibrio cholera*. It is transmitted by the oral-fecal route through contaminated food and water. It can also be contracted by eating raw or undercooked shellfish (e.g., raw oysters) mainly from the Gulf of Mexico. This route of infection is uncommon. Cholera is almost never passed directly from person to person.

Cholera is rare in the United States and most developed countries. It thrives in crowded and unsanitary conditions such as slums and refugee camps where there is inadequate treatment of water and sewage. Outbreaks often occur after natural disasters such as hurricanes and tsunamis during which water supplies become contaminated with untreated sewage. The disease is most often found on the Indian subcontinent, in underdeveloped countries in Southeast Asia, and in central and southern Africa. In 2014, the greatest number of cases were in Afghanistan (more than 45,000), Nigeria, and Haiti. Seven cases were

reported in the United States and two in Canada. Worldwide, researchers estimate there are between 1.4 and 4.3 million cases of cholera each year accounting for between 28,000 and 142,000 deaths.

About 80 percent of people infected with *V. cholera* show no symptoms. Of those who do develop symptoms, the majority (up to 80 percent) have only mild to moderate illness. The remaining people develop severe, life-threatening symptoms. In severe illness, people produce copious amounts of watery diarrhea along with vomiting. Fluids can be lost at the rate of one quart (1 L) per hour causing fatal dehydration, especially among infants, young children, pregnant women, and the elderly. Cholera can be treated successfully with rehydration fluids.

As of 2017, two WHO-approved oral cholera vaccines (Dukoral and ShanChol) are available to immunize against cholera in people over age two years. Dukoral contains heat and chemically killed bacteria and a subunit protein of the bacterial toxin. ShanChol contains whole killed bacteria. Both vaccines can cause headaches, fatigue, and fever. Children under age two years, pregnant women, and immunocompromised individuals should not be vaccinated.

Cholera vaccines are available in Canada, the United Kingdom, Australia, and much of the developing world, but are not licensed for use in the United States. The vaccines are only 50–60 percent effective in preventing the disease, and for most travelers, the risk of contracting cholera is low. Risk can be further reduced by good hygiene practices, boiling water, and avoiding raw foods including unpeeled fruits and raw vegetables.

Dengue

In December 2015, Sanofi Pasteur, the vaccine division of the French company Sanofi, announced that it had received authorization in Mexico to market the world's first vaccine, CYD-TDV (Dengvaxia), against dengue fever. Approvals in Brazil, the Philippines, and El Salvador followed quickly and by April 2017, 22 countries had approved the vaccine. It took 25 years of research and clinical trials in 15 countries before the vaccine was ready to market. Five other dengue vaccines from other manufacturers remain in development as of early 2017.

Dengue fever, also called breakbone fever, is caused by four related strains of a *flavivirus*. It is transmitted from person to person by the bite of infected *Aedes* mosquitoes. The disease is found in about 100 tropical and subtropical countries including Caribbean islands such as Puerto Rico. In the past, outbreaks have occurred in the Southeastern United States and in Hawaii.

Five to seven days after becoming infected, an individual develops a fever, severe headache, body and joint aches, and a rash. After this, patients appear to improve, but some people relapse and develop dengue hemorrhagic fever. With dengue hemorrhagic fever, the blood vessels become permeable. Fluid enters the tissues causing hypotension (low blood pressure) that can lead to potentially fatal shock. Other symptoms include internal bleeding indicated by bloody vomit and bloody stool. There is no specific treatment for dengue, but individuals who survive gradually improve. Every year about 220 million people contract dengue fever. Of those, about two million people, mostly children, develop severe cases with bleeding complications and many die.

The dengue vaccine is a live attenuated recombinant DNA vaccine that protects against four strains of the virus. Like the influenza virus, immunity to one strain does not provide immunity to other strains. The vaccine is licensed for use in individuals ages 9–54 years. Complete immunization requires three doses, the second given 6 months after the first and the third 12 months after the first. The vaccine is about 65 percent effective in preventing dengue fever in people over age 9 years and 93 percent effective in preventing cases serious enough to require hospitalization in this age group

In September 2016, the WHO Strategic Advisory Group of Experts advised that the vaccine should be used only in places where there is substantial dengue present. Initial reports suggest that they vaccine may increase the risk of severe disease in people who have not already contracted one strain of the virus, so the vaccine should be used cautiously in young children. An evaluation of this potential complication is ongoing.

Leptospirosis

Leptospirosis is a disease of humans and animals caused by multiple strains of the spirochete bacterium *Leptospira interrogans*. It is considered among the most common zoonotic diseases in the world. Leptospirosis can be acquired through breaks in the skin when in direct contact with an infected animal or its fluids or feces or through contaminated soil or water. The bacterium can also be inhaled and enter the body through the mucous membranes of the respiratory system. Person-to-person transmission is rare. Carriers of the disease include rodents and almost all domestic animals—cattle, sheep, horses, goats, swine, buffalo, and dogs. People at highest risk are those who work in close contact with animals. Outbreaks also tend to occur after natural disasters in which there is flooding.

Symptoms of leptospirosis mimic those of many other diseases, and diagnostic testing is not easily available. Consequently, the disease is considered

seriously under reported. Based on testing people's blood for antibodies against *L. interrogans*, an estimated 80 percent of individuals living in the tropics encounter the disease during their lifetime. Prevalence in nontropical areas tends to correlate to the size of the rat population, since rats are common urban carriers of the bacterium.

Leptospirosis causes a fever of 100.5–104°F (38–40°C). Most people have influenza-like symptoms, pain behind the eyes, sensitivity to light, nausea, and vomiting. Between 5 and 15 percent of infected individuals develop serious complications such as jaundice, liver damage, kidney damage, bleeding from the lungs, and systemic shock. Leptospirosis is treated with antibiotics.

No WHO-recommended human vaccines are available against leptospirosis, but human vaccines are available in Cuba and China. A vaccine for dogs is available in the United States. Its use is controversial since immunity lasts only one year and it protects against only four strains of the bacterium.

Plague

Plague, known as the Black Death, killed between 75 and 200 million people during an outbreak in the 1300s in Europe. Today, plague is still a serious disease with a mortality rate of 60 percent in untreated individuals. Prompt treatment with antibiotics substantially reduces the chance of death.

Plague is caused by *Yersinia pestis* bacteria. It is a zoonotic disease, which means it can be passed between animals and humans. *Y. pestis* infects small rodents such as rats and ground squirrels. Fleas bite infected animals and become infected. An infected flea then bites a human and transfers *Y. pestis* to the human. Plague can also be acquired through direct contact with fluids from an infected animal or by inhaling respiratory droplets of an infected animal or person.

Three to seven days after being infected, the individual develops a sudden high fever, chills, head and body aches, abdominal pain, nausea, vomiting and general weakness. There are three forms of plague. Bubonic plague (the Black Death of the Middle Ages) develops from the bite of an infected flea causing inflamed painful lymph nodes called buboes. In time, the skin turns black. Septicemia plague develops from flea bites or direct contact with infected fluids. The infection spreads through the bloodstream without forming buboes. Pneumatic plague develops in the lungs from inhaling respiratory droplets containing *Y. pestis*. It is the rarest and most deadly form of plague.

Plague occurs rarely in the United States and usually is confined to the Southwest. On average only three cases are reported each year. However, in 2015, 15 cases and 4 deaths were reported, several of which were linked to a

campground in Yosemite National Park in California. Worldwide, plague is found in all continents except Antarctica. The 1,000–2,000 cases that are reported to the WHO each year are considered a substantial undercount. Most cases occur in Africa.

Researchers have been trying to develop an effective vaccine against plague since 1890. In the past, a vaccine was available in the United States. The vaccine was not very effective and caused unacceptable adverse effects, so its use was discontinued. Canada allows the use of plague vaccine very sparingly for people at high risk of exposure. The vaccine requires multiple doses and boosters to remain effective, and it causes substantial adverse effects. Because of the potential for *Y. pestis* to be used as a bioterrorism weapon, as of 2017, research is ongoing to develop an effective plague vaccine.

Q Fever

Q fever is caused by the bacterium *Coxiella burnetii*. It is one of the world's most infectious organisms. Half of all people infected with a single *C. burnetii* bacterium will develop Q fever. The disease was first recognized in humans in Australia in 1935, but it is found worldwide, including in most of the United States and Canada. Cattle, sheep, and goats can be infected. Humans can become infected when they are exposed to fluids from infected animals. Ticks can also transmit the disease to humans; however, most people become infected by inhaling the bacterium.

Symptoms of Q fever vary substantially from person to person. About half of all people show no symptoms while others have mild influenza-like symptoms. A minority of people develop severe illness with a fever of 104–105°F (40–40.5°C), head and body aches, cough, vomiting, diarrhea, and chest pains. Complications can include pneumonia, hepatitis, myocarditis (inflammation of the heart tissue), and miscarriage or preterm delivery.

Q fever can be treated with antibiotics. Less than 2 percent of hospitalized patients die. *C. burnetii* can remain in the body for long periods and some people, especially those who are immunocompromised, have complications that develop months later.

Q fever became a reportable disease in the United States in 1999. One hundred and sixty-nine cases were reported in 2006 with dairy and slaughterhouse workers at highest risk. Nevertheless, this is likely an undercount since many people develop no or few symptoms. Q fever outbreaks tend to be regional. Between 2007 and 2014, 4,000 cases were reported in the Netherlands. Other recent outbreaks have occurred in Afghanistan and Iraq and have affected U.S. military personnel stationed there.

The Q fever vaccine (Q-VAX) contains chemically killed whole bacteria that have been grown in chicken eggs. It is given as a single subcutaneous injection. Before receiving the vaccine, it is essential that the individual have a skin test to determine if he or she already has antibodies to Q fever. The vaccine *cannot* be given to people who have already had Q fever, who have already received the vaccine, or who have antibodies to Q fever as indicated by the skin test. People who meet any of these three conditions and who receive the vaccine are at high risk for severe adverse reactions. In people who can safely receive the vaccine, about half have redness and soreness at the injections site and about 9 percent develop a headache.

Tick-Borne Encephalitis

Tick-borne encephalitis (TBE) is caused by three subtypes of a *flavivirus* that are related to the viruses that cause dengue fever, Japanese encephalitis, yellow fever, and Zika virus disease. The three subtypes are designated European, Siberian, and Far Eastern. The Far Eastern subtype causes the most severe illness and the highest rate of permanent disabilities. TBE is common in wooded parts of central Europe, Russia and the countries that were once part of the Soviet Union, and parts of China. The disease is transmitted from small mammals to humans by ticks. In humans, it causes high fever, nausea, vomiting, and can attack the central nervous system and cause paralysis and permanent neurological damage. An estimated 10,000 people are hospitalized with TBE each year.

Immunization against TBE is part of the recommended vaccination schedule in many countries where the disease is common. The vaccines (FSME-IMMUN and Encepur with two other vaccines produced in Russia and one in China) contain inactivated virus that provide cross-protection against all three subtypes in children and adults. The recommended age and the number of doses for complete immunization varies across countries and vaccine manufacturers, but in all cases multiple doses across a minimum of six months are required along with regular booster shots to maintain immunity. TBE vaccine is not available in the United States, but FSME-IMMUN is licensed for use in adults in Canada.

VACCINATION OF DOMESTIC ANIMALS AND LIVESTOCK

Diseases and infections that can be transmitted between animals and humans are called zoonoses. The infective agent can be a bacterium, virus, fungus, or parasite. Transmission occurs though direct contact between animal

and human, through inhalation, or through an intermediary known as a vector. Common vectors are mosquitoes, fleas, and ticks.

Zoonoses are an area where human and animal health intersect. Some research suggests that about three-quarters of emerging human diseases such as Ebola will be zoonotic diseases. Reasons for the increase in zoonoses include globalization of trade in animal products, human settlements expanding into new areas where they are exposed to wildlife, and climate change that allows pathogens and vectors to thrive in areas where they were previously unknown.

Zoonoses fall roughly into three categories. A few diseases such as HIV infection, severe acute respiratory syndrome (SARS) and Ebola jump from animals to humans and then express the ability to be transmitted from human to human. Other zoonoses are transmitted from animal to human by a vector, but rarely or never are they then passed from human to human. Examples include West Nile virus, which infects birds and horses and is transmitted to humans by mosquitoes, and Lyme disease, which infects deer and small mammals and is transmitted to humans and dogs by ticks.

A third category of zoonoses are diseases that cause little harm and few symptoms in their animal host, but cause illness in humans. These diseases are spread through food, contaminated water, and by direct contact with infected animals. Several strains of *Salmonella* that cause few symptoms in poultry but cause symptoms of food poisoning in humans fall into this category.

Current human vaccines protect, often imperfectly, against only a few of the more than 200 recognized zoonotic diseases. Table 5.3 lists the zoonotic diseases for which there are human vaccines. Mass vaccination of domestic animals with veterinary vaccines is an essential part of controlling zoonotic diseases.

Veterinary vaccines are developed to serve multiple purposes to meet the needs of animal health, human health, and the economic interest of livestock raisers and the public.

- They improve the health and welfare of individual animals, a benefit to both farmers and pet owners.
- They protect the herd from outbreaks of disease by providing an economical way for livestock raisers to protect their investment.
- They increase the safety of the food and water supply, a benefit to public health.
- They reduce the animal-to-human transmission of disease, a medical and economic benefit to both individuals and society.

Table 5.3 Human Vaccine-Preventable Zoonotic Diseases

Disease	Animal Reservoir	Transmission
Anthrax	Most grazing animals	Direct contact or inhalation
Dengue	Monkeys	Mosquito vector
Japanese encephalitis	Swine, wild birds	Mosquito vector
Leptospirosis	Rodents and most domestic animals	Direct contact
Plague	Rodents	Flea vector
Q fever	Cattle, sheep, goats	Direct contact or tick vector
Rabies	Most warm-blooded animals	Direct contact
Tick-borne encephalitis	Small forest mammals	Tick vector
Tuberculosis	Cattle	Ingestion of unpasteurized dairy products
Yellow fever	Monkeys	Mosquito

Veterinary vaccines are created using the same techniques as human vaccines. In the United States, they are licensed and regulated by the Center for Veterinary Biologics, which is a part of the Department of Agriculture. In the European Union, they are regulated by the veterinary branch of the European Medicines Agency.

Vaccination of animals against rabies and anthrax are probably the most familiar examples of human diseases that are controlled by vaccinating animals, but there are other success stories. Brucellosis is a bacterial disease of cattle, sheep, and goats. People acquire the infection by drinking unpasteurized milk from infected animals. In humans, the disease goes by the names Mediterranean fever, Malta fever, and ungulate fever. Symptoms include fever, headache, joint pain, loss of appetite, weight loss, fatigue, and depression. Mass livestock vaccination has improved herd health and practically eliminated the disease in humans in the United States. Vaccination has been equally effective in other countries. For example, a livestock vaccination program in Mongolia reduced animal-to-human transmission by 52 percent.

Another example of veterinary vaccines improving human health comes from the vaccination of poultry against *Salmonella enteritidis* and *S. typhimurium*. Neither of these bacteria cause serious symptoms in poultry, but bacteria can be transferred to meat products where they are a leading cause of foodborne illness. Symptoms include diarrhea, vomiting, and fever. In the European Union, beginning in 2008, vaccination of chickens against

S. enteritidis has been mandatory in all member states where prevalence levels are above 10 percent.

SUMMARY

No vaccine is 100 percent safe and no vaccine is 100 percent effective. When developing vaccine recommendations, governmental medical agencies must consider the age at which the individual is most vulnerable to a vaccine-preventable disease and must balance the risks and benefits of vaccination based on the severity of the disease, its prevalence in the population, economic costs of both the vaccine and the disease, and frequency and severity of adverse effects.

Most vaccines cause mild adverse effects including transient redness, swelling, and pain at the injection site, low fever, and mild headache and muscle ache. Moderate adverse effects include high fever and transient febrile convulsions. Serious adverse events are rare but include allergic reaction that leads to anaphylaxis, encephalitis, permanent neurological damage, coma, and death. Immunocompromised individuals are more likely than healthy individuals to experience adverse events. In many cases, these individuals should not be vaccinated as risks outweigh benefits. Individuals should always be informed of the potential risks of receiving the vaccine (required by law in the United States) and should share with their healthcare provider any medical conditions and drug or other treatments that may adversely influence the outcome of vaccination.

Chapter 6

Risks, Misuse, and Overdose

Vaccine risk and the way risk is perceived and interpreted are at the root of many of the controversies about vaccination that will be discussed in Chapter 8. Misuse and overdose, however, are rare because unlike prescription medicines, vaccines are never self-administered. When misuse occurs, it results from medical error. For example, the vaccine may have reduced potency from being stored incorrectly (usually a failure to refrigerate) or administered after its expiration date. Medical error can also occur from giving the vaccine at the wrong age, spacing doses incorrectly, or administering it to a person whose medical history contraindicates its use (i.e., the special populations indicated for each vaccine in Chapter 5).

Overdosing is not a problem for vaccines. In fact, many vaccines require multiple doses or booster shots to maintain immunity. If a person has been fully vaccinated without a serious adverse reaction, an additional dose of the vaccine is extremely unlikely to cause harm. For example, individuals who received puncture wounds or animal bites are often given a preventative dose of tetanus vaccine even when their vaccination profile is up to date. The exception is Q fever vaccine which can cause serious adverse events if given more than once.

Underdosing is a greater problem in vaccine administration than overdosing. Underdosing occurs when an individual fails to complete an immunization series that requires multiple doses within a specific time frame. For example, DTaP vaccine requires that five doses be given at designated intervals between two months and six years of age to provide complete immunity in children. Any child who does not complete all five shots or whose shots are delayed is underdosed and

has less than optimal immunity. Underdosing also occurs when older individuals fail to receive required booster shots.

STATISTICAL RISK

Statistical risk is a numerical determination of the likelihood that an event will occur based on historical data. Risk is associated with the probability of bad outcomes. No one worries about their risk of winning the lottery or of dying with a million dollars in the bank. Instead, they are concerned with the risk running out of money before they die.

Risk assessment is the process of determining the probability of a negative event occurring in a defined population. Risk assessment can quite accurately determine what will happen to a large group of people based on what has happened in the past, but it cannot predict what will happen to any single individual in the group. For example, actuarial tables for life insurance in the United States are based on the age at which millions of Americans have died. They predict quite well the life expectancy of the "average" person, but they say nothing about individual life expectancy. Some people will die before age 50 and others live to be 100—and there is no way to predict who will draw the long-life straw and whose life will end prematurely.

The statistical risk of vaccines is calculated as the number of doses administered compared to the number of adverse events that occur after vaccination. An adverse event is any undesirable experience that occurs in a defined period after the administration of a vaccine or drug. The vaccine does not have to cause the experience. For example, if a person reports feeling irritable after receiving the influenza vaccine, irritability would be recorded as an adverse event even if it was caused by lack of sleep the night before or stress at work. There is a temporal association between the vaccination and feeling irritable, but there is not necessarily a cause and effect relationship between the two.

Adverse effects are undesirable experiences that are *caused by* the administration of a vaccine or drug. Adverse effects are a more accurate representation of risk than adverse events, but they are also more difficult to determine. A government surveillance system called the Vaccine Safety Data Link (VSD) uses information from participating healthcare providers to determine the background rate of certain disorders in children who do not receive a vaccine. VSD receives data from about nine million patients (roughly 3 percent of the population) every year. This rate is then compared to the rate at which vaccinated children develop the same disorder to help determine if the vaccine causes an increase in certain events.

Keep in mind that adverse events include *any* reported experiences that occur in a designated time period after vaccine administration plus any experiences that are definitely caused by the vaccine. Adverse events are classified as mild (transient, possibly uncomfortable but not a health risk), moderate (longer lasting and often requiring medical attention), and severe (life-threatening or causing permanent damage). All undesirable experiences that occur after vaccination are adverse events, but many fewer are adverse effects.

HOW WE PERCEIVE RISK

For an individual, assessing risk is more complex than simply looking at a statistical table. Behavioral scientists who study response to risk have found a variety of emotional factors that influence the way people perceive and evaluate potentially harmful events. One factor is the conflict between the ability to predict what will happen to a large group versus the uncertainty of what will happen to any individual group member. For example, the incidence of anaphylaxis or another life-threatening vaccine-induced reaction in children given hepatitis B vaccine is less than one event per one million doses. However, the inability to predict which child will develop anaphylaxis can overshadow the fact that millions of children safely receive the vaccine. A parent may think *What if my child is the one in a million who reacts? Why should I accept that risk, especially for a disease that my child may never get?* For anti-vaccination and vaccine-skeptic parents, the perceived risk of vaccinating their child often appears substantially greater than the actual the statistical risk to the population of vaccinated children.

Behavioral research also tells us that humans are far better at recognizing and responding events that can cause damage in the immediate future than they are to threats where damage is delayed or uncertain. For example, people caught in a thunderstorm perceive a real, although very small, risk of being struck by lightning. They respond by seeking safe shelter. These same people, however, may smoke cigarettes for years, even though they know that smoking can cause lung cancer. The statistical risk of a smoker developing lung cancer is far greater than the statistical risk of being struck by lightning. Nevertheless, the perceived risk of being struck by lightning motivates quicker action than the perceived risk of developing lung cancer because lung cancer takes years to appear, and some smokers never get lung cancer. In terms of vaccination, the chance of an adverse reaction from a vaccine is immediate, while the risk of contracting the disease that the vaccine protects against seems smaller because it may or may not occur far in the future. This disconnect can influence the perception of whether it is safe to vaccinate.

Another factor that affects the perception of risk is familiarity. Most people have heard stories about autism, and many know someone with a child who has been diagnosed with autism spectrum disorder. The idea that certain vaccines can cause autism has been around for decades. Some websites and news stories feature heartbreaking stories of parents who are completely convinced that their child's autism was caused by a vaccine because symptoms developed soon after inoculation, even though this link has not been found after dozens of high-quality studies.

As every politician and journalist knows, people respond to personal stories more intensely than they respond to statistics. Parents who hear stories connecting autism or other disorders to vaccination can imagine the same disorder striking their child and are horrified. On the other hand, few parents have experienced or heard stories about measles, diphtheria, or whooping cough, all of which can be deadly, but which are vaccine-preventable. These diseases seem like problems of an earlier era, so their seriousness is discounted. In the case of vaccines, studies have shown that familiarity with stories about negative consequences of vaccination tend to increase the perception of risk, while lack of familiarity with vaccine-preventable illnesses tends to diminish it.

Finally, behavioral scientists tell us that most people are naturally optimistic. Optimists believe that bad things may happen to other people but will never happen to them. This kind of thinking keeps casinos in business. Gamblers know that the house always wins, but each gambler believes that even though the other guy may lose money, he will be a winner. Natural optimism adds to the difficulty of accurately assessing risk. Optimist parents understand that some unvaccinated children may become ill from vaccine-preventable diseases, but they discount the idea that their child will be one who gets sick. When optimism is factored into the risk equation, parents may ask why they should accept *any* level of risk from vaccinating.

THE ADVISORY COMMITTEE ON IMMUNIZATION PRACTICES

In an effort to make the review of vaccines more uniform and improve vaccine safety, the United States established the Advisory Committee on Immunization Practices (ACIP) in 1944. ACIP reviews clinical trial data, safety, effectiveness of the vaccine, labeling, and package insert information to evaluate benefits and risks of each vaccine. It then makes recommendations about which vaccines should be given, the timing of their administration, the level of acceptable adverse events, and under what conditions individuals cannot safely be vaccinated.

ACIP consists of 15 voting members, 14 of whom are medical professionals and 1 who is a consumer representative. The committee also has 30 nonvoting vaccine experts who represent organizations involved in immunization programs. Medical professionals are chosen by application and interview process by the Secretary of the U.S. Department of Health and Human Services (DHHS).

In an effort to prevent bias, members of the committee cannot be employed by or have a close family member employed by a vaccine manufacturer nor can they hold a patent on a vaccine. They are permitted to be involved in vaccine studies, but they cannot vote on the vaccine they are studying, any other vaccine produced by a company funding the study, or on any similar vaccine manufactured by a different company.

ACIP's goal is to use objective data to maximize public health benefits of immunization while minimizing health risks to individuals. Their recommendations are not binding. It is up to the Centers for Disease Control (CDC), state legislatures, health organizations such as the American Academy of Pediatrics (AAP), and individual physicians to decide whether to follow the ACIP recommendations.

The committee meets at the CDC in Atlanta, Georgia, three times a year. Meetings are open to the public and are broadcast live as webcasts. Dates, agenda, slide presentations, and meeting minutes can be found at http://www.cdc.gov/vaccines/acip/meetings/meetings-info.html.

THE GOVERNMENT TAKES ON VACCINE RISKS

Despite the expertise of ACIP and rules and regulations designed to assure that vaccine are used safely, several vaccine scares have occurred in the United States since the 1950s. These incidents ultimately resulted in better regulation of vaccines and the formation of the National Vaccine Injury Compensation Program (VICP) and the Vaccine Adverse Event Reporting System (VAERS), but they also aroused skepticism in some segments of the population about the safety and value of immunization.

The Cutter Incident

In 1952, a polio epidemic swept through every state in the United States. That year, 57,628 cases of polio resulted in 3,145 deaths and 21,269 cases of permanent paralysis. Children would go to bed mildly ill and be paralyzed or dead by morning. Fear of contracting polio was so great that many parents refused to let their children play with other children. There was tremendous pressure for scientists to come up with a vaccine against the disease.

The National Foundation for Infantile Paralysis (NFIP, now called the March of Dimes) was responsible for supervising research, development, and testing of a polio vaccine from 1932 until April 12, 1955, when the results of a massive field test of inactivated polio vaccine (IPV) created by Jonas Salk were announced (see Chapter 3 for the story of Salk's research). Thomas Francis, director University of Michigan Poliomyelitis Vaccine Evaluation Center that had evaluated the data from the test, declared the vaccine extremely safe and 80–90 percent effective. Within hours after his announcement, the Laboratory of Biologics Control, a federal agency within the Institutes of Health (NIH), signed off on a license for the Salk polio vaccine.

The euphoria surrounding the development of a polio vaccine lasted only 12 days. On April 24, a vaccinated child in Idaho contracted polio and died three days later. Soon there were reports of children in other parts of the country developing polio after vaccination. Something had gone horribly wrong. The Public Health Service sent scientists from Epidemic Intelligence Service, an organization originally established during the Korean War to guard against biological warfare, to investigate. Within a week, they had pinpointed the problem.

The NFIP had anticipated that once a polio vaccine was licensed, there would be an overwhelming demand for it. The organization gambled that the field trial would be successful. Before the data were even analyzed, they contracted with five laboratories to unconditionally buy 27 million doses of polio vaccine at a cost of $9 million regardless of the results of the field trial. Consequently, millions of doses of vaccine were stockpiled ready to ship the minute the vaccine was licensed.

Unfortunately, strict protocols for scaling up to manufacture of large quantities of vaccine did not exist. One manufacturer, Cutter Laboratory in Berkeley, California, experienced problems in successfully inactivating the virus. During testing, the Cutter lab found multiple batches of vaccine that still contained clumps of live virus. The company simply discarded these batches without informing the NFIP, the Department of Health, Education, and Welfare, or anyone else connected to the project. At the time this was legal; there were no requirements to report test results on batches of drugs not sold to the public. But some batches of Cutter vaccine containing live virus slipped through the testing process and were distributed to the public.

When the news broke that polio vaccine was causing polio, public panic was immediate. Four hundred thousand children had already been given the Cutter vaccine and another 400,000 doses were in the process of being distributed. The Public Health Service immediately recalled all the Cutter vaccine, but public fears continued to grow. On May 8, less than one month after it

was begun, the entire vaccination program was stopped. In the end, 94 children contracted polio from the Cutter vaccine. These children then infected other people. Of the 260 people whose polio could be traced to the Cutter vaccine, 192 had permanent paralysis and 11 died.

On May 14, 1955, the immunization program was resumed without the Cutter vaccine, but parents were left with questions. How safe was the vaccine? Was the risk of their child getting polio from vaccination greater than the risk of contracting it naturally? The government needed to assure parents that the polio vaccine was safe.

The Cutter incident brought about many changes to reduce the risk of another Cutter-type incident. Everybody in the government involved in testing and licensing of the polio vaccine, from laboratory scientists to the Surgeon General and even the Secretary of the Department of Health, Education, and Welfare, lost their jobs. In addition, multiple improvements in vaccine safety were implemented. Rules regulating the manufacture of vaccines were tightened and record keeping became more rigorous. Companies now had to report the test results of every batch of vaccine even if it was not released to the public.

After the Cutter incident, the National Institutes of Health (NIH) became responsible for regulating and testing vaccines until this responsibility was moved to the Food and Drug Administration (FDA) in 1972. In addition, the scope and funding of the Epidemic Intelligence Service was greatly expanded. This organization still exists today and is instrumental in tracking viral diseases such as AIDS, Ebola, and Zika.

By contrast, no one at Cutter Laboratories lost their job. Cutter never accepted blame for the polio their vaccine caused. They insisted that they had manufactured the vaccine following the procedures and information they had been given. They asserted that they had become scapegoats for failures in the program because they were the smallest laboratory to make the vaccine.

Polio victims sued Cutter in civil court for damages. The jury found that Cutter had not been negligent. It had, indeed, made the vaccine in accordance with industry standards. But the jury also found that Cutter was financially liable for the damages its vaccine had caused. In other words, a company could follow all the government manufacturing regulations using the best techniques available and still be held responsible for damages from its product. The concept of liability in the absence of negligence opened up a huge new area of risk for pharmaceutical companies and would eventually lead to the U.S. government assuming much of that risk.

The 1976 Influenza Panic

On February 4, 1976, Private David Lewis, an apparently healthy soldier at Fort Dix, New Jersey, died suddenly of influenza. For a month before Lewis's death, soldiers at Fort Dix had been getting sick with runny noses, achy muscles, and low fevers. Colonel Joseph Bartley, the officer in charge of preventive medicine at Fort Dix, believed that their illness was caused by a viral infection similar to the common cold. Dr. Martin Goldfield of the New Jersey Department of Public Health thought the soldiers had influenza.

To prove that he was right, Bartley sent samples from some sick soldiers to an influenza surveillance laboratory for analysis. Seven samples contained an unfamiliar influenza virus. These were sent to the CDC in Atlanta. Two samples were found to contain a new flu virus called H1N1 that looked like a close relative of the swine flu virus that researchers thought had caused the 1918–1919 influenza pandemic that killed millions. It appeared that the next pandemic might be about to erupt. The government decided it had to act.

Less than two months after Pvt. Lewis died, President Gerald Ford announced a $135 million program to immunize 200 million Americans against the new swine flu virus. From the beginning, the program ran into problems. In 1967, there were 26 American vaccine manufacturers. The number had dropped considerably by 1976. One major reason companies got out of the vaccine business was the fear of being wiped out by product liability suits modeled on the concept of liability in the absence of negligence that evolved from the Cutter trials.

In 1976, when the government approached pharmaceutical companies about making a vaccine against the new influenza virus, manufacturers discovered that no insurance company would sell them liability insurance to protect them from lawsuits over adverse effects from the new vaccine. With the expectation that 200 million people would be immunized, insurance companies claimed that inevitably some people would experience serious adverse effects and sue the manufacturers. The pharmaceutical companies issued an ultimatum. If the government wanted a swine flu vaccine, it would have to accept liability for the vaccine's side effects.

Fearing a pandemic was approaching that would be made worse by the shortage of vaccine, Congress acted. On August 11, 1976, it passed the Swine Flu Act (Public Law 94-380). The Act exempted vaccine manufactures, distributors, public and private organizations providing free swine flu inoculations, and healthcare workers in these organizations from being sued so long as they were not negligent in the production or use of the vaccine and received informed consent to from patients to vaccinate. Instead, the federal government assumed

liability for any damages caused by the vaccine. The act only applied to swine flu vaccine.

Forty-five million Americans were immunized at free clinics with the new vaccine in a 10-week period. The projected pandemic never occurred. What did develop was a suspicion that the swine flu vaccine was causing an increase in Guillain-Barré syndrome (GBS). GBS is a rare disease in which immune system cells damage nerve cells. It can appear after some viral infections. Symptoms range from tingling in the hands and feet to muscle weakness to paralysis that in rare cases causes death. About one-quarter of people who develop the disease are left with some degree of permanent impairment.

GBS is a difficult diagnosis to make. In the 1970s, about 4,500 unvaccinated Americans were diagnosed with GBS every year. However, as soon as the report of a possible association between the swine flu vaccine and GBS became public, doctors began reporting a substantial increase in the number of patients who developed GBS two to four weeks after getting the swine flu shot. From the reports, it looked as if the vaccine was causing GBS. On December 16, the national immunization program against swine flu was stopped and the lawsuits started.

Over 5,100 people submitted claims against the government for damages (not all for GBS) that they believed were caused by the vaccine. The government automatically accepted liability for all claims where GBS developed within 10 weeks after inoculation based on a CDC report that the vaccine increased the rate of GBS above the background rate by 1 case for every 100,000 people vaccinated. In the end, the government paid out over $73 million to petitioners. About 500 cases, some claiming GBS that developed outside the ten-week window, went to trial in civil court.

To the distress of vaccine manufacturers, some of civil cases that arose from the Swine Flu Act set a precedent that had the potential to substantially increase the liability of manufacturers in the future vaccine cases. Some judges wrote opinions stating that liability existed because individuals were not specifically warned before inoculation that there was a 1 in 100,000 chance they would develop GBS and a 1 in 2 million chance that they would die of the disease. This left the pharmaceutical industry and healthcare workers feeling threatened.

Government liability applied only to the swine flu vaccine for the 1976–1977 influenza season. What would happen with future vaccines if manufacturers, distributors, and medical personnel were financially liable for failing to warn against rare, unanticipated adverse events that became evident only after several million people had been vaccinated? Did every possible serious adverse event have to be specifically detailed? Confusion reigned. Vaccines

already had a low profit margin. Now the potential for liability had been ratcheted up. And then things got worse.

DPT and Vaccine Liability

In 1979, three-month-old Kevin Toner was inoculated with DPT vaccine and developed a rare infection of the spinal cord called transverse myelitis. The child was left permanently paralyzed below the waist. His parents sued the vaccine manufacturer claiming that the pertussis component of the vaccine had caused the paralysis.

The pertussis vaccine had been in use since the 1940s, and in almost 40 years, no increase above the background rate of spinal inflammation had been observed in vaccinated children. Nevertheless, the jury that heard *Toner v. Lederle Laboratories* awarded Kevin Toner's parents $1.13 million. They based the award not on a connection between DPT vaccine and the child's injury but on the plaintiff's argument that Lederle Laboratories was negligent because they could have made a safer vaccine. The case was appealed, but the award was upheld by the Idaho Supreme Court.

The verdict against Lederle Laboratories sent shock waves through the vaccine industry for two reasons. First, the manufacturer was found negligent in the absence of a scientific connection between their product and the child's injury. Second, the award was far larger than anyone expected. In 1979, the gross annual sales of the DPT vaccine were about $2 million and total gross sales of all vaccines were about $7 million. A few awards the size of *Toner v. Lederle Laboratories* could financially destroy a company, especially a smaller one whose main products were vaccines. Many pharmaceutical companies had already gotten out of the vaccine business. Fear of financial ruin accelerated this trend, and the companies that continued to make vaccines drastically raised their prices. From 1980 to 1986, the cost of a single dose of DPT vaccine rose from $0.19 to $12.00. Something had to be done to stabilize the industry.

THE NATIONAL CHILDHOOD VACCINE INJURY ACT

Various groups lobbied for change in the vaccine industry. Parents wanted a way to receive speedy compensation for vaccine-related injuries rather than having to go through a lengthy trial and appeals process. Pharmaceutical companies wanted protection against outsized financial awards. Medical practitioners wanted protection against being sued, as did manufacturers and distributors. The government wanted to assure that supply of vaccines would

remain adequate to protect public health. Out of these competing interests came the federal National Childhood Vaccine Injury Act (NCVIA, Public Law 99-660) in 1986.

The NCVIA created the National Vaccine Program Office to coordinate all immunization-related activities that occurred in the DHHS, the CDC, the FDA, and the NIH. The Act required anyone who administered a vaccine to provide the individual receiving the vaccine (or that person's parent or guardian) a vaccine information statement (see Document 6.1 below) developed by the CDC that describes the disease being immunized against and the benefits and risks of the vaccine. All current vaccine information statements can be accessed at https://www.cdc.gov/vaccines/hcp/vis. The Act also established the Vaccine Adverse Event Reporting System (VAERS) and the Vaccine Injury Compensation Program (VICP).

DOCUMENT 6.1: A SAMPLE VACCINE INFORMATION STATEMENT

MMR (Measles, Mumps, & Rubella) Vaccine
What You Need to Know
Why get vaccinated?
Measles, mumps, and rubella are serious diseases. Before vaccines they were very common, especially among children.
Measles

- Measles virus causes rash, cough, runny nose, eye irritation, and fever.
- It can lead to ear infection, pneumonia, seizures (jerking and staring), brain damage, and death.

Mumps

- Mumps virus causes fever, headache, muscle pain, loss of appetite, and swollen glands.
- It can lead to deafness, meningitis (infection of the brain and spinal cord covering), painful swelling of the testicles or ovaries, and rarely sterility.

Rubella (German Measles)

- Rubella virus causes rash, arthritis (mostly in women), and mild fever.
- If a woman gets rubella while she is pregnant, she could have a miscarriage or her baby could be born with serious birth defects.

These diseases spread from person to person through the air. You can easily catch them by being around someone who is already infected.

Measles, mumps, and rubella (MMR) vaccine can protect children (and adults) from all three of these diseases.

Thanks to successful vaccination programs these diseases are much less common in the U.S. than they used to be. But if we stopped vaccinating they would return.

Who should get MMR vaccine and when?

Children should get 2 doses of MMR vaccine:

- First Dose: 12-15 months of age
- Second Dose: 4-6 years of age (may be given earlier, if at least 28 days after the 1st dose)

Some infants younger than 12 months should get a dose of MMR if they are traveling out of the country. (This dose will not count toward their routine series.)

Some adults should also get MMR vaccine: Generally, anyone 18 years of age or older who was born after 1956 should get at least one dose of MMR vaccine, unless they can show that they have either been vaccinated or had all three diseases.

MMR vaccine may be given at the same time as other vaccines.

Children between 1 and 12 years of age can get a "combination" vaccine called MMRV, which contains both MMR and varicella (chickenpox) vaccines. There is a separate Vaccine Information Statement for MMRV.

Some people should not get MMR vaccine or should wait.

- Anyone who has ever had a life-threatening allergic reaction to the antibiotic neomycin, or any other component of MMR vaccine, should not get the vaccine. Tell your doctor if you have any severe allergies.
- Anyone who had a life-threatening allergic reaction to a previous dose of MMR or MMRV vaccine should not get another dose.
- Some people who are sick at the time the shot is scheduled may be advised to wait until they recover before getting MMR vaccine.
- Pregnant women should not get MMR vaccine. Pregnant women who need the vaccine should wait until after giving birth. Women should avoid getting pregnant for 4 weeks after vaccination with MMR vaccine.
- Tell your doctor if the person getting the vaccine:
 - Has HIV/AIDS, or another disease that affects the immune system
 - Is being treated with drugs that affect the immune system, such as steroids
 - Has any kind of cancer

- ○ Is being treated for cancer with radiation or drugs
- ○ Has ever had a low platelet count (a blood disorder)
- ○ Has gotten another vaccine within the past 4 weeks
- ○ Has recently had a transfusion or received other blood products

Any of these might be a reason to not get the vaccine, or delay vaccination until later.

What are the risks from MMR vaccine?

A vaccine, like any medicine, is capable of causing serious problems, such as severe allergic reactions.

The risk of MMR vaccine causing serious harm, or death, is extremely small.

Getting MMR vaccine is much safer than getting measles, mumps, or rubella.

Most people who get MMR vaccine do not have any serious problems with it.

Mild problems

- Fever (up to 1 person out of 6)
- Mild rash (about 1 person out of 20)
- Swelling of glands in the cheeks or neck (about 1 person out of 75)

If these problems occur, it is usually within 6-14 days after the shot. They occur less often after the second dose.

Moderate problems

- Seizure (jerking or staring) caused by fever (about 1 out of 3,000 doses)
- Temporary pain and stiffness in the joints, mostly in teenage or adult women (up to 1 out of 4)
- Temporary low platelet count, which can cause a bleeding disorder (about 1 out of 30,000 doses)

Severe problems (very rare)

- Serious allergic reaction (less than 1 out of a million doses)
- Several other severe problems have been reported after a child gets MMR vaccine, including:
 - ○ Deafness
 - ○ Long-term seizures, coma, or lowered consciousness
 - ○ Permanent brain damage

These are so rare that it is hard to tell whether they are caused by the vaccine.

What if there is a serious reaction?

What should I look for?

- Look for anything that concerns you, such as signs of a severe allergic reaction, very high fever, or behavior changes.

Signs of a severe allergic reaction can include hives, swelling of the face and throat, difficulty breathing, a fast heartbeat, dizziness, and weakness. These would start a few minutes to a few hours after the vaccination.

What should I do?

- If you think it is a severe allergic reaction or other emergency that can't wait, call 9-1-1 or get the person to the nearest hospital. Otherwise, call your doctor.
- Afterward, the reaction should be reported to the Vaccine Adverse Event Reporting System (VAERS). Your doctor might file this report, or you can do it yourself through the VAERS website, or by calling 1-800-822-7967.

VAERS is only for reporting reactions. They do not give medical advice.

The National Vaccine Injury Compensation Program

The National Vaccine Injury Compensation Program (VICP) is a federal program that was created to compensate people who may have been injured by certain vaccines.

Persons who believe they may have been injured by a vaccine can learn about the program and about filing a claim by calling 1-800-338-2382 or visiting the VICP website.

How can I learn more?

- Ask your doctor.
- Contact your local or state health department.
- Contact the Centers for Disease Control and Prevention (CDC):
 - Call 1-800-232-4636 (1-800-CDC-INFO) or
 - Visit CDC's vaccine website

Source: CDC http://www.cdc.gov/vaccines/hcp/vis/vis-statements/mmr.html

THE VACCINE ADVERSE EVENT REPORTING SYSTEM

VAERS is a postlicensing vaccine safety surveillance system cosponsored by the CDC and the FDA. (Prelicensing testing and safety reporting are discussed in Chapter 7). The purpose of VAERS is to:

- detect new or rare adverse events that may have gone undetected during clinical trials.
- monitor increases in known adverse events.
- determine risk factors that make some individuals more susceptible to adverse events.
- identify vaccine lots associated with increased adverse events.
- assess the ongoing safety of newly licensed vaccines.

Healthcare providers are required by law to report certain serious adverse events that appear within a specified period after vaccination. However, anyone may voluntarily report any type of adverse event to VAERS. The reporting party does not have to prove that the vaccine caused the event. There is no penalty or liability for reporting a condition not caused by the vaccine, although it is a violation of the law to intentionally file a false report.

Vaccine manufacturers, healthcare providers, and state immunization programs account for about 83 percent of all adverse events reports to VAERS. Another 7 percent come from parents or guardians, and 10 percent from other sources including the affected individual and attorneys who specialize in vaccine injury cases. Reports can be made online or by postal mail and are confidential.

In 2015, 41,335 adverse event reports were submitted to VAERS. The highest percentage of events was reported in people ages 44–61, followed by people ages 17–44. This is somewhat surprising given that the vast majority of vaccines are given to children before age six. Of the reported adverse events, about 13 percent were considered serious, meaning they could cause life-threatening illness, disability, hospitalization, or death. This percentage may seem disturbingly high, but it includes all adverse events, not just adverse effects proven to be caused by the vaccine. In other words, if a person had a stroke the day after receiving a vaccination, it could be reported as an adverse event. The staff at VAERS follows up by asking for additional medical information on the most serious events to help determine if the vaccine caused the reported injury. In at least one case, VAERS reports caused a vaccine to be withdrawn from the market.

VAERS and the RotaShield Vaccine

In 1998, the Wyeth Laboratories licensed the vaccine RotaShield to immunize infants at ages two, four, and six months against four rotaviruses. Rotaviruses cause high fever, vomiting, and severe diarrhea. Almost every child contracts the virus before age five. Before a vaccine was available, rotavirus infection caused between 20 and 40 deaths each year in the United States and thousands more in developing countries where health care was limited.

RotaShield had been tested in 11,000 children before it was licensed. Five vaccinated children in the trials developed intussusception, a rare type of bowel blockage, as did one child in the group given a placebo. The background rate for intussusception during the first year of life is 1 in every 2,000–3,000 children. The difference between the background rate and the number of vaccinated children who developed intussusception in the clinical trial was not statistically significant, so the vaccine was licensed with the warning that intussusception was a possible adverse effect.

Over the next several months, VAERS received occasional reports of intussusception occurring a few days after the RotaShield vaccine was administered. The reports were consistent enough to suspect a causal relationship between the vaccine and the intestinal blockage. Based on the VAERS reports, the CDC launched two large investigations to determine if the rate of intussusception was increased by vaccination with RotaShield. They concluded that children under age 12 months were at greater risk of intussusception within 2 weeks of the first or second dose of RotaShield and that the vaccine caused between one and two cases above the expected background rate in every 10,000 vaccinated children.

In July 1999, ACIP recommended that vaccination with RotaShield be suspended. Three months later on October 22, 1999, Wyeth Laboratories voluntarily withdrew the vaccine from the market. By then, 57 cases of intussusception had been linked to RotaShield. Without the VAERS postlicensing surveillance system, this rare adverse effect might not have been detected. RotaShield has since been replaced with two rotavirus vaccines that were tested on six times as many children before being licensed. The new vaccines have not been shown to raise the rate of intussusception above the background rate.

THE VACCINE INJURY COMPENSATION PROGRAM

The VICP began in October 1988 and continues today. The program is a government compensation program that assumes financial risk for vaccine

injures. It operates outside the civil court system and is financed by an excise tax on vaccines. The VICP has multiple goals. It protects vaccine manufacturers from catastrophic financial loss resulting from liability lawsuits alleging injury caused by vaccines. This encourages pharmaceutical companies to stay in the vaccine business and helps to stabilize the cost of vaccines. The government, in turn, benefits by having an adequate supply of vaccine available to protect public health. The VICP also provides a more streamlined and generally faster way for vaccine-injured individuals to receive compensation than bringing a liability case to civil court. Claims made under the VICP are heard by a Special Master in the U.S. Court of Federal Claims.

As of February 2017, the vaccines covered by the VICP were diphtheria, tetanus, pertussis, *Haemophilus influenzae* type b (Hib), hepatitis A, hepatitis B, human papillomavirus, seasonal influenza, measles, mumps, rubella, meningococcal, polio, pneumococcal conjugate (PCV-13), rotavirus, and varicella in any combination such as DTaP or MMRV. Covered vaccines must be on the CDC list of recommended vaccines for routine administration to children, subject to excise tax by Federal law, and added to the VICP by the Secretary of Health and Human Services. Newly licensed vaccines that fall into the same category as an already covered vaccine, for example, a new rotavirus vaccine, are automatically covered.

Disability or injury caused by adulterants or contaminants in the vaccine is not covered under the VICP. Injury claims resulting from adulterants or contaminants may be filed in civil court. However, preservatives and adjuvants are not considered adulterants or contaminants but are considered a necessary part of the vaccine. Thus, individuals who believe their children were injured by the preservative thimerosal that was once routinely used in several vaccines cannot not file for compensation under the VICP.

Vaccines not covered by the VICP include pneumococcal polysaccharide vaccine (PPV-23), and herpes zoster (shingles), both of which are routinely recommended only for adults, and nonseasonal influenza vaccine. Also not covered are nonroutine vaccines such as yellow fever and Japanese encephalitis vaccine. Anthrax, smallpox, and adenovirus, given almost exclusively to military members, are also excluded. A current list of covered vaccines can be found at https://www.hrsa.gov/vaccinecompensation/coveredvaccines/index.html.

Persons Eligible to Make Claims under the VICP

A person of any age, the parent or legal guardian of a child, or the legal representative of the estate of a deceased person who believes the individual

was harmed by a vaccine can make a claim under the VICP. The injured individual does not have to be a U.S. citizen. Representation by an attorney is not required; however, most petitioners use an attorney who specializes in vaccine injuries in order to make sure they meet the highly specific rules and deadlines for filing. Under most circumstances, the VICP will pay attorneys' fees related to a claim, even if the petitioner is ultimately not compensated. Petitioners do not have to file a VAERS report to file a claim with the VICP.

Conditions regulating who can file a VICP claim include the following:

- The petitioner must have an injury caused by a vaccine on the list of covered vaccines.
- If the person received the vaccine outside the United States, he or she must be a U.S. citizen serving in the Armed Forces or working for the U.S. government or be a dependent of such an individual.
- If the person does not meet the above citizenship and employment criteria, then the vaccine's manufacturer must be located in the United States and the person who received the vaccine must have returned to the United States within six months after inoculation.
- The alleged injury must have lasted more than six months, or if the injury lasted less than six months, it must have resulted in hospitalization *and* surgical treatment *or* death.

There are also time requirements to file. In general, VICP claims must be filed within three years of the first appearance of the symptom or injury or within three years of a significant worsening of the symptom. If the vaccine is believed to have caused death, the claim must be filed within two years of the death *and* within four years of the appearance of the first symptom or of a significant worsening of the symptom that resulted in death. When a new injury is added to the Vaccine Injury Table (VIT, see Table 6.1 below), the time frame is expanded to retroactively cover applicable injuries and deaths that occurred up to eight years before the change, so long as the claim is filed within two years of the published VIT change.

Filing a VICP Claim

Individual petitioners or their representatives filing a VICP petition for damages must produce an abundance of medical records to justify their claim. These include prenatal records for the mother if a young child is the petitioner, hospital records for the delivery and newborn hospital stay including laboratory results, a birth certificate, and all additional medical records such as doctor

visits and laboratory work done outside the hospital prior to vaccination. When possible, the vaccine lot number and manufacturer are requested.

The petitioner must also produce all medical records for emergency treatment, hospital admissions, medications, laboratory reports, evaluations, and outpatient treatment that occurred after vaccination. Depending on the type of injury, school records and educational and psychological evaluations may be requested to determine validity and extent of damage. In the case of death, a death certificate and autopsy (if done) are required.

All medical records along with three copies of the claim form and a $400 (as of 2016) filing fee are sent to the U.S. Court of Federal Claims to begin the process. One copy of the claim and all medical records are also sent to the DHHS, and a copy of the claim goes to the Department of Justice (DOJ). Medical experts at the DHHS review the medical records to determine if the claim meets the medical criteria for compensation. They write a report that is sent to the DOJ. Attorneys at the DOJ write a report that includes the medical recommendations from the DHHS and a legal analysis of the case. This report goes to the Federal Claims Court, which then appoints a Special Master.

The Special Master is a lawyer appointed by a judge of the Court to decide whether the claim is to be paid and if so, the amount of compensation. The petitioner has the opportunity to accept or reject the decision of the Special Master. If the petitioner rejects the decision of the Special Master, the case can be appealed first to a judge in the Federal Claims Court, then to the U.S. Court of Appeals, and finally to the U.S. Supreme Court. However, once the decision of the Special Master is rejected, the petitioner cannot change his or her mind and accept the decision or the offered payment.

The procedure is quite complicated, but few claims go through the complete process described above. Throughout the process, the involved parties are encouraged to use mediation to settle the claim or withdraw it if it is clear that it will not succeed. According to the DHHS, 80 percent of cases are settled through negotiation between the involved parties rather than by the Special Master. Additional information including detailed rules and guidelines for filing a claim can be found at http://www.uscfc.uscourts.gov

How Claims Are Evaluated

To facilitate the evaluation of claims, medical experts and the VICP have developed the Vaccine Injury Table (VIT; Table 6.1). For each covered vaccine, the VIT details illnesses, disabilities, injuries, and conditions that are presumed to be caused by the vaccine unless proven otherwise. Covered events are determined by evidence-based medicine and postlicensing surveillance.

The VIT also lays out the period during which the first symptom or manifestations of the adverse event or a significant worsening of the condition must occur. Information in the VIT is supplemented by the Qualification and Aids to Interpretation. This document gives additional information about some of the conditions listed in the Table. For example, it clarifies what is considered a "significant decrease in consciousness."

The time element is important in linking the cause (the vaccine) to the injury (the adverse event). Timing varies depending on the vaccine and the disorder it may cause. For example, if an individual is vaccinated with MMR vaccine and develops anaphylaxis within four hours, it is assumed that the vaccine was responsible. However, if an individual receives the MMR vaccine and develops chronic arthritis, another condition listed in the VIT, the first symptoms must develop within 7–42 days after inoculation.

Unless there are highly unusual circumstances, conditions are only compensated when they are listed in the VIT, develop within the designated time frame, are adequately documented, and cannot be shown to have another cause. However, the injuries and conditions listed in the VIT are quite limited. For conditions not listed in the VIT or that that develop outside the defined period, the burden falls on the petitioner to prove that there is a cause and effect relationship between the vaccine and the injury. Some of the controversies that have arisen from the stringent cause and effect burden of proof will be discussed in Chapter 8.

During the eight years between 2006 and 2014, 3,521 petitions were adjudicated by the Court. Of these, 2,248 (63.8 percent) were compensated. Only 193 of the 2,248 that received compensation were decided by the Special Master; the rest were the result of a negotiated settlement. During that same period, more than 2.5 billion doses of covered vaccines were distributed. This is the equivalent of one person compensated for every one million doses of covered vaccine. Influenza vaccines generated the highest number of petitions (1,561) during this period. They were followed by DTaP (209), HPV (190), and MMR (179).

SUMMARY

Statistical risk is the mathematical calculation of the likelihood of a negative event occurring. Perceived risk is the level of risk a person feels applies to himself or herself. Perceived risk is influenced by the emotional factors such as immediacy of the risk and familiarity with the risk. Often the perceived risk of a vaccine is greater than its statistical risk. Since the 1950s, laws have been implemented to improve vaccine safety and reduce risk.

Table 6.1 Vaccine Injury Table

Vaccine	Illness, disability, injury or condition covered	Time period for first symptom or manifestation of onset or significant aggravation after vaccine administration
Vaccines containing tetanus toxoid (e.g., DTaP, DTP, DT, Td, TT)	A. Anaphylaxis or anaphylactic shock	4 hours
	B. Brachial Neuritis	1-28 days
	C. Any acute complication or sequela (including death) of an illness, disability, injury, or condition referred to above which illness, disability, injury, or condition arose within the time period prescribed	Not applicable
Vaccines containing whole cell pertussis bacteria, extracted or partial cell pertussis bacteria, or specific pertussis antigens (e.g., DTP, DTaP, P, DTP-Hib)	A. Anaphylaxis or anaphylactic shock	4 hours
	B. Encephalopathy or encephalitis	72 hours
	C. Any acute complication or sequela (including death) of an illness, disability, injury, or condition referred to above which illness, disability, injury, or condition arose within the time period prescribed	Not applicable
Measles, mumps, and rubella vaccine or any of its components (e.g., MMR, MR, M, R)	A. Anaphylaxis or anaphylactic shock	4 hours
	B. Encephalopathy or encephalitis	72 hours
	C. Any acute complication or sequela (including death) of an illness, disability, injury, or condition referred to above which illness, disability, injury, or condition arose within the time period prescribed	Not applicable

(continued)

Table 6.1 (Continued)

Vaccine	Illness, disability, injury or condition covered	Time period for first symptom or manifestation of onset or significant aggravation after vaccine administration
Vaccines containing rubella virus (e.g., MMR, MR, R)	A. Chronic arthritis	7-42 days
	B. Any acute complication or sequela (including death) of an illness, disability, injury, or condition referred to above which illness, disability, injury, or condition arose within the time period prescribed	Not applicable
Vaccines containing measles virus (e.g., MMR, MR, M)	A. Thrombocytopenic purpura	7-30 days
	B. Vaccine-Strain Measles Viral Infection in an Immunodeficient recipient	6 months
	C. Any acute complication or sequela (including death) of an illness, disability, injury, or condition referred to above which illness, disability, injury, or condition arose within the time period prescribed	Not applicable
Vaccines containing inactivated polio virus (IPV)	A. Anaphylaxis or anaphylactic shock	4 hours
	B. complication or sequela (including death) of an illness, disability, injury, or condition referred to above which illness, disability, injury, or condition arose within the time period prescribed	Not applicable

Vaccine	Condition	Time period
Hepatitis B vaccine	A. Anaphylaxis or anaphylactic shock	4 hours
	B. complication or sequela (including death) of an illness, disability, injury, or condition referred to above which illness, disability, injury, or condition arose within the time period prescribed	Not applicable
Haemophilus influenzae type b polysaccharide conjugate vaccines	No condition specified	Not applicable
Varicella vaccine	No condition specified	Not applicable
Rotavirus vaccine	A. Intussusception	1-21 days
	B. complication or sequela (including death) of an illness, disability, injury, or condition referred to above which illness, disability, injury, or condition arose within the time period prescribed	Not applicable
Pneumococcal conjugate vaccines	No condition specified	Not applicable
Hepatitis A vaccines	No condition specified	Not applicable
Seasonal influenza vaccines	No condition specified	Not applicable
Meningococcal vaccines	No condition specified	Not applicable
Human papillomavirus(HPV) vaccines	No condition specified	Not applicable

Source: National Vaccine Injury Compensation Program https://www.hrsa.gov/vaccinecompensation/coveredvaccines/index.html

159

The National Childhood Vaccine Injury Act of 1986 came about as a way to shift some financial risks away from pharmaceutical companies and health-care practitioners and onto the federal government. The Act established the Vaccine Adverse Event Reporting System (VAERS)—a postlicensing system to report adverse events and the Vaccine Compensation Injury Program (VICP) through which people who believe they have been injured by a vaccine can seek compensation without filing a civil liability suit. Overuse and misuse are not significant concerns in vaccine usage.

Chapter 7

Production, Distribution, and Regulation

The creation of a new vaccine is a massive undertaking involving hundreds of scientists and support personnel, years of work, and many millions of dollars with no guarantee of success. Working with living organisms—pathogens capable of causing disease and host cells—imposes the maintenance of specific environmental conditions and restricts the speed at which vaccines can be produced. The presence of live virus in a production facility mandates strict containment measures so that workers and the public are not accidentally exposed to the pathogen. Vaccines containing live attenuated viruses also require special distribution and storage treatment.

Every step of the manufacturing and testing process is overseen by the Center for Biologics Evaluation and Research within the Food and Drug Administration (FDA). On average, it takes 15 years and at least one billion dollars to bring a new vaccine to market. Even after a vaccine is licensed for public use, testing and surveillance continue.

COMPONENTS OF VACCINES

Antigenic molecules that stimulate an immune response are the active part of each vaccine. The antigenic component can be a whole live attenuated organism, a killed bacterium or an inactivated virus, part of the exterior surface of an organism that contains the antigen, or isolated purified proteins made through genetic recombination to produce an immune response.

Table 7.1 below lists the types of vaccines and the way the antigenic component for each type of vaccine is obtained (see Chapter 2 for a review of vaccine types).

Although the antigenic component produces immunity, other substances must be added to the vaccine to dilute, preserve, and stabilize it. Some vaccines also retain trace amounts of the materials used to produce them. A list of all components of each vaccine can be can be found at http://vaccines.procon.org/view

Table 7.1 Production of Antigenic Components

Vaccine Type	Vaccines	How Immunologic Component Is Produced
Live attenuated viral vaccines	Adenovirus, live attenuated influenza vaccine (LAIV),[†] measles, mumps, oral polio vaccine (OPV),[††] rotavirus, rubella, smallpox, yellow fever, varicella, and zoster	Grown in a hostile environment to force mutations that reduce reproductive capacity in humans
Live attenuated bacterial vaccines	Bacille Calmette-Guérin vaccine (BCG), cholera, plague, and one form of typhoid vaccine These vaccines are not normally used in the United States	Grown in a hostile environment to force mutations that reduce reproductive capacity in humans
Inactivated or killed vaccines	Hepatitis A, inactivated influenza vaccine (IIV), Japanese encephalitis, inactivated polio vaccine (IPV), and rabies and whole cell pertussis[††]	Inactivated/killed with chemicals, heat, or radiation
Toxoid vaccines	Diphtheria and tetanus	Purified toxin deactivated with chemicals or heat
Subunit vaccines	Anthrax, hepatitis B, HPV, influenza (Flublok), acellular pertussis, one type of typhoid vaccine, and Lyme disease[††]	Identification and isolation of surface antigens or production of surface antigens by genetic engineering (recombinant vaccines)
Polysaccharide vaccines	Some versions of meningococcal, pneumococcal, and typhoid vaccines	Identification and isolation of surface antigens on polysaccharide coat
Conjugate vaccines	*Haemophilus influenzae* type b (Hib), some versions of meningococcal and pneumococcal vaccines	Protein attached to polysaccharide coat to increase antigen response

[†]Not used during the 2016–2017 influenza season due to history of ineffectiveness.
[††]No longer used in the United States.

.resource.php?resourceID=005206 or in Section 11 (Description) of the vaccine package insert. Inserts are online at www.immunize.org/packageinserts.

Adjuvants

The word "adjuvant" comes from the Latin word *adjuvaere* meaning "to help." Adjuvants are chemicals added to some vaccines to help the antigenic component stimulate a stronger and more effective immune response. This allows immunity to develop using a lower dose of antigen or with fewer doses of vaccine. Diphtheria and tetanus vaccines developed in the 1930s were the first to contain adjuvants.

Vaccines stimulate both the innate and adaptive immune systems (see Chapter 2 for a review of these systems). The innate response happens immediately. Through a series of coordinated cellular and chemical reactions, cells of the innate system activate the adaptive system. After a few days, B cells of the adaptive system produce antibodies that lead to the development of long-term immunity.

The mechanism by which adjuvants boost innate immune response so that it kicks the adaptive system into high gear is not completely understood. Researchers believe various adjuvants work in different ways. Some help to hold the antigen at the injection site allowing slower but longer stimulation of innate system cells. This is called the depot effect. Others are thought to stimulate antigens to form large complexes that are more easily engulfed by antigen presenting cells (APCs) of the innate system. APCs in turn stimulate T cells that secrete chemicals that coordinate antibody-producing B cells (see Chapter 4 for more details).

Adjuvant use in vaccines in the United States is regulated by the FDA. As of 2017, only two types of adjuvants were approved. Aluminum in the form of aluminum hydroxide, aluminum phosphate, or potassium aluminum sulfate (also called alum) is used in hepatitis A, hepatitis B, DTaP and Tdap, Hib, some types of HPV, one form of trivalent influenza vaccine (Fluad) for people over age 65 years, and pneumococcal vaccines. Aluminum is also found in drinking water, some foods (e.g., infant formula), and pharmaceutical drugs (e.g., antacids).

The daily intake of aluminum for an American adult ranges from 0 to 95 mg with a median intake of 24 mg. The amount of aluminum in vaccines is limited to 0.85–1.25 mg per dose. Following the CDC-recommended vaccination schedule for the first year of life, a child would be exposed to a maximum of 4.225 mg of aluminum. Aluminum is rapidly eliminated in feces and urine; it does not accumulate in the body.

The second type of adjuvant, monophosphoryl lipid A, was approved for use in vaccines in 2009. It is a fat-like immune-stimulating compound isolated from the cell wall of a bacterium. This adjuvant in combination with aluminum hydroxide (the combination is called AS04) is found in the HPV vaccine Cervarix. It has also been used in experimental anticancer vaccines. Additional adjuvants are used in Europe and Asia, and some have been approved for experimental use in the United States.

Suspending Fluid

Suspending fluid is the liquid in which all the components of the vaccine are dissolved. Suspending fluid is either sterile water, saline (salt water), or liquid containing proteins. Some vaccines are shipped as liquids in vials ready to be used. Others, (e.g., measles, yellow fever, rabies, and BCG) are not stable and cannot be shipped in their suspending fluid. These vaccines are freeze-dried. The suspending liquid is removed under vacuum so that what remains is a more stable powder that contains the antigen. This dry form of the vaccine retains its potency longer, thus extending the vaccine's shelf life.

Although freeze-drying has advantages, it also has drawbacks. Freeze-dried vaccines must be precisely reconstituted with a diluent liquid before use. The diluent contains stabilizers, preservatives, and the precise amount of sterile suspending fluid necessary to reconstitute the vaccine to its proper strength. Diluents are different for each vaccine and each manufacturer, so only the specific diluent provided by the manufacturer can be used to reconstitute the freeze-dried powder. Once reconstituted, the vaccine must be protected from heat and light and must be used promptly, usually within the WHO recommended time of six hours.

Antibiotics

Small amounts of antibiotics are used in some vaccines to prevent bacterial and fungal contamination. Because more people are allergic to penicillins, cephalosporins, and sulfa drugs than other antibiotics, these antibiotics are not used in vaccines. Instead, the antibiotics neomycin, polymyxin B, streptomycin, and gentamicin, all of which are less likely to cause an allergic reaction, are used for contamination control.

Vaccines against measles, mumps, rubella, chickenpox, shingles, rabies, diphtheria, pertussis, tetanus, hepatitis A, hepatitis B, and some influenza vaccines contain antibiotics, as do combination vaccines against these diseases. The most common antibiotic used is neomycin followed by polymyxin B.

The amount of antibiotic per dose is very small, ranging from 0.15 mg of neomycin in rabies vaccine to less than 0.000000004 mg of neomycin in some formulations of DTaP.

Preservatives

Preservatives are antiseptic chemicals used to kill bacteria and fungi. The use of preservatives in vaccines developed in the 1920s after several incidents where children became sick and some died as the result of contamination of a vaccine with an environmental bacterium such as tetanus. This occurred in the pre-antibiotic era, so the only choice was to add very low doses of antiseptic chemicals to prevent contamination. Four chemical preservatives were licensed for use in vaccines in the United States in 2017: phenol, 2-phenoxyethanol, thimerosal, and benzethonium chloride. Benzethonium chloride is used only in anthrax vaccine, which is reserved almost exclusively for military use.

Phenol, also called carbolic acid, is an antiseptic that was used in carbolic soap until the 1970s and today is found in many drugs, cosmetics, and sunscreens. Phenol is a normal metabolic product that is excreted in urine. The preservative 2-phenoxyethanol is found in perfume, cosmetics, and insecticides. It is effective in killing bacteria and yeasts.

Thimerosal is the most controversial of the preservatives used in vaccines because of its mercury content. As with other preservatives, thimerosal is used to keep vaccines free of bacterial and fungal pathogens. It has been used in vaccines since the 1940s. Anti-vaccination advocates have implicated thimerosal in causing autism, attention deficit hyperactivity disorder (ADHD), and other neurological disorders. This controversy is discussed in Chapter 8.

Humans are exposed to mercury in two main forms, methylmercury and ethylmercury. These two compounds are treated differently by the body. Methylmercury is the type of mercury that accumulates in some fish. It is poorly eliminated by the body and can build up to levels that have the potential to cause neurological damage, which is why pregnant women are told to limit their consumption of certain seafood.

Thimerosal is about 50 percent mercury by weight. In the body, it breaks down into ethylmercury and a compound called thiosalicylate. Ethylmercury is broken down and eliminated from the body much more easily than methylmercury. It is highly unlikely to build up to harmful levels.

Since 2001 with few exceptions, vaccines that are routinely recommended for children under six years in the United States contain either no thimerosal or a only a trace of the preservative. In this case, a trace is defined as less than 0.000001 g (1 μm) per dose. Thimerosal has been eliminated in most vaccines

by changing the manufacturing process and switching to single-dose vials. The remaining vaccines that are not thimerosal-free include vaccines shipped in multidose vials where the potential for contamination exists from multiple needles dipped into the suspending solution. One version of the inactivated influenza vaccine also contains thimerosal. A thimerosal-free version of influenza vaccine is also available.

Stabilizers

Stabilizers are added to vaccines to help protect them from the freeze-drying process, shield them against changes in temperature, and to maintain their potency. Some stabilizers are common sugars and proteins found in many foods and drugs. Examples include the sugars lactose and sucrose, sorbital, which is another common sweetener, the amino acid glycine, monosodium glutamate, a flavor enhancer used in foods, and gelatin. Less familiar chemicals may also be added to adjust the pH (a measure of acidity or alkalinity). These include phosphate buffers, hydrochloric acid (in tiny amounts), and magnesium sulfate. Human albumin, an extracted blood protein, can also be used as a buffer.

Production Residues

Different types of vaccines contain trace amounts of the various materials that were used during their manufacture. For example, formalin (diluted formaldehyde) is used to detoxify the toxin in the toxoid vaccines diphtheria and tetanus and to inactivate viruses so that they can no longer cause disease. Formalin is removed during the production process, but very small amounts remain in vaccines such as IPV, hepatitis A, rabies, diphtheria, and tetanus. The body naturally produces far greater amounts of formalin during normal metabolic functioning than are contained in a dose of vaccine. Both naturally produced and vaccine-introduced formalin are broken down and do not build up in the body.

Certain live attenuated viruses such as influenza, measles, and yellow fever are grown in chicken eggs. When the viruses are harvested, small amounts of egg protein remain in the vaccines, including the combination vaccines MMR and MMRV. This can be of concern to people who have egg allergies (about 1 percent of young children). The amount of egg protein in MMR and MMRV is very small and has not been shown to cause an allergic reaction. However, reactions by people allergic to eggs have been reported with influenza vaccine and yellow fever vaccine. A recombinant influenza vaccine (RIV)

made in the laboratory using only proteins from the coat of influenza viruses does not contain egg protein. It can safely be used to vaccinate individuals with egg allergy.

Hepatitis B vaccine is subunit vaccine made using baker's yeast. Traces of yeast remain in the vaccine whether it is given alone or in a combination vaccine. One version of HPV vaccine (Gardasil) also contains yeast. This can be of concern to individuals with yeast allergy.

Viruses cannot reproduce on their own. They need to enter a cell and reprogram its genetic material to produce more viruses. At some point in their development and production, varicella, zoster, rubella, hepatitis A, and one version of the rabies vaccine viruses are grown in human or animal cells. Although trace proteins from these cells may remain after the viruses are purified, they do not appear to cause adverse responses in these vaccines.

EARLY DEVELOPMENT AND TESTING

Early development begins with basic scientific research that usually is done in a university, medical center laboratory, or government-supported laboratory. Basic research involves studying the genetics and metabolism of the pathogen, identifying and isolating antigens, testing potential host cells, and studying mechanisms by which the immune system responds to the antigen.

The process is incremental, with several different groups of researchers working on the same problem from different angles and publishing their work in scientific journals where it can be evaluated by other scientists. Failure is more common than success. This basic research adds to the understanding of the disease process, but little of it results directly in successful development of a new vaccine. It does, however, give vaccine researchers clues about how to proceed and suggests new techniques to try.

Early Challenges

Once a promising antigen has been identified and isolated, the cost of research often shifts toward a pharmaceutical company, which supports both outside and in-house research. When a likely antigen has been identified, isolated, and adequately purified, it needs to be tested. Researchers are required to develop precise tests to assure the purity of the antigen and to measure its effects. These tests must be shown to produce reliable, consistent, and expected results.

Once this has been achieved, testing usually begins in small rodents— mice, rats, ferrets, or rabbits. The researchers look to see if the animal produces antibodies when challenged with the antigen. If small animal results look

promising, the antigen is tested in larger animals, often monkeys whose biology is more like humans. Animal testing can also provide insight into the strength and duration of immunity.

Meanwhile, other researchers work on developing ideal growing conditions—temperature, oxygen level, pH, growth media, and container shape—for the pathogen and the ideal suspending fluid, which is different for each vaccine. Drug development generates mountains of paperwork. Administrators are assigned to follow all aspects of vaccine development and assure that records are complete and the correct information is filed in a timely way with the FDA (see Regulations below). At this point, hundreds of people are employed developing a vaccine that may never reach the market.

Phase I Clinical Trials

Once the results of animal research show that a new drug or vaccine has promise, a sponsor must file an Investigational New Drug (IND) application with the FDA. Sponsors usually are pharmaceutical companies. For a drug to receive IND approval, it must have proof that it is reasonably safe and has the potential for commercial development. Approval of the IND allows a drug or biological product to be shipped to outside investigators across state lines, something necessary for continued testing.

Human testing begins with Phase I clinical trials. All clinical trials are subject to FDA regulation and oversight. Phase I trials only involve a small number of volunteers—usually somewhere between 30 and 70. The goal of initial human testing is to answer two questions: Is the vaccine safe? Does the vaccine produce the expected immune response? The test vaccine must contain all the adjuvants, preservative, and stabilizers that will be in the final vaccine. It takes many years and millions of dollars to reach Phase I trials. The trial itself usually takes one to two years to complete.

Phase II Clinical Trials

If the results from Phase I trials are favorable to continued development, the vaccine enters Phase II trials. The goal of Phase II trials is to determine the correct dose of vaccine and to study its safety in a larger population. Up to this point, only small amounts of vaccine were needed, but Phase II trials require vaccine for at least several hundred volunteers. The volunteers should be similar to the population for whom the vaccine is intended. Many potential new vaccines never reach Phase II trials.

While Phase I trials were underway, a different set of researchers were studying ways to scale up production of the vaccine. One FDA requirement is that the vaccine used in Phase II trials be manufactured in the building where the final vaccine will be made. This often requires building new facilities, special production and storage rooms, massive amounts of equipment, and a significant financial commitment by the manufacturer before it knows if the vaccine will ever be licensed for sale. The company must also show how the newly manufactured vaccine will be tested and prove that the tests used produce reliable, reproducible results. Even vaccines that do well in Phase I testing may be abandoned because the manufacturer decides the return on its investment will be too low to justify the increased costs of moving forward to Phase II.

Phase II trials can take as few as two years, but getting ready for this phase often take many more because of the FDA building requirements and the difficulty in recruiting volunteers. Volunteers in clinical trials are paid a small amount for their time and travel expenses on the condition that they complete all requirements of the trial. Any volunteer may withdraw from a trial at any time for any reason.

Phase III Clinical Trials

Phase III trials are large-scale controlled field tests necessary before a vaccine is licensed. In most cases, they are double-blind trials, meaning that neither the volunteers nor the healthcare workers running the trial know whether the individual receives the vaccine (the experimental group) or a placebo (the control group). In a few cases, such as with the Ebola vaccine, giving a placebo to people who could contract a fatal disease is considered unethical. The Ebola section of Chapter 9 explains an alternate way of evaluating such a vaccine.

Phase III trials involve thousands of people. The number of volunteers must be great enough to determine statistical differences between the experimental and control groups. Volunteers must meet certain health and age requirements in keeping with the target population for the vaccine. Selection of the test population is important. For example, when testing the dengue vaccine, the pharmaceutical company had to find a population where dengue was fairly common (otherwise it would be hard to tell how well the vaccine worked), but not so common that almost everyone had already contracted dengue and developed natural immunity to it (in which case the effect of the vaccine would be difficult to measure).

At this point, the vaccine is manufactured almost as it would be if it were licensed. Its strength, contents, directions for distribution, storage, administration, expiration date, and labeling are all in place (see Figure 7.1). Tests have been designed and certified to assure the purity and effectiveness of every batch of vaccine. Other tests have been established to reliably determine the volunteers' response to the vaccine and procedures have been developed to record any adverse effects and compare them statistically to background rates to determine risk. Test sites are monitored and visited by representatives of the FDA, and reams of data are collected.

Phase III trials last about four years depending on how common the disease is and how easy it is to recruit volunteers. It then takes the company another 18 months to 2 years to review the data and prepare a Biologics License Application for the FDA. The FDA then reviews the information, inspects the manufacturing facility, and reviews the labeling, all of which can take another year before the vaccine is licensed and can be sold to the public.

Phase IV—Postlicensure Evaluation

Even after a vaccine has been licensed and is administered to the public, the FDA may require the manufacturer to perform additional tests, often on special populations. Government organizations also perform surveillance to assure that no previously unobserved adverse effects occur. The Vaccine Adverse Event Reporting System (VAERS) and the Vaccine Safety Data Link (VSD) were discussed in Chapter 6. Other organizations also perform postlicensure surveillance on vaccines.

The Clinical Immunization Safety Assessment (CISA) Project established in 2001 in partnership with the CDC is a network of eight nationally recognized medical centers and vaccine experts. Its function is to study risk factors in special populations, develop strategies for identifying individuals a higher risk for adverse events from vaccination, develop preventative strategies, and serve as a resource for clinicians in immunization decision making.

The Post-Licensure Rapid Immunization Safety Monitoring (PRISM) system established in 2009 under the direction of the FDA is the largest postlicensing vaccine safety surveillance system in the United States. Through electronic databases, it has access to historical information on over 100 million people. PRISM links databases from national health insurance plans and state immunization registries to perform statistical analyses that when combined with information from voluntary reporting of adverse effects to VAERS allows the detection of the rare adverse effects.

FULL-SCALE PRODUCTION

After a vaccine is licensed and goes into commercial production, the FDA continues to perform periodic inspections of the production facility and has the authority to require the manufacturer to submit results of their in-house testing for potency, safety, and purity for each batch of vaccine. The FDA can also compel the manufacturer to submit samples of each batch for independent testing.

Vaccines differ from most other drugs because they are made using living organisms. In some cases, the finished product contains live but weakened pathogens that, if mishandled, have the potential to cause disease. This imposes stringent manufacturing and containment conditions on the production facility. Some production considerations include the following:

- Individuals who work in the production of vaccines must be protected in the work environment against becoming infected with the disease the vaccine is intended to prevent.
- The public must be protected from pathogens being inadvertently carried outside the facility and into an environment where they could spread disease.
- The medium in which bacteria and viruses grow in must be strictly protected against contamination. Containment and sterility must be enforced.
- Fluctuations in temperature, pH, oxygen level, and similar variables must be tightly controlled in order not to kill or alter the virus or host cells.
- Bacteria, viruses, and cells used in vaccine production have the potential to mutate, so batches must be tested to detect and destroy any unacceptable mutations.
- Animal products such as fetal calf serum or human albumin used in growth media must be free of pathogens.
- Methods of inactivating or attenuating pathogens must be effective and consistent. Every batch of killed or inactivated vaccine must be tested for the presence of live pathogens.
- Growth media and chemicals used to attenuate or kill viruses must be removed from the final product.
- Problems of scale must be overcome. Growing enough organisms to produce a test vaccine for 50 volunteers requires a different environment from growing enough to produce millions of doses for the public.

• Production speed is limited by the time it takes to grow a virus or bacterium, even when optimal conditions of temperature, pH, light, and nutrients are maintained.

STEPS IN PRODUCTION

Figure 7.1 shows the general steps required to produce and transport a vaccine once it has been licensed. Variations exist depending on whether the vaccine is a killed whole-cell vaccine, an attenuated/inactivated vaccine, or a recombinant vaccine. As many as 50 different tests occur during the production process, and when the vaccine is complete, it is sent to an independent health authority for more tests before it is released for public use. A good video review of the manufacturing process can be seen at https://www.youtube.com/watch?v=swmaJRKl6EQ

Each production method has advantages and disadvantages. Viruses need a host cell to reproduce; they cannot reproduce on their own. Incubation of viruses in chicken eggs has been used for more than 60 years. The process is well understood and produces consistent results. In 2011, an estimated 500 million doses of influenza vaccine were produced worldwide using the egg-based technique.

Drawbacks in using chicken eggs include an increased possibility of bacterial contamination that necessitates the addition of antibiotics to these vaccines. In addition, there are stringent requirements for the eggs used in making vaccines. For production of the influenza vaccine, the eggs must be 10–11 days old, fertilized, and certified specific pathogen-free (SPF). SPF eggs come from specially raised chickens and are guaranteed to be free of about 30 common avian pathogens, which limits the number of eggs available.

Figure 7.1 Flow Chart of Vaccine Production

Growth media is assembled in a controlled environment —> Host cells, virus, or bacteria are added to growth media —> Target pathogen begins to grow —> Target pathogen transferred several times to larger vessels —> Growth complete —> Purification process of target pathogen removes growth media —> Attenuation/inactivation/killing of pathogen if required —> Attenuation/inactivation/killing chemicals removed through complex filtration—> Antigen concentrated —> Material quarantined in cold chamber for testing —> Concentrated material diluted with sterile water or saline —> Stabilizers and preservatives added —> Adjuvant added —> Final sterile filtration —> Purity testing —> Sterile vials or syringes filled and labeled —> Freeze-drying if necessary —> Final automated and human inspection and testing of vaccine —> Independent purity testing by health authority —> Packaging with instructional insert —> Finished product quarantined in cold storage —> Vaccine officially released for use —> Cold-chain distribution to end user

Even small changes in the chicken's diet can affect how well the virus reproduces in the egg. With an optimal diet, each egg produces enough virus for only one or two doses of influenza vaccine. The entire process of creating the vaccine takes several months. These are serious limitations should an influenza pandemic suddenly increase demand for the vaccine.

Cell-based cultures avoid some of the problems associated with egg-based production. Mumps, measles, rubella, and polio, rotavirus, and some influenza vaccines are made using the cell-culture method. A variety of host cells is used depending on the virus and the manufacturer. Common host cells are monkey kidney cells, dog kidney cells, and human lung fibroblasts. There are two general methods of production. In one, host cells attach to a surface, often microbeads within the growth medium. In the other, the host cells are suspended freely in a growth medium.

Cell-based culture methods scale up well. Host cells can be grown in large containers and produce the required quantity of viruses faster than egg-based culture methods. In addition, these systems are less likely to become contaminated. Drawbacks include concern that some of the DNA from the host cell may remain in the final product with unpredictable results and that animal-derived components used in the growth medium may introduce animal viruses into the vaccine (see Chapter 8).

In recombinant vaccines, genetic material from the pathogen is inserted into host cells such as yeast or insect cells. This genetic material then integrates itself into the host cell's genetic material and causes the host cell to turn on the chemical processes necessary make the desired antigenic protein. The antigenic protein is separated and purified and becomes the basis for the vaccine. This method of manufacturing, which takes about three months, has the advantage that a living pathogen is not used in the production process, removing many safety concerns about containment of the pathogen. Disadvantages include contamination of the vaccine with traces of growth medium and material from the host cell. Some people, for example, are allergic to yeast and cannot be receive a vaccine made using yeast cells. There is also some uncertainty about the stability of the host cells' genetic material.

DISTRIBUTION AND STORAGE CONSIDERATIONS

Vaccines are extremely sensitive to changes in temperature and exposure to light. Heat, freezing, and light can cause a vaccine to lose potency and potentially fail to provide immunity. The biggest distribution and storage challenge is to maintain the cold chain from the time the vaccine is manufactured until

it is used. Some vaccines lose potency when exposed to normal room temperature for 30 minutes. Whenever the cold chain is broken, the vaccine must be destroyed. Alternately, if vaccines that should be refrigerated are accidently frozen, they also may lose potency and must be discarded.

Vaccine manufacturers provide specific information on both on how to ship and store their vaccines. Temperature management begins with special shipping containers that include temperature monitors. Sensors can monitor cumulative heat exposure, periods of excess heat, and freeze events. For example, all vaccines shipped by UNICEF have temperature-sensitive labels with a white circle containing a white square. The square darkens with cumulative heat exposure. If the square is a darker color than the surrounding circle, the vaccine has been heat compromised and must be destroyed. Labels that are language-independent and require no reading, only visual inspection, are particularly valuable in developing countries where a variety of local languages are spoken and literacy is low.

On arriving at their destination, temperature control continues until the vaccines are administered. Some vaccines must be kept frozen, while others need to be kept refrigerated. To reduce accidental freezing of a refrigerated vaccine (which would necessitate destruction of the vaccine), the CDC recommends separate stand-alone freezers and refrigerators with temperature monitors and alarms that make sound if the temperature rises above or falls below the designated range. Vaccines that must remain frozen until use include MMRV, varicella (chickenpox) and zoster (shingles). MMR vaccine can be either frozen or refrigerated. Freezer temperature must be maintained at a temperature of 5°F (–15°C) or colder.

Inactivated vaccines are sensitive to both heat and cold. All routinely recommended vaccines that are not required to be frozen must refrigerated and maintained in a temperature range of 35–46°F (2–8°C) with an optimal temperature of 40°F (5°C). Diluents should also be refrigerated but never frozen.

Temperature monitors should indicate the maximum, minimum, and current temperature of the storage compartment. The temperature should be checked and recorded at least twice daily, and the storage area should be equipped with an alarm system. Some sensors now allow continuous computer monitoring and recording of the temperature of the storage space. Manufacturers also provide guidance on how to arrange the vaccines in the refrigerator or freezer so that the temperature is the same throughout the entire unit.

Light causes some vaccines to lose potency. Vaccines needing continuous protection from light include HPV, MMR, MMRV, varicella, and zoster.

An extensive discussion of proper vaccine storage can be found at https://www
.cdc.gov/vaccines/pubs/pinkbook/vac-storage.html

In the developing world where the electricity supply may be inconsistent,
or when events like hurricanes cause widespread power outages, keeping vac-
cines at the correct temperature can be a challenge. Complicated emergency
instructions have been developed for safely storing vaccines during power
failures.

Another issue in the developing world is the amount of refrigerated space
needed to accommodate stockpiles of vaccines. The trend in the twenty-first cen-
tury is toward single-dose vials or syringes. Single-dose packaging is more costly,
bulkier to ship, and takes up much more storage space than the multivial contain-
ers used before 2000. Although single-dose vials and syringes reduce vaccine
waste and the likelihood of contamination, the WHO estimates that they need
five times more cold storage space than 10- and 20-dose vials

REGULATIONS

Vaccines are heavily regulated worldwide. Every step from development to
testing to manufacturing and through distribution, storage, and even disposal
is subject to governmental oversight. In the United States, the FDA's Center
for Biologics Evaluation and Research (CBER) is responsible for regulating
vaccines. In Canada, the Biologics and Genetic Therapies Directorate, a part
of Health Canada, regulates vaccines. The European Medicines Agency regu-
lates vaccines within the European Union. In Australia, the Therapeutic
Goods Administration within the Department of Health is responsible for vac-
cine regulations. The WHO has its own set of vaccine regulations that many
other countries have adopted. The information below applies to regulation
in the United States.

Federal Regulations

The first attempt to regulate vaccines at the national level occurred in
February 1813 when Congress passed and President James Madison signed
an Act to Encourage Vaccination. The purpose of the Act was to appoint a
National Vaccine Agent to preserve and distribute a national source of
uncontaminated smallpox vaccine. Dr. James Smith, a Baltimore physician
active in getting the bill passed, was appointed the first vaccine agent.
He was charged with developing policies of the National Vaccine Agency
to distribute uncontaminated smallpox vaccine by mail (postage was free)
across the country.

Almost immediately, Smith ran into funding problems. States were willing to have their residents vaccinated, but they did not want to pay for a federal vaccine program. Residents either could not afford the vaccine or did not feel they should have to pay for it. A major objection was the claim that Congress had given Smith an unfair monopoly on smallpox vaccine.

Smith struggled with various funding schemes until 1822 when a smallpox epidemic started by his vaccine killed 10 people in Tarboro, North Carolina. Smith claimed that Dr. John Ward, who requested the vaccine, had administered it improperly. Ward claimed the vaccine was bad. The issue was escalated to the national level by Representative Hutchins Burton who was running for (and was later elected) governor of North Carolina. In May 1822, Congress found it politically expedient to repeal the National Vaccine Act without ever hearing testimony from Ward. This ended the first national attempt to regulate vaccines.

The next attempt at federal regulation occurred in July 1902 with the passage of the Biologics Control Act. The stimulus for its passage was the death of 13 children in St. Louis from diphtheria antitoxin contaminated with tetanus. The Biologics Control Act required manufactures of antitoxins, serums, and vaccines to be inspected and licensed annually. Production had to be supervised by a qualified scientist, and labels were required to include the name of the product, an expiration date, and manufacturer contact information. Responsibility for enforcement was given to the Laboratory of Hygiene, which eventually became the National Institutes of Health. In 1988, responsibility for regulation of biologic products, including vaccines, was transferred to CBER within the FDA where it remains today.

The next major federal attempt to regulate drugs was the passage of the Pure Food and Drug Act of 1906. Impetus for the Act came from Upton Sinclair's book, *The Jungle,* which exposed appallingly unsanitary conditions in the meatpacking industry. Although the Act did not specifically address vaccines, it prohibited the manufacture, sale, or transportation of adulterated, mislabeled, or poisonous foods, drugs, medicines, and liquors. The Act also required active ingredients and any ingredients designated dangerous or addictive (e.g., alcohol, opium, morphine) to appear on the label. The Act authorized fines for noncompliance, but more importantly, it allowed for the seizure and destruction of any products in violation of the law. Inspection and enforcement powers were given to the Bureau of Chemistry, which became part of the FDA in 1930.

The 1906 Pure Food and Drug Act was replaced by the Federal Food, Drug, and Cosmetic Act of 1938. This Act has been amended many times since its passage to keep up with changing demands of the public and new

technology. For example, the 1962 Kefauver Harris Amendment also known as the Drug Efficacy Amendment required drug manufacturers to perform studies to prove a new drug was safe and effective before licensure The Amendment also required drug advertising to include accurate information on side effects, which is why today when drugs are advertised on television or in magazines, they include a long list of potential adverse events.

The National Childhood Vaccine Injury Act of 1986 established the National Vaccine Program Office, the National Vaccine Injury Compensation Program, and the Vaccine Adverse Events Reporting System. These were discussed in detail in Chapter 6.

State Regulations

Production of vaccines is regulated at the federal level by the FDA, but states have the power to compel vaccination. In 1855, Massachusetts was the first state to pass a law mandating that all school children be vaccinated. Other Massachusetts laws permitted local public health officials to require vaccination of all individuals regardless of age if an outbreak of disease occurred. Those who refused could be fined $5 (equivalent to about $140 in 2017).

In 1902, a smallpox epidemic developed in Cambridge, a small town outside of Boston, and local officials called for the vaccination of all residents. Most people cooperated in the interest of stopping the epidemic, but a few resisted. One of those was Pastor Henning Jacobson. Jacobson had been vaccinated in his native Sweden and claimed that he had experienced life-long pain and suffering as a result. When Cambridge officials ordered him to be vaccinated, he refused, and was fined. Instead of paying the fine, he went to court. Although he was a pastor, his objection to vaccination was not based on religious beliefs. Instead, he argued that mandatory vaccination infringed on his liberty guaranteed the Section 1 of the Fourteenth Amendment to the U.S. Constitution, which reads:

> All persons born or naturalized in the United States, and subject to the jurisdiction thereof, are citizens of the United States and of the State wherein they reside. No State shall make or enforce any law which shall abridge the privileges or immunities of citizens of the United States; nor shall any State deprive any person of life, liberty, or property, without due process of law; nor deny to any person within its jurisdiction the equal protection of the laws.

The case of *Jacobson v. Massachusetts* reached the U.S. Supreme Court in 1905. By that time, 11 states had enacted mandatory vaccination laws, so the

case was of national interest. Jacobson lost his appeal by a 7–2 vote. Justice John Harlan delivered the majority opinion that concluded:

- Mandatory vaccination was not inconsistent with protections guaranteed in the Fourteenth Amendment. The Amendment did not grant individuals the right to be free at all times of all personal restrictions.
- The state had the legal right to grant local health boards the power to enforce mandatory vaccination of all individuals during epidemics.
- Individuals could be fined or jailed for refusing vaccination, but they could not be forcibly vaccinated against their wishes.
- The law should not apply to any individual who could show that vaccination would impair health or cause death.

Jacobson v. Massachusetts became a foundation case for other legal challenges to mandatory vaccination. It established both the right of the state to require vaccination and the right to a personal health exemption, both of which continue to exist today. Chapter 8 discusses the some of the modern controversy and legal challenges to mandatory vaccination.

Modern Regulation of Vaccination

As of early 2017, all 50 states and the District of Columbia have laws that require children entering public school be vaccinated against diphtheria, tetanus, pertussis, polio, measles, and rubella. Many states require additional vaccinations such as varicella and HPV. Some states extend mandatory vaccination to private school students and younger children in daycare or preschool programs. Fully homeschooled children are not required to be vaccinated.

Although there are no universal state laws about vaccination of adults, many childcare and healthcare facilities require workers to be vaccinated against specific diseases that they are likely to encounter in the workplace. Influenza vaccination is the most common adult requirement and the most contentious. Colleges and universities can also require proof of vaccination against certain diseases (e.g., meningitis, hepatitis B) and appropriate booster shots (e.g., tetanus) before enrollment. The military has mandatory vaccination that varies by branch and specific assignment, and some private industries require specific vaccinations (e.g., tetanus boosters for individuals working with laboratory animals).

In keeping with *Jacobson v. Massachusetts*, all 50 states allow specific vaccine exemptions for children. Three types of exemptions are recognized. The ease with which these exemptions are granted varies greatly from state to state.

A complete list of state vaccination exemptions for children entering public schools can be found at http://vaccines.procon.org/view.resource.php?resourceID=003597

All states and the District of Columbia allow medical exemptions from vaccination when the vaccine is likely to cause medical harm. The exemption can be temporary or permanent and must be authorized by a physician. Children whose immune system is weakened by an autoimmune or other disease (e.g., leukemia), chemotherapy, radiation therapy, and certain drugs are likely to be candidates for a medical exemption. Other reasons for a medical exemption include severe reaction to a previous vaccination or, in some cases, having a sibling with a severe reaction to a previous vaccination. Some children with severe allergies may also qualify for a medical exemption. Documented proof (usually by measuring antibodies in the blood) that the child has had the disease the vaccine will prevent is also a recognized medical exemption.

Religious exemptions are permitted in 47 states and the District of Columbia. As of early 2017, California, Mississippi, and West Virginia were the only states that did not permit any religious or personal exemptions. The official stance of different religious groups is often unclear and open to interpretation by individuals and congregations. In general, the Old Order Amish do not vaccinate. Christian Scientists and Jehovah's Witnesses are inclined not to vaccinate, as are some ultra-Orthodox Jews and some members of the Dutch Reformed Church. A small number of Catholics reject the use of vaccines that were originally developed using human fetal cells, although this is not the position of the mainstream Church. Each state has its own set of guidelines for granting religious exemptions. In states that allow these exemptions, they are generally easy to get.

As of early 2017, 17 states permitted personal belief or philosophical exemptions. These exemptions are given based on parents' or guardians' objections to the use of vaccines because they believe they cause harm, do not prevent disease, are a government intrusion into their rights as a parent, or any other reason they think vaccination of their child is inappropriate. These exemptions are very easy to get and generally involve simply filling out a form that says the parent does not want the child to be vaccinated. However, should an outbreak of disease occur, health authorities have the legal right to overrule religious and personal belief exemptions and require vaccination.

INTERNATIONAL VACCINATION REQUIREMENTS

Each country has its own set of recommended and/or required vaccinations for its citizens and for visitors entering the country. These depend on the

prevalence of vaccine-preventable disease in the country, the prevalence of disease in the traveler's home country or countries recently visited, how long the visitor plans to stay, and which part of the country will be visited. It is difficult to generalize these requirements.

Virtually all countries recommend that immunizations required or recommended in one's home country be up to date, but other requirements vary considerably. The United States, Canada, and Mexico have no vaccination requirements for visitors entering the country. Many countries in Africa, the Caribbean, Central America, and South America require a yellow fever vaccination certificate for travelers coming from or having transited for more than 12 hours through the airport of a country with risk of yellow fever transmission. Australia also has this requirement, while nearby New Zealand does not. Saudi Arabia requires anyone taking part in the annual Hajj pilgrimage to have proof of vaccination with meningococcal vaccine less than 3 years and more than 10 days before arriving in Saudi Arabia. The rest of the year, proof of this vaccination not required.

In addition to requiring yellow fever vaccination, many countries strongly recommend other vaccines, such as typhoid, Japanese encephalitis, cholera, or tickborne encephalitis that are not routine in North America or much of the developed world. Recommendations vary by country and may change during periods of disease outbreak. Up-to-date information for Americans about required travel immunizations can be found at the CDC's Travelers' Health website at https://wwwnc.cdc.gov/travel. This site also provides information about worldwide disease outbreaks. Similar information for citizens of the United Kingdom can be found on the National Health Services of Scotland website at http://www.fitfortravel.scot.nhs.uk/home .aspx. Canadians can access travel vaccination information at https://travel.gc .ca/travelling/health-safety/vaccines?_ga=1.121688331.1297898291.1473119 802 and Australians at http://smartraveller.gov.au/countries/Pages/default.aspx.

Although the United States does not have any entry vaccination requirements for tourists and short-term visitors, it does have vaccination requirements for immigrants and individuals who seek to adjust their status to permanent resident. Before individuals can obtain an immigrant visa, they must have a physical examination by an approved physician and obtain proof of vaccination against mumps, measles, rubella, polio, tetanus, diphtheria, pertussis, *Haemophilus influenzae* type B, hepatitis B, and any other vaccinations recommended by the Advisory Committee for Immunization Practices as appropriate for the individual's age. The rules are complex. A list of frequently asked questions can be found at https://www.uscis.gov/news/questions-and -answers/vaccination-requirements.

SUMMARY

The antigenic component of a vaccine is dissolved in suspending fluid or diluent. The completed vaccine also contains adjuvants, stabilizers, preservatives, and trace production residues. Creating a new vaccine is a slow and expensive process. The steps involved, each with its own set of tests, are (1) identification of antigen, (2) animal testing, (3) new drug application for human testing, (4) clinical trials—Phase I (safety), Phase II (safety and efficacy), Phase III (safety and adverse effects), (5) biologics license application, (6) FDA approval, (7) public use and postlicensure monitoring.

Vaccine manufacturing methods vary with the type of vaccine produced, but all require strict contamination containment and environmental controls along with extensive testing. Common production techniques are egg culture, cell culture, and genetic recombinant technology. During transport, distribution, and storage, vaccines are required to be kept continuously refrigerated or frozen at specific temperatures. This is called cold chain supply, and it is essential to maintain the potency of the vaccine.

In the United States, vaccine manufacture is highly regulated at the federal level. Vaccination requirements, however, are imposed at the state level. Exemption from vaccination requirements varies considerably from state to state. Each country has the right to require proof of certain vaccinations before allowing noncitizens to enter. The United States has no vaccination entry requirements for short-term visitors, but does have requirements for immigrants seeking to become permanent residents.

Chapter 8

The Social Dimensions
of Vaccines

From the first inoculation, vaccination has been controversial. Intentionally introducing the variant of a disease-causing agent into the body sounds risky. The idea that this modified agent can effectively prevent the very disease that its unmodified sibling causes is difficult to grasp. Before scientists understood how vaccines stimulate the immune system to form antibodies that "remember" a disease, the public was asked to accept that vaccination was safe and beneficial based on a combination of fear of the disease, faith in the medical establishment, and observable successes.

Historically, an early period of skepticism and rejection of vaccination was followed by a period during which vaccines were almost uncritically embraced as miracle drugs, and vaccine inventors were considered heroes of science. Between 1901 and 1954, six Nobel Prizes in Physiology or Medicine recognized research directly related to vaccines and three more were awarded for fundamental immune system research.

There have always been people who questioned the value and safety of vaccines. Nevertheless, until the last quarter of the twentieth century, skepticism was limited to a small group of alternative medicine practitioners and their followers and to anti-government conspiracy theorists. These groups quoted each other and published in out-of-the-way magazines rather than scientific journals.

In the 1990s, rapidly expanding Internet access changed everything. Anti-vaccinationists now had an easy way to communicate with each other and a worldwide, uncensored platform for their views. Growth of the

Internet coincided with an increased interest in natural lifestyles, greater acceptance of alternative medicine practitioners and therapies, questions about profit motives of pharmaceutical companies, a growing distrust of the government, and a generation of parents who had little or no first-hand experience of vaccine-preventable diseases. These factors combined to increase skepticism about the safety and value of vaccines. Anti-vaccination views were picked up and reported on by mainstream media outlets giving them increased visibility and credibility.

Anti-vaccinationists told human interest stories. The medical establishment countered with statistics and peer-reviewed studies. Anti-vaccinations responded that they believed the medical establishment withheld and manipulated data that proved vaccines caused harm. The medical establishment called anti-vaccine parents ignorant and selfish for failing to vaccinate their children. The war of words, fought first in medical journals, next in popular publications, and finally most vociferously on the Internet, became nasty. Threats were issued and lawsuits filed. Parents were pressured to take sides. Attitudes toward vaccination hardened.

Today, firm anti-vaccinationists believe vaccines cause harm, are often unnecessary, and that mandatory vaccination laws result from a greedy pharmaceutical industry combined with governmental intrusion into what should be a personal choice. Members of the anti-vaccination movement include a coalition of liberal educated parents, a few media celebrities, conservative parents who object to mandatory vaccination, parents who believe their child's disability was caused by a vaccine, a very few traditional healthcare providers, and many more alternative medicine practitioners. This coalition is skeptical about the results of any vaccine research done by the pharmaceutical industry or the federal government and tends to favor personal experience stories over statistics.

At the other end of the spectrum are mainstream medical organizations, traditional medical practitioners, public health professionals, and parents who believe that if a disease can be prevented by a vaccine, then every healthy individual should be fully vaccinated against that disease. The pro-vaccination camp sees benefits of vaccines to both individuals and society. They embrace the statistics that show preventing disease outweighs any potential vaccine risk. This group tends to believe the results of research by pharmaceutical companies and the medical establishment. It considers protecting public health more important than individual choice when it comes to mandatory vaccination and sometimes derisively refers to the anti-vaccinationists as "pro-disease."

Somewhere between these two extremes are vaccine-skeptic or selective vaccinationist parents along with some medical professionals. This group

questions the necessity for specific vaccinations, has reservations about the rec-
ommended timing of vaccine administration, questions the length of immun-
ity some vaccines provide, and is worried about the consequences of genetically
engineered vaccines.

One concern frequently mentioned by this group is that many pediatricians
do not take the time to listen to their concerns and explain the risks and bene-
fits of each vaccine. They see as high-handed the doctor or nurse who comes in
and says something like "Your child is getting an MMR [mumps, measles,
rubella] shot today," as if the parent has no choice in the matter. In an attempt
to educate themselves, concerned parents often turn to the Internet for infor-
mation. There they find a range of views, some backed by science, some pure
speculation. The question then becomes who or what to believe.

Before reading the following discussion about issues and attitudes surround-
ing vaccines, it is useful to review the material in Chapter 6 concerning percep-
tion of risk. Each group—the anti-vaccinationists, the pro-vaccinationists, and
the selective vaccinationists—undoubtedly wants what they believe to be best
for their children and themselves. Each group calls on narrative stories and
research statistics to support their position. The way each group weights and
interprets statistics and stories to reinforce their own perceptions of vaccine
risks makes it difficult for the various sides to understand each other's
point of view.

VACCINES DON'T WORK—OR DO THEY?

In the view of some staunch anti-vaccinationists, vaccines simply don't
work. The traditional medical establishment acknowledges that no vaccine
protects 100 percent of the time. When given on the recommended schedule,
the best are more than 90 percent effective. For example, two doses of measles
vaccine induce antibody formation in 99 percent of children. Traditional
physicians also acknowledge that immunity tends to decreases over time and
repeat inoculations may be needed to achieve and maintain full immunity.

Vaccines given individuals over age 50 are less effective than those for young
people because the aging immune system responds less strongly to antigens.
The zoster vaccine against shingles, for example, is only about 50 percent effec-
tive in preventing the disease. Effectiveness of the influenza vaccine, a frequent
target of anti-vaccinationists, ranges from a high of about 70 percent to a low
of about 35 percent for reasons outline in Chapter 5, mainly the rapid rate of
influenza virus mutation and the difficulty in matching vaccine components
to the prominent flu strains each season. In other words, some people who
get vaccinated will still get sick. Yet despite thousands of studies that show

vaccination is effective in preventing disease or lessening its severity, some anti-vaccinationists continue to make the claim that vaccines do not work. Where does this belief come from?

The Hygiene Theory

One common claim is that an improved standard of living and better hygiene, not vaccines, are the reason for the dramatic decrease in vaccine-preventable diseases beginning in the twentieth century. The "proof" is that a documented decline in many diseases such as diphtheria, polio, and measles began before vaccines against these diseases were introduced. The medical establishment agrees that access to clean water, better sewage treatment, improved food sanitation, better nutrition, less crowded housing, advances in medical treatment, and increased access to healthcare have contributed over the past 100 years to the decline of many contagious diseases, but it asserts that these are not the only reason for disease reduction.

If lifestyle factors and an improved standard of living were the only causes of disease decrease, one would expect to see a simultaneous and gradual reduction in many contagious diseases over the same time period. Instead, decreases in various vaccine-preventable diseases have occurred independently of each other, and each disease has shown a sudden steep decline as soon as a vaccine against it became available. For example, before the measles vaccine was introduced in 1963, about half a million cases and 500 deaths occurred in the United States each year. Within five years of widespread administration of the vaccine, measles cases had dropped by 95 percent, a reduction far greater than could be attributed to improved living conditions alone.

The Chiropractic Connection

Since its founding, chiropractic medicine has been a leader in promoting the belief that vaccines not only fail to prevent disease but also are harmful. This belief was clearly expressed by the field's founder Daniel David Palmer (1845–1913), who started the School of Chiropractic Medicine in Davenport, Iowa, in 1897. Palmer believed that all diseases were caused by misalignment of the joints and could be cured by joint manipulation. He called vaccination "a medical delusion" and vaccines "filthy animal poison" (Barrett 2015). His son, Bartlett Joshua Palmer (1882–1961), who took over the school, went further. He rejected the germ theory of disease and stated that "chiropractors have found in every disease that is supposed to be contagious a

cause in the spine...There is no contagious disease...There is no infection" (Largent 2012, 46).

Although not all chiropractors oppose vaccination, a substantial percentage of modern practitioners continue to endorse the Palmers' vision of vaccines. In 1993, Fred H. Barge, a past president of the International Chiropractors Association (ICA) is reported to have said, "I am a firm opponent of artificial immunization and the antiquated germ theory on which it is based." He went on to state that three generations of his family had not been vaccinated and that "I even try to avoid having my dogs vaccinated" (Barrett 2015). A 1999 survey by *Dynamic Chiropractic* magazine found that 42 percent of respondents declared that their children had received no vaccines and an additional 22 percent that their children were not fully vaccinated.

Official American Chiropractic Association (ACA) and ICA policies oppose mandatory vaccination. In addition, ICA policy states that the organization recognizes that vaccine use is not without risk. Although this sounds like a moderate statement, the ICA continues to endorse and sell Barge's books on its website as of 2017. The International Chiropractic Pediatric Association (ICPA) policy on vaccines is vague, but anti-vaccinationist Barbara Loe Fisher and discredited vaccine autism researcher Andrew Wakefield (see Mercury, Thimerosal, and Autism below) were keynote speakers at its 2014 convention.

Skepticism about vaccines has grown along with the growth and acceptance of chiropractic and other natural and alternative medicine practices. Logically, if one believes that vaccines do not work, the risk of illness remains the same whether one is vaccinated or not. People who are convinced that vaccines do not prevent disease therefore see no benefit in vaccination, only the risk of harm.

VACCINES CAUSE DISEASES AND DISORDERS

While some anti-vaccinationists believe vaccines simply do not work, others object to them on the grounds that they actively cause harm. They claim vaccines cause brain damage, autism (called autism spectrum disorder since 2013), developmental delays, allergies, multiple sclerosis, Gulf War syndrome, and even AIDS. The most common reason parents give for refusing to immunize their children is fear that vaccines can cause irreversible harm. For these parents, the immediate risk of damage from vaccination is not worth a potential future benefit, especially when they believe their child is unlikely to ever contract a vaccine-preventable disease. The medical establishment recognizes that some vaccines do harm a very, very small number of children but counters

that vaccine-preventable diseases are far more likely to cause permanent harm or death than any vaccine.

The safety debate is the most familiar and most contentious of the issues surrounding vaccination. It is fueled by poignant stories on the Internet and in the media about normal children who became ill or developmentally delayed a short time after receiving a vaccine. These powerful human interest stories arouse both compassion for the parents and children involved and fear that one's own child could have the same experience. Stories are reinforced by interpretations of medical studies and statistics (often outdated and highly selective) on anti-vaccination websites such as those of the National Vaccine Information Center, Vaccination Liberation, and Vaccination News.

One common safety argument is articulated by Sherri Tenpenny, an American osteopathic doctor who is firmly in the anti-vaccination camp. She claims that no vaccine has ever been proven safe and effective because none has been studied in a large-scale, double-blind, placebo-controlled investigation. This type of study is the most rigorous way to prove safety and effectiveness of a drug. To do the studies Tenpenny requires for proof, tens of thousands of children would become experimental subjects. Half would be given an inoculation that contained a vaccine, the other half a harmless inactive substance (placebo). Children would then be followed for years to record what diseases and disorders they contracted, their pattern of social, emotional, and physical development, and other health-related measures. Years later, these measures would be analyzed and the health status of the two groups compared.

Researchers in the medical establishment state that requiring such studies to prove vaccine safety is financially and logistically impractical and morally unacceptable. Their position is that it violates medical ethics to withhold a vaccine from a person at risk, especially when the individual does not know if he or she has actually been immunized as part of the study or remains vulnerable to disease. Besides, how many parents would allow their children to be part of this experiment.

The medical establishment counters that the studies it does comparing children whose parents opted out of vaccinating with those who were immunized support their position that vaccines are safe and effective. They cite studies and statistics (up-to-date, also selective, but peer reviewed) on pro-vaccination websites such as Vaccines.gov, Immunization, Vaccines, and Biologicals: Fact Sheets (WHO), and Immunization Action Coalition.

The anti-vaccinationists answer that these studies are small, retroactive, and not rigorous, or that pro-vaccine interests suppress research that contradicts the position that vaccines are safe. They point out that the Vaccine Injury

Compensation Program (VICP) was set up by the government because it accepted proof that some children are damaged by vaccines (see Table 6.1). Some anti-vaccinationists have accused the Institute of Medicine (IOM) of collaborating with the pharmaceutical industry to ignore evidence of harm in order to avoid adding conditions to the list of VICP-covered damages (see Mercury, Thimerosal, and Autism below).

The IOM has responded by pointing out that cause and effect are different from cause and temporal association. In other words, because some illness or disorder occurs in a child soon after being vaccinated, this is not proof that the vaccine caused the event. The IOM insists that the overwhelming balance of evidence shows that vaccines do not cause damages activist parents claim they do. It is unlikely that arguments put forth by either group will change the other group's mind, but it is worth looking at some of the reasoning for and against specific charges of harm.

SV40 and Cancer

Between 1955 and 1963, the polio virus used in vaccines was grown in rhesus monkey kidney cells, some of which were contaminated with simian (monkey) virus 40 (SV40). In 1961, Bernice Eddy (1903–1989) and Sarah Stewart (1905–1976) working for the National Institutes of Health (NIH) found that SV40 from these monkey cells caused tumors in hamsters. Their discovery was confirmed by researchers at Merck, a leading vaccine manufacturer.

According to the government, SV40 was eliminated from polio vaccine by 1963. By then, 98 million people had been inoculated. Not all batches of polio vaccine contained SV40, but between 10 and 30 million people are believed to have received contaminated vaccine. The big question became whether SV40 would trigger cancer in humans. The big problem in answering this question was that no one knew who received contaminated vaccine and who received clean vaccine. A series of studies produced the following inconclusive results.

- Researchers found an increase in certain cancers, primarily mesothelioma (a type of lung cancer) and osteosarcoma (bone cancer) in people who had received polio vaccine between 1955 and 1963. Because they could not tell which individuals had gotten contaminated vaccine and which received clean vaccine, researchers were unable to correlate the increased cancer rate with contaminated vaccine administration, leaving open the possibility that the increase was due to other factors.

- SV40 was found in biopsies of tumors from people with meso-thelioma, osteosarcoma, and non-Hodgkin lymphoma.
- People who were born after 1963 when SV40 was eliminated from polio vaccine and who developed these cancers also had SV40 in their tumors. If there was no SV40 in the vaccine, infection had to have come from another source.

The IOM Immunization Safety Committee concluded in October 2002 that "the biological evidence is strong that SV40 is a transforming [cancer causing] virus...that the biological evidence is of moderate strength that SV40 exposure could lead to cancer in humans under natural conditions, that the biological evidence is of moderate strength that SV40 exposure from the polio vaccine is related to SV40 infection in humans" (Horwin, 2003).

This carefully worded statement did not answer whether exposure to SV40 *specifically from contaminated polio vaccine* was the trigger for the increase in certain cancers. The medical establishment took the IOM statement to mean that the contaminated polio vaccines were harmless with regard to causing cancer. Anti-vaccinationists rejected the government's research, claiming the studies were inadequate and that health officials had suppressed results that would have linked the vaccine directly to cancer. Some claimed (without pro-viding evidence) that SV40 had not been eliminated from the vaccine in 1963 and that contaminated batches were administered into the 1990s.

Concern over contamination of a vaccine with an animal virus and its disease-causing potential if transmitted to humans is real, but vaccine manu-facturers take steps to prevent this happening. For example, pathogen-free eggs from specially raised chickens guaranteed to be free of about 30 avian patho-gens are used to produce influenza vaccine. In addition, vaccine manufacturers now have sensitive DNA and RNA tests that they did not have in the 1960s. These tests can detect the genetic material of microorganisms unintentionally introduced in the manufacturing process. Fortunately, SV40 appears not to have caused mass cases of cancer in humans. Unfortunately, the SV40 scare has given rise in some circles to the broad statement that vaccines cause cancer. For some people, that is a risky enough proposition to avoid vaccination.

The Rise of Anti-Vaccine Sentiment

No vaccine, or for that matter any drug or herbal treatment, is completely risk free. Human biology is variable enough that rare life-threatening allergic reactions or other serious but unusual responses to a vaccine do occur. Until the last quarter of the twentieth century, the overwhelming majority of parents

saw the risk of their children suffering death or damage from a vaccine-preventable disease as a much greater than the risk of damage from an unexpected reaction to the vaccine itself. Fear of the health consequences of disease was so great that even the 1955 Cutter incident (described in Chapter 6), where 260 people were paralyzed and 10 died from inadequately inactivated polio vaccine, did not discourage parents from vaccinating their children.

Things began to change after the influenza panic of 1976 described in detail Chapter 6. That year, a new influenza virus dubbed swine flu surfaced. The virus looked similar to the H1N1 virus that caused millions of deaths worldwide in 1918 and 1919. Although only a few cases and one death were blamed on the new virus, the U.S. government feared the worst. It announced a fast-track program to immunize 200 million Americans against the new virus. From the beginning, the program had problems, but eventually 45 million Americans were vaccinated.

The expected influenza pandemic never materialized, but something else did that helped undermined the public's faith in vaccine safety. Soon after the immunization program started, an increase in cases of Guillain-Barré syndrome (GBS) was reported (this event is discussed in detail in Chapter 6). In GBS, immune system cells attack nerve cells causing weakness and paralysis. The disease is rare but occasionally occurs for unknown reasons after a viral infection.

The government accepted that cases of GBS developing within 10 weeks after immunization against the new virus were caused by the vaccine and paid the victims compensation. The absolute number of people affected was small, estimated at fewer than 5,000 out of the 45 million people vaccinated. Nevertheless, the suggestion of a connection between influenza vaccine and GBS, along with the fact that the pandemic never developed, helped to chip away at the belief that vaccines were safe and that the benefits outweighed any potential risks.

Barbara Loe Fisher and Dissatisfied Parents Together

The next major event to undermine the public's faith in vaccines came on April 19, 1982, in the form of an NBC television documentary called *DPT: Vaccine Roulette*. The program's writer and host, Lea Thompson, interviewed parents who believed that their children had been harmed by the pertussis (whooping cough) component of the diphtheria, pertussis and tetanus (DPT) shot. These parents described previously normal children who experienced seizures, developmental regression, and permanent mental and physical disabilities in the weeks following vaccination.

Scientists had known from the time pertussis vaccine was developed in the 1940s that it caused adverse effects. Most common were temporary pain, swelling at the injection site, and fever. Occasionally children developed serious but still temporary reactions such as febrile convulsions and loss of conscious. Rarely, the vaccine caused brain encephalopathy resulting in permanent damage. Because serious adverse effects were rare (about 1 case per 310,000 immunizations or 50 cases per year in the United States), they were considered tolerable given the life-threatening potential of the disease.

Barbara Loe Fisher was a parent who saw the DPT documentary. For her, it was a revelation. Her normal, healthy two-and-a half-year-old son had regressed physically, mentally, and emotionally not long after his fourth DPT shot. After watching the program, she believed the shot had caused encephalopathy that left him with attention deficit disorder and autism.

Motivated by the information in *DPT: Vaccine Roulette*, Fisher met with other parents whose children had shown similar autism-like regression after the shot. These parents formed the group Dissatisfied Parents Together (later expanded to become the National Vaccine Information Center, an anti-vaccination organization) to advocate for vaccine accountability and reform. Several members of the group had political connections at the federal level and were able to bring the vaccine safety issue to the attention of Congress. Fisher, who had public relations experience, acted as their spokesperson. The group was instrumental in influencing legislation that established the Vaccine Injury Compensation Program described in Chapter 6. Before VICP, only a handful of lawsuits had been filed alleging damage from pertussis vaccine. The year VICP was passed by Congress, 255 new petitions were filed.

Belief that vaccines can cause autism is persistent among anti-vaccinationists and vaccine skeptics. It is fueled both by stories of damaged children and statistics from the U.S. Centers for Disease Control and Prevention (CDC) that show autism has increased rapidly since the 1990s. Between 2002 and 2010, for example, the rate increased 123 percent in eight-year-old children. Some autism experts believe the reported increase is the result of better diagnosis while others see it as a genuine increase in new cases.

Diagnostic signs of autism include:

- mental and physical developmental regression; children lose skills they already have.
- persistent difficulty understanding verbal and nonverbal communication to a degree that interferes with normal social and emotional relationships and social participation.

- repetitive or obsessive patterns of behavior, interests, or activities.
- abnormal response to environmental stimuli.

Signs of autism tend to appear early in childhood. This is also the period during which children receive the most vaccinations. The number of recommended vaccines and new vaccine combinations has increased steadily since the 1990s just as reported cases of autism began to increase. When following the CDC 2017 recommended vaccination schedule, children will have received at least 25 doses of 10 different vaccines against 14 different diseases by age two years. Parents desperate to understand the regressions they see in their child might easily be convinced that vaccines caused the developmental delays.

Many parents who filed VICP petitions believing pertussis vaccine had damaged their child were dismayed and furious to discover the limited conditions that were covered. As of 2017, anaphylaxis within four hours after inoculation and encephalopathy or encephalitis developing within 72 hours are the only pertussis vaccine damages listed for automatic compensation by VICP (see Table 6.1).

To receive compensation outside that time frame or for nonlisted conditions such as autism spectrum disorder or seizures, plaintiffs have the challenging task of proving that the vaccine was the sole cause of their child's disability. Proof is difficult because a group of uncommon disorders known as epileptic encephalopathies usually becomes evident during the period when vaccination is most frequent. Epileptic encephalopathy disorders include Dravet syndrome, West syndrome, Ohtahara syndrome, Lennox-Gastaut syndrome, and Landau-Kleffner syndrome. These disorders involve seizures, chronic illness, and autism-like developmental delays. They appear in early childhood at the same time in both vaccinated and unvaccinated children. Little is known about the cause of some of these disorders, but Dravet syndrome is attributed to a mutation in the SCN1A gene, not to vaccine administration. Parents petitioning the Vaccine Court for damages are now concerned that the Court will require their children be tested for the SCN1A mutation and automatically throw out any vaccine-injury petition where the mutation is present.

Despite the passionate belief among many parents whose children regressed after vaccination and then received a diagnosis of autism, there is no current medically accepted proof that a vaccine causes developmental regression or autism. The cause of autism remains unknown. Current thinking leans toward an interplay of multiple genetic and environmental factors including the environment in the womb.

A subunit acellular pertussis vaccine (aP) was introduced in Japan in 1981 and approved for use in the United States in 1991. It contains antigens from

the cell surface that stimulate antibody formation but no whole attenuated bacteria. Acellular pertussis vaccine has significantly fewer adverse effects than whole-cell pertussis vaccine, but it appears to provide weaker protection against the disease. A study released by Kaiser Permanente in 2016 found that immunity to pertussis disappeared after 3–5 years in teenagers who had received only DTaP vaccine despite undergoing the recommended series of inoculations by age 6 plus a booster shot at age 11 or 12 years. With the introduction of DTaP vaccine, much of the controversy about DPT vaccine and autism shifted to presence of mercury in vaccines as a cause for autism.

Mercury, Thimerosal, and Autism

Mercury has been recognized as a neurotoxin (nerve poison) for centuries. The expression "mad as a hatter," comes from behavioral changes such as such as irritability, depression, extreme shyness, and insomnia that developed in hat makers in England who were exposed to mercury compounds in the preparation of felt. Prolonged mercury exposure can cause tremors, delusions, hallucinations, and memory loss known as mad hatter disease or erethism mercurialis.

In the 1970s, the U.S. Environmental Protection Agency (EPA) began programs to decrease Americans' exposure to mercury. Most mercury pollution comes from burning coal to generate electricity. Natural sources include volcanoes and forest fires. Rain and dust bring mercury out of the atmosphere and deposit it in rivers, lakes, and oceans. Bacteria living in the water convert it into methylmercury. Other organisms eat the bacteria, and methylmercury enters the food chain.

Methylmercury bioaccumulates, which means it is poorly eliminated from the body and builds up tissues. At each step in the food chain, its concentration increases. Pregnant and breastfeeding women are advised to avoid eating swordfish, tilefish, tuna, marlin, and other fish near the top of the aquatic food chain because of the possibility that they contain high concentrations of neurotoxic methylmercury that could harm the unborn child or breastfeeding infant.

Thimerosal (sometimes spelled thiomersal) is a mercury-containing antiseptic compound that has been added to vaccines and other pharmaceutical products since the 1940s. It inhibits bacterial and fungal growth, which is important in multidose containers of vaccine where a series of needles will be inserted into the same vial. So what is mercury doing in vaccines that are given to children and pregnant women? The answer lies in the difference of a single letter.

The body breaks thimerosal down into two compounds, ethylmercury and a compound called thiosalicylate. Although ethylmercury and methylmercury

differ in spelling by only one letter, the behavior of these compounds is quite different. As of 2016, most reputable and reproducible research studies have found that while methylmercury bioaccumulates to toxic levels, ethylmercury is metabolized and eliminated in feces so that it never reaches harmful levels.

This explanation does not satisfy anti-vaccinationists who believe that any exposure to mercury in any form no matter how small presents an unacceptable health risk to children. They emphasize a few studies that suggest ethylmercury is not rapidly cleared from the body. Because of the similarity between some symptoms of mercury poisoning and autism, some parents also claim that mercury exposure from the thimerosal in vaccines is the cause of their child's autism. This is in direct contradiction to findings by both the IOM and the WHO's Global Vaccine Advisory Committee on Vaccine Safety both of which state that there is no evidence of mercury toxicity from exposure in infants, children, or adults inoculated with thimerosal-containing vaccines.

For 50 years, the public paid almost no attention to thimerosal in vaccines. That changed in 1997 when Congress passed the Food and Drug Modernization Act, an update of the 1938 Federal Food, Drug, and Cosmetic Act. One directive in the new Act required the Food and Drug Administration (FDA) to evaluate the effect of mercury on humans. This requirement was added as an amendment by a senator from New Jersey who had no interest in vaccines but was concerned about mercury accumulation in fish. Following the law's directive, the FDA compiled a list of foods and drugs to be evaluated. Vaccines containing thimerosal were on that list.

By 1999, the FDA had concluded that a six-month-old child could receive a maximum of 187.5 μm of mercury from thimerosal-containing vaccines. This exceeded the EPA's acceptable exposure level. The EPA's mercury exposure limit is the lowest of any American or international agency and has a large built-in safety factor. In addition, the EPA makes no distinction between methylmercury and ethylmercury.

The FDA sent a letter to vaccine manufacturers requesting that as a preventative measure they stop using thimerosal in U.S. vaccines. For the manufacturers, this was not a small request. Any change in a vaccine, including removing thimerosal or replacing it with a new antiseptic agent, would require the new formulation go through a new approval process before it could be licensed.

The American Academy of Pediatrics (AAP), the CDC, and the U.S. Public Health Service all supported the removal of thimerosal. Nevertheless, for unclear reasons, instead of pushing forward in requiring thimerosal-free vaccines, the FDA and IOM backed off and began issuing statements claiming there was no convincing evidence that thimerosal in vaccines caused harm.

At the time, few studies had compared the metabolism of ethylmercury and methylmercury, and those that existed had been done in animals, not humans. The FDA was forced to admit that no one had looked at how ethylmercury might affect babies in the womb or young children. Then in 2000, Congress got involved and mercury in vaccines became a hot topic.

Congressman Dan Burton, a conservative Republican from Indiana, called hearings on the relationship between vaccines, mercury, and autism. He came into the hearings with negative relationship with the FDA based on a previous conflict over a cancer treatment. He also had a personal interest in the vaccine-autism question. His grandson was autistic. This he freely admitted, but he did not reveal to his colleagues or the public that he had a personal conflict of interest. His daughter had filed a petition for monetary damages with the Vaccine Court claiming her son's autism was caused by mercury in vaccines. This was not a vaccine-caused disorder recognized by the VICP.

The Burton hearings went on for three years during which time dozens of ordinary people testified before the committee. They told terrifying stories of how their child had been normal and healthy, and then after being vaccinated developed signs of autism. Burton blasted physicians for not explaining the dangers of vaccines to their patients. The FDA and the IOM came under fire for not moving aggressively enough to remove thimerosal from vaccines. In some cases, Burton implied these agencies were covering up what he absolutely believed to be true—that mercury in vaccines caused autism.

During the early 2000s, parents had become increasingly concerned about eliminating chemical risks for their children. Press coverage of the hearings fueled this interest and gave a boost to the anti-vaccination movement. The debate about vaccines, mercury, and autism did not stop when the hearings ended. In 2005, Robert Kennedy, Jr., a politically connected environmental attorney and activist, published an article titled "Deadly Immunity" in *Rolling Stone* magazine. The Kennedy article claimed that the government had deliberately covered up information that showed mercury in vaccines was poisoning children and leading to an epidemic of autism. Almost immediately the magazine was forced to issue corrections and clarifications to the story, which had relied heavily on work by autism activist Mark Geier.

Physician Mark Geier and his son David were vigorous proponents of the theory that vaccines cause autism. Until 2011, the Geier family ran a clinic in Maryland that used unproven medical and alternative treatments to "cure" autism. Geier also frequently testified as an expert witness in Vaccine Court that vaccines caused autism. Nevertheless, his research methods and statistical analyses of data from the Vaccine Safety Datalink were repeatedly discounted by other scientists as unsound and inaccurate.

At the time Kennedy's article was published, Geier had quite a bit of credibility among vaccine skeptics. However, his professional role in the vaccine debate ended in 2011 when his license to practice medicine was revoked as the result of medically unacceptable practices at his autism clinic. That same year *Rolling Stone* completely retracted the Kennedy article.

Beginning in 2001, the pharmaceutical industry began phasing out thimerosal in vaccines for children. By 2007, U.S. vaccines for children under age six years were either thimerosal-free or contained only a residual trace (less than 1 µm) of the compound from the manufacturing process; no thimerosal was added as a preservative. The exception was inactivated influenza vaccine. By 2015, a thimerosal-free version of influenza virus was available in limited quantities, although the thimerosal-containing version continues to be produced. Multidose vials of vaccines used outside the United States still contain preservative amounts of thimerosal and still have WHO approval.

Andrew Wakefield, Measles Virus, and Autism

The controversy over whether measles vaccine causes autism has lasted longer, gotten more media attention, and had a greater effect on vaccination rates than any other vaccine dispute. The debate was kicked off by physician and gastroenterology researcher Andrew Wakefield (1957–). Wakefield is either a hero or a villain in the vaccine world. To the anti-vaccination community and parents of some autistic children, he is a misunderstood hero whose work has been suppressed by the medical establishment and pharmaceutical companies because it challenges mainstream views. To these parents, Wakefield's argument that MMR vaccine can trigger autism offers an explanation for the disorder and possible path to treatment. To physicians and public health officials, Wakefield is a villain who has fed the public's distrust of vaccines and made it harder for them to do their job vaccinating children and controlling contagious disease.

The story begins in England in the early 1990s where Andrew Wakefield was a member of the Inflammatory Bowel Disease (IBD) Study Group at the Royal Free Hospital in London. The group was doing research on the causes of ulcerative colitis and Crohn's disease. Some of their preliminary research suggested that a virus or viruses along with genetic sensitivity and/or an environmental trigger played a role in the development of Crohn's disease. Eventually, the group came to suspect the measles virus might be involved and that the measles vaccine, which is a live attenuated vaccine, might also play a role in triggering Crohn's disease.

While this research was going on, Wakefield began working with a few autistic children who also had serious bowel problems. He became convinced that there was a connection between IBD, measles vaccine, and autism. He eventually claimed this link was the cause of a syndrome he called autistic enterocolitis.

The measles vaccine-autism connection came to the public's attention in 1998, when Wakefield was first author on a paper published with 12 colleagues in *The Lancet*, a highly respected, peer-reviewed British medical journal. The paper had the challenging title Ileal-lymphoid-Nodular Hyperplasia, Non-specific Colitis, and Pervasive Developmental Disorder in Children. Researchers reported on 12 children, 8 of whom developed bowel inflammation and autism-like developmental delays at about the same time. According to the children's parents, the symptoms began soon after they had received MMR vaccine. An additional child was reported to have developed similar symptoms after having naturally acquired measles.

In the interpretation section of the paper, the authors said that they had "identified associated gastrointestinal disease and developmental regression in a group of previously normal children, which was generally associated in time with possible environmental triggers" (Wakefield, 1998). They *did not* say that measles or measles vaccine caused the observed developmental delays, only that a connection appeared possible.

The Public Is Alerted. *The Lancet* paper would probably have gone unremarked upon outside the community of gastroenterology researchers except for one thing. Two days before the paper was published, Wakefield held a news conference at which he announced that because of the soon-to-be published research results, he could no longer support the use of MMR vaccine. In his opinion, giving three vaccines together increased the likelihood of an adverse response that could lead to developmental delays. He particularly identified the measles component of the vaccine as the problematic element. His recommendation was to stop using the MMR combination vaccine and administer each component separately at one-year intervals.

Wakefield's statements were widely distributed by British media, and soon parents began rejecting MMR vaccination for their children. The story spread to the United States, where it was publicized by Barbara Loe Fisher and the National Vaccine Information Center. In the United States, Wakefield's research became conflated with concern about mercury in vaccines as a cause of autism. Again vaccination rates dropped.

Public health officials in Britain were infuriated. They believed the fear generated by Wakefield's press conference was out of proportion to the strength of the research evidence. A substantial number of Wakefield's coauthors also felt

he had gone too far in drawing conclusions from the published research. Wakefield vigorously defended his statements. In his mind, IBD, autism, and the measles vaccine were causally linked.

The Scientific Community Responds.

Other scientists, including 10 of Wakefield's coauthors, refuted in writing Wakefield's assertion of a connection between MMR and autism. Studies by scientists at other institutions also failed to find a link. For example, one study looked at 500 children diagnosed with autism that had received MMR vaccine at different times during childhood. They found no increased onset of autism soon after vaccination regardless of the age at which the vaccine was administered. They also looked back in medical records for a spike in autism diagnoses after the MMR vaccine was introduced and found no increase. Research from Japan where the MMR combination vaccine had been discontinued in 1993 in favor of individual shots found no decrease in autism diagnoses after the switch to individual shots. Multiple other studies failed to find a connection between MMR vaccine and autism, but Wakefield persisted in his belief that there was a link.

With evidence piling up that the Wakefield hypothesis could not be confirmed, Wakefield left his job at the Royal Free Hospital in 2001 and moved to Florida. He was not licensed to practice medicine in the United States but joined the International Child Development Resource Center as a researcher. The Center treats autism with investigational biotherapies and supplements. In 2004, Wakefield moved to Austin, Texas to become executive director of Thoughtful House, an organization founded specifically to further his work on autism.

Charges of Unethical Conduct.

In February 2004, Brian Deer, a British freelance journalist, went to *The Lancet* with what he claimed was proof that the research detailed in the 1998 Wakefield paper was conducted unethically. He made the following charges:

- Wakefield had performed invasive procedures on children without the approval of the hospital ethics board.
- The children in the study had been preselected and referred by to Wakefield by attorneys who planned to represent their families in lawsuits against the vaccine manufacturer.
- Wakefield was paid more than £400,000 (about $600,000) by the attorneys to perform the study, a conflict of interest that he had not disclosed.

Deer's charges were also published in the *Sunday Times* (London), which Deer says paid him for his investigational work. Wakefield supporters claimed Deer was paid by a pharmaceutical industry group interested in discrediting Wakefield's research.

In response to Deer's charges, *The Lancet* issued a statement saying that the research in Wakefield's 1998 paper was fatally flawed. Ten of the paper's coauthors retracted the original interpretation section the paper and issued a new one that stated clearly that that the research on which the paper was based had not proved a causal link between MMR vaccine and autism.

The Wakefield controversy did not end there. In November 2004, Channel 4 in Britain broadcast a one-hour documentary on the vaccine controversy based on Deer's investigations. In addition, Deer released a copy of a patent application filed in June 1997 by Wakefield before the 1998 paper was published. The patent was for a new vaccine/immunization to prevent measles with a therapeutic composition to treat IBD and autism. It appeared that Wakefield intended to profit from what he called autistic enterocolitis by offering a new measles vaccine. Wakefield unsuccessfully sued Channel 4, the production company, the *Sunday Times*, Brian Deer, and Brian Deer's website for libel.

Professional Censure. The British General Medical Council (GMC) began hearings on Wakefield's fitness to practice medicine due to charges of professional misconduct in 2007. Wakefield denied the charges, but on May 24, 2010, he struck from the medical register and lost the right to practice medicine in the United Kingdom. At the same time, he was forced to resign as executive director of Thoughtful House in the United States. Following the action of the GMC, *The Lancet* finally retracted the entire 1998 article that started the controversy about MMR and autism.

This should have been the end of the Wakefield story and the MMR-autism connection, but it wasn't. Brian Deer, who had made his career investigating Wakefield, could not let the story go. He continued to investigate Wakefield's research and in 2011 published an article claiming that medical information about the children in the study had been altered, that three of the nine children who were reported to have regressive autism did not have an autism diagnosis at all, and that although all the children were declared to have been developmentally normal before receiving the MMR vaccine, five of them had documented developmental problems before inoculation.

Wakefield continued to defend himself, publishing an autobiography *Callous Disregard: Autism and Vaccines—The Truth Behind a Tragedy*. He claimed that the charges against him were politically motivated and

maintained that Brian Deer was being paid by the pharmaceutical industry to discredit him. In 2012, Wakefield filed a defamation lawsuit in Texas against Brian Deer, *BMJ*, the British medical journal that had published Deer's second set of charges, and its editor, Fiona Godlee. The suit was dismissed, and Wakefield was ordered to pay the defendant's costs.

The Controversy Lives On. In the United States, the autism-vaccine debate was embraced by several organizations and celebrities, the best known of which is Jenny McCarthy. McCarthy, a former *Playboy* Playmate of the Year, actress, and author, has a son who was diagnosed with seizures and autism in 2005. After searching for information on the Internet, she became convinced that vaccines had caused her son's medical problems and set out to publicize her experience and search for a cure for her son. She has appeared on *Oprah*, *Larry King Live,* and *Good Morning America* blaming vaccines for her son's autism and praising Andrew Wakefield's work.

Meanwhile, J. B. Handley and his wife Lisa had formed the organization Generation Rescue after their son was diagnosed with autism. The Handleys blamed a combination of vaccines including MMR for their son's developmental delays. In 2007, Generation Rescue and Jenny McCarthy joined forces in a media campaign advising about the dangers of vaccines. McCarthy later became president of Generation Rescue.

In 2015, the Oregon Senate Health Care Committee began hearings on a bill that would eliminate personal and religious exemptions from vaccinations required for public school attendance. The bill would allow only medically necessary exemptions. The Oregon Chiropractic Association invited Andrew Wakefield to testify against the bill (see above for chiropractic's attitude toward vaccination), but the meeting at which he was to testify was cancelled. As of early 2017, a medical-only exemption only bill had not passed.

Despite dozens of studies, the vaccine-autism controversy still has not disappeared. The 2016 film *Vaxxed: From Cover-up to Catastrophe* cowritten and directed by Wakefield claims that scientists at the CDC covered up and destroyed evidence about a study that showed a connection between autism and MMR vaccine. The claim is based on a statement made by William Thompson, a senior scientist at the CDC who was concerned that a subset of data suggesting that African American boys who received the MMR vaccine before age three years were at increased risk of autism. This data had been omitted from an article published in the journal *Pediatrics*. The CDC later said that the apparent correlation had not held up under a more in-depth analysis.

Thompson had spoken by phone with anti-vaccinationist Brian Hooker, a professor at Simpson University in Redding, California. Unknown to

Thompson and without his permission, Hooker recorded the phone calls in which Thompson expressed concern that the CDC had not followed the study protocol and had been less than transparent about the potential correlation. Parts of the recorded calls were pieced together in *Vaxxed* in such a way as to suggest a deliberate cover-up and to promote the Wakefield theory that MMR vaccine causes autism.

Vaxxed was scheduled to debut at the Tribeca Film Festival in New York in March 2016 but was dropped after a torrent of criticism from the scientific community. Actor Robert De Niro, founder of the film festival and father of an autistic child, said that he had hoped the film would stimulate a conversation about autism, but that it had become apparent it would not further constructive discussion. The movie was later distributed in a few markets by Cinema Libre.

As of early 2017, William Thompson had retained a law firm to represent him and through the law firm issued this statement: "I believe vaccines have saved and continue to save countless lives. I would never suggest that any parent avoid vaccinating children of any race. Vaccines prevent serious diseases, and the risks associated with their administration are vastly outweighed by their individual and societal benefits" (Thompson, 2014).

Polio Vaccine and AIDS

In 1992, a different type of claim against vaccines hit the mainstream media. This time the charge was that polio vaccine was contaminated with a deadly disease-causing virus. Journalist Tom Curtis published an article in *Rolling Stone* magazine called "The Origin of AIDS." The Curtis article postulated that the polio vaccine developed by Hilary Koprowski (see Chapter 3) was contaminated with a chimpanzee virus that caused AIDS. At the time, AIDS was a poorly understood disease. The reasoning in the article was based largely on information sent to Curtis by Blaine Elswood, an AIDS activist in San Francisco rather than on scientific studies.

Hilary Koprowski, a Polish World War II refugee living in the United States, was the first person to produce an effective vaccine against polio. The vaccine was given orally and contained live attenuated polio virus. His accomplishment was disparaged by a competitor, Albert Sabin, who was also developing a live polio vaccine. Koprowski's vaccine was never used in the United States, but it was widely used in the Democratic Republic of the Congo, Rwanda, and Burundi between 1957 and 1960.

Curtis's story loosely linked a series of facts. First, polio virus was grown in monkey kidney cells. Second, it had already been shown from the SV40

incident (see above) that primate viruses could grow undetected in these cells. Third, some viruses could mutate rapidly. Fourth, examples of monkey and chimpanzee viruses causing illness humans were already known. Fifth, the earliest AIDS cases emerged in the same geographical area and during the same time frame that Koprowski's vaccine was in use. By combining this information, Curtis concluded that Koprowski's vaccine was responsible for the spread of AIDS.

The *Rolling Stone* article received major coverage from mainstream news outlets such as CNN, Reuters, and *Time* magazine. However, researchers who investigated its claims found the conclusion highly unlikely and without scientific merit. Koprowski sued Curtis and *Rolling Stone* for defamation. The case was settled before it went to trial. As part of the settlement, *Rolling Stone* was required to published a statement saying in part that the editors "wish to clarify that they never intended to suggest in the article that there is any scientific proof, nor do they know of any scientific proof, that Dr. Koprowski, an illustrious scientist, was in fact responsible for introducing AIDS to the human population or that he is the father of AIDS" (Origin...Update, 1992 p. 9)

This statement did not kill the theory. It simply reinforced the belief of vaccine skeptics that the government was suppressing information. Seven years later, British Journalist Edward Hooper published *The River: A Journey to the Source of HIV and AIDS.* The book continued to promote the theory that polio vaccine had spread AIDS. Hooper's book received widespread attention, putting the AIDS-polio theory back in the media spotlight. Over the past 20 years, scientists who have studied the polio-AIDS connection have consistently discredited it. Despite this, Edward Hooper continues to promote the connection on his website, http://www.aidsorigins.com.

VACCINATION AND RELIGION

Safety and health concerns are not the only reasons some groups oppose vaccination. Christian church leaders were early objectors to Jenner's cowpox vaccination (see Chapter 3). They believed that smallpox was sent by God as punishment, thus receiving cowpox vaccine interfered with God's will. This view may have prevailed among religious leaders, but once vaccination was shown to prevent smallpox, many common people embraced the procedure. For them, the risk of angering God by being inoculated was less frightening than the risk of contracting smallpox.

Other eighteenth century leaders, including some in the medical establishment, promoted fear of vaccination by emphasizing the "horror" of injecting

animal matter into humans. Physicians who earned fees for performing vario-
lation (a more dangerous procedure against smallpox that preceded Jenner's
cowpox inoculation) did not want to see their source of income disappear.
Ridicule of cowpox vaccination was quite common. The British cartoonists
and satirist James Gillray (1757–1815) published a cartoon in 1802 that
showed people receiving cowpox inoculations having cow heads sprout from
all parts of their bodies.

Modern Religious Views on Vaccination

Today, none of the world's major religions expressly forbids vaccination.
Only a sect called the Congregation of Universal Wisdom, a religious out-
growth of chiropractic beliefs, specifically prohibits vaccination as a formal
part of their doctrine. The sect is based in New Jersey and has about
12,000 members. Some faith groups such as the Church of Jesus Christ of
Latter-day Saints actively encourage vaccination as a responsibility of parent-
ing, but most religious groups avoid taking a firm position on the topic.

Despite widespread religious tolerance of vaccination, faith leaders in
some individual congregations still discourage their members from vaccinat-
ing on religious grounds. This is particularly true among the Old Order
Amish, Hutterites, Jehovah's Witnesses, Christian Scientists, Dutch
Reformed Church, ultra-Orthodox Jews, and congregations that believe in
faith healing.

As of early 2017, 47 states and the District of Columbia allowed people to
opt out of vaccinating for religious reasons. Exceptions are California,
Mississippi, and West Virginia, which permit only medical exemptions.
Requirements for obtaining a religious exemption vary from signing a paper
stating that one has a religious objection to being vaccinated to providing
proof of membership in a faith-based congregation know to opposed the pro-
cedure. Religious exemptions are only a tiny fraction of all vaccine exemptions.
Personal belief or philosophical exemptions allowed in 17 states account for
most nonmedical exemptions.

TOO MANY VACCINES TOO SOON

Little is more controversial than the timing of giving vaccines and the
rationale for giving children vaccines for diseases that are rare in the United
States or that are perceived as mild. Parents and healthcare providers who ques-
tion the standard vaccination schedule are not completely opposed to vaccine
use, but they want to control when and how their children are vaccinated.

Standard vaccination schedules are developed by the Committee on Immunization Practices (ACIP) and the CDC. The schedules are based on multiple studies and the experience of many experts. They take into consideration both the length of time maternal antibodies acquired in the womb remain effective and the point at which the child's immune system is mature enough to produce a long-lasting antibody response.

The CDC releases three approved schedules for healthy children. The standard schedule begins with a vaccination for hepatitis B within a few days after birth and calls for inoculation of healthy children against 15 diseases by age 6 years. The CDC issues an approved catch-up schedule for children who have missed some doses of vaccine because of illness or any other reason. There is also a special schedule for children who move between Mexico and the United States and receive some inoculations in each country. Following these schedules is strongly recommended but not compulsory.

Adjustments to these schedules can be made on an individual basis for children who are either temporarily or chronically ill. Nevertheless, an increasing number of parents are insisting that their pediatrician follow alternative schedules that either increase the time between inoculations, reduce the number of vaccines given at one visit, or that skip certain vaccines the parents believe are either too risky or unnecessary.

Below, we will explore some of the thinking of those parents and medical professionals who support altering the recommended vaccination schedule developed by ACIP. Keep in mind that parents and healthcare providers who support either extending or altering or the standard vaccination schedule are advocating for what they believe is the least risky way to vaccinate. Pediatricians who oppose altering the schedule perceive that it is in the best interest of the child to be protected against potentially life-threatening diseases as early as possible. Both groups want what they believe is best for the child. The difference in outlooks comes from differing perceptions of risk and of who and what information to trust.

Why Start Vaccinating so Young?

Controversy about when to vaccinate begins at birth. The standard schedule calls for newborns to be vaccinated against hepatitis B before leaving the hospital or within a few days of birth. Hepatitis B virus causes liver damage. Most people are mildly ill for less than six months. Overall, in about 10 percent of infected individuals, the disease becomes chronic and can lead to liver cancer and cirrhosis later in life. However, when infants are infected, 9 out of 10 develop chronic infection. Hepatitis B can be passed from an infected

mother to her child during delivery or through contact with blood or other body fluids of an infected person. Most infections are acquired through sexual contact.

There is little disagreement that a child born to an infected mother should be vaccinated immediately. On the other hand, many parents ask quite understandably why the vaccine must be given at birth when their child will not be sexually active for years. The answer from a public health standpoint is that universal vaccination of newborns is the best way to eradicate hepatitis B. Without infant vaccination, some children (estimates were around 10,000 per year before infant vaccination started) will acquire hepatitis B before age 10 though close, nonsexual contact with an infected person. In addition, a certain percentage of preadolescents will never visit a physician for the vaccine, leaving them vulnerable when they do become sexually active. The conflict becomes one of public good versus personal choice.

The same question arises with administration of the human papillomavirus (HPV) vaccine. Vaccination is recommended for both girls and boys and girls at age 11 and can be given as young as age 9. HPV is the most common sexually transmitted infection (STI). Almost all adults are infected, and there is no test to determine infection status. In most people, HPV infection clears up on its own and causes few health problems. In some people, it can cause genital warts and later in life cancer of the cervix, vagina, penis, anus, tongue, and throat.

Vaccine-skeptic parents express several concerns about HPV vaccine. First, they object to the young age at which the vaccine is given. However, vaccination after an HPV infection is acquired provides no protection. Second, some parents are concerned that HPV inoculation will encourage children to become sexually active and/or that a child will believe he or she is protected against other STIs, which is not true. Finally, because the virus is passed only through direct contact, not through the air as, for example, measles virus, parents insist the decision is one of personal choice. They argue that their child will not contract HPV by sitting next to an infected child in school, and therefore, they should not be forced to vaccinate.

Unnecessary Vaccinations

"Why are we giving our children so many vaccines?" asks Jennifer Margolis, a well-educated vaccine skeptic interviewed in the 2010 *Frontline* documentary "The Vaccine War" (*The Vaccine War* 2010). "There's no more polio in the United States, and there's no more diphtheria. When do we take polio off the vaccine schedule?"

It is true that the last case of native polio occurred in the United States in 1979, but wild polio still existed in 2016 in Afghanistan, Pakistan, and Nigeria. Sixteen other countries, mostly in Africa and Southeast Asia, but also Ukraine, Syria, and Iraq, were considered at risk or high risk for outbreaks. A single case of diphtheria occurred in the United States in 2015, but that same year 37 other countries reported diphtheria. India topped the list with more than 2,300 cases. France and Germany both had 14. Most European countries have a handful of cases each year.

Although small children are less likely than adults to visit countries where they may be exposed to vaccine-preventable diseases, international travel is common and affordable for many. Diseases that are rare in the United States can be brought in by visitors from abroad or Americans returning from visits to countries where these diseases are present. They can spread the diseases to the unvaccinated and undervaccinated. An outbreak of measles in California in 2015 that sickened 147 people in the United States was attributed to a single person who contracted the disease abroad and then visited Disneyland while contagious but before symptoms became evident.

Other parents question why certain vaccines are given for what they perceive as relatively mild childhood diseases including rotavirus and chicken pox. Rotavirus causes severe diarrhea and is responsible for 215,000 deaths worldwide, about 90 percent of which are in developing countries. Almost all children contract rotavirus infection, but only a few die in the United States when quality healthcare is available. This leads some parents to skip the rotavirus vaccination because they think of it as a "third world vaccine."

Most parents remember chickenpox from their childhood as a relatively benign disease. Consequently, many vaccine-skeptic parents choose to skip this vaccination. Nevertheless, should a child spread chickenpox to a person whose immune system is compromised by cancer treatment, an organ transplant, or HIV infection, the results can be deadly because people with weakened immune systems cannot be vaccinated against chickenpox. The disease also can have much more serious health consequences if contracted by adults.

Jennifer Margolis, whose children did not receive the chickenpox vaccine, sums up her outlook on the chickenpox vaccine this way. "As a parent, I would rather see my child get a natural illness and contract that the way illnesses have been contracted for at least 200,000 years. I'm not afraid of my child getting chickenpox. . .Getting sick is not a bad thing" (*The Vaccine War* 2010).

A third reason some parents question the need for so many vaccines is failure to trust the pharmaceutical industry and the medical establishment. To them, "big pharma" is all about profit at the expense of their children. Indisputably, pharmaceutical companies are in business to make a profit for

their stockholders. However, a segment of the anti-vaccination community believes that the members of ACIP and the IOM are in league with the industry to promote unnecessary vaccines. They claim members of these committees profit directly from the approval of vaccines. Chapter 6 explains the safeguards in place to prevent this.

Paul Offit (1951–), pediatrician, director of the Vaccine Education Center at the Children's Hospital of Philadelphia, and past member of the CDC Advisory Committee on Immunization Practices is a favorite target of this group. Offit, whom anti-vaccinationists often call "Dr. Profit," is the coinventor of RotaTeq, a rotavirus vaccine. The vaccine has made him rich, but money was not, Offit says, the motivating factor developing the vaccine. His interest in a rotavirus vaccine began years ago when an infant died of the infection while under his care.

Some anti-vaccinationists also take financial advantage of their positions as leaders of the anti-vaccination movement. Andrew Wakefield and Barbara Loe Fisher derive income from their speeches, newsletters, websites, and similar anti-vaccination activities. Osteopathic physician Joseph Mercola uses his anti-vaccination website to promote his book, *The Great Bird Flu Hoax*, and an array of natural products that he sells. Robert "Dr. Bob" Sears has sold more than 200,000 copies of his vaccine-skeptic book *The Vaccine Book: Making the Right Decision for Your Child*. This has led some members of the medical establishment to accuse him of cashing in on parents' fears.

Why Give So Many Vaccines at Once?

In the past 30 years, new vaccines for children under age six have been added to recommended schedule. This has given rise to the practice of administering more than one vaccine at a single well-child visit and the development of combination vaccines to reduce the number of shots a child receives. Physicians see this practice as beneficial in that it reduces the number of office visits and saves parents time and money. Some parents believe that multiple simultaneous vaccinations are detrimental to their children.

The idea that combination vaccines are more harmful than single vaccines got started when Andrew Wakefield (see Mercury, Thimerosal, and Autism above) claimed in a press conference that he could no longer support the use of the combination MMR vaccine because he believed receiving three vaccines at once increased the chance of causing developmental delays. Since then, the number of combination vaccines and the practice of giving multiple single vaccines during the same office visit has grown. So have parents' fears.

Many parents feel strongly that vaccination is less risky if they can spread the process out so that their child receives only one vaccine at a time with a month or more interval between shots. This belief arises from the idea that a young child's immune systems cannot safely handle the number and frequency of inoculations recommended by the standard schedule. No scientific studies support this belief but that has not decreased its popularity.

The mainstream medical establishment supports combination vaccines and multiple inoculations because although an infant's immune system not completely mature, it still functions incredibly well. The immune system begins dealing with challenges the moment a child emerges from the womb. Bacteria, fungi, viruses, and allergens are in the air the child breaths and in virtually everything the child touches or eats. From birth, an infant's immune system deals successfully with thousands of antigen challenges each day. It can do this because of some unique properties of immune system cells (see Chapter 4, VDJ Recombination) that allow individuals to make antibodies against millions of different antigens that they have never before encountered. Adding several dozen antigens in combination vaccines or through multiple shots does not disrupt this incredibly effective system.

Some parents also express concern that combination vaccines do not work as well as individual shots. To win regulatory approval, each combination vaccine must be tested to show that one component does not increase or decrease the effectiveness of another component. When several inoculations are given at the same time, these also are studied to assure that there are no unintended interactions. Testing safeguards do not reassure some parents, however. For example, J. B. Handley, father of a child with autism and founder of Generation Rescue, told *Frontline* that at a single office visit, "my kid got six vaccines. You don't have any science that can show me that the regression [to autism] wasn't triggered by the six vaccines" (*The Vaccine War*, 2010)

Alternative Vaccination Schedules

There are no laws in the United States that say parents and pediatricians must follow the standard CDC-recommended vaccination schedule. One result of belief that children are harmed by giving too many vaccines and vaccine combinations is the emergence of alternative vaccination schedules promoted by some healthcare professionals and websites. These schedules are based on the physician-inventor's personal beliefs and have not been evaluated by vaccine experts. The best known of these schedules are two devised by Robert Sears, a pediatrician in Southern California who goes by Dr. Bob.

Dr. Bob published *The Vaccine Book: Making the Right Decision for Your Child* in 2007 with an update in 2011. The book is advertised as "a fair, impartial, fact-based resource" for parents, but to mainstream pediatricians, it has a vaccine-skeptic slant. In the book, Dr. Bob provides two alternative schedules to the standard CDC vaccination schedule.

Dr. Bob's Alternative Vaccination Schedule is designed for parents who want to vaccinate but are concerned about their child is receiving too many vaccines too early in life. The alternative schedule spaces out and delays most vaccinations when compared to the CDC schedule. It avoids hepatitis B vaccination at birth, moving it to 2.5 years and begins with DTaP and rotavirus at 2 months. After that it recommends no more than two inoculations per visit in months 3–7 and at 9, 12, 15, 18, and 21 months. More vaccines are given at 2, 2.5, 3, 4, 5, 6, 7, 8, 9, 12, 13, and 16 years. In addition, annual influenza shots are recommended each year starting at nine months of age. The goal is to avoid what Sears calls chemical overload.

Following the Dr. Bob Alternative Schedule increases the number of office visits and delays the development of immunity when compared to the CDC-approved schedule. Is this in the best interest of the child? Parents concerned with their child receiving too many vaccines too early believe it is. Most pediatricians, the AAP, and the CDC believe it unnecessarily leaves a child vulnerable to disease during a critical period in early life.

Dr. Bob's Selective Vaccination Schedule is designed for parents who want to avoid "risky" vaccines. The schedule starts at two months again with DTaP and rotavirus, and eliminates all vaccinations against polio, mumps, measles, rubella, and hepatitis A. It delays administration of hepatitis B until age 12–14 years and recommends blood tests for 10-year-olds on this schedule to determine if they have acquired natural immunity for mumps, measles, rubella, chickenpox, and hepatitis. If the child has not acquired natural immunity, Sears suggests vaccinating for these diseases since they cause more serious symptoms in teens and adults than in young children.

Sears also offers suggestions on what vaccinations to give a first child who is in preschool or daycare if a new baby is arriving, since the older child can bring diseases into the home that could have serious consequences for the infant. Schedules for delaying all vaccinations until ages 6 months, 12 months, or 2 years are also suggested.

It should be noted that charges were brought against Sears in September 2016 by the Medical Board of California that could result in the loss of his license to practice medicine. The charges included keeping inadequate and inaccurate medical records, gross negligence for failing to order neurological tests for a two-year-old who had been hit on the head with a hammer, and improperly

exempting the same child from all future vaccinations. A second parent complained to the Medical Board that in April 2015 when Sears testified about vaccination to the California State Education Committee, he inappropriately made statements about the parent's son concerning the child's health status and ability to tolerate vaccination, even though the child was not Sears's patient. Supporters of Sears claim that he was singled out and made an example of because he campaigned against a 2015 California bill that eliminated all personal and religious exemptions for vaccination (the bill passed). As of early 2017, the charges against Sears had not been resolved.

Dr. Bob is not the only physician who has created his own alternative vaccination schedule. Stephanie Cave is a medical doctor who is part of a family practice group in Baton Rouge, Louisiana. Cave's alternate schedule begins at 4 months and recommends one or two inoculations at monthly intervals until 9 months and then at slightly longer intervals through 27 months. She recommends skipping hepatitis B vaccine and doing blood tests to see if the child has had natural chickenpox at age 12.

Donald Miller, a physician and professor of surgery, has one of the more extreme alternative vaccination schedules. He recommends no vaccinations at all until age two years. His theory is that at that point the brain is 80 percent developed and is less likely to be harmed by vaccines. He believes the risk of DTaP outweighs any benefits and that no live attenuated vaccines (i.e., MMR, chickenpox, and rotavirus) should ever be given. He also believes all inoculations should be spaced at six-month intervals. His alternative schedule is endorsed by anti-vaccinationist osteopathic physician Joseph Mercola.

Alternative and selective vaccination schedules frustrate many mainstream pediatricians and the AAP who see no benefit in them for healthy children. Some pediatricians feel pressured into agreeing to alternative schedules in the belief that partial or delayed vaccination is better than no vaccination. Other pediatric practices refuse to take new patients who want to alter the CDC schedule or skip some vaccinations completely. Parents are often frustrated and angered by this inflexibility, while physicians feel their years of education and clinical practice are being ignored in favor of what anti-vaccination activist Jenny McCarthy calls the University of Google. Too little time for genuine communication between parent and doctor and a differing view of risk make it difficult for each side to understand the other's viewpoint.

MANDATORY VACCINATIONS: PUBLIC HEALTH VERSUS PERSONAL CHOICE

Does a government overstep its authority by requiring healthy individuals to be vaccinated even if it is against their wishes? Should people be free to

choose which vaccinations to accept or reject even though they may spread a disease that results in the death of others? Which is more important, protecting citizens' health or protecting personal choice? Different countries approach these questions in different ways. Australia encourages vaccination by withholding certain government benefits from families that refuse to vaccinate their children. Slovenia fines the unvaccinated. In Pakistan failing to vaccinate children can lead to a jail sentence, while in Germany approved vaccines are free, but vaccination is completely voluntary.

In the United States, the only federal laws about immunization apply to immigrants seeking to become legal permanent residents. These individuals are required to have proof of all immunizations appropriate for their age against mumps, measles, rubella, polio, tetanus, diphtheria, pertussis, *Haemophilus influenzae* type B (Hib), hepatitis A, hepatitis B, rotavirus, meningococcal disease, varicella, pneumococcal disease, and influenza. For its own citizens, the federal government lets each state decide which vaccines are mandatory and under what conditions exemptions from immunization are granted.

In 1809, Boston became the first American city to pass a mandatory vaccination law. The law was an attempt to stop an outbreak of smallpox. Other cities in the state soon followed. In 1852, Massachusetts became the first state to provide free public education to all children and to make school attendance compulsory. Children from all walks of life crammed into classrooms, making schools the perfect setting for the spread of contagious diseases.

Public health officials recognized the danger. A single case of smallpox in the classroom could spread throughout an entire town. Consequently, in 1855 Massachusetts began requiring proof of smallpox vaccination for public school attendance. Parents opposed to vaccination could still send their children to private school, and there were provisions for medical exemptions from the law.

The Massachusetts approach to protecting public health by making sure school children were vaccinated became a model for other states. Today all 50 states link public school attendance and proof of vaccination. In some states, the requirement extends to private schools, daycare facilities, and entrance into state colleges. All 50 states also allow physician-certified medical exemptions. All except California, Mississippi, and West Virginia allow religious exemptions, and 17 allow personal belief or philosophical exemptions.

Inevitably, mandatory vaccination laws were challenged in court. The bedrock case supporting the right of the state to enforce mandatory vaccination is the 1905 Supreme Court decision in *Jacobson v. Massachusetts*. This case and a review of current mandatory vaccination laws are described in detail in Chapter 7.

Jacobson v. Massachusetts established that compulsory vaccination laws did not violate the protections guaranteed in the Fourteenth Amendment of the Constitution, that individuals refusing to be vaccinated could not be forcibly inoculated but could be penalized, and that people who could show that vaccination would harm their health could be exempted from the law. These basic principles continue to prevail today, much to the frustration of anti-vaccinationists and those with libertarian leanings.

A new approach to invalidating compulsory vaccination laws arose in the case of *Zucht v. King*. It pitted the right to an education against the school's requirement for proof of vaccination. In 1919, Rosalyn Zucht was not allowed to attend school in San Antonio, Texas, because she had no certificate of vaccination and refused to be vaccinated. The city had an ordinance that required any person attending either public or private school show proof of vaccination. When she was excluded from school, Zucht filed suit. There arguments were as follows:

- The ordinance was unconstitutional because it gave the board of health the right to determine under what circumstances to enforce vaccination and thus under the Fourteenth Amendment deprived Rosalyn of her liberty without due process.
- The law deprived Rosalyn of her right to a free public education.
- The law was discriminatory because it applied only to school children and not to others who might assemble in similar groups (e.g., adults at church).

In 1922, the U.S. Supreme Court refused to hear the case, leaving standing a decision by a lower court that had found the San Antonio ordinance was constitutional and the board of health had the right to enforce it, that it was not discriminatory, and that the right of a child to education did not take precedence over the right of the city to protect public health.

More recent lawsuits have concerned mandatory vaccination as a condition of employment. Courts generally have ruled that private employers such as hospitals and daycare centers can require employees to be vaccinated unless an individual's health will be harmed by the vaccine. The most common employer-mandated vaccination is seasonal influenza.

Anti-vaccinationists and selective vaccinationists believe that the government is intruding on what should be a personal decision when it mandates vaccination. They argue that individuals have the right to refuse medical treatment and that vaccination is a medical treatment, so they have the right to refuse to vaccinate their children. Mentally competent adults may legally

refuse medical treatment, but established law gives the state an interest in child welfare. It can, for example, force parents to send their children to school, prevent them from sending young children to work, or remove them from their parents care in cases of abuse and neglect. These precedents are often cited as giving the state the power to compel vaccination of children and to penalize those who do not comply.

FUTURE SOCIAL ISSUES

Although anti-vaccinationists are likely to continue to claim that vaccines cause harm and to fight for the right to refuse vaccination as an issue of personal choice, several new vaccine issues may be on the horizon. Techniques to develop new vaccines are constantly evolving as genetic engineering tools become more sophisticated. The safety of vaccines using some of these techniques may be open to challenges. In addition, increased threats of bioterrorism create ethical and safety questions about research on vaccines to combat biological weapons.

Genetic Modification and Vaccines

Genetically modified organisms (GMOs) are organisms that have RNA or DNA from an unrelated source inserted into their genome in a laboratory procedure. This foreign genetic material then becomes part of the host organism's genome and replicates every time a cell divides. Agriculture led the way in introducing GMOs in the 1990s with the goal of adding a characteristic to plants such as drought or pesticide tolerance. Since the introduction genetic modification, there has been controversy over whether GMOs are harmful to human health or could mutate into a harmful organism. The European Union has banned GMO foods, while the United States does not even require foods made with GMO crops to be labeled as such

Vaccine scientists already use genetic modification to create recombinant vaccines. Genetic material from a viral pathogen is inserted into a harmless host organism in the laboratory. The host then expresses pathogen antigens on its surface. These antigens are harvested and used to make a subunit vaccine.

Recombinant vector vaccines take this process one step further. Instead of using a host organism to produce pathogenic antigens, a genetically modified harmless-to-humans virus becomes a vector. The vector with its load of pathogen genetic material is injected into the body where it makes antigen that stimulates an antibody response without causing illness. The mechanism of creating recombinant vector vaccines is discussed in more detail in Chapter 9. Using

recombinant vector technology, scientists hope to create vaccines against diseases such as malaria and HIV that have been resistant to traditionally created vaccines. Several veterinary vaccines used in the United States are made using recombinant vector techniques.

Two potential problems with recombinant vector vaccines are inappropriate gene expression and mutation. In inappropriate gene expression, the wrong genes are turned on or off at the wrong time. Misalignment of gene activities is one feature of cancer. It is possible although unlikely that the harmless virus chosen as the vehicle for the pathogen's genetic material could interact with body cells in unexpected ways that inappropriately alter gene expression in body cells.

Another potential concern is mutation. Some viruses are extremely stable and mutate at a very slow rate. Others, for example influenza viruses, are highly unstable and mutate frequently. Researchers would choose stable viruses as vectors, but there is always the chance that the vector could mutate into something harmful. A segment of the public has already expressed this fear about GMOs harming human health. Given the high level of intolerance for vaccine risks, recombinant vector vaccines could become as controversial as GMOs in food.

Risks of Bioterrorism Research

An increase in acts of terrorism around the world since the World Trade Center attack in September 2001 has stimulated biosecurity research. In the United States and many other countries, a defensive effort is underway to create vaccines against the most lethal biological agents. This biosecurity activity is discussed in more detail in Chapter 9. Smallpox, anthrax, plague, bacteria and viruses that cause hemorrhaging, respiratory or gastrointestinal distress, and pathogens that produce high fever are all potential bioterrorism weapons. This creates a dilemma.

To make a vaccine to a high-risk bioterrorism pathogen, scientists must keep a supply of the pathogen on hand, study it, and manipulate it. In the United States, much of this research is carried out by the U.S. Army Medical Research Institute of Infectious Diseases based at Fort Detrick, Maryland. The Fort Detrick facility has the highest level biosafety containment rating in the country. Nevertheless, despite security and containment methods, the possibility exists that these pathogens could fall into the hands of terrorists or accidentally escape and start an epidemic.

Documented cases of live, lethal pathogens escaping containment facilities already exist. In 1971, the Soviet Union maintained a biological weapons testing facility on an island in the Aral Sea where they are believed to have tested

various forms of weaponized smallpox. A Russian research ship collecting water samples inadvertently violated the 24 mile (40 km) security zone surrounding the island, and a crew member became infected with smallpox. She spread the disease to at least nine other people, three of whom died.

More recently in May 2015, a U.S. Army base in Utah where bioterrorism research is conducted accidentally shipped live anthrax spores to facilities in nine states and South Korea. The spores had been improperly irradiated to inactivate them. Lax testing and human error then allowed them to be distributed. Fortunately, no one contracted the disease. Should more incidents like this occur, public pressure could mount to reduce defensive bioterrorism research and make containment sites more secure.

Smallpox was declared eradicated worldwide in 1980. However, the United States and Russia both have preserved a stock of live, frozen smallpox virus. There is debate about the ethics of keeping this material, and periodically there is pressure to destroy it. However, in 2016, a situation was detected that may make having the virus available to scientists a good thing. The situation is related to climate change.

During the 1890s, a smallpox epidemic in Eastern Siberia killed 40 percent of a town's residents. The bodies were buried deep under the permafrost where they have remained frozen year round for more than 100 years. Now Siberia is warming. The permafrost is thawing and along with it the bodies. Although it sounds like something from a bad science fiction movie, some scientists believe that there is a very small but real chance that smallpox virus has survived being frozen in these bodies and could re-emerge during the thaw. In that case, the stock of smallpox kept for research purposed could be critical in combating the threat.

SUMMARY

The Internet has increased the reach and scope of the debate about the safety and value of vaccination. Concerns about vaccines range from the safety of specific vaccines to worries about vaccinating infants and overloading children with too many vaccines at once. Some parents question the need for vaccinating against diseases such as polio, that have been eradicated in the United States, or chickenpox, which many parents consider a mild disease. Others wonder why young children are required to be vaccinated against diseases such as HPV that they are likely to encounter only in adulthood.

Mandatory vaccinations raise the issue of community good versus personal choice. Many parents, because of the risks they perceive in vaccination, want to decide for themselves if, when, and what vaccines their child receives, while

public health officials prioritize protecting community health over freedom of choice. In the United States, childhood vaccination is required to attend public school. Each state sets its own laws concerning which vaccines are required for attendance and who may be exempted from these laws.

There is a long history of resistance to vaccination, but court challenges to school vaccination laws have failed. The right of private employers to require vaccination as a condition of employment has also generally been upheld by the court. The debate surrounding vaccination is likely to continue as new vaccines are added to the recommended schedule and the memory of vaccine-preventable diseases such as diphtheria, polio, and measles fades.

Chapter 9

The Future of Vaccines

For many years, the only effective way to create a vaccine was to kill or attenuate whole pathogens or chemically inactivate their toxins. These techniques produced effective vaccines, many of which (with improvements) are still in use today, but they have limitations. Using whole pathogens can cause unacceptably high rates of adverse events. Some pathogens cannot be weakened enough to be safe, while others mutate rapidly making it difficult to produce a vaccine that has widespread effectiveness. In addition, working with live attenuated viruses requires stringent containment controls during manufacturing and rigorously maintained transport and storage conditions.

Improved techniques for isolating proteins have brought about the development of subunit vaccines in which only the antigenic part of the pathogen, not the whole organism, is used to stimulate immunity. Subunit vaccines eliminate some of the drawbacks of working with live attenuated pathogens, but they have limitations of their own. Because they use a limited set of antigens from the pathogen, they may not produce as effective an antibody response as desired. Research to produce the next generation of vaccines and adjuvants is directed at overcoming limitations of some current vaccines as well as expanding the number of diseases for which vaccines are available.

Recent advances in decoding genomes and precisely isolating small pieces of DNA and RNA have resulted in recombinant DNA/RNA techniques that "rewire" the genetic material of a benign organism so that it will produce antigenic proteins of a pathogen without causing disease. Vaccines made in this way are called recombinant vector vaccines. These techniques have opened a possible path to developing new vaccines against existing diseases (e.g., malaria, HIV) that place heavy economic and health burdens on developing countries.

Genetic recombinant methods are also being used to produce experimental vaccines that may be effective in creating immunity against emerging health threats such as Ebola and Zika.

Older vaccines already in use are being redesigned to cause fewer adverse events, require fewer doses, protect against more strains of a pathogen, or to be given in combination with other vaccines. Reducing the number of doses needed for full immunity and bundling multiple vaccines in a single shot are especially valuable to immunization programs in developing countries where physical and political conditions may make it difficult to consistently get vaccines to the people who need them. Researchers are also experimenting with new ways to manufacture vaccines so that they are less vulnerable to environmental stresses such as heat, cold, and sunlight.

VACCINE RESEARCH INITIATIVES

The WHO's Initiative for Vaccine Research (IVR) is an extensive program that supports the development of new vaccines and the increased use and improvement of existing vaccines. The IVR focuses primarily on diseases that cause widespread disease, death, and economic burden in developing countries. It partners with organizations such as the U.S. National Institute of Health and the National Institute for Allergy and Infectious Diseases, the Wellcome Trust and Medical Research Council of the United Kingdom, France's Institut Pasteur, the Gates Foundation, and research universities and pharmaceutical industry vaccine research programs worldwide.

The IVR's mission is as follows:

- To support basic research and early vaccine development for diseases where no vaccine exists or where an available vaccine has serious drawbacks
- To study how to optimize the public health impact of immunization where existing vaccines are underutilized
- To research ways to improve the introduction of vaccines and postlicensure assessments of risks to benefits
- To improve monitoring and evaluation of vaccines currently used in immunization programs

The IVR has developed a vaccine pipeline tracker available at http://www .who.int/immunization/research/vaccine_pipeline_tracker_spreadsheet/en to chart progress in the development of new vaccines. As of early 2017, it tracked the development of vaccines against the following diseases: HIV,

malaria, tuberculosis, respiratory syncytial virus (RSV), enterotoxigenic *E. coli* (ETEC), shigella, norovirus, and Zika.

RSV causes serious lung infections in infants, the elderly, and those with weakened immune systems. ETEC, shigella, and norovirus, collectively known as enteric diseases, cause severe diarrhea and dehydration. As of early 2017, the effects of Zika are not completely documented, but the virus has been shown to cause microcephaly in some fetuses of women who become infected during pregnancy. Zika is also suspected of causing eye defects, hearing loss, and stunted growth in infected fetuses and a small increase in Guillain-Barré syndrome (GBS) in infected adults.

The WHO has also prioritized dangerous emerging pathogens to be followed in the new vaccine pipeline. These include Crimean-Congo hemorrhagic fever (40 percent fatality rate), Lassa fever (multiorgan disease), Marburg (related to Ebola), Middle East Respiratory Syndrome (MERS), Nipah virus (zoonotic; infects pigs, bats), Rift Valley fever (zoonotic; infects cattle, sheep, goats), severe acute respiratory syndrome (SARS), and chikungunya (similar to dengue). None of these diseases is common in the developed world, but they pose a serious threat to residents and travelers in less developed countries. Current vaccine development is occurring in only about one-third of these diseases, so this is primarily a WHO wish list of future research.

Vaccine research initiatives also are underway for specific diseases, most notably HIV and malaria as indicated below in the discussion of individual diseases. Pharmaceutical companies are investing heavily in the development of new vaccines. The global market for vaccines is expected to increase from $32.24 billion (USD) in 2016 to $40.03 billion in 2021, giving the vaccine industry incentive to support research and development.

THE FUTURE OF VACCINE STORAGE AND DELIVERY

One area of vaccine research centers not only on making new or better vaccine but on developing better ways to store and administer vaccines already available. As discussed in Chapter 7, changes in temperature and exposure to sunlight can degrade vaccines and make them useless. To retain their potency, most vaccines must be kept refrigerated at between 35°F and 46°F (2–8°C) until use. Temperature control can be difficult when transporting and storing vaccines in countries where logistical delays are common, the electricity supply is inconsistent, and refrigerated storage is limited. According to the WHO, the need to maintain the cold chain from manufacture through distribution, storage, and use, increases the cost of immunization programs by 14 percent. Vaccine wastage due to breaks in the cold chain ranges from 25 to 50 percent.

Scientists at the Jenner Institute at Oxford University have had some success in a creating a temperature-stable vaccine against a chicken disease by mixing the vaccine with sucrose (table sugar) and trehalose, a sugar found in plants and animals that can withstand long periods of dehydration. The mixture is left to dry on an ultra-thin membrane and forms sugar glass with the vaccine particles trapped inside. In tests, the vaccine remained active when it was rehydrated after storage at 113°F (45°C) for six months, while the same vaccine stored as a liquid degraded significantly within one week. The challenges are to apply this technology to human vaccines and to develop a method to scale up the process for commercial production.

Stablepharma, a company in the United Kingdom founded in 2012 is one of several companies attempting to so this. Stablepharma's approach is to combine the vaccine, a solution that contains trehalose and a small sponge. As the mixture is dried, the vaccine is preserved in sugar glass in the pores a sponge. This allows the vaccine to be stored at high temperatures without losing potency. The sponge is packaged in a sterile syringe. To deliver the vaccine, sterile water is drawn up into the syringe and the sugar glass dissolves, freeing the vaccine. The water/vaccine solution is then administered as an intramuscular injection. Although this approach is promising, as of early 2017, Stablepharma has been unable to bring their product to market. The biodefense industry is especially interested in eliminating cold-chain requirements in order to facilitate the stockpiling of vaccines against bioterrorism (see Vaccines and Bioterrorism below).

Most vaccines are delivered by an injection that must be performed by a trained healthcare worker using a sterile needle and syringe. Exceptions are rotavirus, adenovirus, and oral polio, which are given by mouth. Researchers are experimenting with other delivery methods that do not require special training and sterile instruments. Their development would make immunization more accessible in the developing world and decrease cost per dose.

One alternate delivery method under development consists of a skin patch containing tiny microneedles filled with vaccine. Various ways of applying the vaccine to the patch and delivering it through the skin are being investigated. Depending on the vaccine, temperature sensitivity could be an issue with the patch. However, the skin patch has advantages over other delivery methods. It is light and easy to ship, can be applied by almost anyone, and does not require sterile instruments the way an injection does. In addition, it is possible that a single patch could release vaccine slowly over a longer period for increased immune response.

For several years, an influenza nasal spray vaccine was available in the United States for people ages 2–49 years. Although it had proved effective

during clinical trials and for the first few seasons in which it was used, later versions (the influenza vaccine composition changes from year to year) did not stimulate adequate immunity in children. Use of nasal spray flu vaccine was halted beginning with the 2016–2017 influenza season. This was a setback for alternate forms of delivering vaccines, but researchers still believe in the potential for delivering vaccines by nasal spray because of the high level of immune system activity in the mucous membranes of the airways.

GENETIC ENGINEERING OF VACCINES OF THE FUTURE

One technique already employed in creating subunit vaccines such as anthrax, hepatitis B, and acellular pertussis is to use only the antigenic portion of a pathogen. Using only a portion of the pathogen guarantees that it can never cause the disease it immunizes against. With advances in biotechnology that have reduced the time and cost of sequencing genomes and new gene splicing tools such as CRISPR, a new generation of vaccines using only the antigenic portion of the pathogen's DNA is under development. There are two types of these emerging genetically engineered vaccines: recombinant vector vaccines and naked DNA vaccines, sometimes called nucleic acid vaccines. Of these, development of recombinant vector vaccines is more advanced.

Recombinant Vector Vaccines

Recombinant vector vaccines use a harmless attenuated virus or bacterium (the vector) that has been genetically engineered as a sort of Trojan horse to introduce a pathogen's DNA into the body in a way that stimulates an antibody response without causing illness. This can be done either by using plasmids or by altering the genome of a virus vector.

Plasmids are free-floating bits of usually circular DNA found in the cytoplasm of bacteria and yeasts. They can reproduce independently of chromosomal DNA, the trait that makes them a useful tool in genetic engineering. To construct a recombinant vector vaccine using a plasmid, scientists first must overcome the challenges of identifying, isolating, and extracting the specific bits of pathogen DNA that code for the proteins that identify the pathogen as foreign or nonself. Next, they select a vector that is either harmless to humans or can be attenuated so as not to cause disease. Using gene-splicing technology such as CRISPR, the pathogen's DNA is spliced into the DNA of a plasmid in the vector. This creates a recombinant vector.

When the recombinant vector is injected into the body, the spliced-in piece of DNA in the plasmid makes the antigenic proteins of the pathogen along

with its own proteins. The antigenic proteins migrate to the surface of the cell, mark the cell as foreign, and stimulate the immune system to make antibodies and memory cells against the pathogen. The result is that the individual acquires active immunity against the pathogen from encountering only the vector-produced pathogenic proteins.

A similar way of introducing a pathogen's DNA into the body is to use gene-splicing techniques to insert genetic material from a pathogen into the genome of an attenuated or harmless virus. Once inside the body, the altered virus enters a healthy body cell and takes over its metabolic activities. When this happens, the host body cell begins using the viral genome, including the spliced-in material from the pathogen, to make proteins. The pathogen's proteins then move to the surface of the body cell where they act as antigens. The immune system responds by making antibodies and memory cells to these proteins, producing active immunity against the pathogen.

Recombinant vector vaccines offer certain advantages over traditional live attenuated vaccines. They cannot cause the disease they are immunizing against. They are more stable and less temperature sensitive than live attenuated vaccines, cost less, are faster to manufacture, and are easier to alter. In addition, vectors at least in theory can be engineered carry the DNA of multiple pathogens, conferring immunity to more than one disease in a single vaccine.

Disadvantages include the risk of inappropriate gene expression or mutation of the pathogen's DNA, difficulties in scaling production to commercial levels, and public skepticism about genetic engineering. Adjuvants must be added to boost the effectiveness of recombinant vector vaccines, and the technique does not work well for pathogens encased in a polysaccharide coat.

As of early 2017, no recombinant vector vaccines were licensed for human use in the United States, although several recombinant vector veterinary vaccines, including a West Nile vaccine for horses, had been approved. According to the WHO, recombinant vector vaccines against HIV and malaria were in Phase II clinical trials in late 2016. A vaccine against Zika and another against dengue that were still in the development stage in 2017 are also a recombinant vector vaccine.

Naked DNA Vaccines

Naked DNA vaccines are made from pieces of a pathogen's DNA that code for antigenic proteins. These bits of DNA and appropriate adjuvants are attached to gold microparticles. When the DNA-covered gold particles are injected directly into the body, some are taken up by body cells. These body

cells then begin producing antigenic proteins from the pathogen's DNA. The proteins migrate to the surface of the cell and make it look like a nonself or foreign cell. This sets off an immune system reaction that ends in the production of antibodies against the pathogen's antigenic proteins. In essence, the body uses the naked DNA to become its own vaccine factory.

Naked DNA with adjuvants that increase uptake by the body's cells can be injected using a needle and syringe or shot directly through the skin using a gene gun. The gene gun is a device that contains high-pressure gas used to bombard the skin with DNA-gold particles. Researchers are also looking at the possibility of using a nasal spray to deliver naked DNA, because the mucosal linings of the body are hotbeds of immune system activity. Research on naked DNA vaccines is less advanced than that of recombinant vector vaccines, so it remains to be seen how effective and practical this approach is on a commercial scale.

VACCINES ON THE HORIZON

Although vaccines against many diseases are in development, some are closer to being realized, are more urgently needed, or have more money and research behind the than others. The vaccines discussed separately below have been identified as ones likely to have the most positive effect on human health. Several are in Phase II clinical trials (expanded human testing) and one has completed Phase III trials and is awaiting licensure. Others represent diseases for which there are no cures or that have recently emerged as urgent threats to human health.

Human Immunodeficiency Virus (HIV)

HIV is a retrovirus that attacks the immune system and causes acquired immunodeficiency syndrome (AIDS). The virus is thought to have originated in chimpanzees and crossed over into humans in the 1920s in the Democratic Republic of the Congo. From there, it spread slowly. The first known human case occurred in that country in 1959. At the time, it was not know why this victim died. Because his cause of death was a mystery, samples of his blood were preserved. Using the samples, AIDS was diagnosed as the cause of death retroactively in the 1980s.

Originally it was believed that the first HIV/AIDS cases in the United States occurred 1981, but research in 2016 strongly suggests that the virus reached the United States in the mid-1970s but remained unidentified as the cause of disease until 1981. The virus is transmitted by exchange of body fluids— blood, semen, vaginal and rectal secretions, and breast milk. Initially most

infections occurred in men who have sex with other men and in intravenous drug users who shared needles. Now, especially in sub-Saharan Africa, heterosexual transmission and transmission from mother to infant often occurs. About 35 million people had died from HIV-related diseases between the early 1980s and 2015. An additional 36.7 million people worldwide were HIV infected at the end of 2015.

HIV was isolated in 1984, and because HIV/AIDS at that time was always fatal, work on a vaccine began almost immediately. The first HIV vaccine clinical trial in the world occurred in 1986, and the first trial in the United States began in 1988. Both failed, as did dozens of trials that followed. Live attenuated vaccines were not acceptable because of the potential for re-activation of the virus. Whole killed vaccines did not stimulate adequate immunity. Subunit and recombinant vector vaccines appear to offer the best chance for success, but many of them have also failed.

Why is it so difficult to make a vaccine against HIV? A major reason is the virus itself. First, there are two distinct types of HIV: HIV type 1 (HIV-1), which is responsible for most infections, and HIV type 2 (HIV-2), which is less common and usually progresses to AIDS more slowly. Vaccine development is directed at HIV-1. Within HIV-1, there are four subtypes, known as M, N, O, and P. Subtype M causes most infection worldwide. But within subtype M, there are at least nine different strains known as A, B, C, D, F, G, H, J and K. In addition, the virus mutates easily, frequently changing its surface proteins. This high genetic variability makes vaccine creation extremely difficult. An added complication for vaccine developers is that some of its surface proteins are shielded by other molecules, making it difficult for antibodies to neutralize them.

Another problem is that HIV interferes directly with the immune system. It reproduces by inserting itself into CD4+ cells (helper T cells) that are part of the immune response to a pathogen and are essential for forming memory T cells (see Chapter 4 for a review of the types of immune system cells). Instead of CD4+ cells fighting the infection, they are turned into factories to produce more HIV.

As of late 2016, the WHO new vaccine pipeline showed four HIV vaccines in Phase II clinical trials. All four were recombinant vector vaccines as were most of the 27 other HIV vaccines in the pipeline that were in earlier stages of development.

Malaria

Malaria is caused by three related parasites, *Plasmodium falciparum*, *P. vivax*, and *P. ovale*. The parasite is transmitted by the bite of the female

Anopheles mosquito; malaria does not spread directly from person to person. Symptoms are debilitating and can be fatal if left untreated. Malaria causes episodes of fever, shaking, chills, and sweats every 48 or 72 hours along with headache, muscle ache, joint pain, and fatigue. In 2015, the CDC estimated that 214 million people developed malaria worldwide and 438,000 people died of the disease. Prevention requires taking antimalaria drugs, government mosquito control programs, and individual behaviors to avoid mosquito bites. These preventative measures are difficult to achieve in developing countries where malaria is common, so making a vaccine against the disease is highly desirable.

A major barrier to making an effective vaccine is the complex lifecycle of *Plasmodium*. When a female *Anopheles* mosquito carrying the parasite bites a person, she injects the parasite into the person's bloodstream. In the early stage of infection, the parasite grows in liver cells. Once it matures, the infected liver cells burst, and the parasite moves into red blood cells where it reproduces. Eventually, the red blood cells are destroyed, and new parasites are released into the blood. If a mosquito bites an infected person, she acquires the parasite. She is not harmed by it, but she can infect the next person she bites.

Various attempts have been made to interrupt the life cycle of *Plasmodium* at the liver stage and the red blood cell stage. Other attempts have been made to interrupt transmission by preventing the parasite from maturing. The most successful vaccine, called RTS,S, (trade name Mosquirix) was developed by a partnership of the nonprofit Program for Appropriate Technology in Health (PATH) Malaria Vaccine Initiative and the pharmaceutical company GlaxoSmithKline. The vaccine protects only against *P. falciparum*, the most common malaria parasite in Africa, but not against *P. vivax* and *P. ovale*. It is the first successful vaccine against any parasitic organism.

As of 2016, RTS,S had completed Phase III clinical trials that involved 15,000 infants and young children in seven sub-Saharan African countries. Infants received the vaccine at 6, 10, and 14 weeks of age with a final dose at 18 months. Older children received their first dose between the ages of 5 and 17 months, followed by doses 1, 2, and 18 months later. The results were encouraging, but not spectacular. The vaccine prevented malaria in 27 percent of infants who received all four doses and 39 percent of older children who received all four doses. However, older children who did not receive the fourth dose had no protection from the disease, suggesting that the protective effect may be short lived.

The European Medicines Agency (EMA) evaluated the trial results and recommended licensure with the understanding that the vaccine would supplement but not replace other malaria prevention strategies. The EMA's

recommendation was intended as guidance for African countries. As of March 2017, the vaccine was still not available because no African country had completed the regulatory process to license it. Once available, postlicensure pilot projects (Phase IV trials) are expected to include between 400,000 and 800,000 children in Africa. Meanwhile, researchers continue to work on an improved vaccine.

Ebola

Ebola viruses belong to a family of viruses that cause hemorrhagic fevers characterized by vomiting, gastrointestinal bleeding, bleeding from mucous membranes, headaches, muscle aches, tissue swelling, low blood pressure, and fever. The death rate ranges from 25 to 90 percent depending on the species of Ebola virus (five species have been identified) and the medical care available. There is no cure for Ebola virus disease (EVD), making development of a vaccine a high priority.

Many animals, including monkeys, chimpanzees, gorillas, fruit bats, forest antelope, and porcupines can be infected with Ebola. The virus is transmitted to humans by contact with blood, secretions, and organs of an infected animal. Once in the human population, the virus spreads from person to person by contact with blood and body secretions. It can also spread by contact with bedding, clothing, or other surfaces contaminated with these fluids, making containment difficult.

The first outbreak of EVD occurred simultaneously in 1975 in the Democratic Republic of the Congo and in what is now South Sudan. The largest recorded outbreak began in March 2014 in West Africa. By July 2015, EVD had sickened at least 27,000 people, of which more than 11,000 died. The hardest hit countries were Guinea, Liberia, and Sierra Leone. This outbreak was declared over in December 2015, but in March 2016, a small outbreak of EVD occurred.

The pressing need to develop a vaccine stimulated a truly international response with more than a dozen countries participating in the development and testing of at least 10 different Ebola vaccines. For most drugs, testing involves giving a group of volunteers the vaccine and a comparable group a placebo. With a disease as deadly as Ebola, it is unethical to provide people with a useless placebo, so a model called ring vaccination was used. In Ebola ring vaccination, all individuals who came into close contact with a person with EVD were immunized. The goal was to create a barrier or ring around the disease to stop its spread. The success of failure of the barrier gave researchers an indication of the effectiveness of the vaccine.

As of early 2017, two of Ebola vaccines had proved highly effective and were in Phase III trials. cAd3-ZEBOV developed by GlaxoSmithKline is a recombinant vector vaccine derived from a chimpanzee virus that has been genetically engineered to express glycoproteins of two Ebola species, Ebola virus Zaire and Ebola virus Sudan. VSV-EBOV, developed by the Public Health Agency of Canada and NewLink Genetics, and manufactured by Merck Vaccines USA, a subsidiary of Merck & Co., Inc., is a live attenuated recombinant vector vaccine genetically engineered to express glycoproteins against Ebola virus Zaire, the species that caused most of the illness in the 2014 outbreak.

In January 2016, Merck submitted a request to the WHO to permit emergency use of the vaccine even though it was not licensed. Permission was granted, and the vaccine was successfully used to ring immunize about 800 individuals exposed to EVD during the March 2016 flare-up. Full approval of one or both of these vaccines is expected in 2017.

Zika

The Zika virus is a flavivirus belonging to the same family of viruses that cause dengue and chikungunya. All three diseases are spread by the bite of two species of *Aedes* mosquitoes, *A. aegypti* and *A. albopictus*. The Zika virus was first isolated from monkeys in Uganda in 1947. Monkeys, apes, cattle, goats, and other animals (but not cats or dogs) can become infected with Zika. The virus causes only mild or no symptoms in animals and cannot be transmitted directly from these animals to humans. In pregnant women, Zika can cause microcephaly and other birth defects in the fetus. Although cause and effect have not been definitively proven, Zika infection is also linked to an increase in Guillain-Barré syndrome in both men and women.

For many years Zika infections were limited to Africa and sporadic cases in Southeast Asia. Unexpectedly in 2013 and 2014, many cases appeared in the islands of the South Pacific. Somehow the virus then jumped to Brazil. In May 2015, a Zika epidemic swept that country. By December 2015, Brazilian health authorities estimated that between 440,000 and 1.3 million people had been infected. Thirty-eight countries reported Zika infections by March 2016. In mid-summer 2016, local transmission of the virus was reported in South Florida.

An international effort to create a vaccine against Zika began immediately. According to the WHO, laboratories in at least 18 countries began work on the at least 29 variations of a Zika vaccine. Developing an experimental vaccine that caused mice and monkeys to make antibodies against the virus proved relatively easy. By August 2016, two vaccines had been approved for small scale

(Phase II) clinical trials in humans. Similar approval for a third vaccine was expected by late 2016. Researchers used different techniques to create each of these experimental vaccines.

ZPIV or purified inactivated Zika virus was developed by researchers at Beth Israel Deaconess Medical Center in Boston in conjunction with researchers at Walter Reed Army Institute of Research. The vaccine is made from whole inactivated Zika virus. A single dose appeared to provide complete immunity in monkeys after two weeks.

A second vaccine, also in Phase II clinical trials, was produced by collaboration between Inovio Pharmaceuticals and GeneOne Life Science of South Korea. This vaccine, known as GLS-5700, is a naked DNA vaccine. DNA that codes for the antigenic proteins expressed on the surface of the Zika virus is injected directly into the skin with a gene gun while a device delivers a short electrical pulse to make the skin more permeable. This technique is called electroporation. The delivered DNA is taken up by body cells and causes changes in those cells so that they express the Zika protein. The immune system then makes antibodies against these proteins. If this vaccine is licensed, it will be the first naked DNA vaccine ever approved.

The U.S. National Institute of Allergy and Infectious Diseases (NIAID) has developed a third vaccine that is expected to be approved for clinical trials by the end of 2016. This vaccine is a recombinant vector vaccine that delivers Zika DNA in a harmless cold virus. If any or all three of these three vaccines move successfully through Phase II trials and move on to large-scale Phase III testing, it will still take several years before a commercial Zika vaccine is available.

THERAPEUTIC VACCINES

Traditional vaccines are preventative vaccines. They are given before an individual becomes ill in order to create T and B memory cells that will spring into action to accelerate an immune response when they encounter a specific pathogen in the future. Recently, advances in understanding the immune system and the ways in which it can be stimulated have opened the possibility of creating therapeutic vaccines. Rather than preventing illness, these vaccines are intended to stimulate the immune system to fight a disease such as cancer that is already active in the individual's body.

Therapeutic vaccines are considered one form of immunotherapy. They are designed to either slow or stop the growth of the disease or to boost the immune system in ways that help it kill diseased cells not killed by other treatments. The most advanced work on therapeutic vaccines has been against cancer.

Multiple therapeutic vaccines are being tested against at least 15 kinds of cancers. Many have reached Phase II clinical trials. These vaccines are designed to be used in addition to standard cancer treatments such as surgery, radiation, and chemotherapy; they are not intended to cure or put cancer in remission alone.

Cancer cells present multiple challenges for researchers because they can trigger the immune system in a variety of different ways.

- They can overproduce self antigens, causing them to appear foreign to immune system cells.
- They can make self antigens that are not normally made by the tissue in which the cancer has developed. For example, adult tissue may make antigens normally made only by embryonic tissue.
- Gene mutations in cancer cells can stimulate the creation of new foreign-appearing antigens.

Cancer cells also have tricky ways of avoiding destruction by the immune system.

- The antigens they express may be only slightly different from self antigens, making it hard for immune system cells to recognize them as foreign.
- They can express both self antigens and cancer-associated antigens, misleading the immune system into thinking the cancer cells are self cells.
- They can start by making cancer-associated antigens and then undergo gene mutations that cause them to lose the cancer-associated antigens and look more like normal self cells.
- They can shut down the actions of cytotoxic T cells.

Not all cancer cells are alike, so many different approaches to making cancer vaccines are being explored. One method modifies the individual's own immune cells to make them more effective in attacking cancer cells. Another uses killed or weakened cancer cells or the antigenic parts of cancer cells to stimulate an immune response. Other approaches use cancer cell DNA to create recombinant vector vaccines or naked DNA vaccines.

Therapeutic cancer vaccines that use the individual's own immune system cells are called autologous vaccines. An autologous vaccine is personalized; it must be made for each individual. One autologous vaccine, sipuleucel-T (Provenge), was approved in the United States in 2010 for use against metastic prostate cancer in certain men.

To make this vaccine, immune system cells are removed from the patient's blood and sent to a laboratory where they are grown in a complex mixture of

proteins and chemicals that activate them to become dendritic antigen presenting cells that will react to the individual's prostate cancer cells. The activated cells are intravenously infused back into the patient where they boost the efficiency of T cells that can kill cancer cells. The process is repeated three times at two-week intervals. In 2016, this therapeutic vaccine cost about $93,000. The vaccine does not cure prostate cancer; it only slows it and extends the patient's life by about four months.

Another approach to making an autologous vaccine involves extracting an individual's own cancer cells and then treating them in the laboratory so that they will become more visible and attractive to immune system cells. These cells are then returned to the patient. As of early 2017, several vaccines of this type were in Phase II and Phase III clinical trials, but none had been licensed.

Time and cost factors limit the usefulness of autologous cancer vaccines. Researchers are working instead to produce allogeneic vaccines. Allogeneic vaccines are made from cancer cells grown in the laboratory. They are not individualized and could work on many different patients with a specific type or subtype of cancer. Several allogeneic vaccines have been tested against melanoma, leukemia, pancreatic cancer, and non-small cell lung cancer. Although results are encouraging, none has yet proved effective enough to be licensed.

Researchers hope to eventually create vaccines against other diseases such as Alzheimer disease. An Alzheimer vaccine would target abnormal proteins that build up in the brain and are associated with increasing dementia and dysfunction. They are also exploring vaccines that can alter the genetic expression of cells in autoimmune diseases such as multiple sclerosis so that the body would no longer attack its own cells. The possibility of producing vaccines such as these is intriguing but appears to lie far in the future.

VACCINES AND BIOTERRORISM

Biological warfare is almost as old as war itself. As early as 300 BCE, the Greeks dumped animal corpses in the wells of their enemies to poison the water supply. The Tartars used catapults to send plague-infected bodies over the walls of the city of Caffa (now Feodosija, Ukraine) during a siege in 1346. Not only did this solve the problem of disposing of the plague-infected bodies, some historians believe this was the source of the Black Death that swept across Europe between 1346 and 1353, killing as many as 200 million people. In the twentieth century, the Japanese practiced biological warfare when they dropped bombs containing 15 million plague-infected fleas on the Chinese cities of Quxian and Ninghsien resulting in the death of at least 120 people.

One week after the September 11, 2001 attack on the World Trade Center and the Pentagon in the United States, letters containing powdered anthrax were sent to two United States senators and several media outlets. Twenty-two people were infected and five died. The letters were eventually suspected to be the work of Bruce Ivins, a mentally unbalanced scientist who was working on developing an anthrax vaccine at the U.S. Army Medical Research Institute of Infectious Diseases at Fort Detrick, Maryland. Ivins committed suicide before he could be charged with the crime. Since then, acts of bioterrorism have been perpetuated by disgruntled individuals, extremist political groups, and terrorist organizations. Many others have been quietly prevented by law enforcement in the United States and abroad.

Legal Implications

In the stressful days following the September 11 attack and the anthrax scare, Congress passed the Model State Emergency Health Powers Act (MSEHPA). It defined bioterrorism as "the intentional use of any microorganism, virus, infectious substance, or biological product that may be engineered as a result of biotechnology, or any naturally occurring or bioengineered component of any such microorganism, virus, infectious substance, or biological product, to cause death, disease, or other biological malfunction in a human, an animal, a plant, or another living organism in order to influence the conduct of government or to intimidate or coerce a civilian population."

MSEHPA was designed to give state and local public health agencies guidance and power to plan for, prevent, and respond to public health emergencies including bioterrorism. The federal Project BioShield Act (Public Law 108-276) passed three years later authorized accelerated procurement, personnel appointments, peer review, and development of biomedical countermeasures, including preventative and therapeutic vaccines against bioterrorism. It also authorized the emergency use of medical countermeasures including administering drugs and vaccines that had not yet been licensed by the FDA and whose safety and effectiveness had not been proven in humans.

The Public Readiness and Emergency Preparedness Act (PREP; Public Law 109-148) passed in 2005 extended the reach of the Project BioShield by authorizing the Secretary of Health and Human Services to issue a declaration that exempts manufacturers, distributors, program planners, their employees and certain other individuals from liability for any claim of loss resulting from the administration or use of emergency medical countermeasures. This law prevents pharmaceutical companies from being sued and suffering catastrophic financial losses if a drug or vaccine not yet licensed for the FDA or

one used in a nonapproved is administered during a biologic emergency or as a countermeasure against bioterrorism. By freeing manufacturers from liability, the government hoped to encourage the development of new vaccines and drugs against biological weapons.

PREP can also be used in life-threatening disease outbreaks. For example, an emergency declaration was made during the Ebola outbreak (see Ebola above) that allowed a not-yet-licensed vaccine made by Merck to be administered without fear of lawsuits. As a result, the disease was contained.

Biological Materials of Concern

For a biological agent to work well as bioterrorism weapon, it should be highly contagious with a short incubation period and cause disease or death in a large percentage of the population. The agent should be relatively easy to produce in quantity, retain its potency, and be easy to deliver to the target population. Certain bacterial, viral, and fungal pathogens and the toxins some pathogens produce meet most of these conditions. The CDC classifies potential bioterrorism agents into Categories A, B, and C with Category A the most lethal. These categories do not include chemical agents.

Category A pathogens include *Bacillus anthracis* (anthrax), *Yersinia pestis* (plague), *Francisella tularensis* (tularemia, a disease that cause high fever, lymph node swelling, chest pain, and difficulty breathing), viruses that cause hemorrhagic fever (Ebola, Marburg, Lassa, and Machupo), the variola virus (smallpox), and toxin from *Clostridium botulinum* (botulism).

Category B agents include ricin toxin derived from the castor bean *Ricinus communis,* the pathogens that cause Q fever, brucellosis, and typhus, and pathogens that cause disease by contaminating food (e.g., *Salmonella, Shigella*) or water (e.g., *Vibrio cholerae*).

Category C agents are emerging diseases. A typical Category C agent is Nipah virus. It normally causes mild illness in pigs, but can cause severe respiratory illness and encephalitis in humans.

Vaccines exist against smallpox and anthrax. A plague vaccine is available, but it is not highly effective. Q fever vaccine is in use in Australia, and a vaccine against Ebola is, as of early 2017, available in small quantities on an emergency basis. An American company is in early stages of exploring a vaccine against ricin. Other vaccines against Category A threats and some Category B threats are on the WHO vaccine priority emerging pathogens list. Some of the pathogens listed can be treated with antibiotics. Nevertheless, having a either a preventative or a therapeutic vaccine provides more flexibility in protecting the population.

National Strategic Stockpile

Vaccines and drugs against bioterrorism are only useful if they can get where they are needed quickly and in large quantities. To facilitate adequate distribution, the CDC maintains the Strategic National Stockpile (SNS). The SNS contains large quantities of medicine and medical supplies needed to respond to a bioterrorism event, pandemic disease outbreak, or natural disaster that is of a scale large enough to deplete local medical supplies. SNS supplies are stored in secret warehouses located so that aid can be delivered to any place in the United States within 12–36 hours. The SNS supplies would then be distributed free to all individuals in need through state agencies.

Many aspects of the SNS, such as the warehouse locations, are classified; however, it is public knowledge that the SNS contains several hundred thousand doses of smallpox vaccine as well anthrax vaccines and postexposure therapeutics such as massive quantities of antibiotics. The SNS has an inventory worth over $7 billion. Vaccines and other drugs must be replaced as they pass their expiration dates so that they do not lose potency. The need to maintain an up-to-date stockpile, along with the liability protection guaranteed by federal laws, provides a profit incentive for pharmaceutical companies to invest in the development of preventative and therapeutic vaccines against biological weapons.

SUMMARY

New developments in genome sequencing and gene-splicing techniques are being applied to vaccine development to create recombinant vector vaccines and naked DNA vaccines. Vaccines against HIV, malaria, and Ebola, are likely to be available soon. A vaccine against Zika is under intensive development.

Another aspect of future vaccine development involves the creation of therapeutic vaccines that will treat a disease as opposed to the current preventative vaccines that keep an individual from getting sick. Most of the research on therapeutic vaccines has involved manipulating immune system cells to make them more effective or alternately treating cancer cells to make them more visible to the immune system.

Infectious agents and biological toxins can be used as weapons of biological warfare or bioterrorism. The U.S. government supports research and development of vaccines against these biological agents. The Strategic National Stockpile is a collection of vital drugs and medical supplies to be used in the event of a bioterrorism incident, pandemic outbreak of disease, or widespread national disaster. Supplying vaccines for the Stockpile provides a financial incentive for pharmaceutical companies to invest in vaccine research.

Directory of Resources

AERAS GLOBAL TB VACCINE FOUNDATION

1405 Research Blvd.
Rockville, MD 20850
310-547-2900
http://www.aeras.org

A nonprofit organization dedicated to developing new and better tuberculosis vaccines that are affordable to all.

BILL & MELINDA GATES FOUNDATION

440 5th Ave North
Seattle, WA 98109
206-709-3100
http://www.gatesfoundation.org

The Gates Foundation is a philanthropic organization with substantial interest in eradicating polio, malaria, and HIV infection. The organization supports the Decade of Vaccines Global Vaccine Action Plan that aims to provide universal vaccination by 2020.

CENTER FOR BIOLOGICS EVALUATION AND RESEARCH

10001 New Hampshire Avenue
Silver Spring, MD 20993-0002

800-835-4709 (toll free); 240-402-8010 (local)
ocod@fda.hhs.gov
http://www.fda.gov/AboutFDA/CentersOffices/
OfficeofMedicalProductsandTobacco/CBER/default.htm

A division of the Food and Drug Administration, the Center for Biologics Evaluation and Research is responsible for ensuring the safety, purity, potency, and effectiveness of biological products including vaccines, blood and blood products, and cells, tissues, and gene therapies. This includes the approval, compliance, and surveillance of vaccines. Information is available in 16 languages.

CHILDREN'S HOSPITAL OF PHILADELPHIA VACCINE EDUCATION CENTER

3 401 Civic Center Blvd.
Philadelphia, PA 19104
800-879-2467
http://www.chop.edu/centers-programs/vaccine-education-center#

The Vaccine Education Center serves as a resource for parents with questions about the safety and effectiveness of vaccination.

GAVI, THE VACCINE ALLIANCE

1776 I Street, NW, Suite 600
Washington, DC 20006
202-478-1050
http://www.gavi.org

Created in 2000, this international organization brings together public and private organizations involved in providing access to new and underused vaccines for children in underserved areas.

IMMUNIZATION ACTION COALITION

2550 University Avenue West, Suite 415 North
Saint Paul, MN 55114
651-647-9009
admin@immunize.org
http://www.immunize.org and http://www.vaccineinformation.org

A pro-vaccination organization that is funded in part by the U.S. Centers for Disease Control and Prevention to educate healthcare professionals and the public about U.S. vaccine recommendations.

INSTITUTE FOR VACCINE SAFETY

Johns Hopkins Bloomberg School of Public Health
615 N. Wolfe Street, Room W5041
Baltimore, MD 21205
410-955-3543
info@hopkinsvaccine.org
http://www.vaccinesafety.edu

Established in 1992 at Johns Hopkins University, this organization strives to provide an independent assessment of vaccines and vaccine safety to help educate decision makers, physicians, the public, and the media about issues of vaccine safety in the interest of preventing disease using the safest vaccines possible.

K.N.O.W. VACCINES (KIDS NEED OPTIONS WITH VACCINES)

Jacksonville Florida
904-280-0546
http://www.know-vaccines.org

This anti-vaccination organization is dedicated to opposing mandatory vaccination laws.

NATIONAL FOUNDATION FOR INFECTIOUS DISEASES

7201 Wisconsin Avenue, Suite 750
Bethesda, MD 20814
301-656-0003
http://www.nfid.org

This organization supports U.S. vaccination policy by providing education and vaccine resources for daycares, schools, and workplaces. The site also includes links to vaccine education lesson plans for teachers.

NATIONAL INSTITUTE OF ALLERGY AND INFECTIOUS DISEASES

Office of Communications and Government Relations
5601 Fishers Lane, MSC 9806
Bethesda, MD 20892-9806
866-284-4107 (toll free); 301-496-5717 (local); 800-877-8339 (for hearing impaired)
ocpostoffice@niaid.nih.gov
https://www.niaid.nih.gov

Researching, preventing, and treating infectious diseases are the focus of this U.S. government organization.

NATIONAL VACCINE INFORMATION CENTER

21525 Ridgetop Circle, Suite 100
Sterling, VA 20166
703-938-0342
contact@NVIC@gmail.com
http://www.nvic.org

A nonprofit organization cofounded in 1982 by vaccine skeptics Barbara Loe Fisher and Kathi Williams. The organization advocates for freedom of choice in vaccinating and vaccine safety with a vaccine-skeptic philosophy.

PUBLIC HEALTH AGENCY OF CANADA

130 Colonnade Road, A.L. 6501H
Ottawa, Ontario K1A 0K9
844-280-5020 (toll free in Canada)
www.publichealth.gc.ca

This gateway site is sponsored by the government of Canada for citizens to access information on infectious diseases, immunization, travel health, and other health issues. Text in English and French.

U.S. CENTERS FOR DISEASE CONTROL AND PREVENTION (CDC)

600 Clifton Road
Atlanta, GA 30329-4027
800-CDC-INFO (toll free); 888-232-6348 (for hearing impaired)
http://www.cdc.gov

The CDC is a government organization that is part of the Department of Health and Human Services. Their mission is to educate and protect the health of Americans. The site provides official information on every vaccine as well recommended vaccine schedules and travel vaccination requirements. Text is available in 16 languages.

U.S. COURT OF FEDERAL CLAIMS/VACCINE CLAIMS

Howard T. Markey National Courts Building
717 Madison Place, NW, Washington, DC 20439
202-357-6400
http://www.uscfc.uscourts.gov/vaccine-programoffice-special-masters

This court was established to hear claims of injury under the National Vaccine Injury Compensation Program and the National Childhood Vaccine Injury Act of 1986. The website explains how the program works and how to file a claim.

U.S. FOOD AND DRUG ADMINISTRATION (FDA)

10903 New Hampshire Avenue
Silver Spring, MD 20993
888-463-6332 (toll free)
http://www.fda.gov

The primary organization responsible for approving drugs, biologicals, and medical devices and developing and enforcing food and drug regulations.

VACCINE LIBERATION

info@vaccinetruth.org
http://www.vaclib.org

This anti-vaccination organization has many to state chapters and also provides information on foreign organizations that share Vaccine Liberation's anti-vaccination views.

THE VACCINE PAGE

editor@vaccines.org
http://www.vaccines.org

A gateway site for up-to-the-minute vaccine news along with an annotated database of vaccine resource website. The site is supported by vaccine advocacy groups such as the Allied Vaccine Group.

VAXTRUTH

www.vaxtruth.org

VaxTruth is an online anti-vaccination organization that provides information on vaccine ingredients, school exemptions from vaccination, and news about hybrid vaccines.

WORLD HEALTH ORGANIZATION

20 Avenue Appia
1211 Geneva 27
Switzerland
http://www.who.int/topics/vaccines/en

The World Health Organization supports multiple international health initiatives including an intensive immunization outreach and up-to-date information on vaccine research program. Information is available in six languages

Glossary

Adjudicate: To make a formal judgment about a dispute.

Adjuvant: A chemical added to a vaccine to boost immune response to an antigenic component.

Adverse effect: An undesirable, usually serious experience provably caused by the administration of a vaccine or drug.

Adverse event: Any undesirable experience that occurs in a defined period after the administration of a vaccine or drug. The vaccine or drug does not have to be the cause of the event.

Allogeneic vaccine: A therapeutic vaccine made from cancer cells grown and processed in the laboratory that will work on many patients with the same type of cancer.

Anaerobic: A bacterium that grows in the absence of oxygen (e.g., the bacterium that causes tetanus or botulism.)

Anaphylaxis: A severe life-threatening allergic reaction.

Animal reservoir: Animals that can harbor the same virus that infects humans so that the virus cannot be eradicated.

Antibody: A protein molecule (immunoglobulin) produced by B cells in response to a specific antigen.

Antigen: A nonself molecule that induces an immune system response resulting in the production of antibodies.

Antigen presenting cell (APC): An immune system cell that engulfs a pathogen and then exhibits some of the pathogen's protein on its surface so that the

APC looks like a foreign cell. Macrophages and dendritic cells are the major APCs.

Antigenic drift: The gradual accumulation of small changes in the genetic composition of a virus, as opposed to antigenic shift, which is a sudden major change in genetic material.

Antigenic shift: A large, sudden change in the genetic composition of a virus thought to occur when a cell is simultaneously infected with two strains of the same virus and a large amount of genetic information is exchanged.

Attenuated: Said of a whole virus or bacterium that has been grown under adverse conditions or chemically treated so that it is weakened to the point where it does not cause disease but stimulates an adequate immune response.

Autism/Autism spectrum disorder: A life-long developmental disorder of widely varying severity that causes difficulties in verbal and nonverbal communication and social relationships, often with repetitive and unusual behaviors and sometimes impaired cognitive skills. In 2013, the American Psychiatric Association combined several disorders with autism-like symptoms into the diagnosis of autism spectrum disorder.

Autologous vaccine: A vaccine made by using an individual's own cells as opposed to an allogeneic vaccine that is made using cells from the same species but derived from a different individual.

B cell: An antibody-producing cell that is part of the adaptive immune system.

Background rate: The frequency with which an adverse event occurs in an unvaccinated population. This rate is compared to the frequency of the same adverse event in a comparable vaccinated population to help determine if the vaccine causes an increase in occurrence of the adverse event.

Bone marrow: Soft tissue that fills the hollow spaces of bones. Red bone marrow produces stem cells that become erythrocytes (red blood cells), lymphocytes (white blood cells) and platelets. Yellow bone marrow produces stem cells that become fat, bone, and cartilage. Red and yellow bone marrow exist within the same bone cavities.

Cell-mediated immunity: Also called cellular immunity refers to the activation of macrophages, cytotoxic T cells, natural killer cells, and the release of cytokines that mediate the behavior of cells in response to an antigen.

Cephalosporins: A class of broad-spectrum antibiotics that includes cefaclor (Ceclor), cefazolin (Ancef, Kefzol, Zolicef), ceftazidime (Ceptaz, Fortaz, Tazicef, Tazideme), and cephalexin (Keflex).

Chemotaxis: The migration of immune system cells toward cytokines released by other cells.

Cirrhosis: A liver disease in which healthy tissue is replaced with nonfunctioning fibrous scar tissue. The disease can be fatal.

Clinical trial: A research study using humans in which volunteers are assigned to various groups to test the safety and effectiveness of a drug.

Clonal expansion: The ability of a cell to divide and create millions of identical daughter cells.

Cold chain: A continuous system of cold boxes, refrigerators, and freezers used to keep biological products such as vaccines within a narrow specified temperature range during transport, distribution, and storage in order to prevent loss of potency of the product.

Colostrum: A thick yellowish liquid that is the first material secreted by the mammary glands after birth. It is rich in IgA class antibodies that provide the newborn temporary protection against some diseases.

Complement proteins: Proteins triggered by immune system cells that help direct and enhance the immune response.

Conjugate vaccine: A polysaccharide vaccine to which a protein has been added to make the immune system respond more forcefully.

Contraindications: Health conditions that prohibit the administration of a drug or vaccine. These could include allergy to a vaccine component, pregnancy, or a disease or treatment that weakens the immune system. Contraindications vary for each vaccine.

CRISPR (Clustered Regularly Interspaced Short Palindromic Repeats): Consists of short repeated segments of DNA separated by spacer DNA and enzymes that act as a cutting tool. This allows genetic engineers to precisely cut and replace specific bits of DNA.

Cytokines: Small signaling proteins released by cells that control the behavior of other cells and help mediate the immune response.

Dendritic cell: An immune system cell that engulfs a pathogen and then expresses some of the pathogen's protein on its surface (called presenting the antigen) to attract other immune system cells.

Depot effect: Administration of a vaccine in a way that allows slow release and gradual absorption, so that the active agent can act for much longer periods than is possible with standard injections.

Efficacy: The effectiveness of a drug, vaccine, or treatment.

Eicosanoids: A variety of signaling molecules some of which are involved in the development and control of inflammation and allergic responses.

Electrolytes: Salts and minerals that ionize in body fluids. Electrolytes control the fluid balance of the body and are important in muscle contraction, energy generation, and almost all major biochemical reactions in the body.

Electroportation: A needleless technique for delivering a naked DNA vaccine in which the skin is zapped with an electrical pulse to make it more permeable while a gene gun delivers the vaccine.

Encephalitis: Acute swelling and inflammation of the brain.

Encephalopathy: Damage to the brain that can have a variety of causes including infection, inadequate oxygen supply, liver damage, kidney failure, or toxins.

Epiglottitis: Swelling and inflammation of the epiglottis that can interfere with breathing. The epiglottis is a flap of tissue in the throat that keeps food from entering the airways.

Fibroblast: A connective tissue cell that produces collagen and is involved in wound healing.

Glycoprotein: A protein that has a sugar molecule attached to it.

Guillain-Barré syndrome (GBS): A rare syndrome in which the immune system attacks healthy nerve cells resulting in weakness or tingling sensations that move up the body and can cause paralysis. GBS appears to increase after infection with the Zika virus. There has been some controversy over whether influenza vaccination also increases the incidence of GBS.

Herd immunity: Also called community immunity, this condition occurs when a high enough percentage of the population is immune to a contagious disease through vaccination or naturally acquired immunity that there is little opportunity for the disease to spread to nonimmune individuals.

Human albumin: A plasma protein in human blood that is produced by the liver and is used in vaccines as a buffer.

Humoral immunity: Also called antibody-mediated immunity, this refers to the response of antibodies to the presence of pathogens in the blood.

Immune tolerance: The ability of the immune system to recognize and leave unharmed an individual's self cells while attacking foreign cells and material.

Immunity: In medicine, the ability of an organism to resist disease, usually through the development of antibodies against the disease-causing pathogen. In law, exemption from certain legal proceedings, such as being sued or prosecuted for a crime.

Immunocompromised: Having a weakened immune system. Most common causes are chemotherapy, radiation therapy, steroid drugs, HIV infection, and inherited immune system disorders.

Immunoglobulin (Ig): Proteins produced by plasma cells that function as antibodies. There are five classes: IgA, IgD, IgE, IgG, and IgM.

Immunological memory: The ability of T and B cells in the adaptive immune system to recognize a previously encountered pathogen and rapidly activate a defense against it so that the individual does not become sick.

Immunotherapy: Treatment of a disease by administering substances that boost the body's immune system to fight against a specific disease.

Incubation period: The time between exposure to an infectious pathogen and the development of signs and symptoms of the disease.

Inflammatory response: A response to injury or entry of a pathogen into the body that initiates chemical reactions resulting in pain, warmth, redness, and swelling.

Intussusception: A rare type of bowel obstruction in which one part of the bowel folds or "telescopes" in on itself causing a blockage. With prompt treatment, most individuals fully recover.

Leukocytes: White blood cells.

Lymph: A clear, yellowish liquid that contains white blood cells. It flows through lymphatic vessels and is eventually returned to the circulatory system.

Lymph nodes: Also called lymph glands. Small bean-shaped organs located in the lymphatic system that filter out foreign pathogens. In humans they are most prominent in the neck, armpits, and groin.

Malaise: A nonspecific feeling of fatigue and illness.

Memory cell: A long-lived lymphocyte that has encountered an antigen and on reencountering it can initiate a rapid immune response (T memory cell) or make antibodies against the antigen (B memory cell).

Meningitis: Inflammation and swelling of the membrane (meninges) surrounding the brain and spinal cord. Meningitis is caused by many pathogens and toxins, and it can be fatal.

Microcephaly: A congenital condition associated with an abnormally small head and abnormal or incomplete brain development. One cause of microcephaly is infection with Zika virus during certain stages of pregnancy.

Monoclonal antibodies: Cloned identical cells made in large numbers in the laboratory. They produce only one type of antibody, making them useful as a therapeutic agent, especially for certain cancers.

Monovalent vaccine: A vaccine that stimulates antibody formation against only one strain of a particular pathogen.

Mutate: To develop a change in genetic information that can be passed on from generation to generation.

Natural killer (NK) cells: Cells that straddle the line between the innate and adaptive immune system by killing altered self cells.

Opportunistic infection: An infection that would normally be contained by the immune system but that can gain a foothold in the body because the body is weakened by a different infection, most commonly influenza or HIV.

Opsonization: A process initiated by the complement system of coating pathogens with a substance that makes them more visible and attractive to phagocytic cells.

Pandemic: A massive global outbreak of disease. An epidemic is an outbreak on a more limited scale.

Peyer's patches: Small areas of lymphoid tissue found in the wall of the small intestine that promote the development of immunity to antigens found in the gut.

Placebo: A harmless substance given to some volunteers during clinical trials so that their responses can be compared to the volunteers who are given the trial drug or vaccine.

Plasmid: Genetic material found in bacterial cells that replicates independently of chromosomal DNA.

Polysaccharide vaccine: A vaccine against a bacterium that is encased in a polysaccharide (complex sugar) coating.

Polyvalent vaccines: Also called multivalent vaccines, these protect against more than one strain of a specific pathogen.

Postexposure prophylaxis: The administration of a drug or vaccine after known or suspected exposure to a disease with the goal of preventing the disease or reducing its severity.

Primary response: The time it takes for the immune system to make enough antibodies against a pathogen to control disease the first time the pathogen is encountered, usually 10–17 days.

Recombinant vaccine: A vaccine made through genetic engineering in which genetic material that produces an antigenic protein from the pathogen is introduced into a harmless host cell. The host cell then produces the protein for use in the manufacture of a vaccine.

Retinopathy: Damage to the blood vessels that supply the retina at the back of the eye. This damage often causes blindness.

Secondary response: Stimulation of antibody production by memory cells on reencountering a pathogen, usually two to seven days. Rapid secondary response is the basis for active immunity.

Spleen: The largest lymphoid organ in the body. Located to the left of the stomach and below the diaphragm, it produces lymphocytes (white blood cells) and removes old and damaged red blood cells from the blood.

Subunit vaccine: A vaccine made by identifying and isolating the pathogen's antigenic proteins without including any of the pathogen's genetic material.

Sugar glass: A brittle colorless sugar-based substance that used to be used on movie sets to make it appear that actors were breaking through a glass window. Vaccine particles trapped in sugar glass become heat stable.

T cell: Immune system cells that mature in the thymus and help direct the chain of reactions that result in adaptive immunity. There are several subsets of T cells with different functions.

Therapeutic vaccine: A vaccine given to treat a person who is already ill. Much therapeutic vaccine research is directed toward fighting various cancers.

Thimerosal: A mercury-containing compound that has been used since the 1930s as a preservative in some drugs and vaccines.

Thymus: A butterfly-shaped lymphatic organ essential to the production of T cells. It gradually decreases in size after puberty.

Toxoid vaccine: A vaccine against the poison (toxin) produced by a bacterium that causes illness.

Variolation: The process of taking material from a person with a mild case of smallpox and inoculating another individual with this material in the hope that they would develop mild smallpox and immunity against a more virulent case of the disease.

VDJ recombination: The process by which a small number of genes are able to code for millions of different antibodies through an unusual form of DNA recombination. VDJ stands for variable diversification joining.

Virion: A complete virus particle.

Zoonotic: A disease that normally exists in animals but that can be transmitted to humans.

Bibliography

Artenstein, Andrew W., ed. *Vaccines: A Biography*. New York: Springer, 2010.

Barrett, Stephen. "Chiropractors and Immunization." *Chirobase*. March 10, 2015. https://www.chirobase.org/06DD/chiroimmu.html (accessed September 11, 2016).

Biss, Eula. *On Immunity: An Inoculation*. Minneapolis, MN: Graywolf Press, 2014.

Carrell, Jennifer Lee. *The Speckled Monster: A Historical Tale of Battling Smallpox*. New York: Dutton, 2003.

College of Physicians of Philadelphia. "History of Vaccines." 2016. http://www.historyofvaccines.org (accessed August 28, 2016).

Conte, Louis and Tony Lyons. *Vaccine Injuries: Documented Adverse Reactions to Vaccines 2014-2015 Edition*. New York: Skyhorse Publishing, 2014.

Croston, Glenn E. *The Real Story of Risk: Adventures in a Hazardous World*. Amherst, NY: Prometheus Books, 2012.

Curtis, Tom. "The Origin of Aids: A Startling New Theory Attempts to Answer the Question 'Was It an Act of God or an Act Of Man?" *Rolling Stone* 626 (March 19, 1992): 54-59, 61, 106, 108 at https://www.uow.edu.au/~bmartin/dissent/documents/AIDS/Curtis92.html (accessed January 9, 2017).

Daniel, Thomas M. and Frederick C. Robbins, eds. *Polio*. Rochester, NY: University of Rochester Press, 1997.

Deer, Brian. "Exposed: Andrew Wakefield and the MMR-Autism Fraud." *Brian Deer.com* http://briandeer.com/mmr/lancet-summary.htm (accessed December 20, 2016).

Deer, Brian. "Wakefield Filed for a Patent on Vaccine Products before Unleashing MMR Crisis." *BrianDeer.com* http://briandeer.com/wakefield/wakefield-patents.htm (accessed January 4, 2017).

Esperj, Roman. *Should Vaccines Be Mandatory?* At Issue. Farmington Hills. MI: Greenhaven Press, 2014.

Habakus, Louise Kou and Mary Holland, eds. *Vaccine Epidemic: How Corporate Greed, Biased Science, and Coercive Government Threaten Our Human Rights, Our Health, and Our Children.* New York: Skyhorse Pub. 2011.

Heller, Jacob. *The Vaccine Narrative.* Nashville, TN: Vanderbilt University Press, 2008.

Herlihy, Stacy and Allison Hagood. *Your Baby's Best Shot: Why Vaccines are Safe and Save Lives.* Lanham, MD: Rowman & Littlefield, 2012.

Horwin, Michael. "Simian Virus 40 (SV40): A Cancer Causing Monkey Virus From FDA-Approved Vaccines." *Albany Law Journal of Science & Technology* 13 no. 3 (2003) http://www.sv40foundation.org/cpv-link.html (accessed September 13, 2016).

James, Cherry. "Historical Review of Pertussis and the Classical Vaccine." *Journal of Infectious Diseases* 174 suppl. 3 (1996): S259-63.

Kirby, David. *Evidence of Harm: Mercury in Vaccines and the Autism Epidemic: A Medical Controversy.* New York: St Martin's Press, 2005.

Kleinman, Daniel L., et al., eds. *Controversies on Science & Technology*, Vol. 3. New Rochelle, New York: Mary Ann Liebert, Inc., 2010.

Kluger, Jeffrey. *Splendid Solution: Jonas Salk and the Conquest of Polio.* New York: G. P. Putnam's Sons, 2004.

Krishnan, Shobha S. *The HPV Vaccine Controversy: Sex, Cancer, God, and Politics: A Guide for Parents, Women, Men, and Teenagers.* Westport, CT: Praeger, 2008.

Largent, Mark A. *Vaccine: The Debate in Modern America.* Baltimore: Johns Hopkins University Press, 2012.

Link, Kurt. *The Vaccine Controversy: The History, Use, and Safety of Vaccinations.* Westport, CT: Praeger, 2005.

Merino, Noel. *Vaccines.* At Issue. Farmington Hills, MI: Greenhaven Press, 2015.

Mnookin, Seth. *The Panic Virus: A True Story of Medicine, Science, and Fear.* New York: Simon & Schuster, 2011.

Offit, Paul A. *Deadly Choices: How the Anti-Vaccine Movement Threatens Us All.* New York: Basic Books, 2011.

Offit, Paul A. *The Cutter Incident: How America's First Polio Vaccine Lead to the Growing Vaccine Crisis.* New Haven, CT: Yale University Press, 2005.

Offit, Paul A. *Vaccinated: One Man's Quest to Defeat the World's Deadliest Diseases.* New York: HarperCollins, 2007.

"Origin of AIDS Update" *Rolling Stone*, December 9, 1993, p. 39 *at* https://www.uow.edu.au/~bmartin/dissent/documents/AIDS/rs93.html (accessed January 19, 2017).

Palmer, Bartlett Joshua. *The Philosophy of Chiropractic.* Davenport, IA: Palmer School of Chiropractic Publishing, 1909.

Plotkin, Stanley A. and Walter A. Orenstein. *Vaccines.* 4th ed. Philadelphia: Elsevier, 2004.

Price, Daniel. "How It Works." *British Society for Immunology.* http://www.immunology explained.co.uk/HowItWorks.aspx (accessed December 18, 2015).

ProCon.org. "State Vaccinations Exemptions or Children Entering Public Schools." July 8, 2016. http://vaccines.procon.org/view.resource.php?resourceID=003597 (accessed September 7, 2016).

Reiss, Dorit Rubinstein. "Index of Articles by Dorit Rubenstein Reiss." January 2015. *Skeptical Raptor.* http://www.skepticalraptor.com/skepticalraptorblog.php/index -articles-guest-author-professor-dorit-rubinstein-reiss (accessed November 20, 2016).

Rhode, Wayne. *The Vaccine Court: The Dark Truth of America's Vaccine Injury Compensation Program.* New York: Skyhorse Publishing, 2014.

Sanofi. "Making Vaccines—Part 1: The World of Vaccines." June 12, 2012 *YouTube.* https://www.youtube.com/watch?v=-XG6-2AtJiE (accessed January 11, 2016).

Sanofi. "Making Vaccines—Part 2: Vaccine Production." June 12, 2012 *YouTube.* https://www.youtube.com/watch?v=-XG6-2AtJiE, https://www.youtube.com/ watch?v=swmaJRKl6EQ (accessed January 11, 2016).

Scheibner, Viera. "History and Science Show that Vaccines Do Not Prevent Disease." *Health Impact News.* 2013. http://healthimpactnews.com/2013/history-and -science-show-vaccines-do-not-prevent-disease (accessed July 27, 2016).

Science Museum Group. "How Does the Immune System Work?" *Science Museum.* http://www.sciencemuseum.org.uk/WhoAmI/FindOutMore/Yourbody/ Whatdoesyourimmunesystemdo/Howdoesyourimmunesystemwork.aspx (accessed February 7, 2016).

Sears, Robert. *The Vaccine Book: Making the Right Decision for Your Child.* 2nd ed. New York: Little, Brown, 2011.

Thompson, William. "Statement of William W. Thompson, Ph.D., Regarding the 2004 Article Examining the Possibility of a Relationship between MMR Vaccine and Autism." August 27, 2014. https://morganverkamp.com/statement -of-william-w-thompson-ph-d-regarding-the-2004-article-examining-the-possibility -of-a-relationship-between-mmr-vaccine-and-autism (accessed May 27, 2016).

UK Patent Application GB 2 325 856 A https://briandeer.com/wakefield/wakefield -patents.htm

United States Centers for Disease Control and Prevention. "Yellow Book." November 13, 2015. http://wwwnc.cdc.gov/travel/yellowbook/2016/table-of -contents (accessed December 8, 2016).

United States Centers for Disease Control and Prevention. "Pink Book." April 28, 2016. https://www.cdc.gov/vaccines/pubs/pinkbook/chapters.html (accessed May 1, 2016).

"The Vaccine War." DVD. *PBS Frontline*, April 27, 2010. https://www.pbs.org/ wgbh/frontline/film/vaccines (accessed May 16, 2016).

Van Panhuis, W.G., et al. "Contagious Diseases in the United States from 1888 to the Present." *New England Journal of Medicine* 369, no. 22 (November 28, 2013): 2152-2158. http://www.ncbi.nlm.nih.gov/pmc/articles/PMC4175560 (accessed January 7, 2016).

"VDJ Gene recombination" January 20, 2012. *YouTube*. https://www.youtube.com/watch?v=-zEMfAXPLUA (accessed October 5, 2016).

Wakefield, Andrew, et al. "Ileal-lymphoid-nodular Hyperplasia, Non-Specific Colitis, and Pervasive Developmental Disorder in Children." *The Lancet* 351 no. 9103 (February 28, 1998): 637–641. Article Retracted 2004. http://www.thelancet.com/journals/lancet/article/PIIS0140-6736(97)11096-0/abstract (accessed October 7, 2016).

World Health Organization. "National Regulatory Authorities (NRAS) and National Control Laboratories (NCLS) in Countries Producing Vaccines Prequalified for Purchase By UN Agencies." 2012. http://www.who.int/immunization_standards/national_regulatory_authorities/offices/en (accessed July 26, 2016).

World Health Organization. "Vaccine Safety Basics E-learning Course." 2017. http://vaccine-safety-training.org (accessed January 15, 2017).

Young, Leslie (MD). *The Everything Parent's Guide to Vaccines*. Avon, MA: Adams Media, 2010.

Index

About the Author

TISH DAVIDSON, AM, is a medical writer specializing in making technical information accessible to a general readership. She is the author of *Fluids and Electrolytes* and has contributed to *Biology: A Text for High School Students* and *Adolescent Health & Wellness*. Davidson holds membership in the American Medical Writers Association and the American Society of Journalists and Authors.